FIRST UNDER HEAVEN

THE FOURTH HALI ANNUAL
Published by Hali Publications Limited

A catalogue record for this book is available
from The British Library

ISBN 1-898113-35-1

Hali Publications Limited are the publishers of
HALI, *The International Magazine of Antique
Carpet and Textile Art,* which appears bi-monthly

Hali Publications Limited
Kingsgate House
Kingsgate Place
London NW6 4TA
United Kingdom
Tel: (44 171) 328 9341
Fax: (44 171) 372 5924
E-mail: hali@centaur.co.uk

Hali Publications Limited is a member of the
Centaur Communications Limited Group

Editor
Jill Tilden

Associate Editors
Daniel Shaffer
Donald Dinwiddie
Jenny Marsh

Picture Research
Rachel Evans

Design
Anderida Hatch
Liz Dixon

Publisher
Sebastian Ghandchi

Sales & Promotion
Andy Powell
Conrad Shouldice
Angharad Britton
Ralph Emmerson
Christiane Di Re
Piers Clemett

With thanks to Nicholas Purdon, Sheila Scott
and Imogen Tilden for their editorial assistance

Imagesetting
Disc to Print
London, United Kingdom

Colour Origination
Vision Reproductions Limited
Milton Keynes, United Kingdom
The Repro House in association
with Robert Marcuson
London, United Kingdom

Printing & Binding
Snoeck, Ducaju & Zoon
Ghent, Belgium

Cover pictures
Front: courtesy The Hermitage Museum
St Petersburg; Museum für Völkerkunde,
Vienna
Spine: The Hermitage Museum
St Petersburg, photo courtesy LACMA
Back: courtesy Michael McCormick
Collection, New York

FIRST UNDER HEAVEN

THE ART OF ASIA

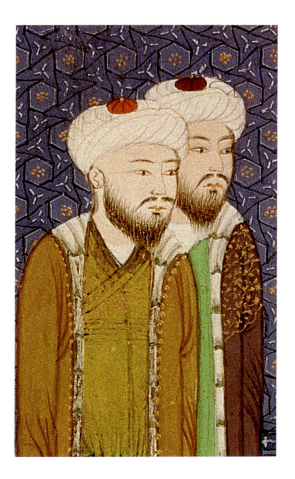

Hali Publications Limited

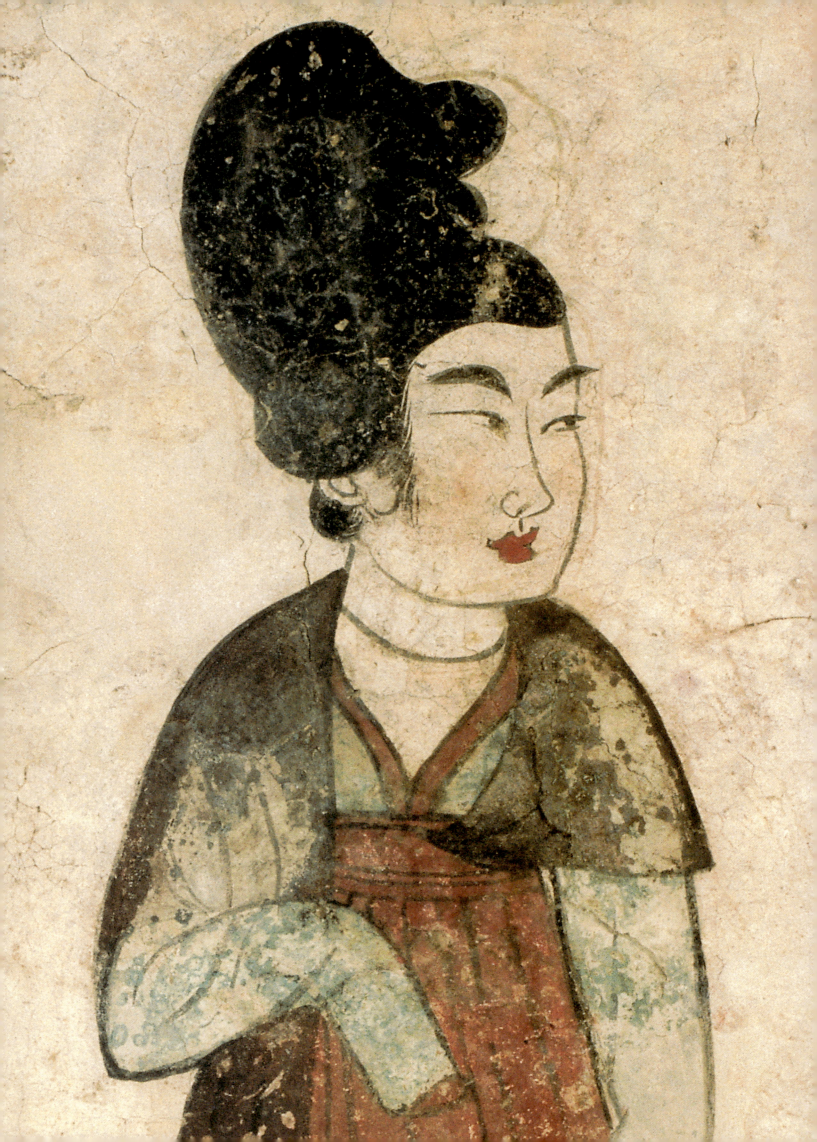

CONTENTS

INTRODUCTION

A visit to the Victoria and Albert Museum's T.T. Tsui Gallery of Chinese Art, which includes in its display crudely faked objects once acquired as genuine by collectors, vividly illustrates the dramatic advance in connoisseurship of the arts of China. The same process of visual familiarisation is taking place in many areas of Asian art but, surprisingly, there are relatively few publications that aim to shed much needed light on art historical topics across the range of cultures that produced these objects.

This book, the fourth anthology in the series, explores the context and meaning of a considerable range of Asian art media. Although vast in both territory and time, this artistic universe is one still characterised by skill and synthesis, in which art provides potent metaphors of authority. The confident assertion of a twelfth century commentator that the celadons of Korea were 'First Under Heaven', typifies a formal hyperbole that exists now only in the debased language of advertising and politics.

Authority and confidence do not of course legislate against subtlety. Questions of art as language, explicit and implicit messages, text and subtext, abound in this year's Annual. Adam Hardy confronts the linguistic analogy head on in his study of the merging of Hindu architectural 'languages' by temple builders in the Deccan. The vocabulary and formal rules of each language provided the medieval architects with a starting point for the creation of complex hybrid forms. Hardy points to the obvious delight they felt in performing vertiginous formal gymnastics in which each element was pushed further and further towards abstraction.

Ernst Grube's study of Timurid decorative art shows the extent to which the medium was the message in Timur's imperial 'garden'. The arts flourished mightily in this visionary empire, drawing strength from the percipient authority of the founder of the dynasty and of his descendants. The vitality of this energetic, ordered and often monumental art, expressed primarily in the two extremes of architecture and the arts of the book, would continue to resonate through the arts of the Safavid, Mughal and Ottoman empires.

The influence of Chinese forms and ideas can be seen in Timurid art of all media. One of the purely Muslim features of this art, however, is the decorative use of calligraphy, which furnishes the subject of Sheila Blair and Jonathan Bloom's essay. Stating that the pen was the first thing created by God, the Qur'an places the whole of life under the sign of written language. This teaching is reflected in the fundamental importance of the written word throughout Islamic art and architecture. The function of inscriptions goes well beyond that of communicating meaning. Within a religious architectural context they create space and focus, emphasising the proportions of the building, while in the case of moveable objects, particularly metalwork and ceramics, calligraphic decoration can offer the viewer a formula for 'reading' the object.

Mark Zebrowski describes the artefacts of gold, silver and bronze produced under the patronage of the Mughal emperors as possessing the "attenuated, ethereal elegance of Islam married to the feeling for weight and volume that ultimately derives from India's great tradition of pre-Islamic Hindu sculpture." One of the most poised and least ambiguous of Islamic art forms, Mughal metalwork represents the balance between power and control that characterises the classical phase of any art. While they have a solemnity and restraint, the objects Zebrowski discusses are also jubilant, even downright glamorous, as in the case of the multicoloured enamel and gold or silver objects that are among the most unforgettable images in this book. Yet in spite of the fundamental importance of metalwork within the Indian cultural tradition these objects are little known and relatively unpublished.

Mughal design elements are among the wealth of influences present in the textile traditions of Indonesia, for example on silk resist-dyed cloths from Java, Bali and Palembang. Drawing on examples in the collection of the Vienna Museum für Völkerkunde, Heide Leigh-Theisen and Rheinhold Mittersakschmöller show the breadth and depth of these traditions, fuelled by iconographic elements derived from Hindu and Islamic, Chinese and European cultures. The cultural richness of these textiles, whose patterns are compared to coded messages, makes of them documents

as cogent as written texts for the understanding of the cultures within which they were (and are) produced.

Mural paintings decorating the imperial Tang tombs, the subject of Ning Qiang's essay, similarly provide a compelling documentation of their time. Descending passageways leading into the tombs are lined with mural paintings, as are those of Egyptian New Kingdom rulers in the Valley of the Kings. But while the Egyptian fresco programmes aimed to secure the tomb occupant's safe passage through the multiple dangers of his journey into the afterlife, the Chinese murals are concerned with communicating messages of temporal power and status. As the political situation deteriorated the messages became more complex. Thus a painting of a polo game not only speaks of courage and resourcefulness but affirms the ascendancy of the heir apparent in the face of powerful and unscrupulous rivals.

It is again the subtext that proves to be crucial in understanding the Tibetan portraits discussed by Jane Singer. Rival claimants to the leadership of Tibet's Buddhist communities looked for ways of asserting their spiritual legitimacy. Portraiture offered them a powerful weapon in this political battle. Beneath the sublime confidence of the images of hierarchs such as Taglung Thangpa Chenpo is a determined effort to emphasise the impeccable nature of the subject's spiritual lineage, borrowing conventions developed for the depiction of Buddhas and Bodhisattvas.

All the Tibetan portraits discussed, whether of Buddhas, secular or religious leaders, stress the spiritual accomplishments of the person depicted. The *Yamato-e* paintings discussed by Stephan von der Schulenburg evoke a very different reality, in which stories of love and adventure unroll in a courtly or fairytale world. Many of these illustrations were commissioned by people from the newly affluent merchant class of the Edo period (1603-1868). The simple, even rustic style of *Yamato-e*, midway between folk art and the sophisticated handscrolls, meant that they were dismissed until recently as unimportant, and many of the examples discussed here are being published for the first time.

Reasons of trade rather than aesthetic judgement lie behind the relative neglect of Korean ceramics, compared to the connoisseurship lavished in the West on Chinese wares. In particular, the excellence of the best Koryo period celadons is too little appreciated. Robert Mowry redresses the balance, tracing the history of celadon production in Korea, which alone with China possessed the technological sophistication to create high-fired stonewares and refined glazes between the eleventh and the fourteenth centuries. Korean potters developed and perfected forms and ideas from the aristocratic Chinese celadon tradition, as well as evolving new techniques such as that of inlaid decoration.

The same qualities of quiet strength and controlled formal elegance are strongly realised – albeit on a different scale – in the classical furniture of the late Ming period. Grace Wu Bruce sees in these wonderfully crafted objects a sculptural sense worked through and integrated into a practical context. Forms such as that of the Eight Immortals table and the yokeback armchair have passed into the design vocabulary for their purity and equilibrium. Such furniture is entirely in harmony with the silk carpets and covers made in Western China during the same period. Little has been written about these weavings: documentation is almost non-existent and examples scarce. This is in part due to the fact that, as Michael Franses emphasises, in Islamic Western China old objects tended to be disregarded in favour of the new, in contrast to the traditional attitude of respect on the part of educated Chinese people for antique craft objects. This essay provides the first thorough overview and discussion of these silk pile weaves, whose designs explore much of the traditional repertoire of Chinese decorative art as well as reflecting the powerful influence of Mughal culture.

Many of the key images in this book are previously unpublished, or found only in limited scholarly sources. Our hope is that this anthology will open up new areas of enjoyment and understanding in the vast resources of the arts of Asia.

Jill Tilden

1

THE WORLD IS A GARDEN

The Decorative Arts of the Timurid Period

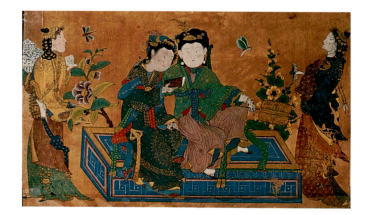

ERNST J. GRUBE

The great warlord Timur (1338-1405) and his descendants ruled an empire that extended across Central Asia and Iran, lasting for almost a century and a half. Their cultural and political legacy was immense and inspired the rulers of the eastern Islamic world – Safavid Iran, Uzbek Central Asia and Mughal India – for generations. Timur's extraordinary artistic patronage responded to his vision of empire: architecture, metalware, ceramics, jades, textiles, stone and woodcarving all served as vehicles for the expression of power and the glorification of his rule and his view of the world as his dominion. A treatise on statecraft, copied in the fifteenth century for a Timurid prince, affirms an ethical ideal of power and justice in which "The world is a garden for the state to master".

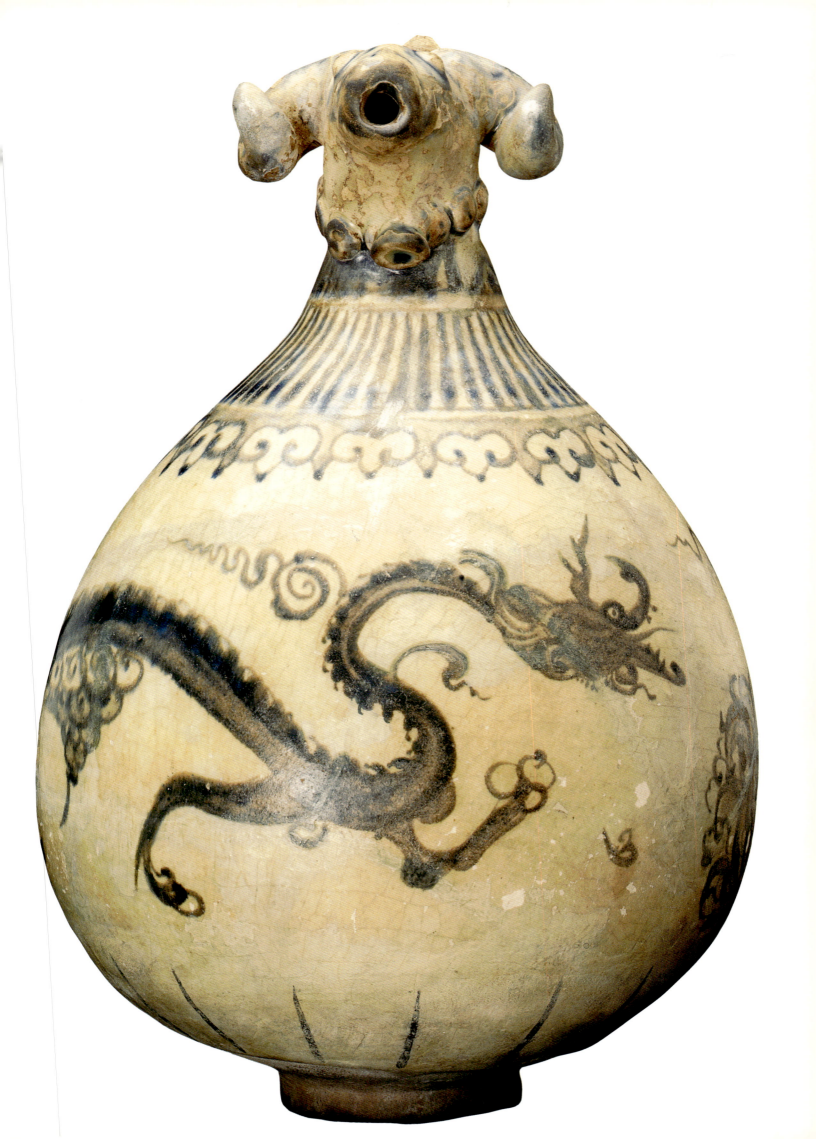

The art of the Timurid period is probably best known for its monumental architecture[1] and the extraordinary paintings that illustrate a large number of magnificent manuscripts of both historical and poetical texts. Many still retain their original bindings, which often match in their elaborate decorations the quality of the illumination of the manuscripts themselves. Both the architecture and the paintings of this period have been well published,[2] the book bindings less so, but relatively little is known of the other arts that flourished at the Timurid courts of Central Asia in Samarkand (Uzbekistan), in Herat (Afghanistan) and in Tabriz, Isfahan, Shiraz and Yazd (Persia). Many fine metal objects inlaid with gold and silver,[3] carved stonework, woodwork and jade, gold and silver jewellery, and underglaze painted pottery of a great variety of shapes and types of decoration – the most widely appreciated being that painted in blue on a white ground – have survived, but very little of it is known to a wider audience in the West.[4]

Timurid art takes its name from the founder of the dynasty – Timur, or Tamerlane, as he is better known in European languages, a name derived from Timurlenk (Timur the lame), referring to a crippling wound to his leg in early youth. An almost mythical figure, Timur rose to power about 1370 in the territory of the Ulus Chaghatay in the eastern territory of Central Asia. He was the last of the great nomad conquerors and rulers. Claiming descent from Chingiz Khan through marriage to Serai Mulk Khatun, daughter of Kazan Sultan Khan,

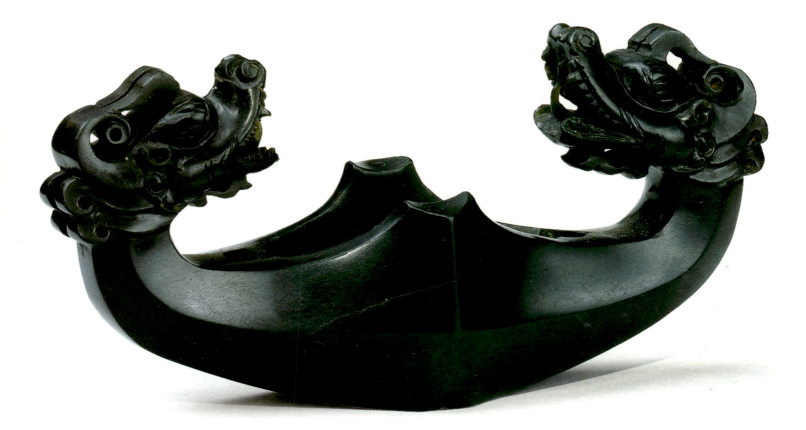

a direct descendant of that 'world conqueror', he effectively reunited the old Mongol empire.[5] Serai Mulk Khatun became Timur's favourite wife and the mother of his favourite son and successor Shah Rukh (1405-47), who ruled the empire for almost half a century after his father's death.

Timur carved out for himself an immense empire in Central and Western Asia and Iran, leaving it almost intact to Shah Rukh, who established his own court in Herat, while Samarkand became the capital in turn of *his* son Ulugh Beg, who for the brief period of two years succeeded to the throne after his father's death in 1447. The vast territories ruled over by Timur were divided into regions administered by his sons and nephews, most of them highly sophisticated patrons of the arts: Umar Shaykh (1354-94) and his son Iskandar Sultan (1384-1415), first in Ferghana (northeast of Samarkand, today's Khirgizia), then in Shiraz (Fars, southern Persia), taken over by Ibrahim Sultan (1394-1435), Shah Rukh's second son, after Iskandar's revolt against his uncle and his death in 1415. Iskandar Sultan was probably the greatest of the bibliophiles of the dynasty; major manuscripts commissioned by, or

*4. Binding of a manuscript
of Amir Khusrau Dihlavi's
Hasht-Bihisht, copied and
illustrated in Herat in 902* AH
(1496-1497 AD*). One of the very
few polychrome painted and
lacquered bindings of the period
that have survived intact.
Topkapı Saray Museum,
Istanbul, H. 676.*

*5. Folio with marginal drawings
of addorsed fishes (detail), in
Iskandar Sultan's Anthology,
copied and illustrated in Shiraz
in 813-814* AH *(1410-1411* AD*).
The British Library, London,
Add. 27261, fol. 408v.*

attributable to him, date between 1397 and 1411;[6] they testify to this prince's extraordinary erudition and interests and his unsurpassed artistic sensibility. His cousin, Ibrahim Sultan, inherited some of Iskandar's artists and created an important school of painting in his own right in Shiraz; he was also a noted calligrapher. Baysunghur Mirza (1399-1434), Shah Rukh's fifth son, never ruled, although he governed for a period of time in Tabriz (Azerbaijan, northern Persia) in his father's name, and later established a court and cultural centre of his own in Herat, where some of the finest illustrated manuscripts of the period were created. He was himself one of the truly great calligraphers of his time.

The struggle for power that erupted among Timur's successors after Shah Rukh's death resulted in a period of great confusion, political instability and, eventually, the loss of territory to the Turkomans in northwestern and then central and southern Iran. By about 1468, however, Sultan Hussayn Bayqara (1438-1506) managed to regain political power, restoring as the capital of the realm Herat, where a second flowering of Timurid art and culture took place. In the meantime the Turkomans, who had wrested considerable territory from the

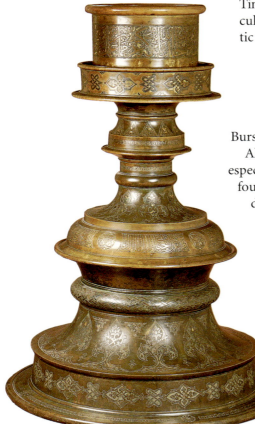

6. *Bronze oil lamp, commissioned by Timur for the Shrine of Ahmad Yasavi in 1396. Height 85.5 cm (34"). According to an inscription engraved at the base this object was made by Izzuddin (ibn) Tajuddin Isfahani in ramadan 799 AH (October 1396 AD). The Hermitage Museum, St Petersburg, SA-15931.*

7. *Bronze water basin, commissioned by Timur for the Shrine of Ahmad Yasavi in 1397. Height 158 cm (62"), diameter 243 cm (96"). The Hermitage Museum, St Petersburg, SA-15930.*

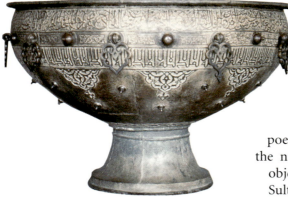

Timurids in the west and made Tabriz their capital, inherited much of early Timurid culture; their buildings and many of their decorative arts continued Timurid artistic trends.[7] Finally, when the Safavids defeated both the Turkomans and the Timurids, Timurid material culture was not extinguished but, quite to the contrary, passed on to the Safavids a rich and long-lasting heritage. The fifteenth century is, in fact, one of the most glorious periods in the history of Muslim art and culture. The arts of the Timurid and Turkoman courts lived on at the courts of the Uzbeks in Bukhara, the Safavids in Tabriz, the Ottomans in Bursa and Istanbul, and the Mughals in India.[8]

Albeit clearly indebted to the cultural traditions of the eastern Muslim world, especially of Central Asia and Iran, which had been conquered by Timur in the later fourteenth century and then ruled by his successors throughout the fifteenth, the decorative arts of the Timurid world were also, in one way or another, profoundly inspired by the arts and iconography of China. It was to China that the Timurids looked for inspiration, and it was in Chinese decorative arts that Timurid artists often found their most immediate models. Delegations from China, bringing rich and varied gifts, came regularly to Timur's court and, almost annually, Timurid visitors were received at the court of the Chinese emperor.[9] Not only did the exchange of gifts have an important impact on the production of art forms in the Timurid lands, but the Chinese continually traded their goods – especially patterned silks and painted porcelains – in the 'West'. In fact, the Muslim world had obtained Chinese porcelains from the earliest centuries of Muslim rule onwards, imports in numbers that increased during the Ilkhanid (Mongol) period when China itself was ruled by a Mongol dynasty, the Yuan. Historical records and finds of Chinese objects, especially porcelains, in the West make clear that the cultural contact between China and the eastern Muslim world was intense, especially during the Timurid period, and the appearance of Chinese motifs in Timurid art is only too obviously due to these continuous contacts.

Timurid art is especially obsessed, it would seem, with the dragon. It appears everywhere: in paintings and drawings,[10] on book bindings (4),[11] jades (3, 13),[12] and on metalwork – as in a group of candlesticks with dragon-headed candleholders (10),[13] and as handles of engraved, inlaid jugs (8),[14] as well as on woodwork (15), on jewellery (9, 11) and upon painted pottery (2).[15] Textiles, few of which have survived but which are represented in every conceivable variety in Timurid paintings, were equally inspired by Chinese models, especially in their gold embroidered figurative patterns and in certain details, such as the so-called cloud collars which appear in Timurid painting as early as the end of the fourteenth century.[16] A famous embroidered cloud collar in the Kremlin Treasury (32) has recently been attributed to Iran in the first half of the fifteenth century.[17]

While it is true that the decorative arts of the Timurids owe a profound debt to the arts of China, at the same time they developed a visual language entirely their own. Indeed it would be impossible, even in the case of almost direct 'copying' (as with some of the later fifteenth century blue and white decorated pieces of pottery – see 23), for a work of Timurid art to be mistaken for Chinese. Subtle changes in the use of Chinese motifs, or the incorporation of such motifs into basically non-Chinese pattern structures, the application of traditional geometric designs, not to speak of the entirely Muslim use of Arabic calligraphy for its decorative quality but more frequently as a significant, and integrated element, adds an extra dimension and meaning to the work of art so 'decorated'. These objects have a special quality that is unmistakable, truly original and full of genuine energy and life.

The use of inscriptions as part of an object's 'decoration' is an age-old tradition in Islamic art. Apart from its monumental application in architectural decoration, it is particularly prominent on the metalwork of this period, of which a considerable amount has survived. The pieces are engraved with floral arabesque patterns which contrast with inscriptions contained in cartouches. These are often poetry, but not infrequently they also include artists' names and dates, and the names of the patrons for whom they were made. Several monumental objects made for Timur himself have survived, as have objects made for Sultan Hussayn Bayqara, the last of the great Timurid rulers.[18] To Timur is due

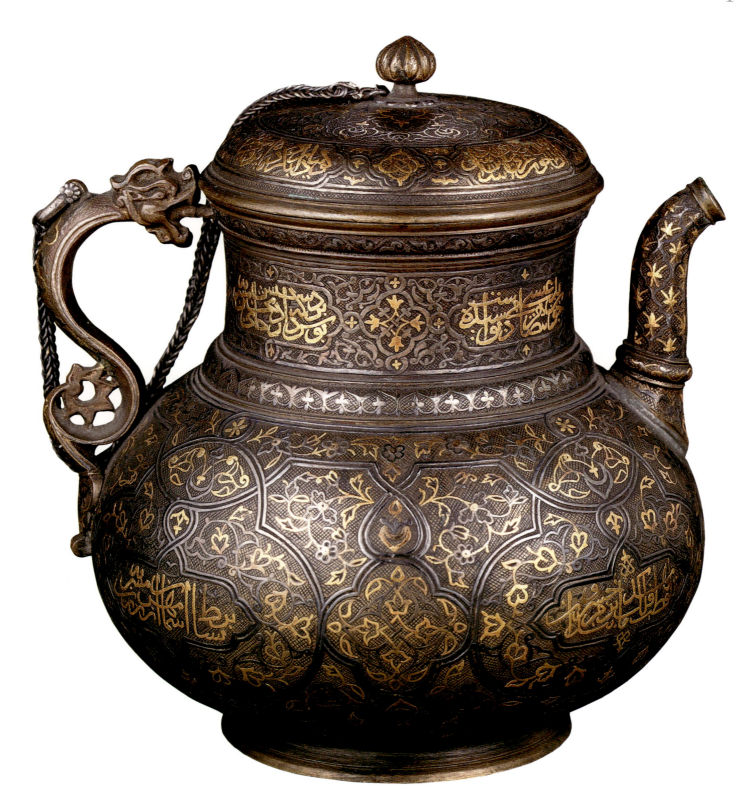

8. *Brass jug with silver and gold inlay, probably made in Herat by Hussayn Shams [al-Din] Shihab [al-Din] al-Birjandi in rabi' al-awwal, 871 AH (October-November 1466 AD). Height 16.5 cm (6¹/₂").* *Türk ve Islam Eserleri Müzesi, Istanbul, 2961.*

a set of oil lamps (**6**) and a monumental water basin (**7**), made for the Shrine of Khwaja Ahmad Yasavi in Yasi, Turkestan, the burial place of the twelfth century Sufi Shaykh (d. 1166) to whom Timur was devoted and whose shrine he visited in 1396. He ordered a new, monumental shrine to be erected over the Shaykh's tomb and commissioned its furnishings, including the metal objects.[19] Many of these objects, made both of bronze and of brass, are inlaid with copper, silver and gold, creating a sumptuous surface of delicately intertwined geometric, floral and calligraphic patterns.

One of the finest pieces of the later fifteenth century (**8**), retaining its original cover, and with a spout – a somewhat unusual feature – is inscribed with the name of the artist who made it: Hussayn Shams [al-Din] Shiha[b al-Din] al-Birjandi. It is also dated: "in [the month of] *rabi' awwal* [in the] year eight hundred and seventy-one" (October-November 1466). The artist is known from other vessels of this type, where he adds to his *nisbah* (place of origin) a second such indication: "al-Quhistani". Birjand is, in fact, a city in Quhistan

9. Silver bracelet, Samarkand, first half 15th century. The Metropolitan Museum of Art, New York, 64.1333.3-4.

(Khorasan), which was, it would seem on the evidence of many such Khorasani *nisbah*s, an important centre of metalwork production in the second half of the fifteenth century.[20] Its features are quite typical: the rich gold and silver inlay; the combination of a division of the body's surface into geometric cartouches containing abstract, as well as freely flowing floral, patterns and inscriptions of poetry; the articulated snake-like dragon which forms the jug's handle; and the inscription on the base with the maker's name and the date. All these are features found on many Timurid metalwares, but here they are combined to perfection. The piece also demonstrates the close relation between the decoration of Timurid objects and the designs of the illuminators of manuscripts. Many, if not all, of the decorative elements – the cartouches, the floral scroll and arabesque patterns, the fan-shaped leaves and multipetalled flowers – appear in the chapter headings and marginal decorations of contemporary manu-

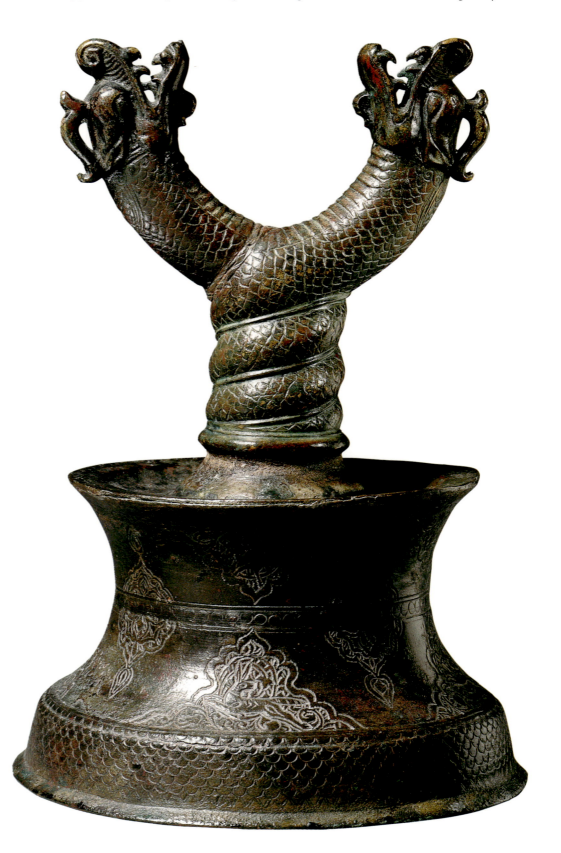

10. Bronze candlestick, Herat or Samarkand, first half 15th century. Height 25.1 cm (10"). The David Collection, Copenhagen, 38/1982.

scripts,[21] as they equally decorate stone- and woodwork, book bindings and carpets (as rendered in paintings of the period). Metalwork of this type continued to be made into the sixteenth century.

Figurative motifs, so frequently encountered on earlier Persian metalwork, do not seem to have been employed in the Timurid period. This is curious, as most of the objects in question appear to have served personal and non-religious functions. Painting, which flourished in this period as almost never before in the Muslim world, clearly demonstrates that the Timurids had no aversion to the representation of figural subjects. Animals were frequently incorporated into decorations of objects in this period. Mention has already been made, for example, of elaborate renderings of dragons on carved woodwork, jades (**3, 13**) and jewellery (**9, 11**). The candlestick illustrated (**10**) is from a series with candleholders in the form of

11. Gold ring with jade seal, Samarkand, first half 15th century. Diameter of seal 3.5 cm (1¹/₂"). The Metropolitan Museum of Art, New York, 12.224.6.

12. Carved wooden doors, Shrine of Ahmed Yasavi, Yasi, Turkestan, built by order of Timur between 1396 and 1399.

snake-like dragons; the bell-shaped bases are decorated with engraved floral patterns in some of which appear small animals.

Bookbindings are a particularly good example of this tendency. Entire landscapes populated with all kinds of creatures, including angels and demons, cover the outsides of many of the finest leather bindings of the fifteenth century. The designs are generally executed in delicately moulded relief which was often gilded (the gold often now worn away). A small number of surviving bindings are executed in polychrome paint that was then lacquered. Again, these are profoundly inspired by Chinese models, for dragons, phoenixes and *qilin* form the principal elements of their figurative designs.

The finest surviving such binding covers a copy of Amir Khusrau Dihlavi's *Hasht Bihisht* (**4**) that was copied in Herat in 902 AH (1496-97 AD).[22] In perfect condition, its red and gold designs on a black ground present the full range of Timurid design: on the outside, a central-lobed medallion contains a landscape with lion-*qilin*s under a tree, and pairs of addorsed fishes appear in the small appended medallions, a motif also encountered in marginal deco-

13. *White jade ewer, made for Ulugh Beg in Samarkand, between 1417 and 1449. Height 14.5 cm (5 ³/₄"). Inscribed on the neck with the name and titles of Ulugh Beg ibn Shah Rukh Gurkani. Calouste Gulbenkian Museum, Lisbon, 328.*

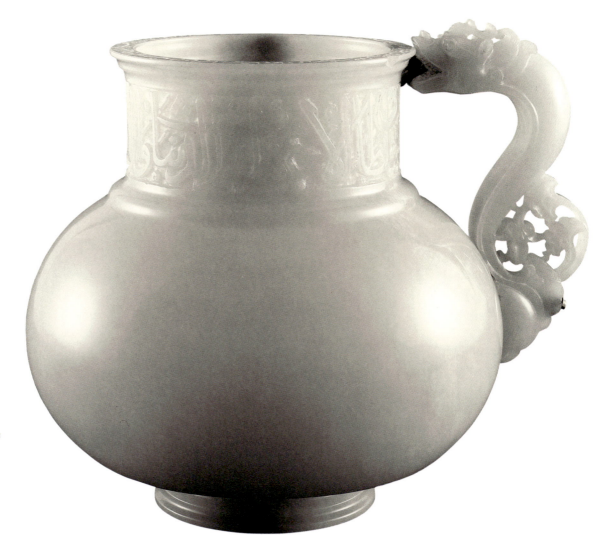

14. *Jade cup (Cheng), Chinese, late 14th century, inscribed with the name and titles of Ulugh Beg. 6.4 x 19.4 cm (2½" x 7³/₄"). The cup was probably a gift of the Chinese delegation that visited Samarkand in 1445. The British Museum, London, OA 1959.11-20.1(36).*

15. *Carved sandalwood casket made for Ulugh Beg in Samarkand, between 1417 and 1449. 19.5 x 17 x 31.2 cm (8" x 6½" x 12½"). Topkapı Saray Museum, Istanbul, 2/1846.*

rations in manuscripts (**5**) and in the pottery of the period (**22**). The central medallion is set against an elaborate floral background executed exclusively in gold. Twisted dragons occupy the corner sections, and the outer frame is filled with an elegant polychrome floral double scroll with elongated half palmette leaves and large fan-shaped leaves. The inside is devoid of figurative elements but is as fine as the outside. Its field is black, and is divided by an intricate abstract geometric pattern creating a number of interlocking cartouches. The black background is decorated with highly abstract floral patterns and large sinuously moving cloudband designs. The outer border is filled with a delicately intertwined double scroll with slender half palmette leaves and small blossoms executed in black, white, grey, red and orange against an (originally) bright yellow background. No other surviving lacquer binding from the Muslim world matches this in its richness of patterns and elegance of execution.

Indeed, many bindings of the period display only abstract patterns, the ubiquitous cloudband often being used as the principal motif.

The magnificent doors to the shrines, tombs and mosques of the period both in Central Asia and in Iran are among the many surviving woodcarvings (**12**). Combining geometric and floral patterns with monumental calligraphy, they testify to the highly developed sense of ornament that is, of course, best represented by the decoration with polychrome tilework of the buildings themselves.

A particularly fine wooden object on a much smaller scale is a sandalwood box[23] made for Ulugh Beg, one of Timur's grandsons, who made his residence in Samarkand after the emperor's death in 1405 (**15**). This clearly documented association with the Timurid royal family makes the box an object of exceptional art historical interest. The most striking aspect of its decoration is the highly controlled floral design. What would at first appear to be a

simple, repetitive, overall pattern covering the -entire casket reveals itself, on closer inspection, to be delicate and differentiated in design and scale, according to the areas decorated. On the front and the back of the casket are elongated polylobed cartouches, in which scrolls with large leaves and blossoms are arranged. They are set against a background filled with tightly intertwining scrollwork of a more abstract nature, consisting almost exclusively of a half palmette arabesque scroll with only the tiniest leaf and flower additions. This same scrollwork also appears in the quatrefoil superimposed on the scrollwork in the centre of the larger cartouches, as well as inside the quatre-lobed medallions (only partially seen at the ends of the long sides).

The arrangement is reversed on the narrow sides of the casket. The larger scroll with flowers and blossoms fills the background, and the central polylobed cartouche and the quarter sections of the cross-shaped cartouches in the corners of the field are filled with a fine, abstract arabesque scroll. A similar arabesque scroll fills the slanting panels of the casket's cover and the field of its top. Against that background are superimposed three polylobed medallions, in between which are two sets of elongated cartouches with circular appendages. The outer lobed medallions are filled with small-scale scrollwork that appears to be a combination of the leaf and blossom and the arabesque scroll, arranged

around a central stellate floral device. The central medallion carries the figure of a thin-bodied snake-like dragon twisted into an undulating, almost circular form; the creature spits fire and is surrounded by flickering flames.

The elongated cartouches contain inscriptions with the name and titles of Ulugh Beg; the small circular appendages bear highly abstract arabesque devices. The entire field is surrounded by a narrow frame filled with a simple continuous floral scroll with large feathery leaves. The inscription reads: "The Sultan, the Greatest and the Khaqan, the Noble (or the Bountiful), the Tranquillity (or the Protection, or the Peace) of the Age (or the World) Ulugh Bayk (Beg) Gurkan." This last honorific 'title' is a Persian rendering of the Chaghatay Turkish *küragän*, derived from the Mongol *khurghen*, meaning son-in-law, a title that emphasised Timur's family connection with the line of Chinghiz Khan through his marriage to Serai Mulk Khanum in 1369.[24] The title was adopted by Ulugh Beg in 1417 and used until his death in 1449, which gives a precise date for the object and indicates Samarkand, the prince's residence, as the place where it was made.

In fact it is in Samarkand that some of the finest carved wooden doors have survived, the city being at the time probably the most active in the production of works of art of all kinds, continuing the traditions established by Timur himself. Most of the decorative elements of Ulugh Beg's casket, and the dragon figure itself, can be traced back in Timurid decorative design to the manuscripts created for Iskandar Sultan, another of Timur's grandsons, who had served with his father Umar Shaykh in Farghana (the region northeast of Samarkand, today's Khirgizia) at the end of the fourteenth century. He was thoroughly familiar with both Chinese and classical Persian traditions.

Jade carving is another craft that flourished in Samarkand at this time, as is proven by the inscription on the neck of the white jade ewer **(13)** in the Gulbenkian Collection,[25] identical in its style of writing and containing the same formulas as appear on Ulugh Beg's casket. It is inscribed on the neck with the name and titles of Ulugh Beg ibn Shah Rukh Gurkani: "The Sultan, the most mighty saviour of the world and of religion, Ulugh Beg Gurgan – may his reign and power endure forever". It was Ulugh Beg who procured the monumental slab of

16. Lustre-painted tile, Persia or Central Asia. 30.4 x 21 cm (12" x 8¹/₂"). The tile formed part of a building inscription recording a foundation of Abu Sa'id (ibn Sultan-Muhammad ibn Miranshah) in 860 AH (1455 AD). The Metropolitan Museum of Art, New York, 30.95.26.

17. Fragmentary lustre-painted ceramic bowl, Persia or Central Asia, dated 822 AH (1419 AD). Diameter 28 cm (11"). This is the only 15th century piece of lustre-painted pottery to survive, other than tilework. Sold at Drouot, Paris, October 2nd, 1986, lot 235, present owner unknown.

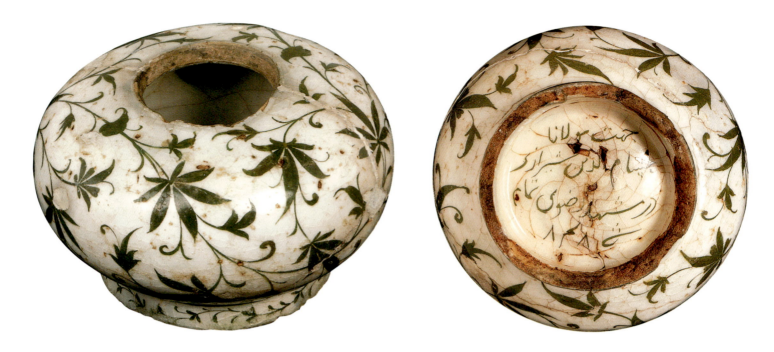

18. *Fragmentary underglaze-painted vessel, made in Mashhad in 848 AH (1444-1445 AD), for Maulana Husam al-Din Shirazi. Height 6.6 cm (2½"). National Museums of Scotland, Edinburgh, 1888.570.*

dark green jade for his grandfather's sarcophagus in the Gur-i Amir in Samarkand, which he brought home as booty after his defeat of the ruler of Moghulistan in 1425.[26] It is also Ulugh Beg's name that is engraved on a Chinese jade cup in the British Museum (14). It has been suggested that this piece was actually made in Central Asia copying a Chinese original, but more recently an attribution to a Chinese workshop has been accepted also by Chinese scholars. It was probably a gift of the Chinese delegation that visited his court in 1445.[27] A considerable number of Timurid jade jugs and cups survive, one of them in Varanasi (Benares) again inscribed with the name and title "Ulugh Beg Gurkani".[28] A fair number of uninscribed cups and ewers with dragon handles have also survived,[29] and while some of these pieces may be difficult to date, there seems little reason to doubt that the use of jade in Timurid art goes back to the earlier fifteenth century, as, for instance, the magnificent dark green jade quillons in New York (3), for a long time thought to be of Chinese rather than Central Asian workmanship.[30] So close an affinity to Chinese models might indicate that the quillons were perhaps made during Timur's reign.

Very few of the immense variety of other beautiful objects produced at Timur's court have survived, but we have descriptions of many of them, and of others that were collected by the emperor or brought to him by numerous visitors. Ruy Gonzalez de Clavijo, the ambassador of King Henry III of Castille, visited Samarkand in the year preceding Timur's death; he describes the lavish receptions he witnessed and tells of the presence of a delegation of Chinese envoys. They were, in fact, one of many such delegations to Timur (who, in turn, had been sending annual delegations to the Ming court since 1387), and among the many

19. *People in a landscape with a china cart, album painting attributed to an atelier active in the late 14th or early 15th century in Central Asia (Samarkand or Herat). Topkapı Saray Museum, Istanbul, H 2153, fol. 130r.*

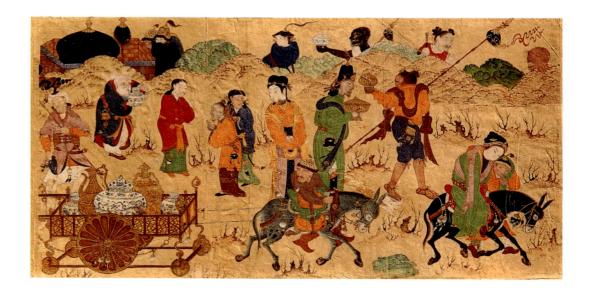

objects they brought were, of course, Chinese porcelains. Clavijo especially mentions these porcelains, used for serving meat, at one of the many receptions he attended:[31]

> The slices of meat were placed in large trencher-like basins, some of gold and some of silver, while others were of vitrified earthenware, or else of what is known as porcelain, and these last are much esteemed and of very high price.

Such porcelains, imported into all parts of Southeast Asia, India, Central Asia and Iran, greatly inspired local ceramic makers to emulate both their quality and beauty of design.

There must have been a thriving Timurid manufacture of ceramics of all kinds, as witnessed by the unmatched polychrome tilework produced in immense quantities for architectural decoration. Yet Timurid pottery is little known in the West. Only very recently have attempts been made to reconstruct this art form from the surviving fragments found in excavations in Central Asia and various parts of Iran, and to construct a framework into which may be fitted much of the surviving material not found in controlled excavations or surface surveys. Only a handful of dated objects survive. The earliest piece, a fragment of a rather tradition- ally decorated lustre bowl (**17**), dates only from 1419,[32] and a number of lustre painted tiles (**16**) from a building inscription of Abu Sa'id ibn Sultan Muhammad ibn Miranshah of 1455[33] demonstrate the long survival of lustre painting in the Timurid period.

20. Small blue-and-white deco- rated ceramic bowl, Central Asia or Persia, about 1410. Diameter 20 cm (8"). Found in the 'House of the Mosque', gateway to the mosque in Kilwa (Kenya), built about 1420. National Museum, Dar es-Salam.

21. Small polychrome decorated ceramic bowl, so-called lajvardina ware, dated muharram 778 AH (May 1376 AD). Diameter 17 cm (6³/₄"). The Nasser D. Khalili Collection of Islamic Art, pot 503.

22. *Blue-and-white ceramic bottle, Khorasan, later 15th century. Height 32 cm (13"). The Nasser D. Khalili Collection of Islamic Art, pot 1118.*

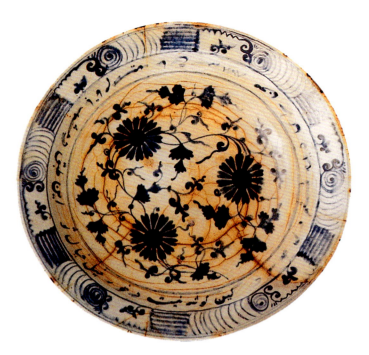

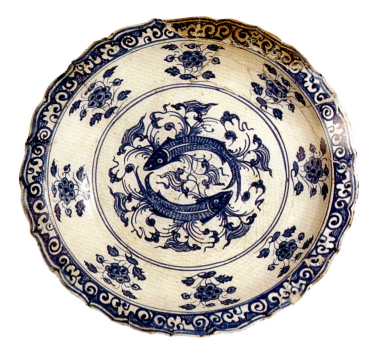

The first underglaze painted 'blue and white' piece dates from 1444 (**18**).[34] Circumstantial dating is possible in a few cases, such as the group of small ceramic vessels embedded in the vaults of a gateway to the mosque in Kilwa (Kenya) erected around 1420 (**20**).[35] They allow further precision in the assessment of material from the late fourteenth to the mid-fifteenth century, for this pottery is not of local production but imported either from Central Asia – as the finds on the Timurid citadel of Samarkand prove[36] – or from Khorasan (Eastern Iran), where finds in Nishapur and Mashhad have proved a long established tradition of ceramic making that may be documented further by historical references to families of potters in the region.[37] It is obvious that the widespread import of Chinese underglaze painted porcelain, especially of the blue-and-white variety, created a fashion that appears to have begun in the later fourteenth century, if we are to trust their representations in paintings of the period (**19**).[38] The earlier, pre-Timurid tradition appears to have been continued without major changes – even such techniques as the overglaze painting known as *lajvardina* (**21**), which is documented as late as 1376.[39] But soon the impact of the Chinese blue-and-white fashion makes its appearance. Pottery with basically non-Chinese design structures begins to incorporate elements 'borrowed' from the Chinese repertoire; and these soon give way to truly Chinese patterns (**2**) which then dominate Timurid ceramic decoration. This fashion continued for several centuries. There is no true break between the products of the Timurid kilns at the beginning of the sixteenth century and those produced in kilns operating after the demise of Timurid political power and the takeover, by the Safavids and Uzbeks, of the various regions that had been under Timurid sway.[40]

Among the dated material of the second half of the fifteenth century are pieces that allow us to establish a grouping of both underglaze blue-and-white and black slip-painted pieces. A fine plate[41] in the Hermitage made in 1473-74 in Mashhad (**23**) provides a focal point for a large number of blue-and-white 'peony' plates and much related material (**24**). A magnificent blue-and-white bottle in the Khalili Collection (**22**) clearly belongs to the same group, as indicated by both the potting and glazing, and the decoration of addorsed fish pairs and cloudbands, reserved in white in the cobalt blue ground. Two plates in Rome and Baltimore, dated 1468-69 and 1480-81 respectively,[42] are of equal importance for the attribution and dating of a very large number of related pieces of pottery, although these are decorated with underglaze slip painting in black under a cobalt blue, or at times a deep green, glaze (**25**).[43] Pieces decorated in the same manner on a white ground under a translucent colourless glaze

23. Blue-and-white ceramic plate, Khorasan (Mashhad), dated 878 AH (1473-1474 AD). Diameter 35 cm (14"). The Hermitage Museum, St Petersburg, VG. 2650.

24. Blue-and-white ceramic plate, Khorasan, late 15th century. Diameter 37.1 cm (14½"). The Hermitage Museum, St Petersburg, VG-730.

25. Underglaze slip-painted ceramic plate, Khorasan, (Nishapur), second half 15th century. Diameter 36.9 cm (14½"). The Metropolitan Museum of Art, New York, 17.120.72.

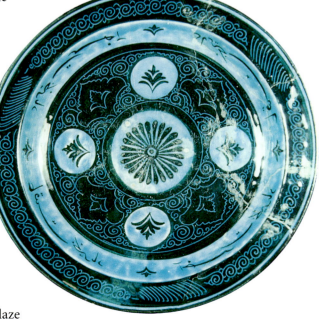

26. The silk 'Chess Garden' carpet (detail), attributed to Central Asia, late 14th-early 15th century. 168 x 368 cm (5'6" x 12'1").

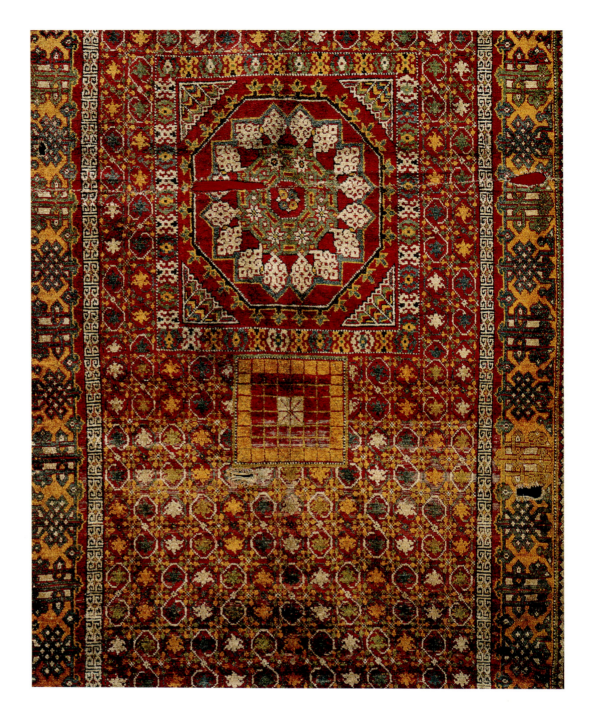

27. Fragment of a carpet, attributed to the 15th century, 30 x 65 cm (12" x 25½"). Benaki Museum, Athens, 16147.

have also survived in considerable numbers and must be dated to about the same period.[44]

The last but not least focus of this brief survey of Timurid decorative arts – textiles and rugs – has been left to the end. The reason is only too obvious: while Timurid paintings are full of textiles, costumes and rugs, only a few scraps have so far been identified as being incontrovertibly of the Timurid period. A small fragment of a rug in the Benaki Museum in Athens (**27**) has convincingly been attributed to the fifteenth century.[45] A large rug with an allover floral pattern and a chessboard woven into the fabric of the rug (**26**) has, equally convincingly, been attributed to the Timurid period and may actually have been produced in Timur's own time.[46] A few textiles – for instance, the brocade that lines the inside of Ulugh Beg's wooden casket in Istanbul[47] – have also been attributed to the same period. But the vast majority of costumes and textiles depicted in Timurid paintings, not to speak of the very large number of rugs, have as yet to find counterparts in surviving objects.

While I used to amuse my students in the 1960s by pointing out that fifteenth century Flemish and Italian paintings were full of nineteenth century rugs, it seems now that many scholars in the field have come to accept the fact that a larger number of surviving rugs than so far acknowledged should indeed be dated into the fifteenth century. In comparing such rugs with representations in Timurid paintings as well as some of their design

details with those of Timurid ceramic decoration, especially Timurid ceramic tilework, a considerable affinity between the designs in both areas of craftsmanship will be noticed. These may lead, in the future, to a more accurate identification of other rugs as products of Timurid looms. Yet, for the time being, we must rely on the problematic evidence of pictorial representations.[48]

There can be little question that contemporary painters are unlikely to have depicted anything with which they were not familiar, and it is not unreasonable therefore to assume that the objects and costumes that appear in the miniature paintings of the period were actually

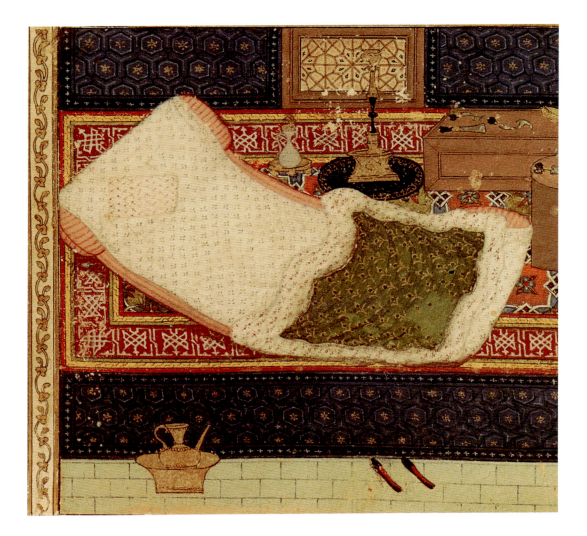

28. *Detail of a painting in a manuscript of Nasr Allah's Kalilah wa Dimna, copied for Baysunghur in Herat in 834 AH (1431 AD). Topkapı Saray Museum, Istanbul, H.362, fol. 36v.*

29. *Oil lamp (chiraghdan), made by order of Abu'l-Nasr Sultan Hasan beg Bahadur, known as Uzun Hasan, ruler of the Aqquyunlu Turkoman dynasty in Tabriz between 1470 and 1478, probably for the mausoleum of Haci Bayram Veli in Ankara. Height 121 cm (48"). Private collection.*

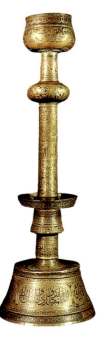

used and worn by contemporaries. However, this can only be taken at face value when an object, or a certain costume form, appears for the first time. Even then, the question arises whether we have an accurate record of the painter's immediate personal experience, or whether he did not derive his inspiration from a pictorial, rather than a 'real life', source. The fact that the painters of the period relied heavily on older compositions, which were often repeated 'verbatim', is well known.[49] It is therefore advisable to be cautious in the interpretation of the material world that is rendered in the paintings of the period.

With such reservations in mind, it is still possible to reconstruct in many instances details of the lost works of art that have been described by visitors to the Timurid courts. In some instances surviving objects, such as the curious composite oil lamp/candlesticks (*chiragh-dan*), can assure us of the validity of the representation of objects in a painting. Such a *chiraghdan* is depicted in two paintings illustrating episodes of Nasr Allah's *Kalilah wa Dimnah* which were re-used in a manuscript copied for Baysunghur Mirza ibn Shah Rukh in 1431 (**28**).[50] If the attribution of the paintings to the period around 1400 is accurate, these are the earliest representations of this type of object, and they correspond perfectly to surviving examples.[51] The type survives into the later fifteenth century (**29**).[52] It is therefore not unreasonable to assume that other objects in these paintings may equally be understood as documenting objects existing at that time, although they may not be new forms only recently invented. There are rugs and blankets, costume details, and several other objects, including a

30. Farhad brought before Khusrau, painting in a copy of the Khamseh of Nizami, copied and illustrated in Herat in 849 AH (1445-46 AD), fol. 62r, 14.8 x 10.7 cm (6" x 4½"). Topkapı Saray Museum, Istanbul, H.781.

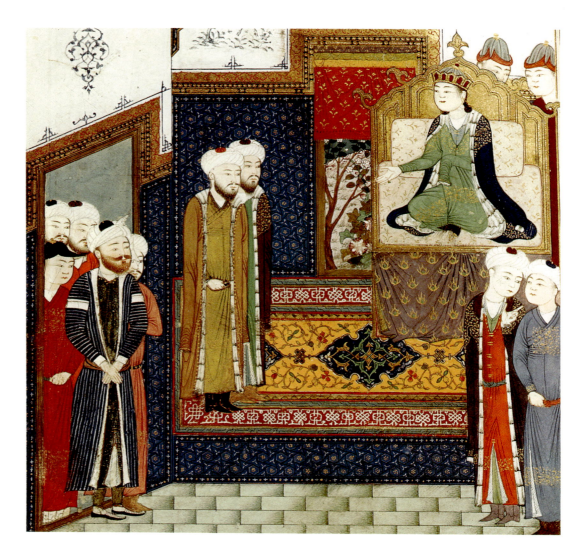

31. Cloud collar, embroidered silk, Persia or Central Asia, first half 15th century. 184.5 x 95 cm (73" x 37"). Treasury of the Kremlin, Moscow, TK-3117.

shoemaker's tools, in these pictures that appear too real to be mere inventions or borrowings from other – that is, earlier – paintings.

It has been generally assumed that rugs with geometric patterns, which are frequently represented in Timurid paintings, were replaced only by the end of the fifteenth century and under the direct influence of the court school of painters directed by Bihzad.[53] This is disproved by rugs in two paintings in a copy of Nizami's *Khamsa* (**30**), copied and illustrated in Herat in 849 AH (1445-46 AD).[54] In other words, it would seem highly likely that the floral patterned rug appears at the Timurid courts already in the first half of the fifteenth century, although the geometric rug also continues to be depicted in Timurid paintings. Whether this means that the tradition of weaving rugs with geometric patterns continues, or whether here the painters simply followed a well established formula, is still an open question. (If true, this is an instance that would confirm the need for caution in using such pictures as documentary evidence.)

An equally problematic question is, of course, the accuracy of costume representation in these paintings. As practically no costumes of the period have survived, save perhaps the cloud collar in Moscow recently attributed to the fifteenth century (**31**),[55] one must again rely largely on contemporary painting to reconstruct yet another aspect of the lost decorative arts of the Timurid period. Details of costume abound in these paintings, but while they may recall the general appearance of the rich garments worn at court (**1**), they are often rather more fanciful evocations than realistic documents, although there are notable exceptions, such as the portrait of Sultan Hussayn Bayqara attributed to Bihzad (**32**). Although it remains unfinished, the preparatory coloured drawing gives a great deal of detailed information about the sultan's dress, turban, belt and dagger. This may also be counted as one of the earliest true portraits in Muslim painting. Still, in this field, as in almost all areas of the decorative arts of the Timurid period, a great deal of basic work remains to be done.

Notes and acknowledgments see Appendix

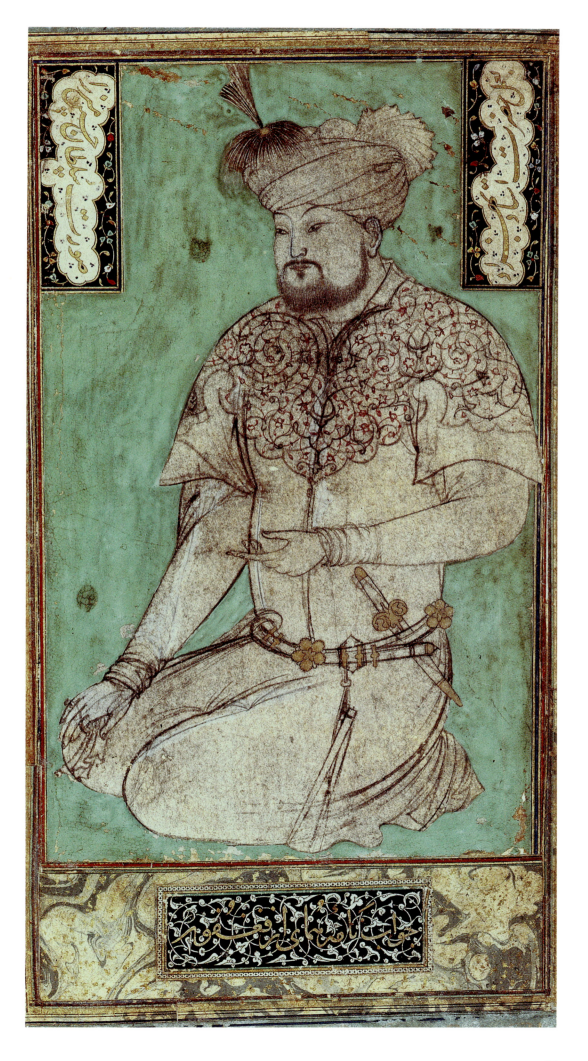

32. *Portrait of Sultan Hussayn Bayqara, unfinished painting attributed to Bihzad, Herat, about 1500. 34.4 x 32.7 cm (13½" x 13"). Arthur M. Sackler Museum, Harvard University Art Museums, Cambridge, Massachusetts, gift of John Goelet, 1958.59.*

2

HYBRID TEMPLES IN KARNATAKA

Medieval Hindu Temples in the Deccan

ADAM HARDY

A delight in combining disparate forms or beings – from composite mythical monsters to syncretic or androgynous deities – is very evident in Indian culture. Such acts of merging may imply many things, from the symbolisation of archetypal dualities to the pursuit of playful ingenuity. In certain traditions of Indian temple building, distinct kinds of temple architecture are sometimes deliberately mixed together. Whatever metaphysical truths might be expressed through such formal gymnastics, it is clear that the virtuosity displayed in merging two highly structured formal 'languages' was enjoyed for its own sake.

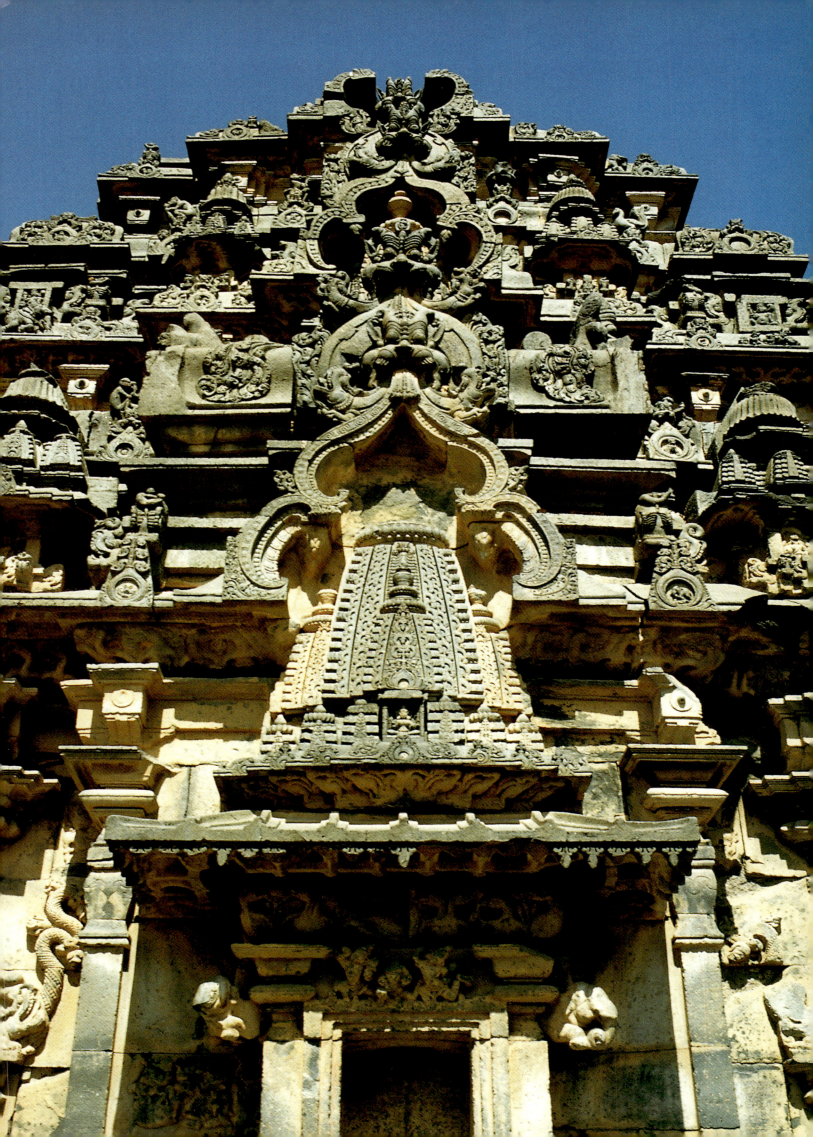

1. *Title page: Shiva image from an aedicular shrine, Durga temple, Aihole (see 8).*

2. *Previous page: Shekhari central wallshrine, Kashivishvanatha temple (detail of 12).*

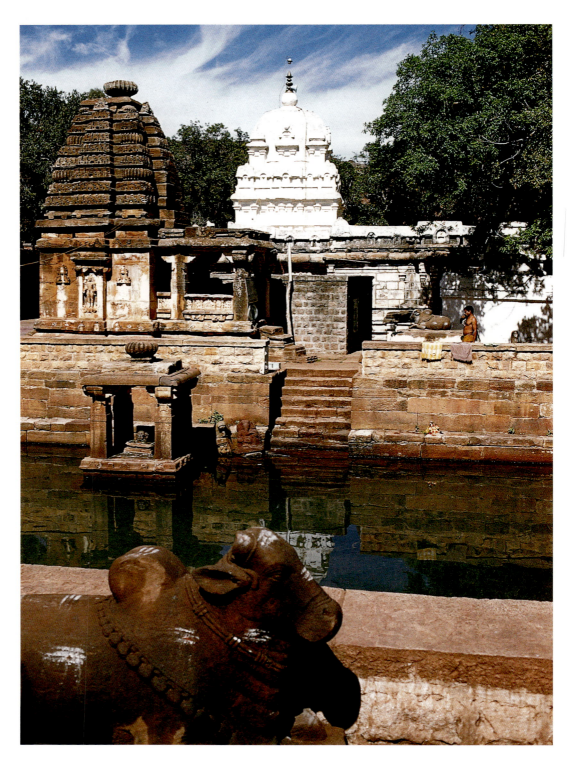

3. *The Sangameshvara at Mahakut, a Nagara temple of the Latina mode, with the Mahakuteshvara, a Dravida temple, in the background. Both late 7th century.*

4. *Radiating bands of kuta-stambhas on the Udayeshvara temple, Udayapur, Madhya Pradesh. Stellate Bhumija, 11th century.*

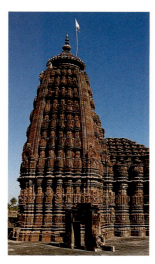

Architectural hybridity can be found at many periods and in many different parts of the world. Any undigested stylistic influence could be classed as such, from a simple borrowing of motifs to a wholesale clash of formal systems. One could cite English eighteenth century Classical houses dressed up as Chinese, Gothick or Hindoo, or the prodigious creations that emerged when, especially in France, the liturgical and craft traditions that had built Gothic cathedrals absorbed a vocabulary newly arrived from Renaissance Italy. In these examples one architectural 'language' governs layout and construction, while another governs the applied ornament and associational symbolism. It is difficult, however, to think of a European equivalent to the deliberate hybridisation of Indian temples, where two 'languages' of formal composition and symbolic ornament, sharing essentially the same planning and constructional principles, are brought together on equal terms. The Sanskrit canonical texts, the *Shastras,* refer to these hybrid forms as *mishraka,* 'mixed'.

The architectural 'languages' in question are the Nagara and Dravida, the two main categories of Hindu temple architecture. The Nagara is associated with northern parts of India, the Dravida with the south, though they are not entirely confined to their respective

regions. Notably, as might be expected, in the middle – the Deccan – these two branches meet and intertwine. Meeting and mixing happened nowhere more vigorously than in the region now known as the state of Karnataka, first between about 650 and 750 AD under the rule of the Early Chalukyas of Badami and then, between the eleventh and thirteenth centuries, under the Later Chalukyas of Kalyani and the Hoysalas.

During these two periods Nagara as well as Dravida temples were built, and experiments in hybridity were made. A comparable phenomenon can be found in Andhra Pradesh to the east, and to a small extent in Maharashtra to the north. Here, however, the focus will be on Karnataka. It should be pointed out that Dravida temple architecture was predominant in Karnataka, and shows uninterrupted development from the early seventh century to the end of the thirteenth. This article is concerned with the interaction of Nagara and Dravida temple architecture within this Karnataka tradition, as well as its experiments in combining the two.

NAGARA AND DRAVIDA 'LANGUAGES'

Before we can understand how this tradition created hybrid temple designs, it is necessary to understand something of the basic elements of both the Nagara and Dravida. The two are often referred to as the Northern and Southern 'styles', although, without taking the linguistic analogy too literally, architectural 'languages' is a more appropriate term. Independent of local accent, each provides a vocabulary – a range of elements – and certain rules for putting components together.

Both Nagara and Dravida temples are essentially representational in nature, in the sense that stone or brick structures are based on images of wooden buildings translated into a 'language' of masonry. The depiction is not literal, but symbolic, and increasingly abstract; yet the imagery is never lost. It is the shrine proper – the sanctum (*garbha-griha* or 'womb chamber'), housing the deity's image, and its superstructure – that is the symbolic and ritual focus of the temple. Here, around four cardinal axes and a vertical axis rising from where they cross, the organisational rules of Nagara and Dravida come primarily into play. The shrine proper in a Dravida temple is called the *vimana*, in a Nagara temple the *mula-prasada*.

Except in the simplest edifices, the imagery of these shrines evokes the idea of a many-storeyed heavenly palace. But the whole is composite – a divine abode with many mansions. The temple exterior, in all but the most basic forms, is composed of niches in the shape of miniature shrines or aedicules: a great house for the god is made up of a collection of these little houses, of various kinds and sizes. Just as each sculpted divinity housed in aedicules on the temple walls (1) displays an aspect of the unity whose supreme embodiment is enshrined at the centre of the main shrine, so every aedicule reflects the totality of the god's house of which it is a part. It is important to understand that the aedicular elements of composition are not 'surface decoration', but are conceived three-dimensionally, embedded in and emerging from their background or one another (B).

Increasingly in Nagara traditions, and in the Dravida tradition of Karnataka, the whole of the principal shrine is imbued with an expression of growth and dynamism. Interpenetrating forms are made to appear to emerge and expand centrifugally, surging downwards and outwards towards the four cardinal points, issuing from the infinitesimal point at the summit, at the head of the vertical axis. Bearing in mind the cosmic associations of an Indian temple,

A. Shekhari mode of Nagara shrine.

5. Ganesha shrine, Tarakeshvara temple precinct, Shekhari (see 11).

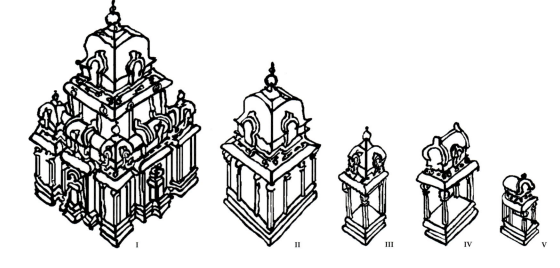

B. Aedicular components: I, II Principal shrines of the Dravida 'language'; III Kuta-aediculae; IV Shala-aedicule; V Panjara-aedicule.

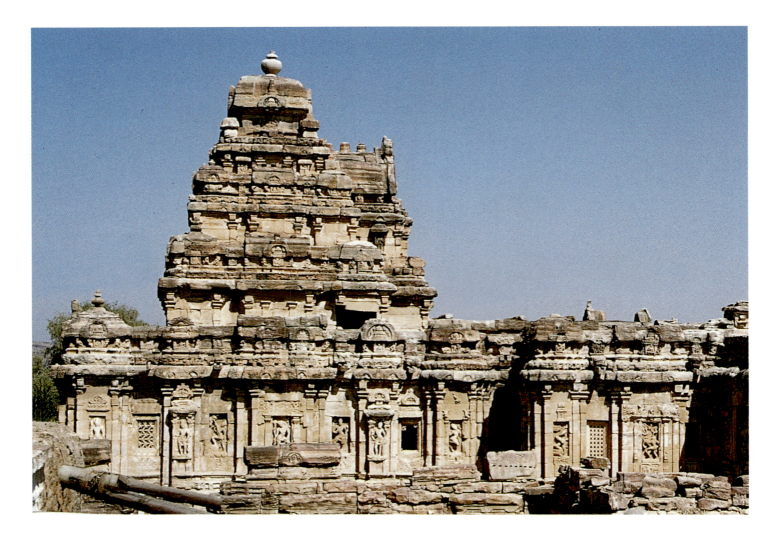

6. *Virupaksha temple,*
Pattadakal. Dravida, ca. 740.

7. *Surya temple, Ranakpur,*
Rajasthan. Mixed Shekhari-
Bhumija, 15th century.

the whole form of the shrine can thus be understood as a vivid symbol of divine manifestation as a continuous process, by which unity appears in multiplicity as the Absolute pours out into the world.

A Nagara temple is most immediately recognisable by its curved spire *(shikhara)*, found in its simplest form in the type known as Latina (3). A Latina shrine appears as one unit, having already, at an early stage, undergone a process of abstraction and fusion, disguising a previous composite conception which need not be considered here. The coursed strata of the spire, symbolically depicting thatched eaves, are ornamented with horseshoe-shaped window-gable motifs, wholes and halves of these woven into net patterns, increasingly proliferating and overlapping to convey a sense of cascading centrifugal growth.

During the tenth and eleventh centuries, in central and western India, there emerged two more complex, clearly composite modes of Nagara temple, the Shekhari and Bhumija. In both of these the Latina curved spire is a basic compositional element, either by itself or capping a *kuta-stambha*, a pillar form topped by a miniature spire (B). In the Bhumija mode, sometimes on a stellate as opposed to an orthogonal or right-angled plan, the segments of the Latina, with the exception of the cardinal projections, are replaced by radiating bands of *kuta-stambhas* (4). In the Shekhari mode (5, A), a minor spire form emerges from each face of the central spire, and from each minor spire may emerge yet smaller versions, and so on in a diminishing sequence. Ranks of *kuta-stambhas* appear across the corners of the shrine. Entirely Nagara hybrid forms are occasionally created by mixing the Shekhari and Bhumija, as in the fifteenth century Surya temple at Ranakpur in Rajasthan (7).

Although Dravida *vimanas* may take on a variety of shapes of ground plan and super-structure, and although the number of tiers varies, the basic, stepped pyramidal form is universal. The primary aedicules surrounding the tiers of the pyramidal structure represent two-storey shrines crowned, most often, by upper pavilions in the form of domed *kutas* or barrel-roofed *shalas*. These compositional elements may be referred to as *kuta*-aedicules and *shala*-aedicules (B).

Another typical crowning element is a *panjara*, an end-on *shala* with horseshoe gable. In the illustration, *panjara*-aedicules are shown not as a primary element, but as wall-shrines (B).

Nagara as well as Dravida temples often display various kinds of secondary temple image projecting out of the main components. Being at a lower level in the compositional hierarchy, with limited effect on the whole, wall-shrines are fertile ground for individual carvers to show their ingenuity in creating untried and hybrid forms.

EARLY CHALUKYA PERIOD
Dravida and Nagara Temples

The formation and early development of Dravida temple architecture can be traced nowhere more clearly than in the heartland of the Early Chalukya dynasty, around their capital, Badami. Already in the rock-cut cave temples at Badami of the late sixth century we find proto-Dravida details, such as the chain of depictions of shrines over the doorway to the sanctuary of Cave 3. Other features here can equally be described as proto-Nagara, such as horseshoe arch gable motifs of a curvaceous form that develop as the Northern *gavaksha* (cow eye) rather than the Southern *nasi* (beak) type. As seen elsewhere (for instance in the Buddhist monuments of second century Gandhara or fifth century Ajanta), forms later associated with the Nagara sit side by side with forms which later become Dravida. In the Badami caves there is as yet no real distinction between the two.

Evolving from the simple Dravida shrines of the early seventh century, the principle of articulating the exterior as an interconnected framework of embedded aedicules progressively takes hold. The late seventh century Mahakuteshvara temple (3, centre back temple) still has very wide stretches of wall between aedicular projections. In fact, in the first storey, the *kuta* pavilions at the corners of the parapet have no corresponding projections or paired pilasters in the wall below, and so do not create full aedicular components. A few decades later, around 740, in the great Virupaksha temple at Pattadakal (6), we find the entire exterior overflowing with the imagery of shrine forms, aedicular niches emerging from primary aedicules, and miniature temples bursting from every orifice.

While the grandest royal projects of the Early Chalukyas are Dravida, a variety of other temple types were built, especially the Latina form of Nagara. Though the basic 'language' has its origins elsewhere, the Early Chalukya examples are among the earliest surviving truly Latina shrines in India. Relatively simple versions are found at Aihole and Mahakut (3), but the ones at Pattadakal are complex, more closely related to the prolific Nagara school at Alampur, the important Early Chalukya centre in Andhra Pradesh. Until the heyday of Pattadakal there seem to have been no strict divisions between workshops making Dravida and Nagara temples – the range and character of mouldings is largely the same, and one pilaster type is universal. Nevertheless, no sooner are the two architectural 'languages' recognisably distinct than the game of deliberately mixing them up begins.

Hybrid Temples

Rather than in the designs of entire temples, it must have been easier to be adventurous in the miniature architecture of the wall-shrines and of the depictions of small shrines garlanded over doorways and windows and along blind clerestories. The simplest kind of mixing here is by placing Nagara and Dravida shrine types side by side. A further degree of hybridity, perhaps not always conscious, is introduced through details, as where Dravida shrines exhibit horseshoe arch motifs of the *gavaksha* form instead of the *nasi* form, or ribbed crowning members (*amalakas*) instead of pot finials (*stupis*).

But a more complete cross-breeding occurs where Nagara elements have been adapted to mimic the domed Dravida *kuta*. Over a window of the Naganatha at Nagaral, three '*kutas*' are lined up (C), each with the typical moulding sequence of a curved spire (*shikhara*), 'neck' (*griva*) and monster-headed joist course (*vyalamala*), all sitting on a roll cornice (*kapota*). But instead of the usual Dravida dome we find the Nagara device of two half *gavakshas* surmounted by a whole one. Over a window in the Mahakuteshvara at Mahakut are three '*kutas*', shown with nothing but a pair of bracketed pillars supporting the domes (D). The outer cupolas are normal Dravida, while the central one consists of a pair of half *gavakshas* crowned by an *amalaka*.

More complex contortions of Nagara elements in emulation of the Dravida *kuta* are seen in two wall-shrines of the Durga temple at Aihole of circa 700 (8). One, predominantly Nagara, has a superstructure of three eaves mouldings, the top one resembling a *kuta* cupola and sitting over a 'neck' (E). In another, the Dravida *kuta* affinity is made more explicit by the addition of a dentil moulding (F), with only a single eave moulding (corresponding to the Dravida *kapota*) at the base. The roof element is formed from a *gavaksha* horse-shoe shaped rim stretched almost beyond recognition to make the outline of a *kuta* dome. Inside this out-

C. *Entablature with mixed Nagara and Dravida details.*

D. *Entablature with three 'kutas'.*

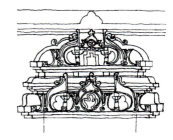

E. *Wall-shrine hybrid superstructure.*

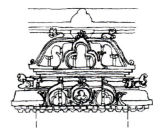

F. *Wall-shrine hybrid superstructure.*

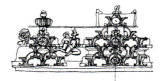

G. *Hybrid overdoor element.*

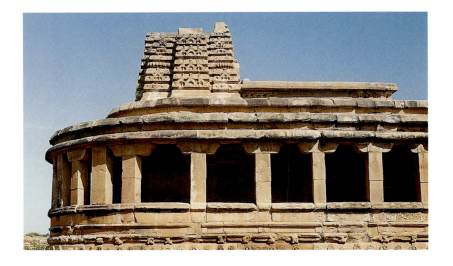

line is an attenuated version of the imagery commonly seen inside horseshoe gables, which at their centre derive ultimately from the kind of cross-section found in Buddhist *chaitya* halls (such as the well-known first century BC rock-cut sanctuary at Karli in Maharashtra). Where a *kuta* cupola would have a horseshoe-shaped gable of the *nasi* (beak) variety, however, there is instead a three-lobed *gavaksha* (cow eye) forming the crown of an overall *gavaksha* configuration slicing through the lower mouldings.

A subtle hybrid of slightly later date is the overdoor decoration from Huccappayyagudi, a Nagara temple at Aihole (G). The end pavilions are Nagara, while the central element is composed of two eaves mouldings and a crowning

8. Durga temple, Aihole. Hybrid, ca. 700.

10. Opposite: Dravida parapet on the Papanatha temple, Pattadakal (see 9).

Dravida barrel-shaped *shala* roof. The central *nasi* style horseshoe-shaped gable of the *shala* roof is again rendered as a *gavaksha*, which forms the peak of a cascading net pattern of the complex kind that was developing by this time.

A small number of Early Chalukya period temples can be classified as mixed mode or hybrid. Yet these cannot be said to achieve, in their overall composition, a true marriage of Nagara and Dravida, except perhaps in the little-known Parvati temple at Sandur, of around the late seventh century. Entirely Dravida elements create a curved spire-like superstructure, with a pronounced central spine.

Two monuments roughly contemporary with the Sandur temple juxtapose Southern and Northern elements in more or less equal proportions. Both are unique in their overall form. One is the Jambulingeshvara at Badami, perhaps the earliest temple in India to have three sanctuaries. The other is the Durga temple at Aihole (8), apsidal in plan and surrounded by a verandah. Sheltered by the verandah, which is raised on a high Dravida plinth, the walls of the encased temple display a rich gallery of sculpture and of secondary architecture – Dravida, Nagara and hybrid – including the niche pediments already discussed. Above the sanctuary rises a Nagara spire, sitting rather uncomfortably on the apse below, and possibly not part of the original conception.

Two or three decades into the eighth century, at Pattadakal, the architectural character is on the whole one of generic purity and maturity. Yet one deliberately hybrid work at this site, the Papanatha (9), belongs to this phase. Combination of the architectural 'languages' is again largely through juxtaposition, but the Papanatha comes a step closer to overall union. A very long temple, with two halls, it seems to have been built in at least two stages. It is predominantly Nagara, with its Latina spire and with Northern style wall-shrines running round the walls. But the walls outside are topped by a Dravida parapet of *kutas*, *shalas* and *panjaras* around the whole perimeter.

9. Papanatha temple, Pattadakal. Hybrid, early 8th century.

Since the notion of an entablature-like parapet of this kind is foreign to the Nagara idiom, it is perhaps natural to use a Dravida one. But at a time of assertion of the identity of the Dravida 'language', it is unlikely that such a mixture would be motivated by expediency. One kind of parapet pavilion in particular (10) shows a deliberate attempt at synthesis, on the principle that we have already observed in minor aedicules, where the Dravida *kuta* is imitated using Nagara details. Instead of the dome we find two Northern eaves mouldings, fronted by a *gavaksha* horseshoe pattern. In the horizontal recesses run schematically depicted colonnades.

LATER CHALUKYA PERIOD
Dravida Temples

Following the defeat of the Early Chalukyas by the Rashtrakutas in 754, the centre of power in the Deccan shifted north to Ellora, in present-day Maharashtra. Here the Karnata traditions

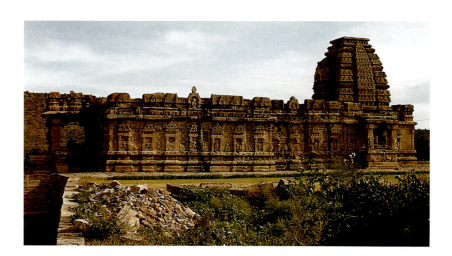

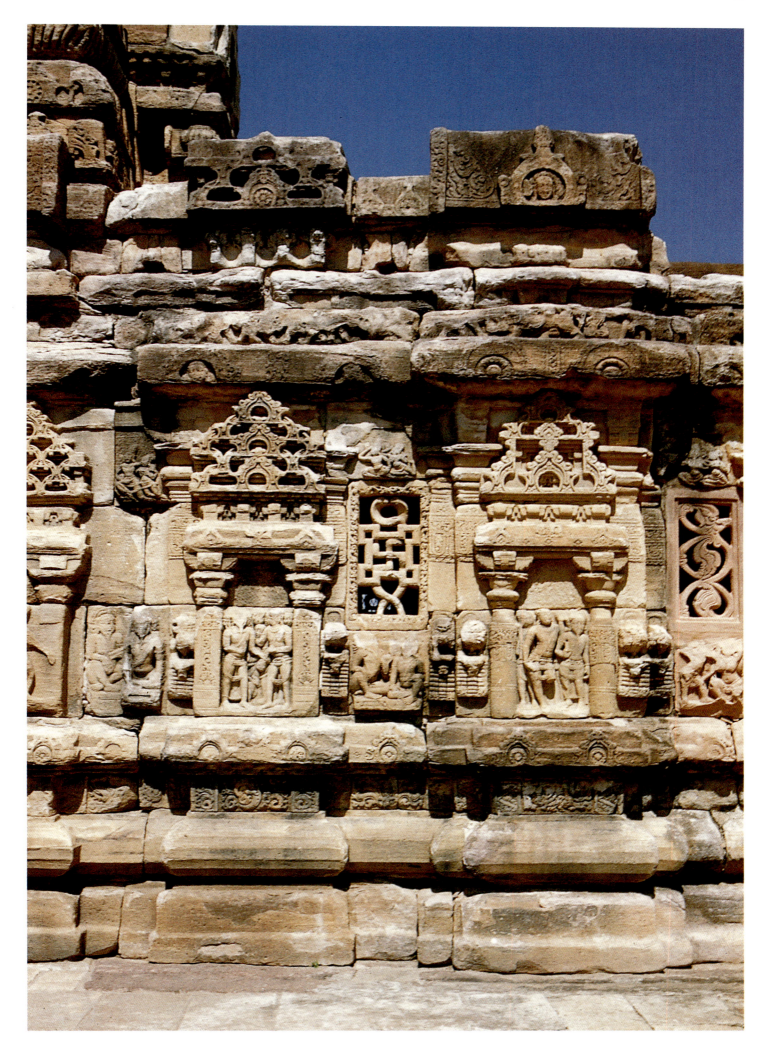

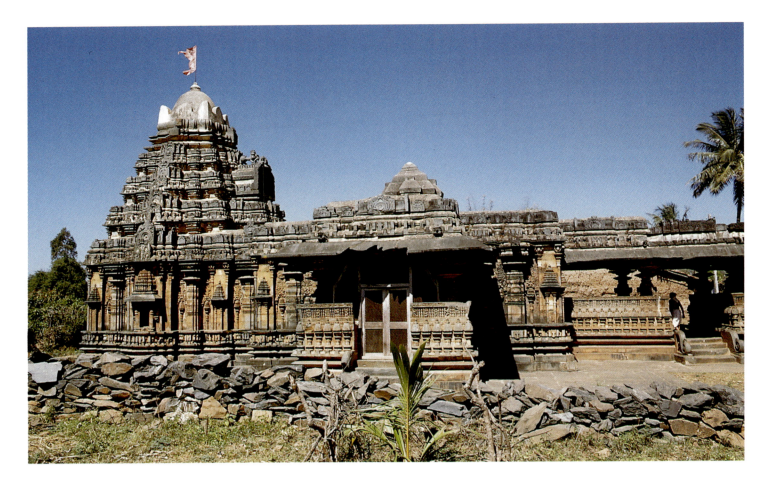

11. Tarakeshvara temple, Hangal. Late Karnata Dravida ('Vesara'), 12th century.

of both Dravida and Nagara influenced a new phase of rock-cut temples, including the Kailasa temple, the largest monolith in India and one of the greatest Dravida temples. Meanwhile, many temples continued to be built in the former Chalukya heartland of northern Karnataka, though on a more modest scale than previously. These are all Dravida, and through them may be traced a continuous evolution that links the earlier and later periods.

After the Later Chalukyas of Kalyani took possession of the Karnata empire in 973, temple building activities rapidly accelerated and spread. The pattern of temple foundation was comparatively dispersed, reflecting a decentralised administrative system and a wide spectrum of patronage. Consequently the temples, though lavish and numerous, are far smaller in scale than the late works of the Early Chalukyas.

By the beginning of the eleventh century, Dravida temple forms in Karnataka had been transformed to the extent that they are no longer immediately recognisable as Dravida **(11)**. Temples transformed to this degree were labelled 'Chalukyan' by the nineteenth century

H. Evolution of Karnata Dravida temples (top), and Nagara (Shekhari) temples (bottom).

I. A late Karnata Dravida temple: I Vimana; II Single staggered shala-aedicule; III Double staggered shala-aedicule.

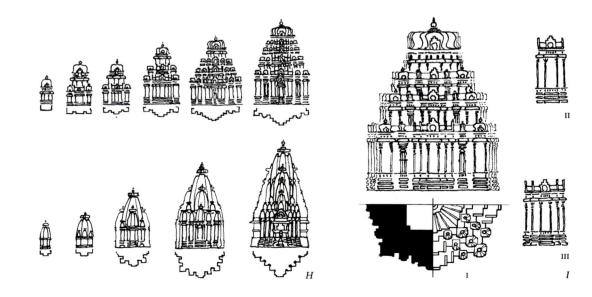

scholar James Fergusson, a category which he distinguished from 'Indo-Aryan' (Nagara) and 'Dravidian' (Dravida). Scholars have suggested that Fergusson's 'Chalukyan' could be what is referred to in the canonical texts as the 'Vesara', a third main class of temple, distinct from Nagara and Dravida. This identification is plausible, since *vesara* means 'mule', i.e. hybrid, and the temples in question do exhibit some Nagara-seeming characteristics despite their fundamentally Dravida details.

Any discussion of the interaction of Nagara and Dravida in this part of India must consider the question of 'Vesara'. It might easily be thought that these 'mule' temples are the hybrids that are our focus – deliberate mixtures of Northern and Southern style temple architecture. However, in these works, the underlying tiered pyramid and the aedicule and moulding types, regardless of the degree of transformation, remain Dravida. The Karnata Dravida tradition is an unbroken and continuous transformation, and it would be impossible to say at what moment temples ceased to be Dravida and became 'Vesara'. Whatever they were called, these 'Vesara' temples of the eleventh to thirteenth centuries represent a regional variation of the Dravida temple and are therefore perhaps best termed 'late Karnata Dravida'.

If the tradition is looked at as a whole (**H**, above), it can be seen that the Nagara-seeming characteristics of the later Karnata Dravida temples arise because they have evolved in the same extraordinarily organic way as do temples in Nagara traditions (**H**, below), through centrifugal emergence and growth, with axial projections pushing further and further out, and with components proliferating and fragmenting. Individual elements, in this process, lose definition under the sway of the whole. Increasingly stepped-forward walls are accompanied by a proliferation of offsets within individual components.

In particular, in the Karnata Dravida tradition, the staggered *shala*-aedicule developed around the ninth century is further transformed into a double staggered form (**I**). Positioned centrally, this element is essential to the complex, dynamic character of late Karnataka Dravida shrines. Conceptually it is a configuration of five aedicules: at the centre a *panjara-*

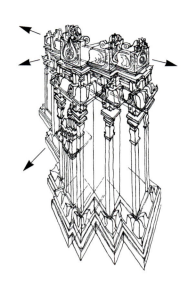

J. Dynamics of the double staggered shala-aedicule.

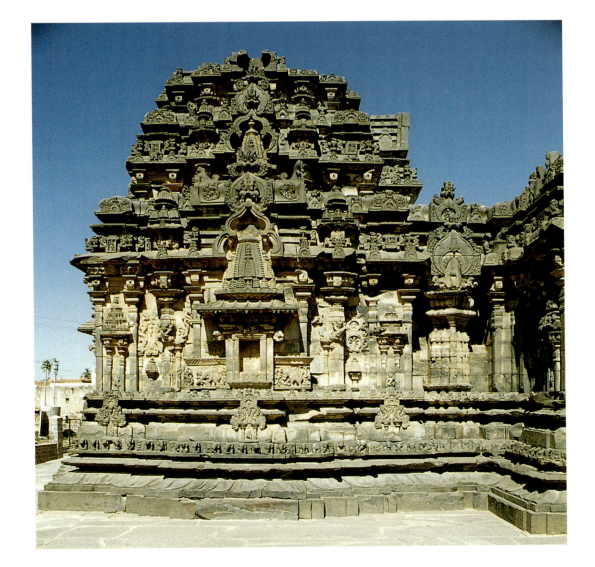

12. Kashivishvanatha temple, Lakkundi. Mid-11th century.

*13. Bhumija wall shrine,
Kashivishvanatha temple
(detail of 12).*

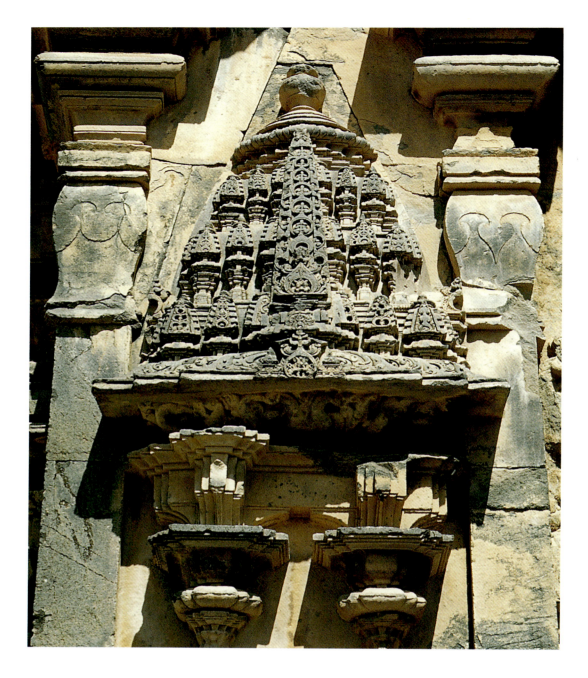

*14. Central projection and
hybrid wall-shrine,
Trikuteshvara temple, Gadag.
11th century.*

aedicule (that is, an end-on *shala*-aedicule with horseshoe gable) with two barrel-roofed *shala*-aedicules emerging one from the other on either side. This 'double staggered *shala*-aedicule', used already by the turn of the eleventh century, is the first and most widespread of many ingenious composite, interpenetrating forms (J).

The Tarakeshvara at Hangal (**11**) is a typical twelfth century Karnata Dravida shrine. Built of close-grained blue-grey chloritic schist, or soapstone, rather than the sandstone which had earlier been usual, it has four identical storeys, with *kuta*-aedicules at the corners and central double staggered *shala*-aedicules. In the latter, a looped archway pouring out from each central horseshoe-shaped dormer creates a cascade down the face of the superstructure. Intermediate projections take the form of Dravida *kuta-stambhas*, consisting of a *kuta* crowning a pillar form.

Nagara Temples

Evidence of renewed contact with Nagara forms is first apparent during the early decades of the eleventh century, among the wall-shrines of Karnata Dravida temples. Whereas in the Early Chalukya period the Nagara had quickly become naturalised and established as one of two familiar alternatives, now it seems exotic, in varying degrees, seen through Karnata Dravida eyes.

In the wall-shrine designs, the simple Latina is most widespread, but the Nagara 'language' Shekhari and Bhumija modes are also found. Both are seen in the walls of the mid-eleventh century Kashivishvanatha temple at Lakkundi (**12**). The large central wall-shrines (**2**) are of

15. Siddheshvara temple, Sirur.
11th-12th century.

16. Hybrid central projection,
Vishvanatha temple, Huli.
11th century.

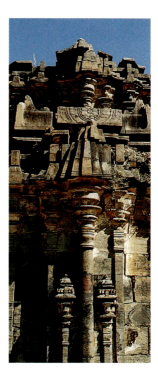

the Shekhari type, emerging at the foot of a cascade of arch forms spewed forth from monster jaws, and thrusting a tower up above the cornice-eaves. Two corner wall-shrines (13) are Bhumija. All give an impression of authenticity through their fine detail and sense of conviction, but on close inspection a number of schematisations become apparent, as do a number of 'Southernisms', by which I mean Northern details subtly distorted by Southern habits and perceptions. The net-like patterns look convincing, yet their constituent horse-shoe arches are just the local *nasi* type spiced up to give an exotic Northern flavour. One of the Bhumija designs has a multi-staggered Dravida dome instead of a crowning ribbed member, and at the base of the spine some Dravida mouldings and a miniature Dravida *kuta*. Furthermore, while Dravida wall-shrines at this time are always fully three-dimensional, these Nagara towers are conceived for frontal viewing, recesses between the *kuta-stambhas* occurring only on the front.

It was not until the end of the eleventh century that full-sized Nagara temples began to reappear in the Deccan. Mouldings and details, as well as geographical proximity, point to Malava (Madhya Pradesh) and Seunadesha (Maharashtra) as the sources from which the Nagara 'language' was reimported. In northern Karnataka it was mainly the Shekhari mode that was built, but also occasionally the Latina. Often the superstructure is missing, but the Ganesha shrine at Hangal (5), in the precinct of the Tarakeshvara temple (11), is intact. This is the mature Shekhari design of this later period (A), though its details betray a similar character to the Lakkundi wall-shrines, with no *amalakas* punctuating its layered corners, and with locally invented net or grille patterns merely incised into smooth surfaces.

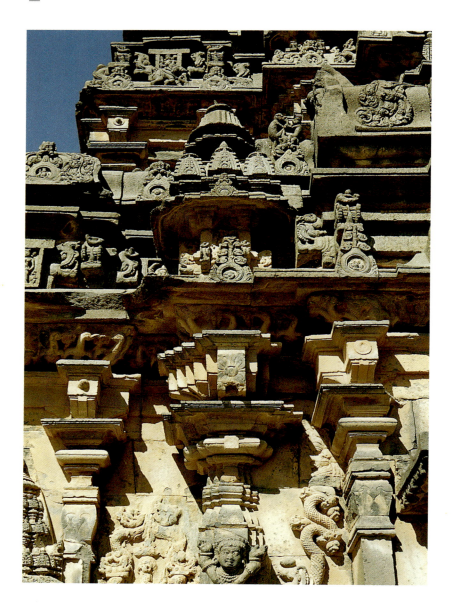

A Nagara temple which gives a particularly strong impression of having been conceived in a Karnata Dravida frame of mind is the Siddheshvara at Sirur, not far from Aihole (**15**). Its principal shrine is a kind of primitive Shekhari style, its walls, like those of the Ganesha shrine at Hangal, having five projections. While the corner and intermediate projections in the wall form Nagara *kuta-stambhas* (pillars topped by miniature spires), as would be expected, at the base of the main spire the central projection supports a half or embedded spire placed over six slender, Dravida-like pilasters, producing a double staggered aedicule. Another Southernism is the way in which the miniature spire forms are thought of as 'parapet' pavilions, forming a 'garland' running round the whole temple and sitting on a rounded roll cornice. A further regional trait is a clearly defined, Later Chalukya style *vedi* (rail moulding) platform at the 'shoulder', supporting the crowning member just as a *vedi* supports the dome of a Karnata Dravida temple. The circular crowning member of the main spire, rising above a *vedi* platform, is not an *amalaka* (grooved crowning member), but a tight-waisted Karnata Dravida dome, circular and ribbed. And the three mouldings of the plinth, while corresponding to the three essential Nagara plinth mouldings, are indistinguishable from their equivalent local Dravida mouldings.

Hybrid Temples

Before looking at examples of full-blown hybridity, it is worth considering two types of more partial mixtures: Nagara compositions containing Dravida elements, and Dravida compositions containing Nagara elements. Both phenomena have been met with in the Early Chalukya period. But since, in the later period, the Nagara never becomes an entirely familiar alternative to the Dravida, the two mixtures are generally not, at this stage, of the same kind. The first, where Dravida elements appear in a Nagara temple, is the phenomenon of the 'Southernism' that we have just been observing: the foreign tongue intoned in the accents of the region. The second, where the opposite takes place, is a display of something exotic.

We have already discovered Southernisms in the Nagara wall-shrines of the Kashivishvanatha at Lakkundi (**2, 12, 13**). The presence of these Nagara shrine images in a Karnata Dravida temple has exotic Northern elements in its primary aedicular composition. These are the intermediate projections, in the form of *kuta-stambhas*, where the crowning pavilions are of the grooved bell form sometimes found at the summit of Northern halls, girdled with Latina-style spires (**17**).

Inventive combinations of aedicular forms are often, in this period, created purely within the Dravida 'language'. One such combination is the central element in the *vimana* of the Vishvanatha temple at Huli (**16**), in which partial *kuta* pavilions emerge from the ends of a staggered *shala*. But while these primary forms are Dravida, the whole component is dominated by a Nagara *kuta-stambha* pushed forward as an exotic centrepiece.

Exoticism here clearly stems from a desire to create something new through a process of hybridisation. But a few hybrid parts do not make a hybrid whole. The Kashivishvanatha and the Vishvanatha are not fully hybrid. So at what point does exoticism become full hybridity? Exoticism and hybridity may be said to differ only in degree, dependent on the relative proportion of elements belonging to each of the two 'languages' and, more importantly, on the position of the respective kinds of elements in the compositional hierarchy.

17. Hybrid projection, Kashivish-vanatha, Lakkundi temple (see 12).

19. Opposite: Fully hybrid vimana, Someshvara temple (see 20).

18. Vimana wall, Doddabasappa temple, Dambal. Early 12th century.

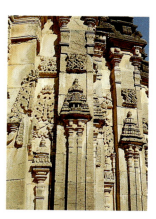

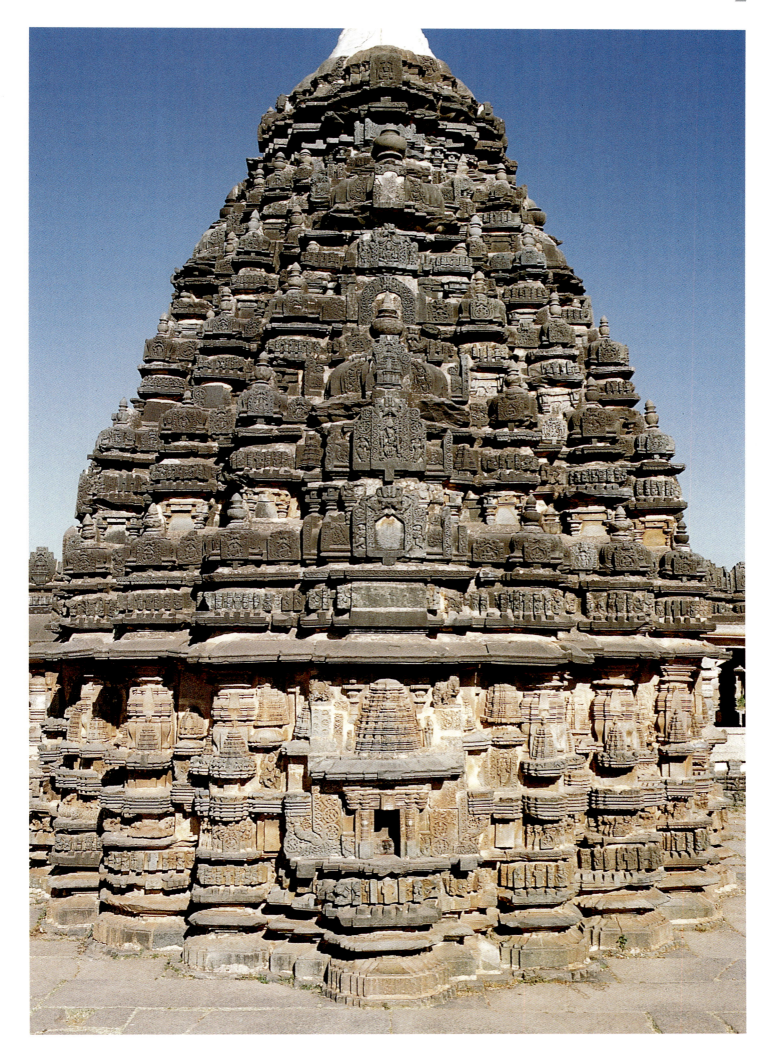

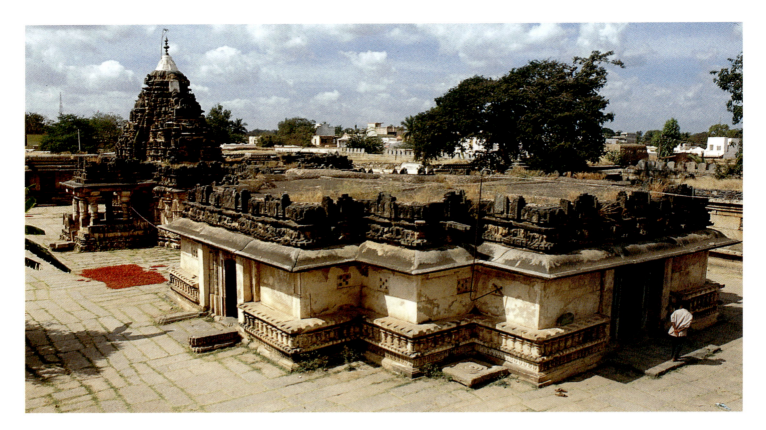

20. *View from the east of Someshvara temple, Lakshmeshvara. 12th century.*

21. *Diagonal view of vimana superstructure, Someshvara temple (see above).*

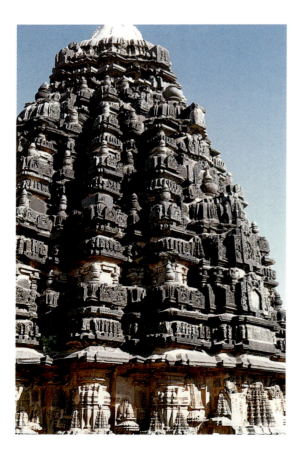

The Kashivishvanatha remains Dravida because its Nagara characteristics are in wall-shrines (secondary elements) and intermediate primary components, not in central or corner ones.

A full hybrid, then, might be defined as an equal combination of the Nagara and the Dravida, at the primary level of order. The temple builders of the Later Chalukya period had principally two ways of achieving this. The first, common in wall-shrine designs, was to introduce a large central feature belonging to one 'language' into a shrine basically of the other style, in the manner of a 'foreign' central wall-shrine, but emerging through the superstructure, as well as through the wall. In such cases it could be said that the background 'language' is the primary one, but the central feature is so prominent that a full hybrid is clearly intended.

In an example from the crinkled, stellate walls of the Doddabasappa at Dambal (18), a Latina spire grows from the centre of a Dravida *vimana*. Two impressive hybrid decorations hanging over the giant wall-shrines of the Trikuteshvara at Gadag (14) are the reverse of the Dambal idea. In these two, a Dravida form becomes a second order 'chest-spire' in a Shekhari *prasada* or shrine. This clear conception is modified by *kuta-stambhas* rising up the corners – giving an impression of the Bhumija mode, and by the presence of an extra lower storey.

A second way of mixing languages in the Later Chalukya period is to put together components belonging to one system in a compositional pattern belonging to the other system. This is perhaps the subtlest kind of intermingling, and the closest to true synthesis. One outstanding temple design follows this principle – not a wall-shrine but an actual temple. The large principal shrine of the Someshvara temple (19, 20) at Lakshmeshvara is an attempt to create virtually a new mode within the Karnataka Dravida architectural 'language', in the sense that Latina, Bhumija and Shekhari are three modes of Nagara. This bold experiment is the first and only *vimana* of its kind.

Whereas, in experimental wall-shrines, problems may be 'fudged', this is not possible in a full-scale building. Any awkwardness in the Someshvara should be seen in this light. A slight lack of resolution in some respects, and some poor repairs which have returned fragments to the wrong positions, together with the complexity of the whole conception, make this a difficult composition to understand at first.

The underlying idea is of a *vimana* made up entirely of Dravida parts but put together in a Nagara, predominantly Shekhari, way. As in one relatively simple mature form of Shekhari shrine (A), from each face of the superstructure projects a smaller, embedded superstructure, and from this another, still smaller (21). However, the Dravida 'language' provides no unitary equivalent to the monolithic Latina spire. The embedded spires of the Someshvara are not unambiguously defined like their equivalents in the Shekhari style, but emerge out of the aedicular matrix through a grouping together of architectural elements in the observer's mind (K).

The Someshvara has a 'stepped diamond' plan, such that the corner elements are the same size as the intermediate ones. (Apart from the cardinal projections, all the projections in this kind of plan, including the re-entrant ones, are based on overlapping squares, so that all the components interpenetrate very densely.) A wall-shrine design at the Someshvara (22) shows a simpler version of the temple's principal shrine itself, with the more usual expanding square plan rather than the stepped diamond. The same kind of effect is created, as in the full-size version, through different formal tricks.

HOYSALA PERIOD TEMPLES

In southern Karnataka some three hundred temples built under the Hoysala rulers survive from between the twelfth and early fourteenth centuries. The most spectacular monuments were built during the twelfth century, while the dynasty was still nominally a feudatory of the Later Chalukyas.

Two general characteristics distinguish Hoysala from Later Chalukya temples. One is the abundance of figure sculpture that frequently adorns the walls of the former, the other is the ornateness of Hoysala architecture. In terms of overall aedicular composition, Hoysala

K. *Elevation and roof plan of the Someshvara temple (see 20).*

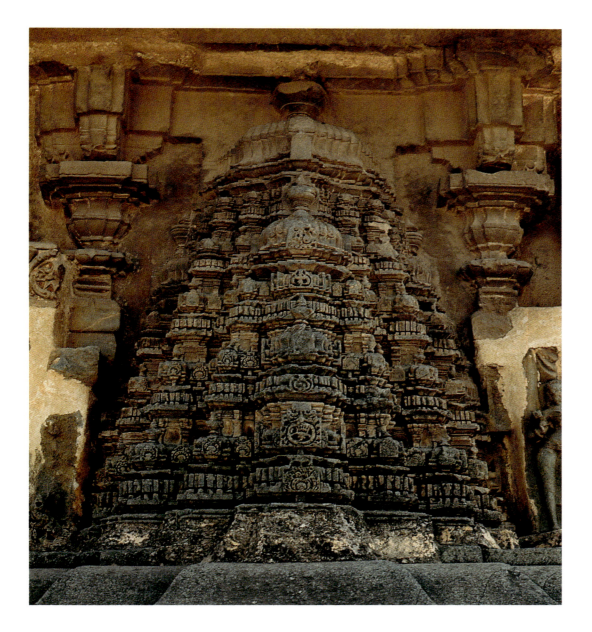

22. *Wall-shrine, Someshvara temple, Lakshmeshvara (see 20).*

L. *Rotational design of semi-stellate shrines in Hoysala temples.*

23. *Vira-Narayana temple, Belavadi. Hoysala, ca. late 12th century.*

temples are on the whole rather less complex than their northern Karnataka equivalents, but they are indeed often more ornate by virtue of their richly decorated surfaces. Mouldings, already at the height of abstraction, are dissolved by grooves and beads and under-cutting, which fully exploit the workability of the soapstone.

The Hoysalas built orthogonal shrine types which they took over from the Later Chalukyas, and developed varieties of stellate *vimanas,* based on a square rotated about its centre. Reflecting the same delight in combination as leads to merged aedicule types and hybrid temples, some shrines are semi-stellate, with orthogonal central and corner projections, but with intermediate elements positioned according to the rotational principles of stellate *vimana* design (L). Such is the northeast shrine of the Vira-Narayana temple at Belavadi, of circa the late twelfth century (23). Certain features give this shrine a typically Hoysala character. One is the diagonal type of horseshoe arch motif; the element previously representing the gable end of the *shala* barrel roof now wraps around the corner, so that instead of pointing sideways it points diagonally outwards. The monster-face finial is, as it were, folded down the nose, and the dissolutionary expansion implied by the double staggered *shala*-aedicule ceases to be orthogonal, seeming now to radiate directly from the heart of the shrine. Another feature is the two-tier wall, divided by a continuous eave moulding half-way up the wall of the first storey, dividing a sculpture gallery from an upper zone

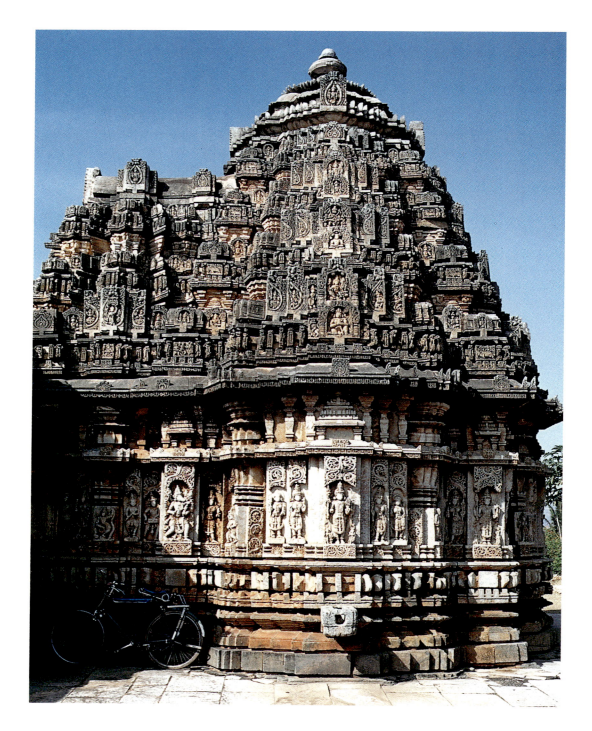

of wall-shrines. The resulting horizontality is enhanced by the canopy of the wide eave moulding placed below the roll cornice (*kapota*) of the first storey.

In contrast to the Shekhari form predominant among Nagara temples in northern Karnataka, the full-size Hoysala versions are of the Bhumija mode, found in several stellate types, with superstructures of pyramidal outline rather than the 'authentic' Nagara curvature. The Hoysala conception of the Latina spire, the basic component of any Nagara form, is rather crude. Tendencies to simplify or schematise the Nagara architectural 'language', and to Southernise it, are even stronger in this more southerly region than in the Chalukya heartland. Paradoxically, however, the Hoysala Nagara temples are not tentative experiments but have an air of assurance and confidence in their own variety of the Nagara.

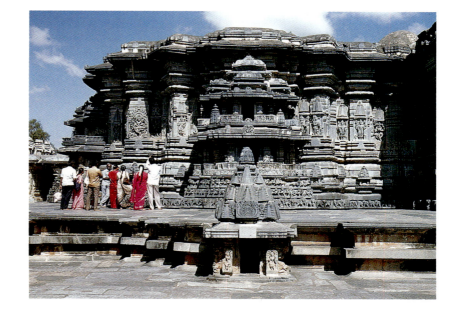

24. Chenna-Keshava temple, Belur. Hoysala Nagara, dated 1117.

Northern forms no longer appear exotic but a familiar part of the local tradition. These temples appear not to have been built by separate specialist workshops, as they often seem to have been in northern Karnataka. The fact that all the Hoysala Nagara temples have Northern plinth mouldings is an indication that the Nagara is understood as a complete alternative 'language' to the Dravida, even if it is transformed by Karnata Dravida habits.

The introduction of the Nagara style into the Hoysala territories must be due to the early example of the Chenna-Keshava at Belur, dated 1117 (**24**). Surprisingly, here the Northern forms and details seem to derive from more direct contact with the 'pure' Nagara schools of Seunadesha (Maharashtra) than is evident in most examples in northern Karnataka. Though there is no surviving superstructure, its Nagara plinth and the pillar mouldings of its walls, in combination with a stellate plan, show the principal shrine to have been a Bhumija conception, like the miniature shrines flanking the flights of steps up to the temple. Raised on a podium, its plan is based on sixteen-point rotated-square stars, but with orthogonal central projections from which emerge giant wall-shrines. These are almost free-standing either *vimanas* or subsidiary shrines, containing two chambers, one above the other, and articulated in the manner usual in open halls. This axial extrusion of an alien species is a development of the notion underlying the Shekhari wall-shrines at Lakkundi (**2**). If the Belur giant wall-shrines had bulged out even further, up into the superstructure, the whole could be classed as a hybrid. This principle of hybridity is found among Hoysala wall-shrine designs.

25. Mule-Shankareshvara temple, Turuvekere. Hoysala hybrid, 13th century.

However, as far as I know, only one full-size Hoysala hybrid temple survives, the Mule-Shankareshvara at Turuvekere (**25**). At first sight it is a four-tier Bhumija composition tinged with schematisations – the triangular shape of the spine, the absence of net patterns, and 'Southernisms': the straight-sided conical tower, the miniature spires treated as parapet pavilions. But it is neither orthogonal nor stellate but semi-stellate, with its intermediate *kuta-stambhas* based on a rotated square. In plan, the disposition of its parts is like that of the semi-stellate principal shrine at Belavadi (**23**). It is uncertain whether this is the result of a deliberate attempt at synthesis, but the result is a hybrid that is the converse of the Someshvara at Lakshmeshvara, assembling Nagara parts in a pattern originally conceived in terms of the Dravida.

Glossary see Appendix

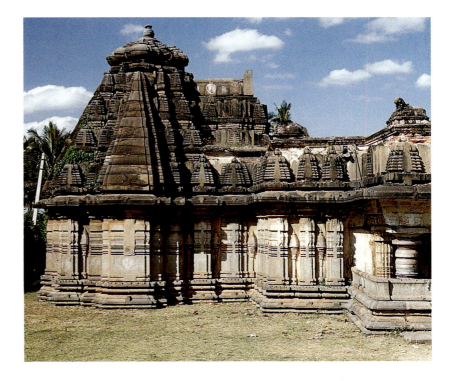

3

PATTERNS OF LIFE

A Gateway to Understanding Indonesian Textiles

REINHOLD MITTERSAKSCHMÖLLER AND HEIDE LEIGH-THEISEN

Textiles have always played a crucial role in Indonesian culture, both in ritual and in the everyday life of the community. Their detailed designs carry elaborately coded meanings, reflecting a network of relationships determined by tradition, family ties and religious concepts. Looking at textile types as diverse as the islands of the archipelago themselves, the authors discuss a wide range of imagery characteristic of different social groups. Among key themes to emerge are the ship, and the abstracted human figure.

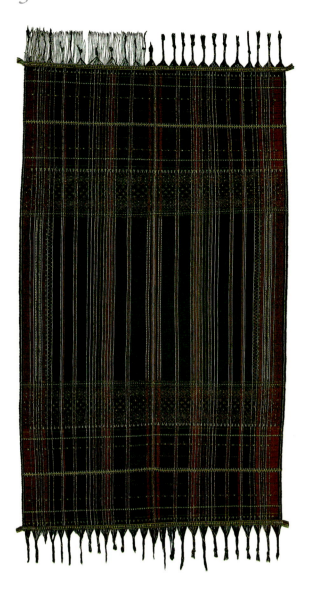

'Indonesian textiles' is a broad term, collectively used for garments, ritual objects and – more rarely – decorative objects from the Indonesian cultural sphere, which includes areas of present-day Malaysia. The process of cataloguing such a wide variety of 'textiles' according to scientific criteria presents a considerable challenge to curators of museums, galleries and private collections. Using information derived from field work and a study of the comparative literature, an attempt is made to describe each object, as far as is possible, according to geographical region, ethnic affiliation, age (time of acquisition and/or production), material, technique and purpose. During the colonial period the identity of producers and the place of production were considered unimportant and were rarely recorded, since the aim of collectors at the time was primarily to acquire reference examples of exotic crafts, to be categorised later according to typological criteria. Identifying the place of origin of a textile is further complicated by the fact that textiles similar in type are found over a wide geographical area, a result of trade links which go far back into history.

Most 'antique' textiles from Indonesia – and even fabrics produced in the twentieth century qualify for this description – have small, detailed patterns which, like coded messages, bear information about the cultural context of the object. These patterns not only reflect the external appearance of the world, they also show social interrelationships, and tell us of ways in which these have changed over the course of history. To this extent textiles in Indonesia are comparable to written texts, expressing cultural characteristics through colour and ornamentation. In rituals, they act as metaphors for social relationships; as clothing they often define gender, age, marital status, and social status. They contribute to the formation of identity, and place the wearer within a continuum of time and space.

In this sense, the patterns on Indonesian textiles are not just portrayals of nature and human beings, but of reality as it is actually lived. Everyday reality in Indonesia involves being linked into a network of relationships, which even today are determined to a considerable degree by tradition, by family ties, and by religious concepts. All these elements are reflected in their turn in the motifs that appear on the textiles, and can be broadly described – since they include all the important areas of life – as 'patterns of life', a phrase that has been used as the title of scientific publications,[1] of a symposium held in Basel in 1991, and also as the title of an exhibition mounted at the Museum für Völkerkunde in Vienna in 1995/6.[2]

Textiles with patterns that convey significant cultural meaning also possess, for the same reason, the indefinable aura which is the hallmark of a work of art. Nowadays, with many textile traditions undergoing radical change, collectors primarily look for 'old' examples, while there is little demand for high-quality contemporary material. 'Genuine' and 'old' are often wrongly used as synonymous terms in the textile marketplace. Synthetic fabrics with bright, often garish colours are regarded as culturally meaningless objects and dismissed as signalling the transition of textiles to the status of cheap merchandise. It is important to understand, however, that in many areas of Indonesia, even modern textiles enjoy a high cultural status and continue to fulfil a function as objects of ritual barter. Their circulation as gifts within various kinship groups still serves to cement the community.

With textiles that fulfil this function as ritual gifts, great significance is placed not only on the accuracy of execution but on the precise combination of motifs, which have been handed down from one generation to the next by women weavers. Although creative freedom is limited both by the technique of production and the restricted palette, the combinations of patterns applied are as complex as the traditions they represent. Outstanding weavings can be created through the use of relatively simple devices such as the backstrap loom, and readily available locally grown dyestuffs, which include indigo for blue shades and the roots of *Morinda citrifolia* for red tones.

In any attempt to understand the complex historical and religious background of this textile production and the hierarchical significance of many of the patterns, the high status accorded to fabrics imported from India is clearly a major factor. It can be assumed that the use of Indian fabrics in Southeast Asia was already well established at the time the great monu-

3. *Ceremonial shoulder cloth (abit godang), North Sumatra, Angkola or Mandailing Batak, before 1896. Cotton, mixed technique, 111 x 235 cm (3'7" x 7'8"). Museum für Völkerkunde, Vienna, 56.821. See Appendix for additional technical information.*

1. *Title page: ceremonial sarong, East Sumba (detail of 19).*

2. *Previous page: Ceremonial cloth (patolu), Gujarat, India, acquired in South Sumatra, 19th century. Silk, double ikat, 98 x 421 cm (3'2½" x 13'9¾"). Museum für Völkerkunde, Vienna, 146.385.*

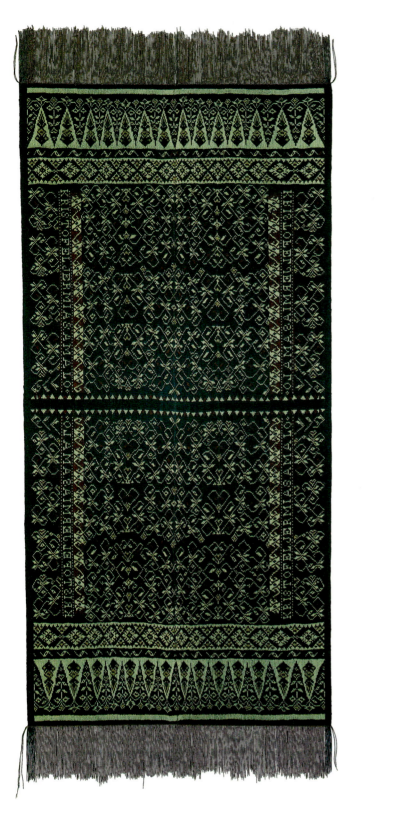

ments of Central Java and Cambodia were erected at the end of the first millennium AD. With the beginning of Mughal rule (1526-1858), there was a sharp increase in the production of high-quality textiles in India. A significant part of this production was intended for export and reached as far as Japan to the east and Egypt to the west, via the maritime trade routes.

Indian textiles were admired throughout Southeast Asia. They were exported to Indonesia from northwestern India and from the Coromandel coast in great quantities as commercial goods. The greatest demand was for the *patola* (silk double ikat fabric) (**2**) and for the printed, painted or resist-dyed cotton fabrics which are generally termed 'chintz' and are known in Japan as *sarasa* (**6**). For the elite of Indonesia, these frequently served as prestige objects: *patola* were worn by Javanese nobles and court dancers, while chintzes were probably used as ceremonial wall hangings and banners. *Sarasa* similar to those used in South Sumatra and dating from the thirteenth to the seventeenth century have been found by archaeologists working in Egypt. Textiles of this type reached as far as Nagasaki via the trading

4. Above left: Wrap for a man (lafa), Termanu, Roti, before 1905. Cotton, warp ikat, 75 x 192 cm (2'5¹/₂" x 6'3¹/₂"). Museum für Völkerkunde, Vienna, 73.352.

5. Above: Ceremonial hip or shoulder cloth (kain limar), Palembang region, South Sumatra, before 1911. Silk, weft ikat, embroidery, 94 x 181 cm (2'8" x 6'4¹/₃"). Museum für Völkerkunde, Vienna, 87.460.

6. *Ceremonial cloth (sarasa),*
India, acquired in Lampung,
South Sumatra, 18th century.
Cotton, painted resist, 206 x 269 cm
(6'9" x 8'10"). Museum für
Völkerkunde, Vienna, 175.363.

ports of the Portuguese, Dutch and Chinese from the sixteenth to the early seventeenth century. These historically important examples often show possible precursors of the textile patterns which continued to be symbol bearers in Indonesia on ritual occasions until deep into the twentieth century.[3] When, in the nineteenth century, the quality and the supply of Indian textiles waned, they gradually took on the function of ritual objects for use in religious

ceremonies. Owing to the high symbolic value of the *patola*, printed imitations were sold until the twentieth century. On the 'outer islands' (e.g. Sulawesi, Lembata and Babar), Indian textiles are still important ritual objects today.

A striking example of how foreign influences were integrated into existing textile traditions is provided by the textiles of Roti, a neighbouring island to Timor. The example shown is a shoulder cloth made for a nobleman, produced on Roti around the turn of the century (4). The spatial divisions, the rows of *tumpal* (triangular motifs), and the design of the main field with heart-shaped motifs clearly reflect the influence of the *patola*. Roti textiles characteristically show great precision in the warp ikat, and have deep, intense colouring – primarily blue-black with fine lines of light patterning accentuated by a little red. The Christian name woven into the cloth reflects the strong influence of the Roman Catholic mission active on the island from the sixteenth century.

Silk and gold and silver thread were luxury materials from the earliest times in Indonesia, as they were in their countries of origin – China, India, France and Japan. With the rise of the Srivijaya kingdom (seventh to thirteenth centuries AD) in the vicinity of Palembang, there was a great upsurge in production and importation of silk into South Sumatra. Silk fabrics, gold brocade cloths and textiles patterned with gold leaf were part of the rich life of the court. The designs and compositions of recent Palembang textiles still show a close affinity with fabrics from northern India, and exude an aura of luxury and splendour.

Among the best known Palembang region textiles are the *kain limar* (5), usually a combination of weft ikat and supplementary weft technique. These often have religious significance and are used in Islamic rituals.[4] Their patterns display the entire gamut of historical influences: birds and winged lions, possibly originating in the iconography of the Middle East, Indian floral garlands and palmettes, snakes or dragons *(nagas)* from India or China, Chinese butterflies, and Garuda wings reminiscent of Javanese batik motifs. Silk tie-dye shawls (7) are also characteristic of the Palembang region. On these cloths design zones are distributed in the same way as on the *kain limar*, while the ornamentation in glowing colours was frequently adopted from the Indian Mughal repertoire.[5] Similar cloths were used in Java and Bali.

The rich gold brocade textiles of the Minangkabau in West Sumatra reflect both Islamic elements and older, indigenous traditions. The female weavers of Minangkabau are masters of the supplementary weft technique, which is known throughout Indonesia as *songket*. In the local context, *songket* is the term used both for the design and the product itself. The term is derived from the word *jungkit* or *sungkit* and describes the technique in which the warp thread is raised in order to insert an additional weft thread of gold, silver or a different-coloured yarn.[6] Early *songket* pieces were decorated with fourteen-carat gold thread. Lozenge and star motifs are still, today, characteristic of these textiles.

The Minangkabau generally distinguish two categories of *songket*, according to the density of the gold or silver thread: the dense gold brocading covers almost the entire upper surface of the *songket balapak* (9), whereas in *songket batabua* or *bertabur*, the gold or silver decoration is less opulent. These fabrics, which are very heavy as a result of the gold, are items of

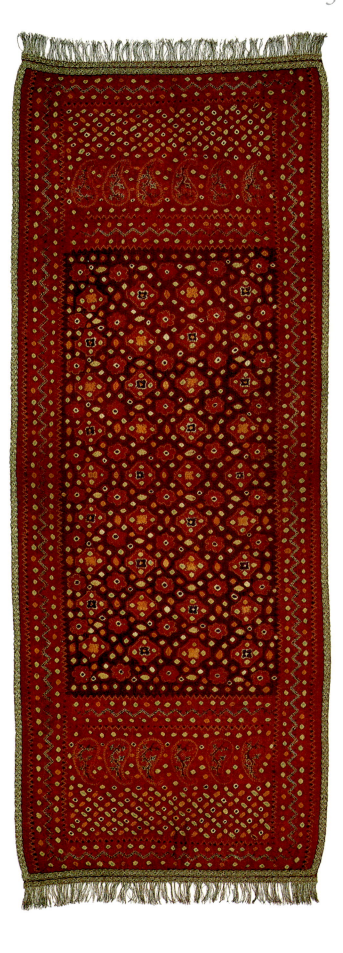

7. Shoulder cloth and shawl (selendang pelangi), Palembang region, South Sumatra, first half of 20th century. Silk, tie-dye, 82 x 236cm (2'8¹/₂" x 7'11"). Museum für Völkerkunde, Vienna, 146.470.

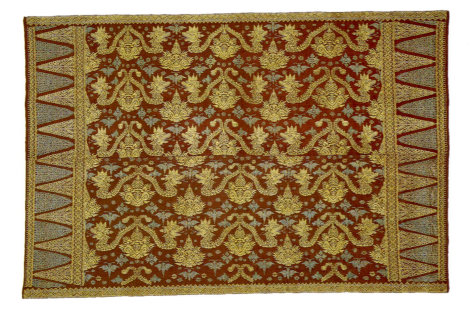

8. Upper hip cloth for a man (kampuh), Munduk, Buleleng, Bali, before 1905. Silk, gold and silver thread, supplementary weft brocade. 116 x 168 cm (3'9½" x 5'6"). Museum für Völkerkunde,

9. Shoulder cloth (selendang, salempang), West Sumatra, Minangkabau, before 1946, probably around 1900. Silk, gold thread, supplementary weft brocade, 94 x 202 cm (3'1" x 6'7½"). Museum für Völkerkunde, Vienna, 131.125.

considerable value within the kinship group. At an influential symposium held in 1985, Peggy Sanday and Suwati Kartiwa first differentiated between the 'value in' and the 'value of' Minangkabau songket. The first is determined by adat, the indigenous tradition, while the second corresponds to a financial market value.[7] This differentiation arises from the fact that since the global economic crisis in the 1930s, the weaving of costly fabrics has declined rapidly. As a songket represents a specific kinship group as well as a material expression of the rules of adat, it is difficult to conceive of such textiles being sold. This is even more true of the conservative villages of Payakumbuh, where traditional textiles are understood to be 'the skin of adat', in other words an important safeguard of traditional customary law in the face of disturbing outside influences, just as the skin protects the body against numerous dangers. Nevertheless, with the steep decline in traditional weaving in many villages, it is now impossible to meet the demand for such ceremonial clothing within the community. Copies of traditional songket produced in the weaving centre of Pande Sikek are therefore used as ceremonial objects as well as being sold commercially, an interesting compromise in which tradition is upheld by the market economy and vice versa.

On the island of Bali, where the culture has strong Hindu elements, costly silk textiles were primarily reserved for members of the upper castes. The complicated production process, the silk itself, and the use of expensive, imported raw materials, precious dyestuffs, and gold and silver thread, made them prestige symbols at the princely courts, to be displayed at temple festivals, palace ceremonies and dance and theatrical performances.[8] Even the production of such textiles occurred within a socially privileged milieu. Brahman and aristocratic women wove silk cloths with silver or gold brocade and weft ikat exclusively for their own use. Well-preserved textiles of this type are rare, and usually no more than a hundred years old. Typical of Balinese court textiles is the upper hip cloth for men (8, 11), composed of two woven widths joined together – both the pieces illustrated come from the North Balinese principality of Buleleng, which appears to have been an important textile centre with influence over a large area around the turn of the century. These weavings characteristically have a background of deep brown-red and purple tones, and the combined insertion of

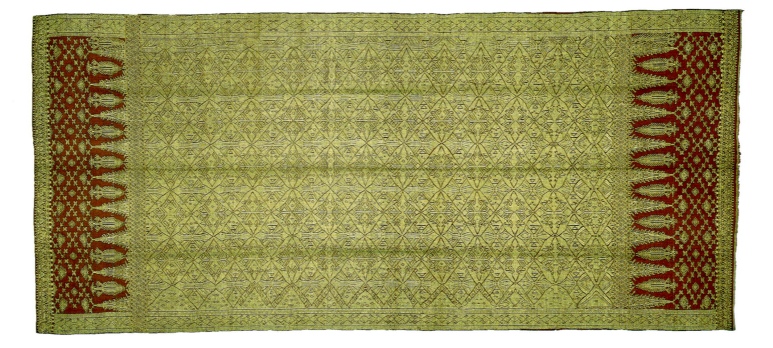

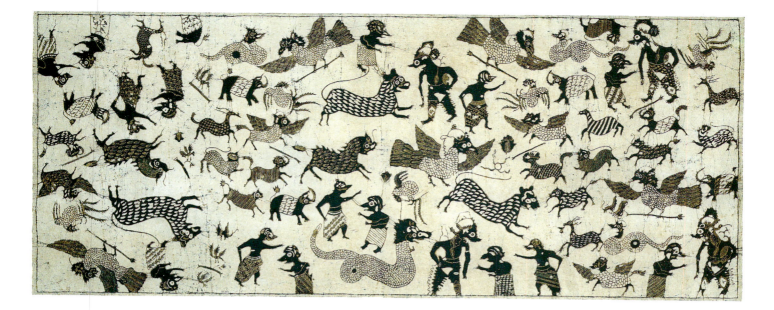

gold and silver thread. Apart from geometric and floral designs, in part influenced by the *patola*, representations of gods, demons and animals derived from Hindu mythology were popular. The crowned snakes seen on (11) as paired mirror images were probably understood as symbols of rulership; beside them it is possible to make out turtles and highly stylised demon heads *(boma)*, with an almost floral effect. The anthropomorphic figures in this hip cloth correspond stylistically – head in profile, body facing the front – to figures from Balinese shadow theatre *(wayang kulit)*.

The complicated double ikat technique of *kain geringsing* ('not ill-making cloths') makes them the most famous example of another category of Balinese textiles: those understood to have protective qualities. While highly regarded throughout Bali, *kain geringsing* are only produced in a single place, the traditional Balinese village of Tenganan Pergeringsingan. Unique in Indonesia, these double ikat cloths are used at rites of transition, from teeth filing to the burning of a corpse.[9]

Fabrics made in the batik technique are often taken as representative of the entire textile repertoire of Java, and even today, Javanese batiks take pride of place among Indonesian clothing. Traditionally, they were used primarily in the ceremonial dress of the aristocracy. From the second half of the eighteenth century, in Central Java certain batik patterns were reserved exclusively, by decree, for the sultan, his family and the higher officials of his court. Nowadays the elite no longer have an exclusive claim to these prestige symbols, and the 'forbidden patterns' appear on batik fabrics for everyday use. Batik has now become so widely diffused that it has come to symbolise the artistic production of the whole archipelago.

The batik of the north coast of Java is livelier and more colourful than the more sombre Central Javanese production. Many of the designs look back to Chinese models, with textiles intended to demonstrate wealth and prestige adopting the kind of animal motifs used on Chinese export ceramics, such as dragons, birds and fish. Indian chintz also influenced batik, both in its combination of a light ground with airy and delicate floral motifs and in the use of finishing techniques such as polishing or the application of gold leaf.

During the nineteenth century not only the Javanese but also immigrant Chinese and European expatriates founded batik businesses on the island, ranging in size from

10. Hip cloth (kain panjang), Surabaya, East Java, before 1883. Cotton, batik tulis, 107 x 258 cm (3'6" x 8'5½"). Museum für Völkerkunde, Vienna, 17.985.

11. Upper hip cloth for a man (kampuh), Munduk, Buleleng, Bali, before 1905. Silk, gold and silver thread, weft ikat, supplementary weft brocade, 116 x 150 cm (3'9½" x 4'11"). Museum für Völkerkunde, Vienna, 73.562.

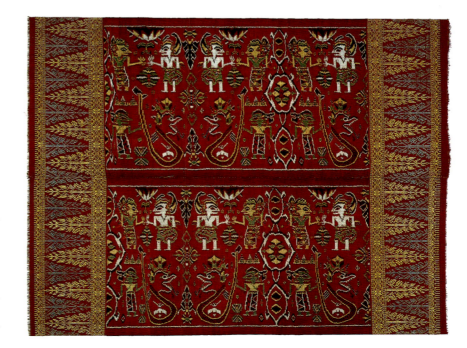

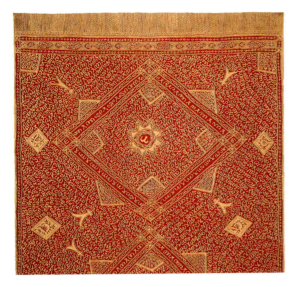

12. Batik cloth (kain batik tulisan Arab; detail), Java, north coast, probably around 1900. Cotton, batik tulis, 93 x 212 cm (3¹/₂" x 6'11 ¹/₂"). Museum für Völkerkunde, Vienna, 176.002.

14. Hip cloth (kain panjang; detail), Cirebon, Java, before 1950. Cotton, batik tulis, (105 x 259 cm (3'5¹/₄" x 8'6"). Museum für Völkerkunde, Vienna, 175.035.

13. Batik cloth (kain batik tulisan Arab), Java, north coast, acquired in Palembang, South Sumatra, probably around 1900. Cotton, gold thread, batik tulis, 93 x 214 cm (3'0¹/₂" x 7'0¹/₂"). Museum für Völkerkunde, Vienna, 175.196.

small family workshops to factories. Many of these businesses were run by women. As an export market evolved – mainly to Sumatra and Bali – synthetic dyes were introduced in order to compete with cheap printed imitations of batik imported from Europe, and new labour and time-saving techniques, such as *batik cap* (stamped batik) were developed. Javanese colours, among them the soga brown (extracted from the bark of *Ceriops tagal* and *Pelthophorum ptero-carpum*) characteristic of inland production, as well as geometric designs and other motifs copied from woven textiles and basketwork, from shadow theatre and paintings (**10**), were combined with local colours and motifs. Chinese producers drew inspiration from their own traditions, drawing on porcelain, paintings, lacquerware, brocades and embroidered textiles, and even carved furniture, to create a series of designs based on mythical and real animals, as well as stylised landscapes with rocks, mountains, clouds and water. Specific symbols such as flower vases and coins, characters from Chinese mythology and from everyday life, gave the batik a new character.

The northern region of Cirebon with its princely courts was an important centre for the manufacture of high-quality batik fabrics. As well as court insignia, the designs of these textiles include painstakingly hand-drawn *(tulis)* motifs taken from the local fauna. On the hip cloth shown opposite, the tendrils of the *ganggeng* (sea grass) curl around a swarm of marine creatures such as fish, prawns, rays and cone shells, and terrestrial animals such as elephants, predatory wild cats, deer, crocodiles and a multitude of birds and butterflies (**14**). The snake (in Javanese, *nogo*) bears the traits of a mythical beast that appears in a similar form on the magnificent buildings of the princely courts of Central and North Java. Similar batiks were also made in the northern Javanese kingdom of Indramayu.[10]

The archipelago was 'Islamicised' in the fifteenth century, and today 87 per cent of the Indonesian population follow Islam. The initial diffusion of the Islamic faith in Java was carried out by nine preachers *(wali)*, among them Sunan Gunung Jati, who was active in the Cirebon region. One of his wives was the Chinese princess Ong Tie, who may have been responsible for introducing Chinese designs as models for batik production when she came to Java for her marriage bringing with her many *objets d'art*, in particular ceramics.[11] With the advent of Islam the Arabic script was introduced as a graphic element in Indonesian textiles, particularly along the north coast of Java, at Cirebon, Kudus and Demak. Arabic calligraphy is found on items such as batik flags, shawls and headscarves. The latter have a protective function; they are still made in the neighbourhood of Cirebon[12] as well as being popular in Aceh and South Sulawesi.

Batiks incorporating Arabic calligraphy were specifically made for religious Islamic communities on Java, but were also exported to Sumatra. In general, ornamental calligraphy appears within compartments or cartouches similar to those on ceramic tiles and carpets from the

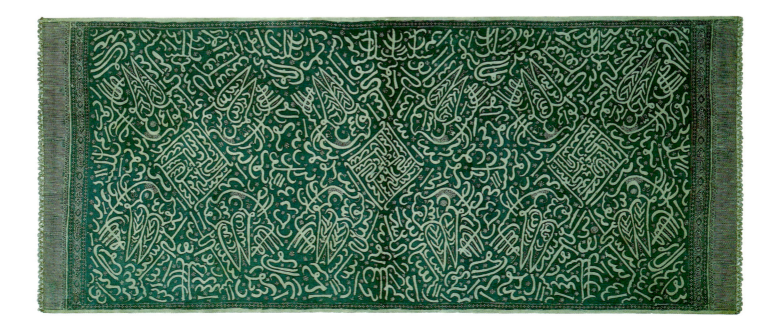

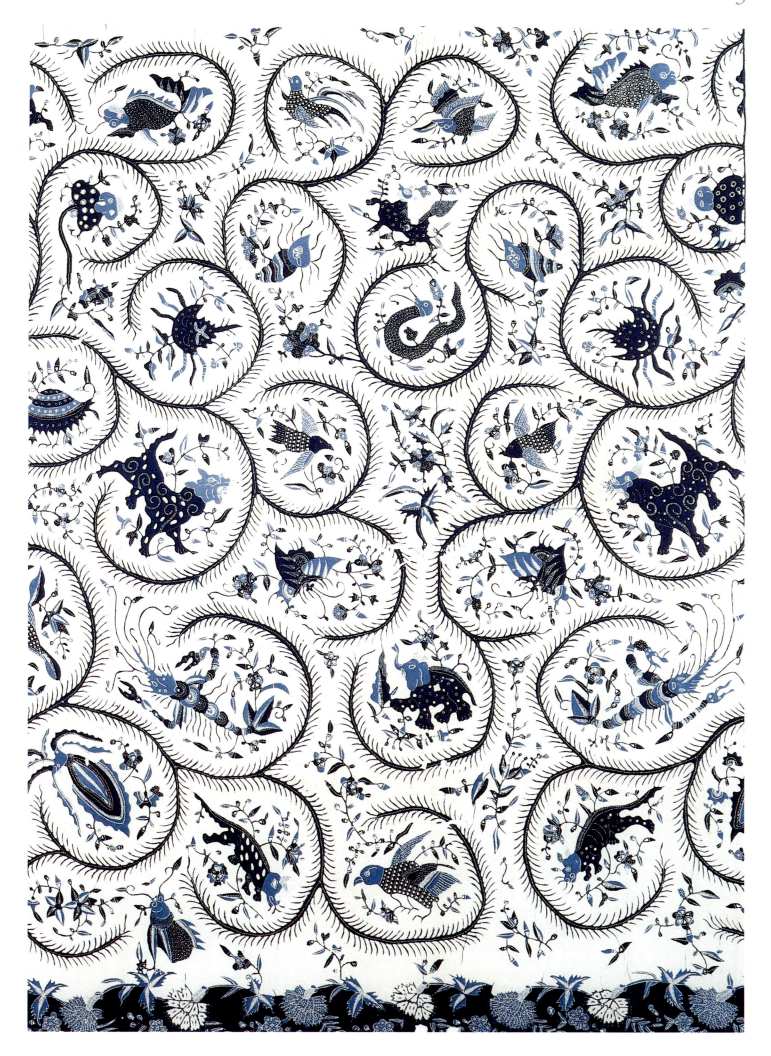

16. *Opposite: Ceremonial cloth (tampan), Lampung, Sumatra, Kota Agung (?), probably around 1900. Cotton, silk, floated supplementary weft, 60 x 66 cm (1'11½" x 2'2"). Museum für Völkerkunde, Vienna, 175.184.*

17. *Opposite below: Ceremonial cloth (sipa tangan) and appliqué of glass bead work (jenar), Sukadana, Sekampong, Lampung, Sumatra, before 1886. Cotton, floated supplementary weft, 60 x 70 cm (1'11½" x 2'3½"). Museum für Völkerkunde, Vienna, 30.376 and 30.377*

15. *Fragment of a sarong (batik kompeni), north coast, Java, first half 20th century. Cotton, batik cap, 106 x 182 cm (3'5¾" x 5'11½"). Museum für Völkerkunde, Vienna, 175.427.*

Middle East (12), and was sometimes used, again reflecting Middle Eastern traditions, to create figural designs such as birds (13). Batiks of this type are still in demand in Jambi and Palembang, with copies of surviving originals being produced in Bengkulu.

Mythical creatures from Middle Eastern iconography such as the *bouraq* (a winged horse with a human head that bore the prophet Mohammed to heaven) also found their way into Indonesian art through the spread of Islam. Others already present in Indonesian traditions, such as the lion, were reinterpreted as a result of the influence of Islamic doctrine. The *singa putih* (white lion) motif – white was said to symbolise purity – was derived from the white tiger, the symbol of the West Javanese and non-Islamic kingdom of Pajajaran, which was conquered by the second sultan of Bantam in the late sixteenth century. Under Islamic influence the tiger became a lion, and is also known as the *singa Parsi* (lion of Persia).[13]

The development of the batik produced on the north coast of Java was dependent on communities which could afford to import fine cotton fabrics from India or, later, from Europe. An association of dealers supplied the batik businesses with raw materials and dyestuffs and allocated jobs. The sarong and the *kebaya* (woman's blouse) were increasingly also worn in the Eurasian and Dutch communities, creating a demand for batik designs that reflected their tastes, with nostalgic, romantic representations in Western style, fairy tales or historical events coming into use, particularly in the region of Pekalongan.

The textiles known as *batik kompeni* (*kompeni* being a synonym for the Vereenigde Oost-Indische Compagnie or VOC, known in English as the Dutch East India Company) reflect the relations between Indonesia and Europe at the end of the colonial period. Europe saw the Indonesian islands as a major source of much-sought-after spices, particularly cloves and nutmeg. A colony of indigenous workers became employees of the VOC, which also controlled the trade in Indian textiles.

The European colonial rulers often only communicated with their Indonesian subjects – for this was how they saw them – with a Bible in one hand and a weapon in the other. The indirect violence that underpinned their rule is only hinted at in textiles and is hidden behind depictions of Western hierarchical designs, prestige symbols and signs of the industrial revolution. Textiles which combine European steamships with local designs are typical of the first half of the twentieth century. The way in which these features are combined in (15), with floral designs in a decorative field (the dark field on the right), and the use of borders, is characteristic of the Javanese north coast style.

A further example of European influence comes from South Sumatra and is one of the so-called 'ship cloths' (16). Here a European galleon is depicted in highly abstract fashion.[14]

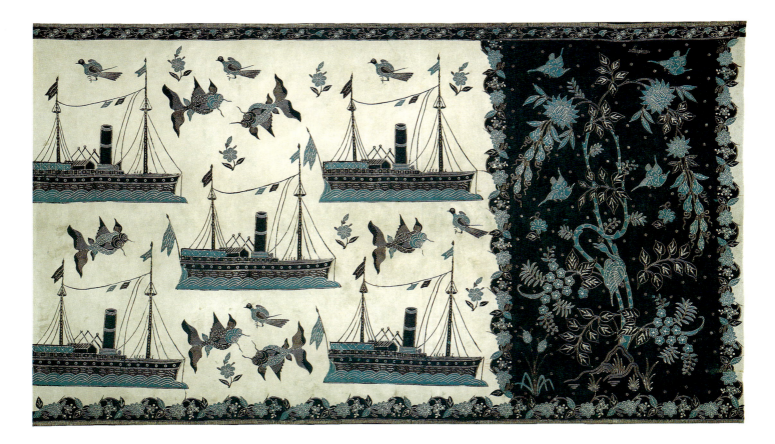

Among the numerous identifiable details are portholes, and several masts with sails and flags; on deck and in the background stylised human figures can be seen. The ship is a common motif in the art of Southeast Asia. Coffins and sculptures of wood and stone in the form of ships are known from many Indonesian cultures. Representations of boats, even when they are sometimes reminiscent of European models, are usually to be understood as religious metaphors, or symbols of the interaction of powers within a society. This, for example, applies to the 'ship cloths' from Lampung worked in supplementary weft technique. Of all the textiles from this small province in South Sumatra, the almost square *tampan* are the most widespread objects in ritual life. Whereas *tampan* from the mountainous hinterland usually have, in addition to geometric designs, angular abstractions of trees, animals, houses and ships (to which they owe their name), the cloths produced near the coast often have much more finely executed scenic representations. Figures are shown from different perspectives, a creative approach which goes beyond the frontal representation or the bird's-eye view so common in Indonesia. The drawing of humans and animals in profile and the strong contrast between the dark foreground and the light background is typical of this

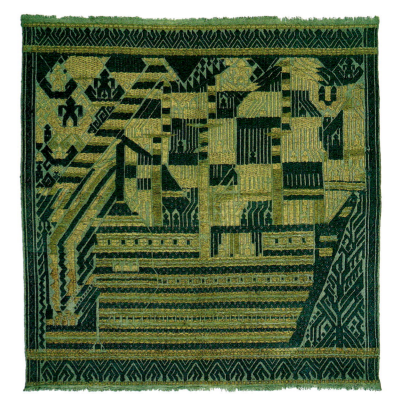

type of textile, and reminds one of the Indonesian shadow theatre, *wayang kulit*, in which the characters are represented by highly stylised puppets made of leather.[15] On many pieces, human figures are depicted in this style, so that the influence of nearby Java seems probable.

The rare ensemble seen in (**17**) consists of a *tampan* and a beaded cross. According to records from the collector of the piece, this cloth was called *sipa tangan* (cloth for the hand) and was used at ceremonies to cover food set out on a wooden plate. Over the cloth was laid a lid made from nipah leaf along with bands of glass-beaded fabric *(jenar)* in the shape of a cross and small horns sewn from fabric. The central element in this *tampan* (partly covered here by the beaded cross) is an anthropomorphic figure. Part of the frame around the figure symbolises a ship, although this is less dominant than on the larger ceremonial cloths called *palepai*. The latter, today among the rarest textiles from the Indonesian region, can be up to five metres long and were made exclusively for the aristocracy. In the ethnological literature of the first half of this century the significance of the ship was often associated with the cult of death and the transmigration of souls. But the very fact that *tampan*, the most common ship-cloths of Lampung, are used as ceremonial seats, pillows, covers for ritual gifts, and reliquaries at ceremonies of birth, death, circumcision, marriage, petition, house-raising and ascendancy in rank, shows that their function goes even further. On one level they may also serve as symbols of the ordered hierarchical structure of society, in which the ship is understood as a spiritual lifeboat that safely conveys the community through danger and uncertainty.[16] This order can be seen as a central theme of the region. As an archetype it is found in various versions throughout Indonesian art – a 'pattern of life' in the very best sense.

Lampung today has an Islamic culture. The weaving of 'ship cloths' was discontinued around the turn of the century, and the tradition can now only be pieced together as part of a cultural-anthropological

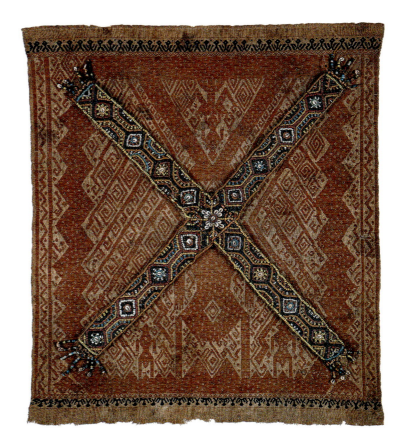

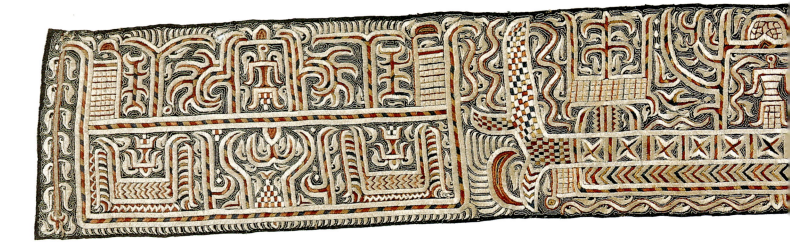

18. *Strip of pattern from a ceremonial sarong (tapis), Lampung, Sumatra, probably around 1900. Cotton, silk, embroidery, 19 x 132 cm (7¹/₂" x 4'4"). Museum für Völkerkunde, Vienna, 142.372.*

19. *Ceremonial sarong for a woman (lau pahudu – shown with seam opened), East Sumba, before 1890. Cotton, supplementary warp, painting, 127 x 151 cm (4'2" x 4'11¹/₂"). Museum für Völkerkunde, Vienna, 83.272.*

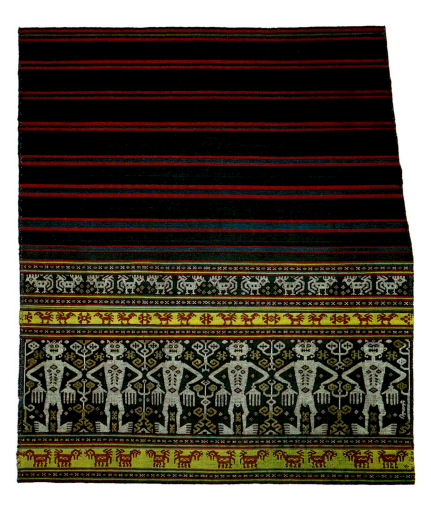

puzzle. However, another textile type from this region has survived to the present day – probably because of its function as an item of clothing. This is the ceremonial sarong *(tapis)* for women, which combines different techniques such as ikat, embroidery and appliqué in one length. The more expensive pieces are worked, at least partially, in silk. The most commonly seen *tapis* have bands of ikat and narrow strips embroidered with a variety of motifs, including ships, humans, plants, animals, and geometric patterns (**18**). Whereas the ikat patterns often imitate *patola* designs, the iconography of the embroideries may relate to stylistic elements from mainland Southeast Asia.[17]

Like the ship, the motif of the human figure is widely diffused throughout Indonesian art. It appears in house painting, on carved objects used both in ritual and in everyday use, on decorative objects, on beading and basketry work and, particularly, on woven textiles from Borneo and East Indonesia. Anthropomorphic figures are often arranged serially in horizontal or vertical rows and could thus be directly associated with rows of ancestors. This aspect is strengthened even further in abstract representations where the figures are linked to each other. The dominant prototype is a standing, naked figure, reduced to straight lines and diagonals – the occasional representation of genitalia indicates fertility as well as gender. The human figures on the textiles of Borneo and East Indonesia express the main theme of the tradition-bound societies of this region: they serve as motifs of life in which genealogical survival and fecundity are set forth as existential values.

Ceremonial sarongs from East Sumba, patterned in the complicated supplementary warp technique, often show human figures standing facing the front with elbows and knees pointing outwards. In the textile illustrated (**19**), the space between the human figures is filled with two motifs which initially give the impression of being purely geometric. Looked at more clearly, the motif rising from below shows the so-called *andung*, a pole on which the trophy skulls from head hunting were fastened. From bottom to top one can identify the following elements: the stone base, the vertical male pole with buffalo horns (here represented by brown double spirals), above this the horizontal female beam and two skulls (the brown diamond shapes). The narrow patterned bands show a cockerel and other birds and a four-legged animal – probably a horse. These sarongs, known as *lau*

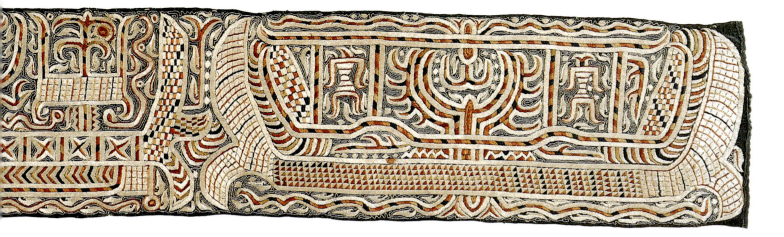

pahudu, were reserved for aristocratic women, who created the designs themselves and recorded them on pattern guides.[18] The warp ikat wraps worn by men *(hinggi)* also carry human figures – which in this case are shown much more frequently with raised hands – as well as European-influenced designs such as heraldic animals. On both textile types the anthropomorphic figures symbolise the *marapu*, the ancestors, whose cult is greatly revered on Sumba.

Figures similar to those on Sumba textiles are also found on certain weavings made by the Atoni of the central mountainous region of West Timor. The 'people of the dry land', as the Atoni call themselves, produce colourful textiles which stand in strong contrast to the barrenness of the country. Particularly luminous colours can be obtained using synthetic dyes and yarns, which were already in use around the turn of the century. Among these is a remarkable red, which in earlier times symbolised bravery and was used in the war dress.[19] The central field of these textiles frequently carries animal and human figures, shown paired – as on Sumba – in mirror-image. In the ikat textiles of Central Timor, reptiles and human beings often undergo a symbiosis. Again, they probably represent the ancestors, as well as the transformation which occurs with the changing of the generations.[20]

Highly abstract anthropomorphic figures appear on textiles from the Galumpang region of Sulawesi, which have not been produced since the end of the nineteenth century. They are distinguished by their particularly glowing colouring – although natural dyestuffs were used – and their dynamic composition. The exact function of the rare ceremonial cloths known as *papori tonoling* is unknown. Possibly they were hung up at burial ceremonies or used as shrouds, like other large ikat cloths from the same region. As on other examples of this type, the predominant motif in (**20**) is the so-called *sekong* motif – a diamond with two double hooks (here rather flattened). This motif, which can also be found on textiles from Borneo and from the Sangir and Talaud islands, represents an entirely abstracted human figure.[21] The lengthwise asymmetry and different end borders in this example give it a special dynamism and liveliness. An effect of perspective is created by the dramatic contrast in size between the small and large motifs, emphasised even further by the dark-brown shading of the *sekong* figures. The repeated cross motifs are intended to demonstrate

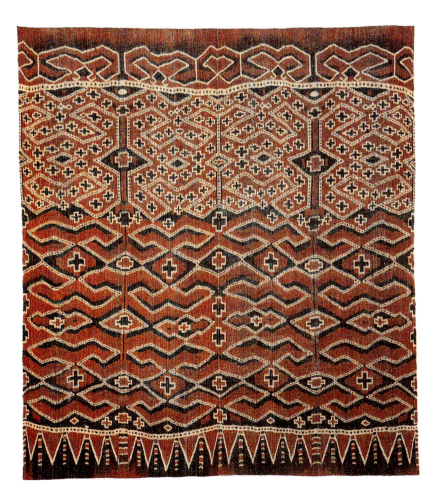

20. Ceremonial cloth *(papori tonoling)*, Galumpang, South Sulawesi, To Mangki, before 1929, probably 19th century. Cotton, warp ikat, 138 x 165 cm (4'6½" x 5'5"). Museum für Völkerkunde, Vienna, 98.273.

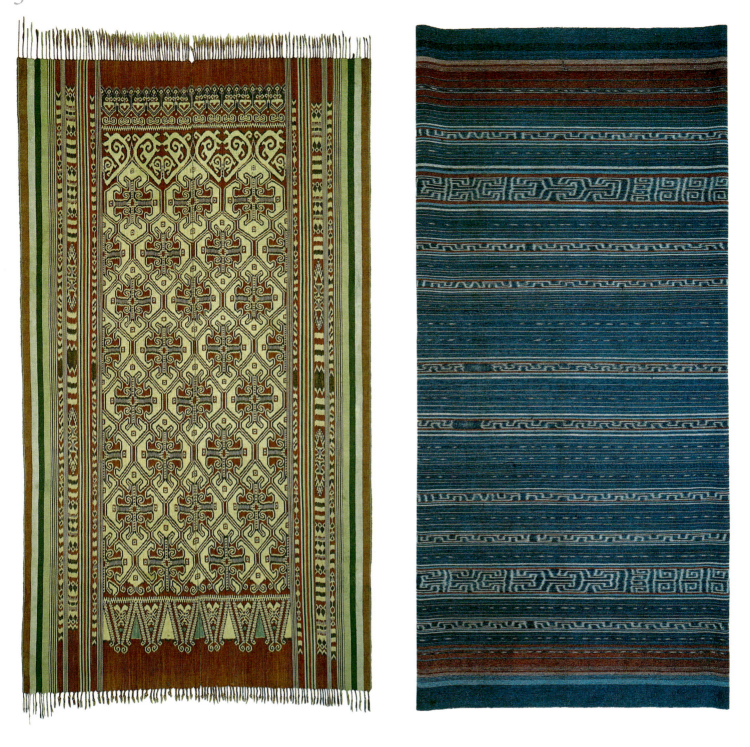

21. Above: Ceremonial cloth (pua kumbu), Sarawak, Borneo, Iban, before 1970, probably ca. 1900. Cotton, warp ikat, 104 x 210 cm (3'5" x 6'10½"). Museum für Völkerkunde, Vienna, 175.362.

22. Above right: Ceremonial sarong for a woman, Galumpang (?), South Sulawesi, To Mangki, probably ca. 1900. Cotton, warp ikat, 78 x 165 cm (2'6½" x 5'5"). Museum für Völkerkunde, Vienna, 167.476.

abundance.[22] The form is not in any way related to Christian influence, but probably results from the reduction of certain *patola* designs. A harmoniously coloured ceremonial sarong (**22**) from the same region shows dominant, glowing graduated blues, with a pale turquoise shade that is found only in pieces of the highest quality. This type, too, has not been produced since the end of the nineteenth century.

Prominent among the creative elements on the large-format ceremonial cloths *(pua)* of the Iban of Borneo and related ethnic groups are representations of crocodiles and snakes, two of the most common as well as the most original design motifs in Indonesia. Some of these ceremonial textiles show realistically drawn figures of humans and animals, but more frequently the forms are highly stylised, their significance known only to the weaver herself. A *pua kumbu* from Sarawak (**21**) displays a combination of two different patterns: the main field clearly shows the influence of the *patola* in the distinctive four-lobed *habaku* elements often seen on the central field of *patola* in Sumba ikat *hinggi*,[23] while above, on the upper border of the main field, are abstract faces or masks (with a further small mask inserted), which are stylistically reminiscent of carvings, paintings, and tattoo designs – all of which are executed by men.

The fabrics of the various Dayak groups living on Borneo are made using a multitude of

techniques. The production of barkcloth was common until the turn of the century. Best known is the barkcloth of the Kayan and Kenyah of Central Borneo with its complex curvilinear style of painting, sometimes used for the making of war jackets. Cords of plant fibre worked in the technique of twining (an intermediate form between plaiting and weaving) and pieced together from several individually made parts are used to make another striking type of war jacket, also painted (23). Similar jackets were also used on Sulawesi and Flores. It seems likely that the unusual cut imitates hide garments – until recent times war jackets fash-

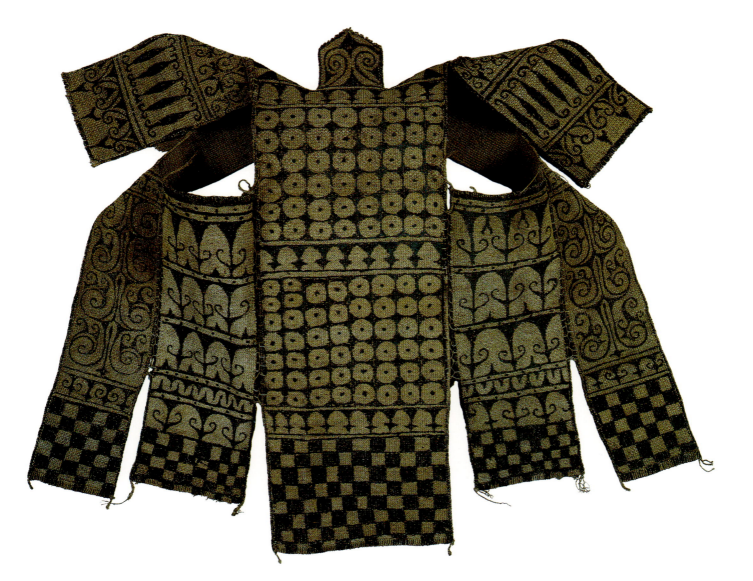

ioned from goat, bear and tiger cat skins were worn by some Dayak tribes. The simplicity and linear arrangement of the painted, geometric ornamentation creates a clear, powerful effect. On Bali and Java it is said that the chequered design exerts a protective function, its combination of light and dark fields representing the forces of purity and darkness. The circles with a central dot, prominent on the back, probably correspond to the shell disks which are normally sewn on to the war jackets.

Even today, a multiplicity of textiles are produced in Indonesia in accordance with traditional standards. Weavers still prefer the old, tried and tested methods when making fabrics for their own use. At the same time far-reaching changes in living conditions have enormously broadened the repertoire of designs. Frequently, in place of the mythological interpretation of the world, we now come across realistic symbols of the contemporary political and economic situation in Indonesia. These can range from patriotic images such as the national emblem (an eagle) and the *pancasila* motif (a symbol expressing the five fundamental ideals of the Indonesian nation), to elements of a modern industrial society such as aeroplanes and cars, or representations of tourist attractions. We must wait and see to what extent the Indonesian textile arts will be able to adapt to new conditions in the future.

Notes and additional technical information see Appendix

23. Warrior's jacket, Kalimantan, Borneo, before 1877. Bast fibre, twining and painting, 66 x 70 cm (2'2" x 2'3½"). Museum für Völkerkunde, Vienna, 5.322.

4

PUBLIC SHOWCASE PRIVATE RESIDENCE

The Early Tang Tombs Revisited

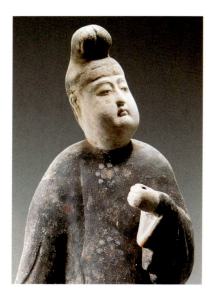

NING QIANG

The political, military and cultural influences of the Tang dynasty (618-907 AD) were a powerful force in their day, and their effect on many different Asian cultures can still be felt. This great Chinese empire also left behind a more material legacy in the form of buildings and funerary monuments. Significant among these are the furnishings and pictorial programmes of the large and lavish tombs of the Tang imperial family, aristocracy, and high-ranking officials.

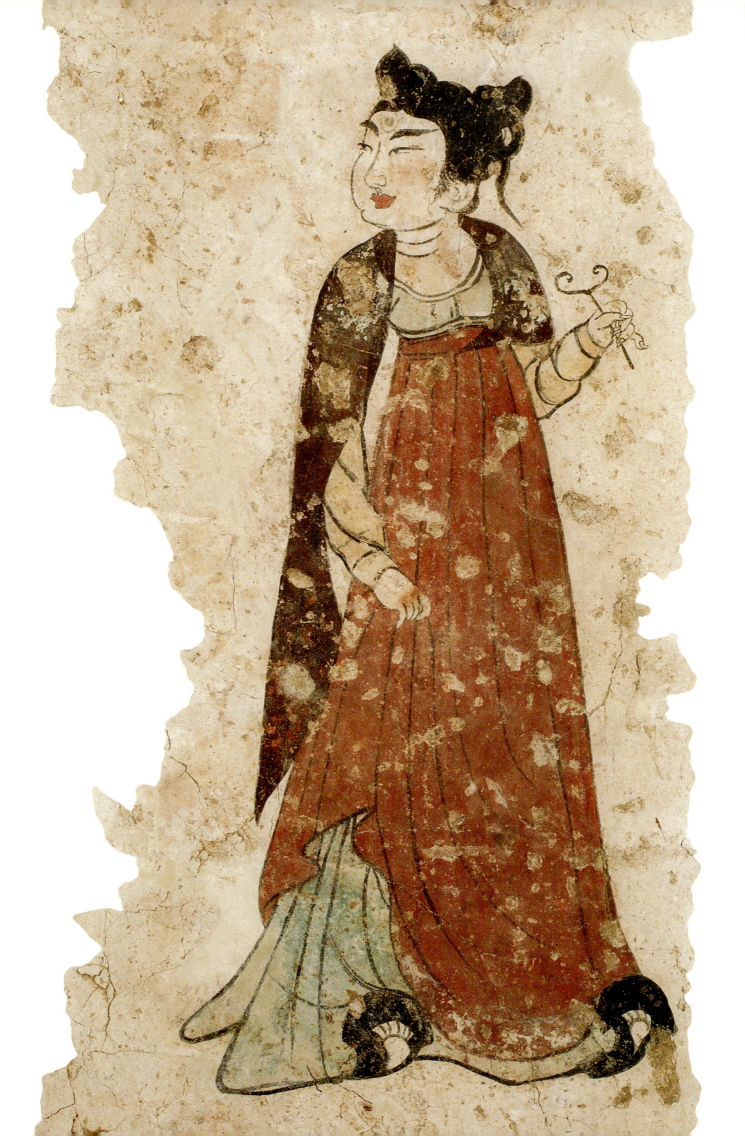

The magnificently furnished tombs of the Tang imperial elite survive as the best material evidence of a dynasty considered by many to have presided over China's golden age. While the above-ground monuments and sculpture of most of the tombs of the Tang (618-907 AD) have disappeared, many of the actual tomb mounds remain. Inside these, the tombs typically consist of a long sloping passageway leading to a chamber located deep underground (3). The passageway is very long and wide, allowing for the easy conveyance of the coffin by a large funeral cortege. The chamber itself is large and shaped like a living space. Both the passageway and chamber are usually decorated with extensive murals, and there are also numerous ceramic figures of people and belongings, intended to accompany the tomb occupant into the afterlife. This discussion will focus primarily on the pictorial programmes of tombs from the first half of the Tang dynasty – the early seventh to the late eighth century – asking what they reveal of the dual function of the tomb as 'public showcase' and as 'private residence'.

According to an inventory made by Chinese archaeologists, the occupants of twenty-four Tang period tombs excavated in Shaanxi province include eight imperial relatives, nine military officials, five civil officials, a eunuch's wife and an official whose rank and position is unclear. The patrons of these tombs were the families of the deceased, assisted by the government. For example, when the powerful court official Li Yifu (614-666) re-buried his grandfather, the governor of Sanyuan County sent many labourers with ox-carts to carry earth for the construction of the tomb, and they worked ceaselessly on the project night and day. The governors of the seven neighbouring counties were also obliged to send men and ox-carts to join them. The kings (in Tang China, the title of 'king' was one of high government position usually conferred on imperial relatives) and dukes and other officials presented numerous expensive gifts to Li Yifu. When the funeral ceremony was performed, the funeral procession of horses, carts and portable ancestral shrines extended over thirty-five kilometres. The tomb construction and the funeral ceremony were thus very public events, and as such provided an excellent opportunity to demonstrate the political power and beliefs of the tomb occupant or tomb patron.

Evidence shows that the overall design and at least aspects of the decorative schemes of the early Tang imperial tombs were made by high-ranking artist-officials, and it is very likely that the emperors themselves were personally involved in the design of the tomb. Official records reveal, for instance, that Yan Lide (d. 656), one of the most famous artist-officials at the early Tang court, was the chief designer of the tombs of the first emperors Gaozu (r. 618-626) and Taizong (r. 627-649). His younger brother Liben (ca. 600-674), one of China's first great painters, was also a court official, and reputedly contributed to the decorative scheme of Taizong's tomb. The design of the 'Six Great Horses' sculptures that stood outside the Second Emperor's tomb (two of which are now in the collection of the University of Pennsylvania Museum in Philadelphia, while the remaining four are in the Shaanxi Provincial Museum in Xi'an, Shaanxi province), has traditionally been attributed to Yan Liben. Each of these powerful horse sculptures was accompanied by an engraved poem in praise of horses, composed by Emperor Taizong himself and executed in the calligraphy of the famous calligrapher-official, Ouyang Xun (557-641). Any reading of the pictorial programmes of the tombs must therefore take into account the political and social environment within which they were created, and the realities of court politics in particular.

The mural programmes in the tomb passageway often held the most public significance, depicting scenes almost certainly meant to emphasise the importance of the tomb occupant's position in society and to comment on political concerns. The subjects of these large and detailed murals are commonly processions of ritual guards, officials and foreign envoys, and sometimes public monuments, including palace buildings, and the gates of the Tang capital, Chang'an (present-day Xi'an).

As these passageway murals seem to be more or less dictated by temporal power and beliefs, so they also changed with the evolution of Tang society, particularly as it impinged on life at the imperial court. At the very beginning of the dynasty, the theme and composition of the pictorial programmes of

0 5m

the tombs were more obviously dominated by Confucianism, which had been formally adopted by the first two emperors as the state ideology. In this way they were able to offer a visual substantiation of their claim to have replaced the several hundred years of military and political chaos with a government based on the ethical priorities and social harmony advocated by Confucianism.

An example of this is the pictorial programme in the passageway of the tomb of Li Shou (577-630), a general of the Tang army, seasoned veteran of battles with the preceding Sui dynasty (581-618), and cousin of the first emperor, Gaozu. In the reign of Taizong, he was granted the title of King of Huaian and heaped with honours. Built in 630, his tomb includes the standard long sloping passageway leading to a front and a rear chamber, the whole of which is covered with a programme of murals. The paintings on the walls of the passageway have been divided into upper and lower registers. While the lower register represents the procession of ritual guards, the larger upper register is concerned with hunting scenes (5). For the early Tang emperors with their newly-won empire, hunting served as a form of military exercise. When criticised by some advisers for his enthusiasm for the sport, Taizong had argued: "We are now living in peace, but we cannot forget military preparation!" Given Li Shou's involvement in helping to win the empire for the Tang, it is no surprise to find hunting scenes featuring so prominently in tomb murals.

Three subjects are depicted in the tomb chambers and in the corridor connecting them with the main passageway: agricultural production (farming and pasturing), ritual (setting the 'halberd shelf' and performing music), and religion (Daoist and Buddhist temples). The first two themes constitute key concepts of Confucianism – *ren* (kindness) and *li* (rite). To encourage production and let common people live in a wealthy and happy society is the essence of *ren zheng* (policy of kindness), and the detailed representations of farming and pasturing in Li Shou's tomb parallel and possibly comment on Taizong's 'policy of kindness' in the early years of his reign. In the Confucian mind, rites were the key for organising society, and, accordingly, during the Tang dynasty the official ranks of tomb occupants are usually represented by a painting of a 'halberd shelf' in their tombs: the more halberds depicted, the higher the rank of the deceased. The painting of the ritual of setting the 'fourteen halberds' on the shelf in Li Shou's tomb indicates that the rank of the tomb occupant was that of king. Again, the depiction in the same tomb of a musical performance, taking place in what may be the courtyard of an ancestral temple, serves to underline further the significance of Confucian rites.

The tombs of imperial relatives such as Li Shou were often sponsored by the emperors themselves. The tomb of the first emperor Gaozu, for example, was sponsored by his son Taizong, who also built his own tomb. In the reign of his son and successor, Gaozong (r. 650-683), political struggles between the imperial Li family and Gaozong's empress, Wu Zhao (624-705), intensified. The pictorial programmes of the tombs soon began to reflect the changing political situation at court, becoming less a representation of imperial righteousness than a forum for political and personal vendetta.

Unlike his two predecessors, Emperor Gaozong was a weak-willed man, but his empress was just the opposite – aggressive, smart and ruthless. Soon after his death, she formally took the throne and created her own Zhou dynasty (684-705) – the first and only woman emperor (note that she was not known as 'Empress' Wu) in Chinese history. Once in power, Wu elevated her deceased mother to the rank of empress, rebuilding her tomb in 690 on a grander and more lavish scale in accordance with the new title. On the other hand, she destroyed the ancestral tombs of those who had opposed her rise to power, such as the two officers, Xu Jingye and Hao Xiangxi, who joined the rebellious troops when she took over the throne. Wu Zhao ordered that the ancestral tombs of both be opened and the coffins destroyed, and in the case of Hao Xiangxi she went further, burning the corpses. Surprisingly, for her own burial place she modestly chose to share the tomb of her husband, Gaozong, and left us a huge stone stele without a single word on it.

Wu Zhao's ruthless treatment of her political and personal foes, particularly the members of the imperial Li family (more especially her own children), terrified the Tang aristocrats and high-ranking officials and their families. The political terror not only influenced social behaviour during her reign, but, with the continuing power of the Wu family after her death (ending only with the rise of Li Longji,

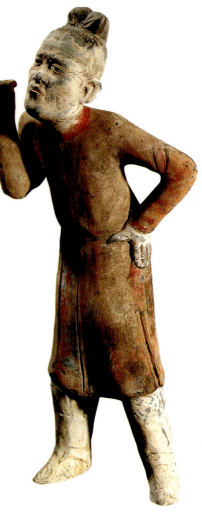

4. Palace official. Ceramic tomb figure, early Tang period (7th century). Height 25 cm (10"). Private collection, photo courtesy John Eskenazi.

5. Huntsman. Detail of a mural painting, passageway, tomb of Li Shou (577-630), Xi'an, Shaanxi province, 630.

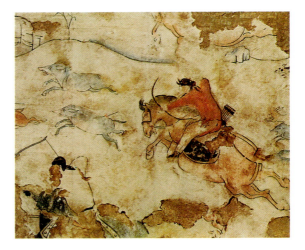

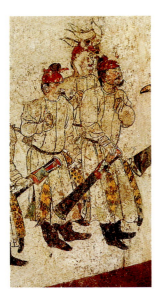

6. *Procession of ritual guards. Detail of mural painting, passageway, tomb of Li Xian (d. 684), Xi'an, Shaanxi province, 706.*

the future Emperor Xuanzong), directly impacted on the programme of the tomb paintings in the period that followed. Her successor, Emperor Zhongzong (r. 705-10), attempted to use the tomb projects as a weapon against the powerful influence of the Wu family. The most he was able to achieve directly, however, was to reject a proposal for the posthumous elevation in rank of a member of the Wu family, while the two subsequent emperors, Ruizong and Xuanzong, each took the bolder step of degrading the title of the tomb of Wu Zhao's mother.

Another tactic Zhongzong pursued against the Wu family was to build new tombs for those Wu Zhao had murdered, reburying them with great honour. In particular, he built extremely large tombs for his own son Li Chongrun (Prince Yide; 682-701) and daughter Li Xianhui (Princess Yongtai; 684-701), murdered by Wu Zhao at the respective ages of nineteen and seventeen. The design and naming of these tombs was in accordance with the full imperial status due to an emperor or empress, and in the murals in Prince Yide's tomb forty-nine halberds are depicted, far beyond the regular eighteen for an imperial prince, but in keeping with his posthumous rank of heir apparent.

A similar case was that of Li Xian, the second son of Emperor Gaozong and Empress Wu Zhao, who was designated heir apparent by Gaozong in 675. This did not accord with his mother's plans and in 680 she had him falsely accused of treason. Stripped of his rank as heir apparent and reduced to the status of commoner, he was banished to the Sichuan province. After his father's death in 684 he was forced to commit suicide, and was initially buried in this remote place. In 706 a new tomb was built for him in the capital by his brother Zhongzong (3), who had already prepared new tombs for his murdered daughter and son. The original decoration of this tomb reflected the fact that the Wu family still posed a threat. Specifically, the inscription on his stele did not dare to mention the reason for his death, and the title of 'Da Tang' (Great Tang) was left out – the inscriber of the stele did not even dare to put his name on the inscription. The size and decoration of the tomb accorded with Li Xian's rank as King of Yong, the posthumous title given him by Wu Zhao in 685. By the time the next of the brothers, Ruizong, became emperor in 710, the power of the Wu family had been broken and Ruizong was able to restore Li Xian posthumously to the rank of heir apparent. The tomb was accordingly reopened and the 706 murals overpainted with new ones reflecting this reinstatement. A new stone stele was prepared, declaring that Wu Zhao was the 'empress dowager' of the Tang dynasty, and not an 'emperor'. It also condemned Li Xian's banishment and death as acts of injustice.

It is hard to imagine that the highly sophisticated paintings commissioned to cover the earlier murals were created without an audience in mind. If no one was to be admitted to the tomb, then surely a new stele with an inscription outside the tomb would have served to denounce Wu Zhao and her family publicly and to exonerate Li Xian. Interestingly, both the 706 and 711 steles were placed inside the tomb. The construction and decoration of most Tang period tombs, particularly imperial ones, appear to reflect the expectation that they would be seen by a living audience. Indeed, the inscription on the stone stele in Li Xianhui's (Princess Yongtai's) tomb gives a detailed description of the funeral procession, suggesting that this inscription was completed after the funeral ritual. This would mean that the door of the tomb was not closed and participants in the funeral would have been able to view the tomb paintings.

Those who viewed the tombs would have been from a wide social spectrum, including commoners and foreigners as well as emperors and officials. Commoners would probably have viewed the huge monuments from a distance, impressed by their massive dimensions and above-ground decorations. Certain officials, close relatives of the dead and foreign envoys might however have entered the tombs to pay their final respects, and in so doing would have viewed the pictorial programmes and read the inscriptions engraved on the

7. *Chinese officials escorting foreign envoys. Detail of a mural painting, passageway, tomb of Li Xian (d. 684), Xi'an, Shaanxi province, 706.*

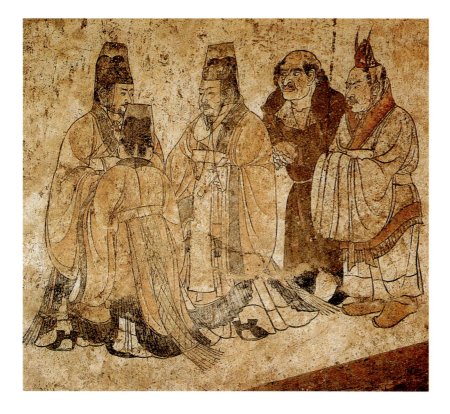

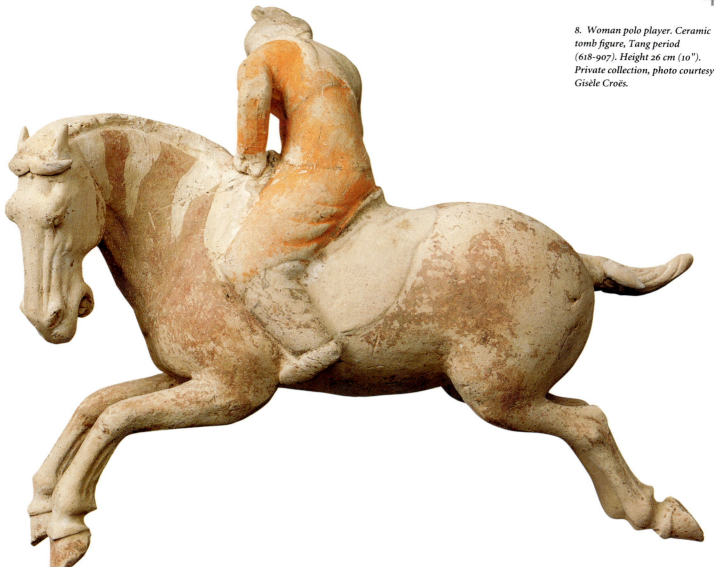

8. *Woman polo player. Ceramic tomb figure, Tang period (618-907). Height 26 cm (10"). Private collection, photo courtesy Gisèle Croës.*

stone steles. Some of the figures depicted in the passageway murals of Li Xian's tomb mirror the viewing process of the tomb decorations. The two walls of the twenty-metre-long passageway are painted with four groups of figures along either wall. The second group of figures on the passageway's left and right walls represent three Chinese officials escorting three foreign envoys (7): their gestures suggest that they are walking into the tomb chamber to pay their respects to the dead. Based upon an analysis of the costumes and facial features of the foreign envoys, a Chinese archaeologist has suggested that they hail from such places as Byzantium, Tibet, Korea, Arabia, Karakhoja and northeastern China. The third of the groupings depicts the ritual guards who would have been in the funeral cortege (6).

9. Polo players. Detail of mural painting, passageway, tomb of Li Xian (d. 684), Xi'an, Shaanxi province, 706.

According to the *Xin Tang Shu* (New History of the Tang Dynasty), when an emperor visited the imperial tombs, all court officials, attendants, royal relatives and foreign envoys had to accompany him. This retinue would stand at the left and right sides of the long 'Spirit Path' leading to the tomb mound. The left and right locations of the officials and foreign envoys recorded in this text parallel the actual murals of Li Xian's tomb. The first images to be seen, however, on entering Li Xian's tomb, are a hunting expedition (10) and a polo game (9). We have already discussed the significance of hunting scenes, but what of the polo game? More than twenty players are depicted, divided into teams by the colour of their dress. Polo was a new pursuit of the Tang aristocracy, having been introduced to China in Taizong's reign, although it apparently become popular only in 710. It is doubtful, therefore, that it would have been a sport that Li Xian himself was much involved in. The sudden appearance of the polo game in Li Xian's tomb, however, does coincide with an

10. *Hunting scene. Detail of mural painting, east wall, passageway, tomb of Li Xian (d. 684), Xi'an, Shaanxi province, 706.*

important political occurrence of 710 or 711. According to the sixth volume of the *Fengsi Wenjian Ji* (Record of Things Heard and Seen by Mr Feng):

> In the Jingyun era [710-711], Tibetan envoys came to welcome Princess Jincheng. Zhongzong let the envoys watch a polo game at the courtyard of Liyuan. The chief envoy of Tibet told the emperor that his own people were good at polo playing and asked for a competition with Chinese players. The emperor agreed to let them try. The Tibetan team won several times. Zhongzong thus asked the King of Linzi [Li Longji, the future Emperor Xuanzong], the King of Kuo [Li Yong], and his sons-in-law Yang Shengjiao and Wu Xiu to compete with ten Tibetans. Because [the future] Xuanzong acted as fast as a whirlwind and lightning, and nobody could run ahead of him, the Tibetan team could never win.

At the time of this event Li Longji, the King of Linzi, was a rising political figure. In fact, the imperial throne was turned over to him the following year. In this historical context, the sudden appearance of the polo game in Li Xian's tomb should be viewed as a visual version of the polo competition story that praises Xuanzong's excellence and bravery. However, there is an even more unusual political context to the story. In the sixth month of 710, Empress Wei poisoned Emperor Zhongzong and forged a testamentary edict appointing his fourth and youngest son, Emperor Wenwang, to the throne, while she herself was to preside over the court as empress dowager. Li Longji organised a coup and killed Empress Wei, and the throne was given to his father, Zhongzong's brother, Emperor Ruizong. Li Longji thus became the heir apparent, but his authority was challenged by one of Wu Zhao's daughters, the ambitious Princess Taiping. Li Longji successfully fought off the challenge and took the throne in 712. It was in 711, when the bloody competition between Li Longji and the Princess Taiping would have been at its most intense, that the repainting of Li Xian's tomb, took place.

Viewing the painting project for Li Xian's tomb against this dangerous and highly charged political context, one can easily understand the strong implications of the images. They remind the public of the terror of Wu Zhao's reign and warn of the rising power of Wu Zhao's ambitious daughter. The large painting of the polo game related to the heir apparent reaffirms his political ascendancy and his formidable position in court politics.

When Emperor Xuanzong took the throne and led the country into a new period of prosperity and peace, he did not follow his great-grandfather Taizong's Confucian credo of social responsibility. Instead, he devoted himself in his later years to the passions of women and music. He had thousands of consorts in his palace and fathered fifty-nine children. His sons and daughters, in turn, made him a grandfather many times over. His fourth son had fifty-five children, his sixth son had fifty-eight and his twentieth son, thirty-six. Why was the emperor so interested in acquiring wives and consorts and in fathering children, and what does the great number of his offspring mean to our study of the tombs constructed during his reign?

Before taking the throne, Li Longji personally experienced the terror of Wu Zhao's reign and saw many of his relatives die untimely deaths, and the atmosphere of his court was imbued with a sense of life's transience. As Li Bai (701-62), the most famous poet of the Tang dynasty, writes in his 'Ready to Drink':

> *My hair looks like black silk in the morning,*
> *It turns into white snow in the dusk.*
> *Fully enjoy your life when you are able to,*
> *Don't leave the golden cup empty to face the moon.*

Xuanzong's passions, therefore, reflect a strong desire to perpetuate his physical existence,

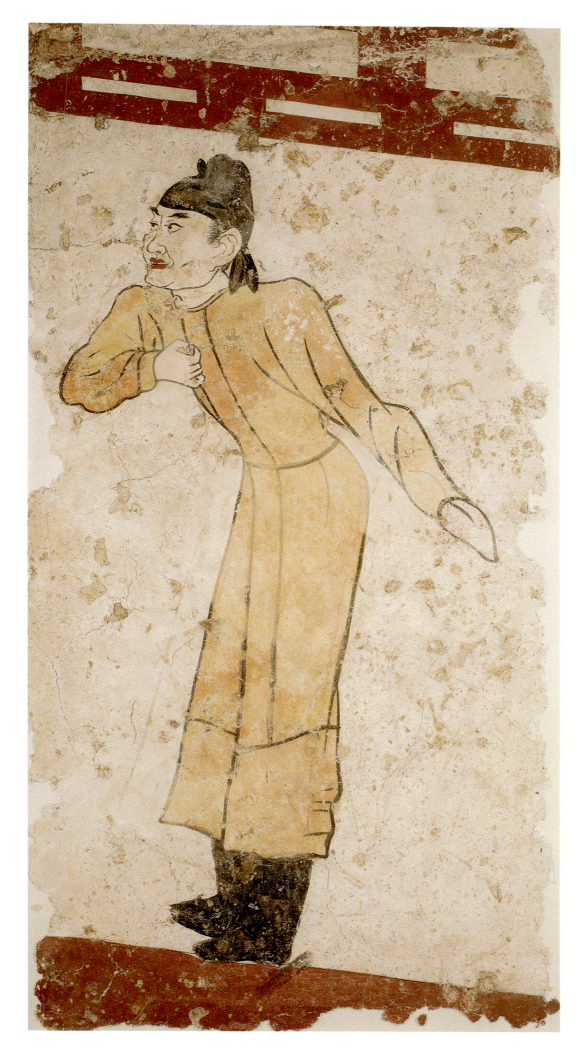

12. *Male attendant. Mural painting, Tang period (618-907). 137 x 70 cm (4'6" x 2'4"). Private collection, photo courtesy Gisèle Croës.*

11. *Opposite: Groom. Ceramic tomb figure, early Tang period (7th century). Height 31 cm (12"). Private collection, photo courtesy John Eskenazi.*

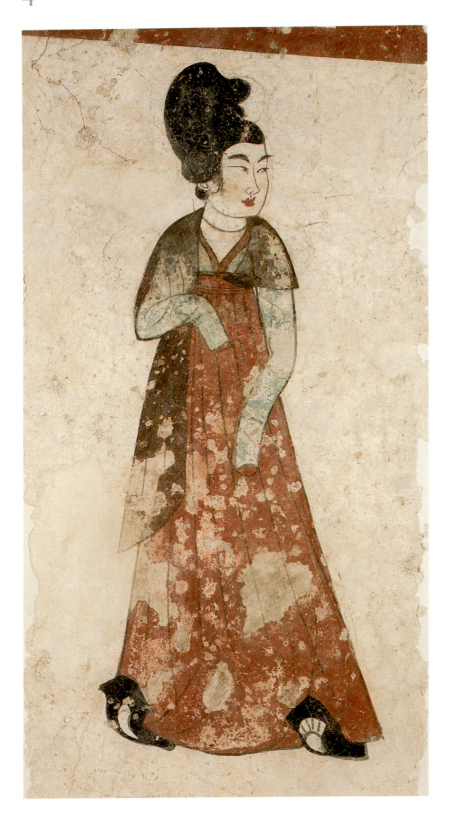

13. Female servant of an aristo-cratic family. Mural painting, Tang period (618-907). 131 x 52 cm (4'3" x 1'8"). Private collection, photo courtesy Gisèle Croës.

even after his death. Similarly, his indulgence in music can be understood as a form of escape from tragic feelings about human life. His behaviour and taste strongly influenced the whole of society, and pleasure-seeking and indulgence in wine were a mainstay of life at court and among the aristocracy.

In the tomb paintings of Xuanzong's reign, there are two striking changes: the sudden emergence of portraits of the tomb occupant, and a sharp decrease in ritual and hunting images. In the tomb of Gao Yuangui, dated to 756, the deceased is depicted on the northern wall of his tomb chamber seated in a chair flanked by female attendants, watching female dancers performing on the eastern wall. While musicians also feature on one of the chamber walls of the slightly earlier tomb of a woman in Nan Li Wang village, Shaanxi province, the other wall contains not just a single portrait, but a series of panels with portraits of the lady engaged in various pursuits in a garden (14). These multiple portraits are particularly fascinating. They are not an attempt to summarise the life of the deceased, but rather to demonstrate through repeated portrayals his or her continuing physical existence even after death. These new motifs reveal the rise of individualism and the emphasis on the value of the existence of the self during Xuanzong's reign.

This growing sense of the importance of the individual is further reinforced by the frequent portrayals of the deceased's personal servants and officials who would have worked in his residence. Most of these figures hold in their hands objects for the personal use of their masters or mistresses, indicating their duties inside the tomb chamber in its function as the private residence of the dead. A group of such figures, probably from a single tomb, offers graphic insight into the range of inner palace functionaries and courtiers who would have formed the retinue of the early Tang imperial family (2, 12, 13, 18). The original location of these paintings within the tomb and the rank of the tomb they adorned are unknown, but these extremely rare and well-preserved images are nevertheless fascinating for their iconography and function.

Those who worked in the palace of the Tang emperor and his heirs apparent were organised according to a system of 'inner officials' (*neiguan*), which included eunuchs and ladies-in-waiting. The inner officials for an heir apparent alone numbered 116, and their roles were many. Among them were the Household Manager (*Zhangting*), who was in charge of bed-curtains, spreads, tables and chairs, holding the fans, cleaning the houses and receiving guests; the Head Decorator (*Zhangyan*), who took care of clothing, hair styling, bathing, toys and ritual objects; the Treasurer (*Zhangzang*), who had responsibility for gold, jade, jewellery and silk; the Head Chef (*Zhangshi*) whose province was not only food and wine, but lanterns, candles, charcoal fire and table wares; and the Head Doctor (*Zhangyi*), in charge of both medicine and music.

Two of the murals from this set show a pair of male figures dressed in light yellow gowns and wearing black hats and black boots, probably servants who worked in the department of

the Household Manager. One holds a small wooden sceptre in both hands in front of his chest, while the other figure (12) raises his right arm to the chest and uses his left arm to point the way, bowing in respect to his master or guests. The humble gestures and pale colour of dress suggest their low official rank and indicate their role of receiving visitors. Both men are clean-shaven, their skin white and smooth, probably indicating that they are eunuchs.

Among the female servant figures is one holding a hairpin in her left hand while her right hand lifts the lower part of her long red skirt to avoid stepping on it. The Y-shaped hair style indicates her youth, while the hairpin denotes her role in the department of the Head Decorator (2). Another of the female figures holds a pillow to her chest with both hands, suggesting that she worked as a personal attendant within the department of the Household Manager. She wears a long, striped skirt similar to those of women donors in early seventh century images in the Buddhist cave-shrines at Dunhuang, or, by contrast, to that of a dancing lady depicted in the tomb of a Tang army officer, Zhishi Fengjie, in Chang'an county, Shaanxi province (658).

In one of the paintings a lady stands casually with her left arm hanging loosely and her right arm raised (13). Her posture and dress are almost identical to that of a female figure represented on a panel in the inner part of the passageway of the tomb of an imperial relative, Li Feng, in Fuping county, Shanxi province, and dated to 675. Her long narrow sleeves suggest her lower social status, probably as a servant in an aristocratic family. There are similar ladies-in-waiting in Li Xian's tomb chamber; some hold objects of daily use or musical instruments while others stand in casual postures. The grouping illustrated (15) shows three such women at leisure in a garden.

Not only female servants but also women of high rank are depicted in these murals. One such is a woman wearing a long red skirt and a dress with very wide sleeves (18). Most female figures in early Tang period tomb murals are shown with the close-fitting sleeves seen in the other examples from the same group. It appears that the wide-sleeved dress was reserved for aristocratic women, and the empress in particular. One contemporary example of this is the depiction of a woman in a wide-sleeved dress with a chubby face on a silk painting found in Cave 17 at Dunhuang, and now in the collection of the British Museum (17). The wide-sleeved dress, however, could be worn by one other kind of woman from a very different social class – a dancer, such as those carved on the stone coffin in Li Shou's tomb.

It is worth noting that *Shi Nu Hua* – pictures of women – were much admired during the Tang period. Of one hundred famous painters listed by the art historian Zhu Jingxuan (active 806-848) in his *Tang chao minghua lu* (Records of the Famous Paintings of the Tang dynasty) thirty specialised in the depiction of female subjects. Such ancient texts typically focus on painters, while sculptors are generally missing from the historical record. Nevertheless, anecdotes relating to one painter-turned-sculptor, Yang Huizhi (active early 8th century), clearly show that use of live models and the pursuit of realism were important features of Tang sculpture. These characteristics can be seen in the painted ceramic figures found in high-ranking Tang tombs. They are usually placed in small niches located in the walls of the corridors connecting the passage-way with the tomb chamber, and mirror those figures painted on the walls – ritual guards, officials, male and female servants, musicians, dancers, entertainers and polo-players.

Most of the ceramic figures belong to the private life of the tomb occupant. They are workers, entertainers or noblewomen in the private residence of the dead. One interesting figure has a wrinkled face, and is shown raising

14. Panels of portraits of the tomb occupant. Detail of a mural painting, tomb, Nan Li Wang village, Shaanxi province, ca. 750.

15. Three women by a tree. Detail of mural painting, tomb chamber, tomb of Li Xian, King of Yong (d. 684), Xi'an Shaanxi province, dated 706.

his right hand to his mouth (**4**). In all likelihood this gesture indicates that his role in the inner official system was communication of some sort, possibly between the inner and outer sections of the palace. His lined face would suggest he was a trustworthy retainer of rich experience, and, if he did journey into the inner palace and the women's quarters, it is likely he was a eunuch. Traces of red pigment on his robe imply a high rank in the inner official system.

Probably from the same group of tomb figures as the old man is a male servant who stands steadily with his two arms raised, wearing a characteristic Tang felt cap. He seems to be the groom of the household, holding the halter of a now absent horse (**11**). He is knitting his brows and blinking his eyes as the wind lifts the lower part of his robe. All these features suggest he is standing in an open courtyard on a windy, bright spring day. A third male figure probably depicts a eunuch working in the innermost section of the palace. His colourful silk dress with floral patterns, and his elegant posture with right hand down-stretched as if holding a fan, is testament to the luxurious life of the Tang aristocracy and imperial court (**1**). Another elegant denizen of the inner palace is the figure of a noblewoman with her two hands held to her chest (**16**). Her chubby aspect, well-shaped hair, and fully decorated wide-sleeved dress indicate her nobility.

As in the mural paintings, most of the ceramic figures related to the tomb occupant's private household are inner officials or servants. Some women polo-players, however, have also been found in the tombs. Historical records mention that some court ladies were trained to play polo within the palace with the emperors and members of the imperial family. In the example illustrated earlier (**8**), we see a young lady riding on a horse with her right arm raised in an elegant gesture to strike the ball.

On the whole, the pictorial programmes in the Tang tombs, including both paintings and ceramic figures, indicate a clear division between the public activities and the private lives of the Tang emperors, aristocrats and officials, emphasising the dual function of the tombs as a private residence for the deceased and a public showcase for the living. But what of the craftsmen who actually executed the designs of emperors, and their artist-officials? They have remained almost entirely anonymous. Archaeological evidence from the tomb of Prince Yide suggests that the painters who created the beautiful and sophisticated murals spent a great deal of time enclosed in the dismal and uncomfortable environment of the tomb, working and eating meals there. Not only have tools used by the artists been discovered inside the tombs, but remains of millet, suggesting that their diet and living conditions were fairly rudimentary.

No painters left their names on the tomb murals except for one Yang Biangui, who twice signed his name and expressed his wish for regular employment with the imperial household. This painter made an obvious mistake in his short inscription, writing, "[I] wish to obtain frequent opportunities of *gongyang*." The term *gongyang* (worship) was often used by donors and artists who sponsored or personally made Buddhist images, to describe these offerings to Buddha. We find this term in various inscriptions on the murals of the caves at Dunhuang, including many dating to the Tang dynasty. In this case, however, Yang Biangui was working on tomb decorations for the imperial family, and the correct term would have been *gongfeng* (service to the court). It is possible that here the character reading *gongyang* is the result of a slip of the brush. This 'slip', however, would appear to indicate that the painter must have worked on the walls of Buddhist temples and thus have become accustomed to the term. Very possibly, many mural painters worked in both religious temples and secular tombs. This mistake, together with the quality of Yang's calligraphy, is convincing evidence that he was not a high-ranking artist-official, but a well-trained and skilful painter of common status. Zhao Sengzi, a sculptor who worked in the Buddhist cave temples at Dunhuang, shared a similar economic and social status with Yang Biangui. According to documentation found at Dunhuang, Zhao could not support his family by making Buddhist sculptures and had to sell his son for food and money. The poor economic and social status of the artists forced them to rely on their patrons, and as we have seen earlier, it was these patrons who determined what should be represented and which themes should be emphasised. In turn, the artist-officials who designed the imperial tombs must also have followed the bidding of their powerful imperial patrons. The motives of the patrons thus become more important than the abilities of the artists in understanding the meanings and functions of Tang tombs.

In conclusion, the pictorial programmes of the Tang tombs should not be viewed as 'pure' decoration for aesthetic purposes. These apparently decorative works contain a socio-political message. Interpreting their meaning can help us understand not only the art but also the culture and society of the Tang dynasty.

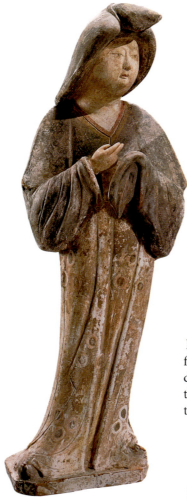

16. Noblewoman. Ceramic tomb figure, Tang period (618-907). Height 49 cm (19"). Private collection, photo courtesy Gisèle Croës.

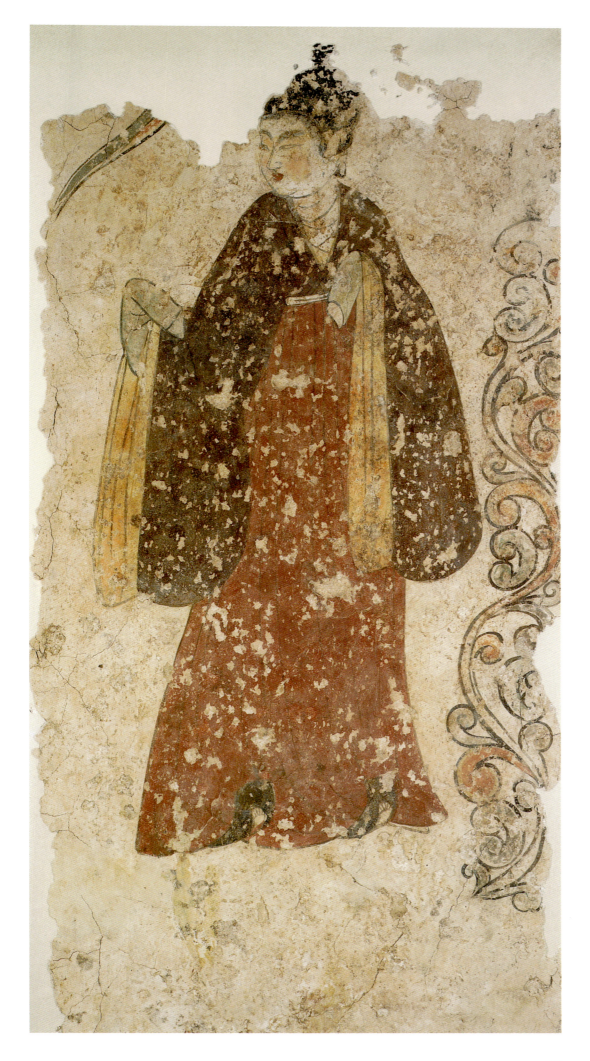

17. *A noblewoman, from Bodhisattva as a guide of souls. Detail of silk painting from Cave 17, Dunhuang, Gansu province. Tang period, late 9th century. 80.5 x 54 cm (2'8" x 1'9"). British Museum, OA 1919.1-1.047.*

18. *Noblewoman. Mural painting, Tang period (618-907). 166 x 79 cm (5'5" x 2'7"). Private collection, photo courtesy Gisèle Croës.*

5

SCULPTURES TO USE

Classical Chinese Furniture

GRACE WU BRUCE

The rare, beautiful and ingeniously constructed furniture of the sixteenth and seventeenth centuries represents the golden era of this craft in China. In the mansions of the imperial family, scholar-officials and wealthy merchants, the pure sculptural lines and deceptively simple design of this finely crafted furniture set the tone for a subtle elegance that has come to typify Chinese aristocratic culture.

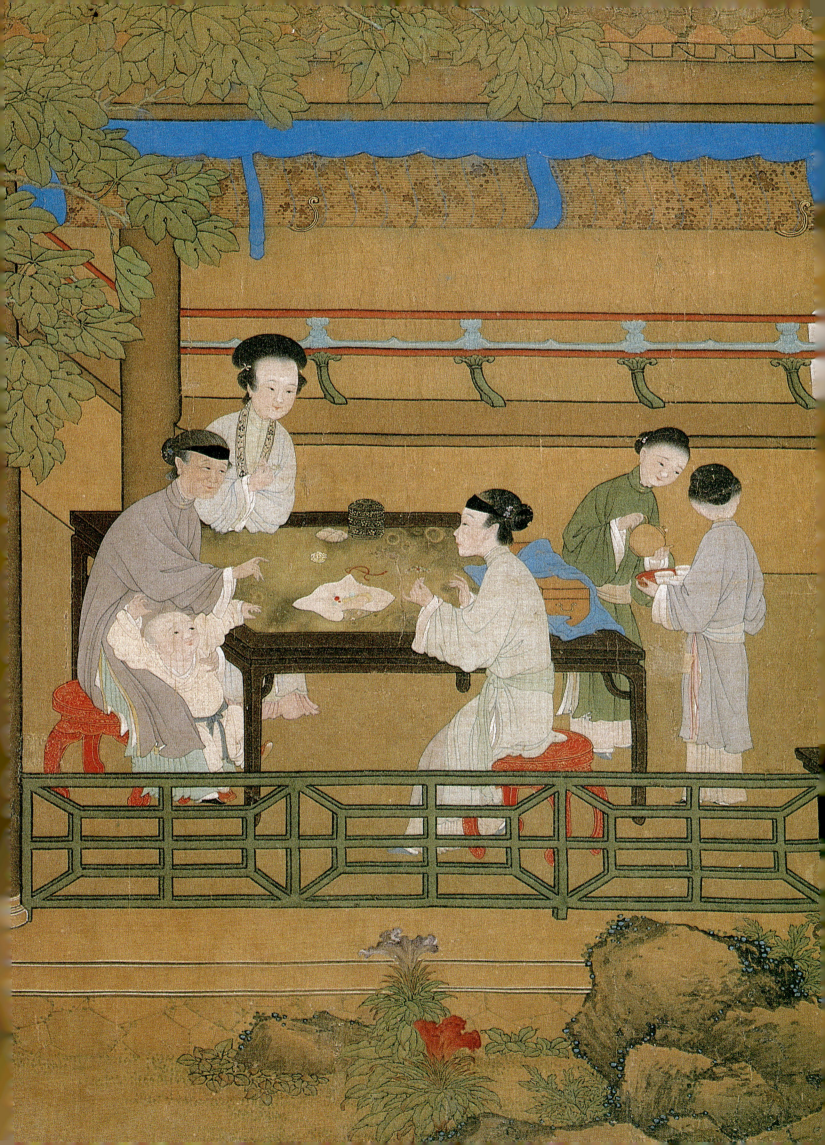

1. Title page: Baxianzhuo (Eight Immortals table), huanghuali wood. Late 16th/early 17th century, width 95.5 cm (3'1'/₂"). Courtesy Grace Wu Bruce Co. Ltd.

2. Previous page: Painting of women seated around an Eight Immortals table (detail), late 17th/early 18th century. Courtesy Sotheby's, New York.

4. Painting of schoolroom with pingtouan table (detail), Song dynasty (960-1279). Present location unknown (after Tian Lai Ge Jiu Cạng Song Ren Hua Ce, Shanghai, 1924).

The earliest surviving body of furniture from China was crafted during the second half of the Ming period (1368-1644 AD). Over the past ten years these elegant and harmonious artefacts have become the subject of intense scholarly attention, and what is broadly called 'Ming furniture' is now the focus of one of the most active fields of study and collecting in the twentieth century Chinese art world.

Life in ancient China was conducted at the level of the mat. People knelt, then sat on their heels on mats placed on the ground. The furniture of the time was low and complemented a lifestyle where people ate, slept, worked and lived at ground level. The evolution of Chinese furniture from the low pieces associated with living on mats to the higher ones for usage with chairs was a gradual process. Evidence of the transition of this mat level culture to one of chairs and raised tables can be found in frescoes and sculptures with images of furniture in the Mogao caves at Dunhuang, Gansu province, two thirds of which date from the fourth century AD to the Five Dynasties period (907-960). It would appear that the Chinese began to construct higher furniture during the fifth and sixth centuries, a trend that continued during the Tang dynasty (618-907) and Five Dynasties period, making this a time of transition between low and high furniture.

By the Song dynasty (960-1279), high furniture was widely accepted and adopted by all echelons of society. The types of furniture available were quite varied, and from contemporary paintings we can see that the designs, forms and shapes used later in the Ming period had already fundamentally been finalised. Continuous evolution and refinement over the next few hundred years led to a period in the late Ming when China's furniture reached the height of its development and entered its 'golden age'.

Many factors contributed to the flowering of the Chinese furniture tradition in this period. During the reign of the early Ming emperors, artisans living in or near the capital were required to report for work in the palace workshop for ten days each month, while those from other parts of the country worked three months every three years, mainly for the Board of Works. In the mid-fifteenth century, the requirement that artisans report for duty

was relaxed, and, by late in that century it had become the custom to commute the service period into a payment in silver. By the sixteenth century all artisans paid tax rather than giving their labour. This improvement in working conditions led to more people becoming artisans, swelling the ranks of carpenters and cabinet-makers.

Other policies adopted in the early Ming were successful in improving agricultural production. The amount of land under cultivation increased by almost five times from 1368 to 1393. The population also increased. Large advances were made in many areas including the production of silk, textiles and ceramics, the smelting of iron ores, and in shipbuilding. Commercial activities blossomed, causing unprecedented expansion in cities and towns as well as the mushrooming of new centres for commerce. During the fourth year of the reign of the Xuande emperor (1425-1435), thirty-three cities along the Yangtze river and the north–south canal set up organisations to collect taxes associated with commercial activities. By the mid-Ming, many small towns in the Jiangnan region, comprising the provinces of Anhui, Jiangsu and Zhejiang, grew into important cities with the prospering of the silk and textile industries, and by the time of the Jiajing, Longqing and Wanli emperors (1521-1620), the population and trade in these parts had multiplied by up to ten times. The citizens of this prosperous China greatly increased their demand for luxury products including fine furniture, thus providing fresh impetus for its development.

During the reign of the Longqing emperor (1567-72), the ban on maritime trade was lifted, with the effect of stimulating more trade and bringing more prosperity to the coastal provinces of the Jiangnan region. One of the side effects was that large quantities of tropical hardwood timber were imported from Southeast Asia, providing the cabinet-makers with

3. Opposite top: Pingtouan (flat-topped, narrow recessed-leg table), huanghuali wood. Late 16th/early 17th century, length 184 cm (6'0"). Courtesy Grace Wu Bruce Co. Ltd.

5. Woodblock print of men dining around a pingtouan (flat-topped, narrow recessed-leg table), from Imperial Proclamations Illustrated and Explained, 1662-1723 edition.

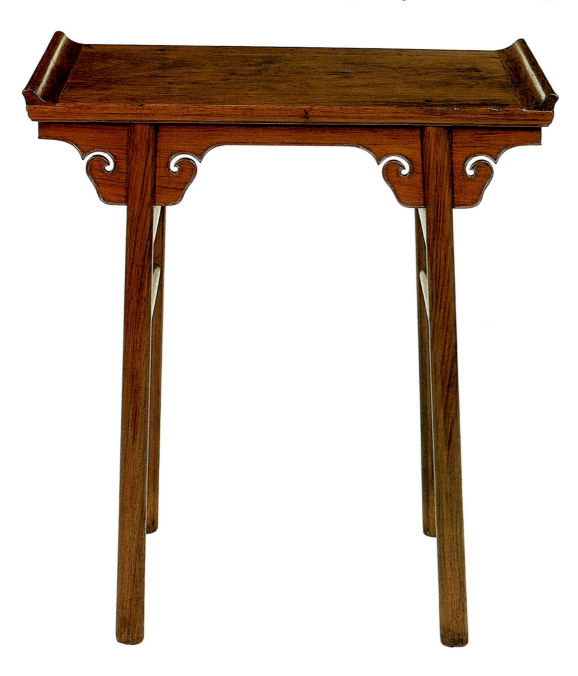

6. Qiaotouan (recessed-leg table with everted ends), huanghuali wood. Late 16th/early 17th century, length 76 cm (2'6"). Author's collection.

7. Examples of joints used in the construction of Ming furniture. Courtesy Wang Shixiang.

8. Jiuzhuo (wine table), huanghuali wood. Late 16th to early 17th century, length 95 cm (3'0"). Private collection, Johannesburg.

9. Spring Dawn in the Han Palace (detail), painting by Qiu Ying (1494-1552), National Palace Museum, Taipei.

excellent materials to ply their craft. The resultant products surpassed their predecessors. From the mid-sixteenth century, furniture making reached new heights in terms of design, craftsmanship and the material used. The pieces of furniture made were not only functional, they were objects of beauty with great artistic value.

The majority of surviving fine Ming furniture pieces were made from a tropical hardwood called *huanghuali*. It is very dense and hard with a fine texture and has considerable colour variation, from pale honey to rich mahogany. Often highly grained and beautifully figured, it has a characteristic scent when worked and a natural golden sheen when polished giving it a translucent quality. Its botanical name is *Dalbergia odorifera* and the only indigenous supply came from the southernmost region of China, on Hainan Island. Most of the *huanghuali* used in the Ming was imported from Southeast Asia.

The finest craftsmen working with this wood lived in the Jiangnan region, near present-day Shanghai and around the wealthy and cultivated cities of Suzhou and Hangzhou. The prosperous merchants and scholar-officials in this region were patrons of fine furniture, and discourses on its relative merits and arrangements were part of elegant life in the sixteenth and seventeenth centuries. Other patrons included the emperor. It is recorded that the imperial palace workshop in the capital Beijing made hardwood furniture for use in the emperor's household, and that the finest craftsmen for this kind of work came from this southern region.

Among the items these and similar craftsmen would have produced, the *Baxianzhuo*, or Eight Immortals tables (**1** and **2**), is certainly one of the best known and admired. These tables were often, though not exclusively, used for dining, and it would seem that the name derived from the number of people who could be seated around the table. Indeed, Four and Six Immortals versions of this design are also found. The present example (**1**) has an apron as well as the support stretchers wrapping round the legs to join up with each other, and raised high to connect with the top frame. The table thereby displays a sleek spatial design as well as being admirably functional by providing more leg room for the diners.

This design is the result of the direct efforts of Ming carpenters to copy the forms of cane and bamboo furniture. In sixteenth century China, the furniture of the ordinary people was made from indigenous materials such as softwoods, bamboo and cane, while the highly prized hardwood and lacquer furniture was intended for the exalted and affluent. It must therefore have been the ultimate reverse snobbery to order expensive furniture made of a precious hardwood to simulate furniture made of common materials. This approach was in tune with the philosophies and aesthetics of the literati in the late Ming.

Little of the circumstances of the origin of Chinese furniture design and construction is known. We do, however know that the complicated and ingenious system of joinery used in Ming furniture had its origins in the Neolithic period, six to seven thousand years ago. At the site of the Yangshao culture at Banpo in western China's Shaanxi province and at those of the Hemudu culture in southeastern China, evidence has been found of wooden structures using lashed joints and primitive mortise and tenon joints. Excavations undertaken in the past forty years have yielded a large body of wooden objects from the Warring States period (476-221 BC). Studies of these pieces have shown that several dozen types of joints were already in use, and that the principle and utilisation of a basic form of modern-day

joinery had already been invented and mastered by Warring States carpenters over two thousand years ago. We have scant information regarding the evolution of Chinese joinery from its basic form to the complicated, precise and ingenious construction methods of Ming furniture (7). These joints allow for the accurate, stable and all-directional linking of members of all sizes and shapes in a manner that enhances the beauty of the whole piece, and requires metal nails and glue only as auxiliaries.

A good example of how this type of joinery was used is a *pingtouan* – a flat-topped, narrow recessed-leg table (3) – which with its simple lines and pure form exemplifies what to many twentieth century connoisseurs is the beauty and timelessness of Ming furniture. There is an underlying complexity, however. The table top is made of a mitred frame with a tongue-and-grooved floating panel supported by dovetailed braces underneath. This allows the centre panel to contract or expand according to the climate; the movement is guided by transverse braces underneath, thus minimising any warping that may occur in the movement. This ingenious design is typical of Ming furniture construction. The gently splayed round legs are angled to offer greater stability, a feature of ancient Chinese wooden architecture.

This classic design, in its fundamental form, is frequently depicted in Song paintings. Continual refinement in construction resulted in its perfect Ming form, and its popularity is evidenced by the *pingtouan* design being used for all sorts of other tables: for example writing desks, dining tables and even altars. A schoolroom scene in an anonymous Song dynasty painting (4) depicts country boys playing in class while the teacher takes a nap on his desk, a table which is a slightly less narrow version of the piece illustrated (3). In the 1662-1723 edition of *Imperial Proclamations Illustrated and Explained*, two dignitaries are sitting at a *pingtouan* table laid out for a meal (5).

A small, beautiful piece is a variation of the classical recessed-leg *pingtouan* table with two everted ends and is called a *qiaotouan* (6). The long legs, again gently splayed outward, are

10. Yokeback or sichutou guanmao armchair, huanghuali wood. Late 16th/early 17th century, Height 118.5 cm (3'10'/₂"). Courtesy Grace Wu Bruce Co. Ltd.

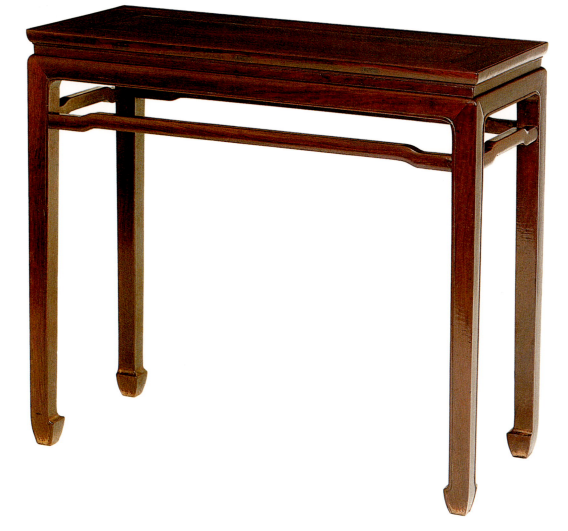

11. Portrait of Wang Shimin seated in a yokeback armchair (detail), painting by Gu Lianjong (1606-after 1687). Courtesy Christie's, Hong Kong.

12. Banzhuo (half table), zitan wood. Ming dynasty, late 16th/early 17th century, length 97.5 cm (3'2'/₂"). Courtesy Grace Wu Bruce Co. Ltd.

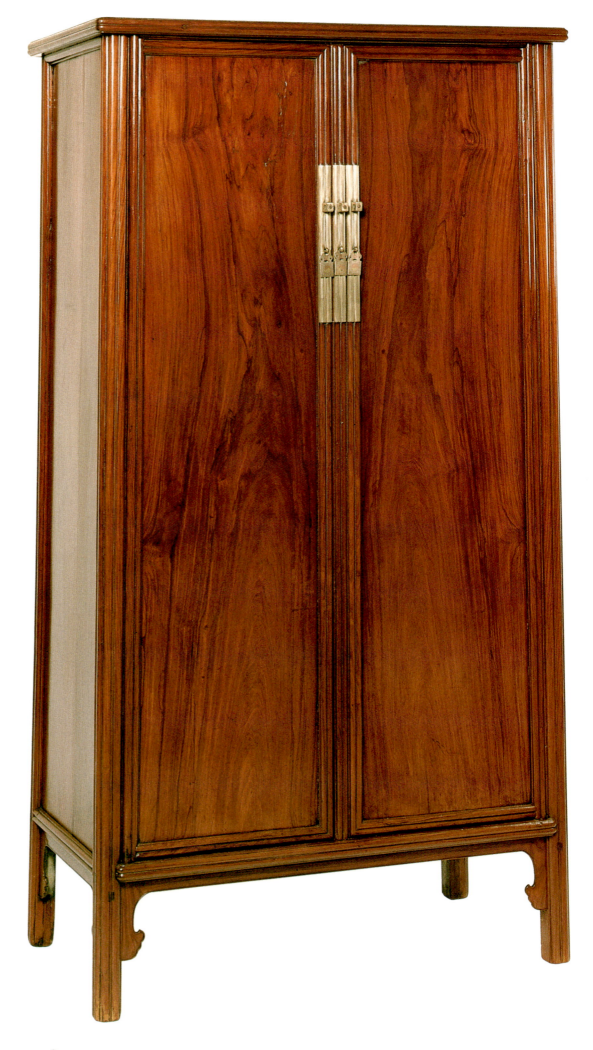

13. *Muzhougui (wood-hinged cabinet) with sloping stiles, huanghuali wood. Late 16th/early 17th century, width 93 cm (3'0"). Courtesy Grace Wu Bruce Co. Ltd.*

balanced by the small flanges at the ends of the table top. Together with the eye-like spandrel apron, they create an extraordinary design that resembles the commemorative stone arch-gates still seen in many parts of China. The designs of these arches in turn have been influenced by ancient architecture in wood. The construction of this piece is very similar to the previously discussed *pingtouan* table (3), the sole addition being the everted flanges. Small tables like this are seen in paintings bearing the incense burners used to perfume a room, or as stands to display rock sculptures or vases with flowers, pots of plants or peacock feathers.

The exquisite *jiuzhuo* (wine table) with the figured green stone top (8) embodies features and details reminiscent of earlier lacquer furniture. The fluid, curvilinear-shaped apron with filigree-like leaf spandrels, the long slender legs stretching to finish as leaf-shaped feet with pads surprisingly extended again as if raised on stilts, render the piece a fine and delicate work of sculpture. Other subtle details decorate the table. The edge of the frame is moulded from about one third of the way down and ends in small, double-beaded mouldings which are also found on the centre of the slender, well-shaped legs.

The joining of the legs to the apron and the top in a flush bridle join, with a housing for the apron, and then mortised and tenoned to the top, is a feat of engineering that entails twenty-seven to thirty-six surfaces meeting and joining in a precise and exact manner to lock each leg in place. This intricate joinery is seen on the exterior only as two slanted lines between the leg and the apron. Wine drinking must have been a crucial part of Chinese merrymaking for tables to be specifically termed 'wine tables'. The painting *Spring Dawn in the Han Palace* by Qiu Ying (1494-1552) in the National Palace Museum, Taipei, illustrates a table of this construction being used as a painting table (9).

Chairs were considered an exalted form of seating and were ranked in hierarchy, with the larger sizes reserved for the elderly and the revered. Smaller chairs were for less important guests, while stools were frequently used by women and in casual gatherings. Ming chairs are predominantly constructed with soft seats, an ingenious system in which holes are drilled on the seat frame, palm fibre is webbed and threaded through for support, and then smooth cane mats are threaded though the same holes on top for comfort. Narrow wooden strips applied on the edges conceal the ends of the fibre and cane threads. This allows for easy renewal of the seats when required by wear and tear.

Those who consider Chinese chairs uncomfortable have not sat on a chair like the yoke-back armchair (10), as it is called in the West, which in China is instead termed a *sichutou guanmaoyi* (official's hat armchair). Its back is high enough for the sitter to rest their head against the top rail which serves as a headrest while the back splat curves and bends in

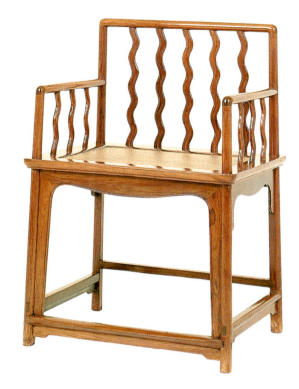

14. Meiguiyi (rose chair) with wave pattern, huanghuali wood. Late 16th/17th century, width 59.5 cm (2'0"). Private collection, London.

15. Woodblock print of a bed with wave-patterned decoration, from Min Qiji's 1640 edition of the Romance of the Western Chamber. Museum für Ostasiatische Kunst, Cologne (After Dittrich).

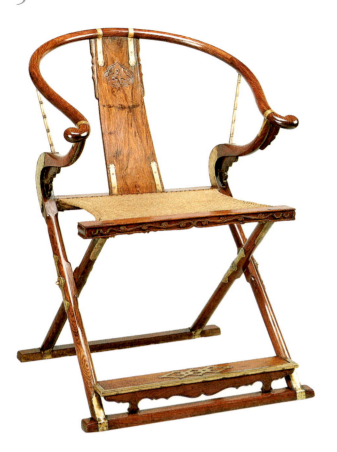

16. *Jiaoyi (folding armchair), huanghuali wood. Late 16th to early 17th century, width 61.5 cm (2'0"). Private collection, Taiwan.*

18. *Opposite page: Liuzhuchuang (six-post canopy bed), huanghuali wood. Late 16th /early 17th century, width 221 cm (7'3"). Courtesy Grace Wu Bruce Co. Ltd.*

17. *Woodblock print of man seated in a jiaoyi (folding chair), from Imperial Proclamations Illustrated and Explained, 1662-1723 edition.*

empathy with the human body. The arms, stiles, posts and arm supports all arch and sway in lyrical movement, the whole structure in perfect harmony. The chair is completely plain with nothing to distract a sitter from meditation, or to disturb his state of contentment. The portrait of the scholar-painter Wang Shimin (1592-1680) by Gu Lianjong (1606-after 1687) represents the subject seated in a chair of this design (11).

The construction methods of the chair are integral to its fluid design. The posts and stiles both extend beyond the seat frame to become legs. This continuity achieves a balance visually and structurally, adding immeasurably to the unity of the form as well as the stability and durability of the seat. The exaggerated backward arching S-shaped elements below the arms are weight-bearing in function, yet the curves move in concert with those of the arms and back to create the music in the design.

Other tropical hardwoods besides *huanghuali* were used to make fine furniture in the Ming dynasty. *Zitan* belongs to the genus *Pterocarpus* of the *Leguminosae* family, and of all the hardwoods it is the heaviest, the most closely grained and the hardest. Its colour varies from a reddish brown to a purplish black. Some examples are as black as lacquer, and the grain and figuring are hardly discernible. The bulk of hardwood traded as *zitan* in Ming dynasty China was most probably *Pterocarpus indicus*, which the botanist Chen Rong in *The Classification of Chinese Woods* indicated as growing in India, the Philippines, the Malay peninsula and in China's Guangdong province. However, the *zitan* pieces made in the Ming represent but a fraction of the number made from *huanghuali* wood. It would seem that *zitan* furniture became high fashion only a hundred or so years later, during the reign of the Qianlong emperor (r. 1736-1795) in the following Qing dynasty (1644-1911).

The solemn and sober atmosphere evoked by a black *banzhuo* table (12) made of *zitan* wood has a very different appeal to that of its *huanghuali* counterparts. The design is classically Ming, with the typical mitred-frame floating panel top, a waist (the recessed part above the apron), and straight, slender legs ending in feet resembling animal hooves. Tables of this high rectangular form can be seen in tomb murals as early as the Jin and Yuan dynasties (1115-1368). The design developed from the earlier low platform seats, raising them off the ground by extending the upright supports into legs with hoof feet. The waist, recessed from the apron, lightens the appearance of the joining of the top to its support structure without lessening its load-bearing ability – an ingenious solution. The name *banzhuo*, literally meaning 'half-table', derives from the fact that such tables were originally made in pairs, to combine together to form a single square-shaped surface.

By contrast, the desirable qualities of *huanghuali* are best illustrated amongst our present examples by the door panels of the tall *muzhougui* (wood-hinged cabinet) with sloping stiles (13). The tightly grained, fine, smooth texture exudes a warm translucent radiance, while the active figuring of the panels can almost be viewed as a painting. The sloping-stile wood-hinged cabinet is one of the most ingenious and beautiful designs of classic Chinese furniture. The four main stiles are recessed from the corners of the top and slope outwards in a subtle, almost imperceptible, splay. This simple design feature gives the cabinet its refined elegance and its sense of balance and stability. The doors, with extended dowels on both ends, fit into sockets in the cabinet frame members and act as hinges. As there is no necessity for applied hinges, nothing interferes with the clean lines of the cabinet. The rectangular metal plates with their lock receptacles and door-pulls not only serve a practical function but are also judiciously placed as decoration for the otherwise completely plain piece. Ming furniture enthusiasts might view this piece, raised on high legs tapering upwards, as a sublime monument and not just a simple cabinet for storage.

Another shape full of movement is a *meiguiyi* (rose chair) with wavy back and arm panels (14), which gives the impression of being simultaneously antique and modern. It is antique in its similarity to a bed with waves in the beautiful seventeenth century woodblock illustration to the well-known Chinese classic *The Romance of the Western Chamber*, now in the Museum für Ostasiatische Kunst in Cologne (15). Modern, because the total symmetry and fluidity of the shape of the chair are found in familiar twentieth century designs.

Also dynamic in its design, but totally different in its appeal is the *jiaoyi* (folding arm-chair). The exquisite piece illustrated here is a rich brown colour and made from beautifully grained *huanghuali* wood (**16**). Perhaps the most elegant piece of portable furniture known to medieval man, this is now one of the most sought after items among twentieth century collectors of Ming furniture. The folding armchair, developed in the Song period, probably evolved from the ancient folding stool that had been used in China since the second century AD, and recorded as the favourite seat taken along on hunting trips by the Han emperor Lingdi (r. 168-188 AD). The stool probably originated among the non-Chinese nomadic Hu tribes in the north. Viewing the chair from the side, one can see how the addition of a Chinese horseshoe-shaped top to a folding stool might create a folding armchair: an amazing addition that results in a powerful arch, an extension above the legs bending again to a curve to meet the downward sweeping horseshoe shaped arm, balanced by the C-curve of the backsplat. The whole structure is set in place by the horizontal seat frames, footrest and floor stretchers. Small wing-like spandrels below the hand-grip and leg-arm join help transfer the weight as well as adding another dimension to the rhythmic sweep. The folding chair form is perhaps the most popular seat in the Ming and is often depicted as the most important in the room, as seen in the seventeenth century edition of *Imperial Proclamations Illustrated and Explained* (**17**). It would appear that, on festive occasions, at

19. *Woodblock print of liuzhuchuang (six-post canopy bed) hung with curtain, from Pictorial Encyclopedia of Heaven, Earth and Man, 1573-1619 edition.*

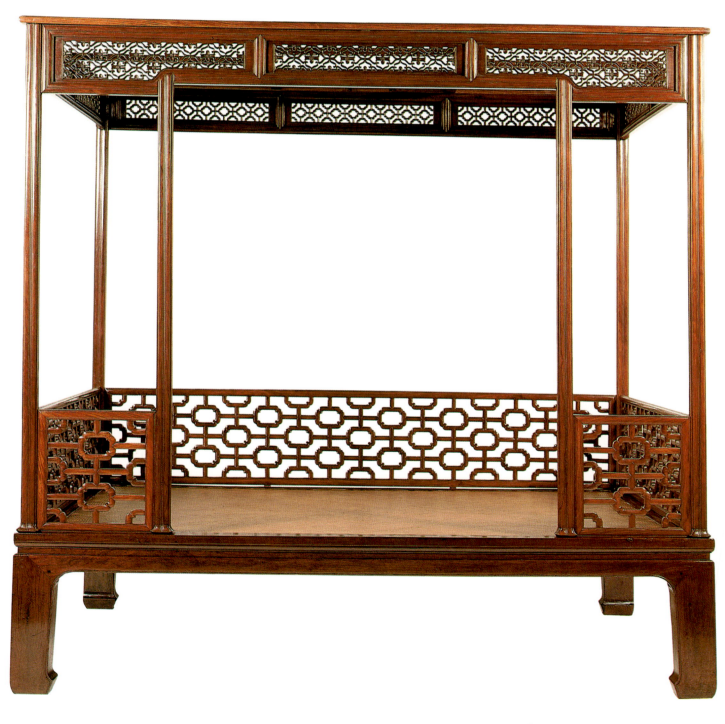

20. *Ta (daybed), huanghuali wood. Late 16th/early 17th century, length 231 cm (7'6"). Private collection, Brussels.*

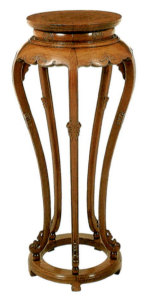

21. *Five-legged xiangji (incense stand), huanghuali wood. Late 16th/early 17th century, diameter 28 cm (11"). Author's collection.*

22. *The Forest Pavilion's Enchantments (detail), painting by Qiu Ying (1494-1552), National Palace Museum, Taipei.*

celebrations and formal gatherings, the Chinese covered their seats with textiles and brocades.

Ming beds are exceptionally beautiful, with four or six posts rising above the typical soft mat surface to support a canopy. This is surrounded by railings of either geometric patterns made of small mitred members or panels of highly elaborate carvings, often of dragons or phoenixes, but occasionally with floral or figurative motifs. In the example shown (**18**), which is a six-post canopy bed or *liuzhuchuang*, the canopy is decorated with a geometric pattern in the shape of stylised begonias. The work on the top railings appears as fine as filigree and the bed is usually overhung with paintings and draped with curtains to create a 'room within a room' for privacy. With its six upward rising posts topped by an open-worked canopy the bed must indeed have given the sensation of being in a beautifully worked chamber. In the Ming period *Pictorial Encyclopedia of Heaven, Earth and Man*, a six-post bed is draped, like a room, with gauze curtains painted with sprigs of plum blossom (**19**). Hanging on the sides are two hooks to hold the curtains in place when drawn in the daytime, allowing the bed to be used as a seat for various household activities.

Elaborate and beautiful bedsteads are usually bedroom furniture. However, *ta* (daybeds), which are like large benches without railings or canopies (**20**), are often depicted as being placed in the study or in the garden. The Ming painting *The Forest Pavilion's Enchantments* (**22**)

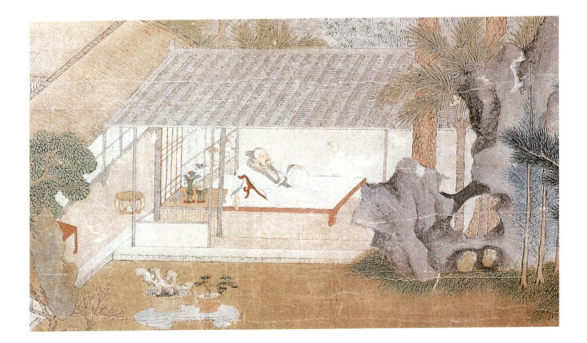

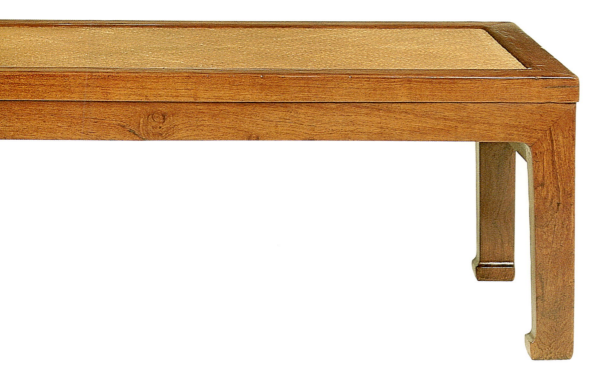

23. *Woodblock print of a secret betrothal, from Qinlouye, 1644-1661 edition.*

by Qiu Ying shows a scholar reclining in contemplation on just such a piece in a pavilion lined with books, the austere and simple lines of the furniture blending in well with the view of nature from the open pavilion: trees, rocks and lakes.

It is not only the large pieces of furniture that incorporate ingenious design and exquisite elegance. The smaller portable or occasional pieces are in many ways the ideal forms for the Ming craftsman's prodigious talents. One such piece is a five-legged incense stand or *xiangji* (21). Incense is still commonly used in China not just as a perfume, but also when offering up prayers to heaven, as shown by the couple forging a secret betrothal in a seventeenth century woodblock print (23). The gentle curve of the legs and the delicate carving epitomises the Ming aesthetic of restrained elegance. Similarly, a *zitan qinzhuo* (lute table) seemingly of one piece of wood bent into a scroll shape (24) displays the virtuosity of an artisan with a rich repertoire of joinery at his disposal to create a table actually made up of several planks, but ingeniously put together with twelve hidden joins. Mere words cannot describe the power, beauty and mystique these two pieces hold for me.

While we know that some designs for the furniture in this article were already in use hundreds of years prior to the Ming, and that many were influenced by ancient architecture, how the Ming dynasty cabinet-makers arrived at their timeless, pure forms – with sometimes elegant, sometimes powerful, but always perfect proportions – is as yet unknown. In addition, history mentions no great furniture craftsmen whose innovative designs revolutionised the genre. The classic furniture shapes and designs seem to be the product of centuries and perhaps millennia of evolution, being perfected gradually over time. Throughout its history, variations in classical Chinese furniture occurred only within defined parameters, refining the basic designs into an aesthetic at once antique and modern.

24. *Qinzhuo (lute table), zitan wood. Late 16th/early 17th century, length 162 cm (5'4"). Chen Chite Collection.*

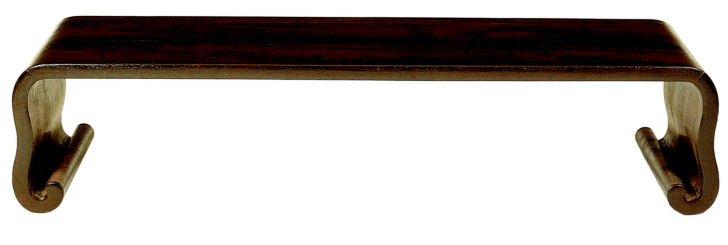

6

FENGRUAN RUTAN

Silk Pile Covers from Western China

MICHAEL FRANSES

In the grand scheme of Asian art history, antique western Chinese silk pile covers, as indeed all Chinese carpets, are a little known chapter. With scarcely any research and documentation available at present from within China itself, substantive knowledge of these rare and beautiful artefacts rests with a handful of individuals in the West – scholars, dealers and collectors – with hands-on experience of the genre.

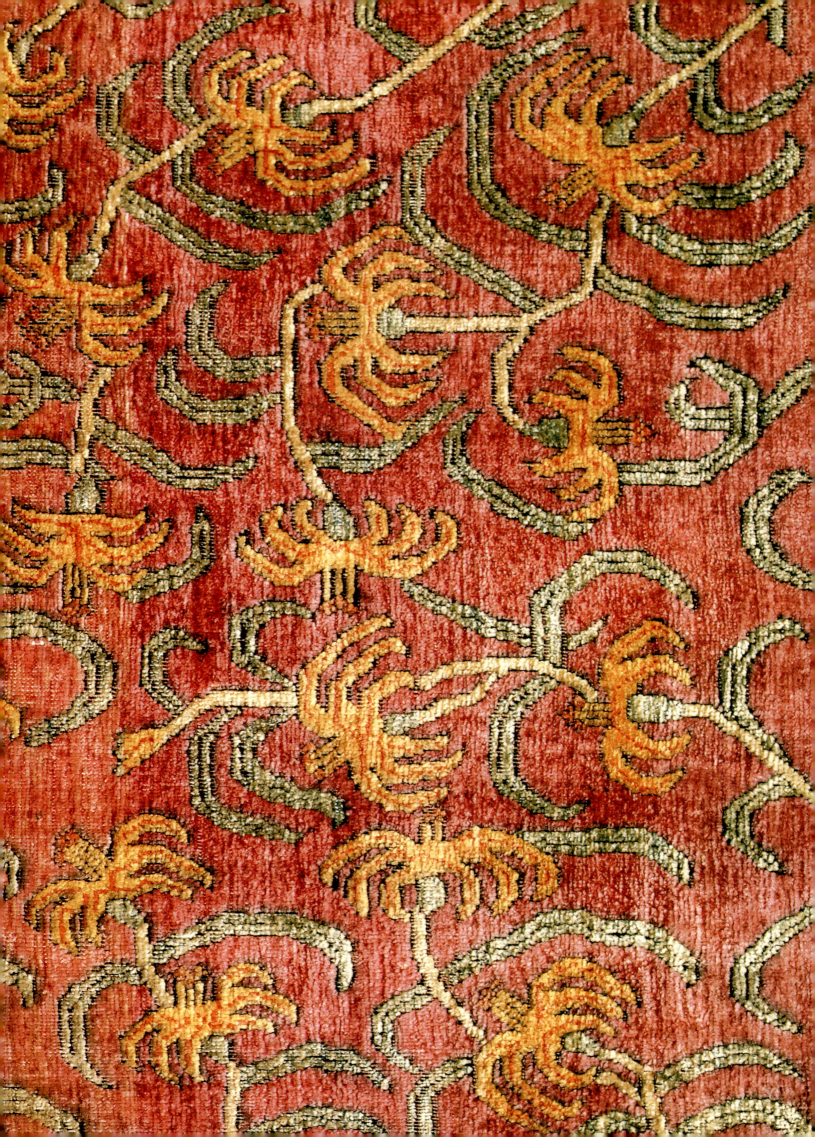

For some two thousand years, from at least the fifth century BC, the ancient Silk Road linked the oasis towns situated east of the Pamirs and north of the Himalayas on the long caravan trails across Central Asia. Merchant caravans laden with goods trekked the unforgiving road across the high mountains and through seemingly endless deserts. All manner of items were traded, including spices, ceramics and silk. As decorative designs and craft techniques were also studied and copied along its entire length, this famous trade route helped to influence their development and artistic traditions. During this period, and up to the beginning of the twentieth century, parts of Central Asia were ruled over by the Chinese, Parthians, Sasanians, Sogdians, Huns, Turks, Arabs, Mongols and Timurids. While these various cultures and their religions have left their mark on the art of the region, the textile art of Central Asia has itself influenced cultures along the entire length of the Silk Road – from Japan to Spain.

The tribal chieftains who controlled the oasis towns and villages of Xinjiang – formerly known in the West as East Turkestan and now an 'Autonomous Region' in the far northwest of the People's Republic of China – paid homage to each conquering nation in turn. For the purpose of this essay Xinjiang is considered part of western China, but it should be borne in mind that China only began to exert political control from the end of the eighteenth century – and that political control is not necessarily a prerequisite for cultural exchange.

In 1487, the Portuguese explorer Pero Covilhã, travelling by way of Aden, reached India. A decade later, Vasco da Gama circumnavigated Africa and, in 1498, arrived in Calicut. By 1614, Portuguese ships had landed in Macao, leading to a rapid decline in the volume of overland trade along the Silk Road, as European trading companies started to transport their goods along the new sea routes. Many of the Central Asian oasis trading towns that had thrived on Silk Road trade for some two thousand years began to decline, and those in the most barren areas became isolated and were abandoned. It was not until the expansion of the Russian Empire in the early nineteenth century that Xinjiang regained international importance. But this time it was not as a series of trading posts, but of watch stations, since Kashgar, in the west of the province, marked one of the gateways to British India.

EARLY SILK CARPETS

The technique of knotted pile, believed to have been invented by sheep-rearing peoples, is extremely ancient: the earliest surviving example, the Pazyryk carpet, is attributable to the fourth century BC. Such weavings not only represented the height of luxury, but were an important medium for the expression of the aspirations of the people.

The fabled Sasanian 'silk carpet' of Khosrow I (r. 531-579) adorned the Great Hall of the Palace of Ctesiphon in Mesopotamia.[1] Silk carpets are also mentioned in inventories dating from at least as early as 1341.[2] The earliest surviving silk carpet is probably the 'Chess Garden' carpet in a London collection, illustrated in Ernst Grube's essay in the present volume.[3] Attributed to the beginning of the fifteenth century, it is thought to have been made in the Timurid city of Samarkand, using silk yarns possibly imported from China.

Silk pile carpets from later in the fifteenth and the sixteenth centuries are known from many centres, from western China across Asia and North Africa to Spain. The next oldest surviving silk carpet is probably the magnificent Mamluk in the Österreichisches Museum für angewandte Kunst, Vienna.[4] This is thought to have been made in Cairo in the last quarter of the fifteenth or the first quarter of the sixteenth century. A fragment of a sixteenth century silk pile carpet, probably from Alcaraz in Spain, survives in the Wher Collection, Switzerland. However, the most famous surviving silk pile carpets were made in Safavid Persia in the sixteenth century, where an unbroken tradition continues to this day. Amongst the earliest examples are the famous Hunting carpets in Boston and Vienna, the Royal Swedish and the Count Branicki Kashan carpets, and the group of so-called 'small silk Kashan' rugs,[5] as well as others from neighbouring regions. Persian silk carpets from the seventeenth century survive in considerable numbers, along with a few examples from Mughal India.

SILK PILE CARPETS IN CHINA

In this essay we review a number of patterned silk covers made in the knotted pile technique in western China between 1500 and 1800. Some have already been published in the literature on oriental carpets, several survive in Western museums and private collections, and others have appeared on the international market over the past century.

Authors such as Hans Bidder, Hans Lorentz, Ulrich Schürmann, Hans König and Murray Eiland have helped to form the foundation of our knowledge of these beautiful objects. Over the past decade, more examples in Western collections have become known, adding to our

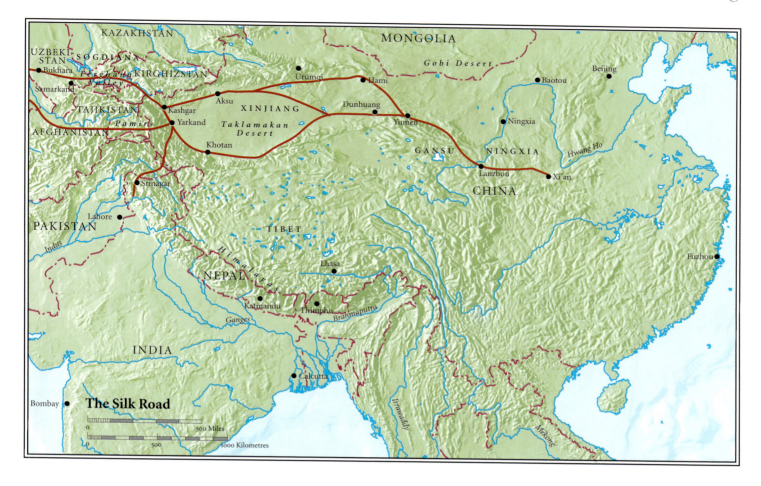

understanding of a little known art form that had developed over several thousand years but declined rapidly in the nineteenth century as ancient traditions were lost.

The relatively few examples which survive from the Silk Road towns of the sixteenth century are some of the most beautiful of silk pile carpets. They display a range of colours, a balance of design and harmony of hues that assure their place among the most magnificent art of Asia. They were made in various sizes, the largest being dais covers. While only a few of these are known from the sixteenth and seventeenth centuries, a greater number of smaller examples have survived, made either to cover the raised daybeds (kang) of northern China, or as seating squares, chair backs, table covers and saddle rugs or covers.

These luxury items were originally probably made for use at spiritual and religious ceremonies as well as for important secular occasions such as births, marriages and deaths, and for laying out for eminent visitors as a symbol of great prestige and importance. Often the ancient motifs they carried were associated with ideas of fertility or the smooth passage into the afterlife: hence the mystical stories of flying carpets that are so deeply rooted in the traditions of the East. The esteem in which these items were held when they were woven is best judged by the fact that several are known to have been used as pious gifts from noble-ranking pilgrims to Buddhist monasteries.

Although their significance and function have often been misunderstood in the West, the beauty of these important objects has been legendary for centuries. It is because they were avidly collected by foreigners when the region began to reopen to the outside world in the nineteenth century that the majority of examples known to have survived are in Western private and museum collections: the author is not aware of any examples in Asian collections dating from earlier than the second half of the eighteenth century.

Since the Song dynasty (960-1279 AD) or earlier, educated people in China have greatly admired and respected antiques and fine craftwork, which were collected and handed down through the generations. However, in the western regions, the more typically Islamic attitudes of respect for the new and indifference to the old have tended to prevail. So, while the marvellous weavings produced in the region were greatly treasured and admired when they were new, sub-sequent generations used them until they were worn out, and then discarded them.

Over the past thirty years we have examined several thousand Chinese carpets made in the many different weaving centres of the western provinces of China, from Ningxia in the east to Kashgar in the west, and have kept photographic records of many of these and other

published examples. We believe that more than seven hundred of these, knotted in both wool and silk, date from the early sixteenth to the middle of the eighteenth century.

We know of about one hundred and seventy-five Chinese silk pile weavings that can reasonably be attributed to before 1800;[6] a figure that probably represents only a tiny proportion of the thousands or tens of thousands that were made. To offer an insight into this lost tradition based upon this small sample could therefore be misleading. In trying to date them, for example, it is tempting to assume that there were periods of strong Chinese influence on designs and others when local Xinjiang traditions dominated. But the size of the sample allows no firm conclusions to be drawn, particularly in the absence of specific dated examples. It is more likely that different styles continued in parallel. Until recently, most such carpets woven before the early eighteenth century have been attributed to Kashgar. Closer examination, however, makes it clear there are several different weaves. We believe that some originate from Ningxia, others from centres across Central Asia. Many of the surviving examples can be divided into groups, based on colour, design and technique, which probably represent different workshops and traditions from various regions spanning a period of more than three hundred years.

It is easy to appreciate the beauty of the silk carpets of China, but it is difficult to appraise their individual merit when they are discussed in isolation from the other carpets of the area, which fall outside the scope of this essay. They must be seen not only in the context of wool carpets of the major oasis towns of Xinjiang – Kashgar, Khotan and Yarkand – but also those of the provinces of Gansu and Ningxia to the east, and even of the Chinese copies of Xinjiang silk carpets made in the nineteenth century in Ningxia or by Ningxia weavers in Beijing. Despite the limited scope of this essay, our selection of silk pile covers – presented in groups that are partly chronological and partly determined by similarities of design and technique – allows a glimpse of the splendour and beauty of this little known art.

THE DAVISON SADDLE RUG AND OTHER DRAGON DESIGNS

The tradition of making silk pile carpets in this area undoubtedly goes back many centuries. One of the two earliest firmly datable examples we know is the Davison saddle rug (3), which caused quite a stir when it appeared on the market in 1978. It was the first oriental rug to be scientifically dated using the carbon-14 method, the sample indicating a date of 1490-1650 with 95 per cent probability.[7] Although many people were extremely sceptical about this methodology at the time, it has now achieved far greater, if not unqualified, acceptability.

Chinese saddle rugs and covers – the former made to go under and the latter to fit over a horse's saddle – were made in two separate pieces, which were joined with the pile on each side pointing downwards, so that moisture would run off easily. Known examples use a strip of leather or other fabric to join the pieces, and the same material is used to bind both the edges and the four holes in the field that allow the cover to be secured. It is possible that the binding material used for the Davison cover was a fine silk brocade that has long since been removed.

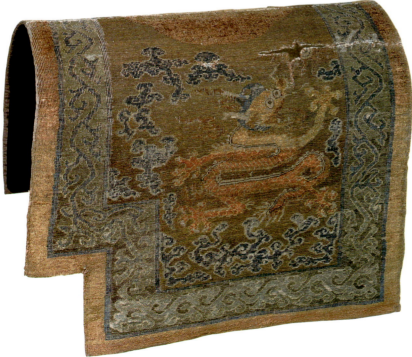

3. Saddle rug with imperial dragons, probably Ningxia or Kashgar, C[14] dated 1490-1650. Silk pile with brocaded thread on a cotton foundation, 79 x 158 cm (2'7" x 5'2"). Formerly collection of J. Davison, London.

As with all known saddle rugs and covers, the same pattern is repeated on both sides. The overall design of this unique weaving, a dragon with a flaming pearl surrounded by cloud scrolls, and a scrolling meander border, indicates that it was made specifically for the Chinese market. The five-clawed imperial dragon, with its staring eyes and brushed-back mane, is characteristic of sixteenth century Chinese art, and indicates that the rug was either a Chinese commission or was made as a presentation gift to the imperial court, such as those given by foreign embassies.

The cover is made of silk pile with silver brocading on a cotton foundation, and has depressed warps, an effect created by the weaver tightly pulling the second weft after each row of knots, causing alternate warps to be aligned almost on top of their adjacent warp. This allows the weaver to produce more curvilinear designs regardless of the fineness of weave. It also tends to produce a

denser surface, thus causing the pattern to be more clearly delineated. Depressed warps are not usually found in Ningxia carpets, but were commonly used in those examples attributed to Kashgar and Yarkand (**29**).

While it is tempting to assign this saddle rug to Ningxia, because that is traditionally where early Chinese carpets are thought to have been made, the depressed weave and use of metal would seem to indicate otherwise. Unfortunately, contemporary references to the use of metal threads on carpets seem to be exceedingly rare – carpets were for the most part overlooked by Chinese chroniclers, and to date we know of no one who has looked thoroughly into local literature in the Turkic or derivative Indian languages. Hans Bidder refers to a private account of Kashgar written by a certain Fu Jing in the eighteenth century, which mentions that: "There are also more respectable people who excel in the weaving of silk carpets embroidered in gold and silver, and of five-coloured pile carpets."[8]

The Davison saddle rug does, through its border design, bear some stylistic relationship to a few of the known imperial dais carpets of the Ming dynasty (1368-1644).[9] While the latter are knotted with camel-like pile, several have silk warps and a depressed weave. However, we are aware of no carpets known to come from Ningxia with similar field designs in conjunction with this border pattern. This might suggest that there were carpet workshops in other areas during the Ming that had ceased production by the Qing period (1644-1911), although this possibility needs to be explored further.

Other silk pile covers with dragon designs but different borders are known. A green-ground example with areas of metal thread, probably made in Xinjiang, can be dated to the eighteenth century (**4**).[10] It was acquired over a decade ago in Nepal, reportedly originating from a Tibetan monastery, and is in outstanding condition with its original fringes intact. The field design is a traditional Chinese pattern: four dragons surround a central dragon. The inner border depicts lotus and peony flowers connected by scrolling foliage; at each of the four corners is the character *shou*, a symbol of good fortune. The continuity of the background colour behind the inner border separated by overlaid guard stripes is a feature generally associated with knotted pile weavings from the seventeenth century or earlier. Its unusual shape suggests that it might have been woven as a table cover – the wide outer border with the 'T' motif would have draped over the edge of the table – but it could also have been a seating mat.

There is also a small group of pieces of possible Chinese origin whose designs include a phoenix and other auspicious symbols with the Imperial five-clawed dragon.[11] Several authors have suggested that the combination of these motifs indicates that they were made for use on Imperial wedding beds. Possibly the earliest of these, now in the Metropolitan Museum of Art, New York, has been tentatively attributed to the seventeenth century. However, it is difficult to be certain of either the place of origin or the date without having had the opportunity to examine it: stylistically the dragon is drawn in the manner of other Ming Imperial dragon motifs from around 1600, but it could equally well be an eighteenth century copy. A similar example in the Royal Ontario Museum, Toronto, has

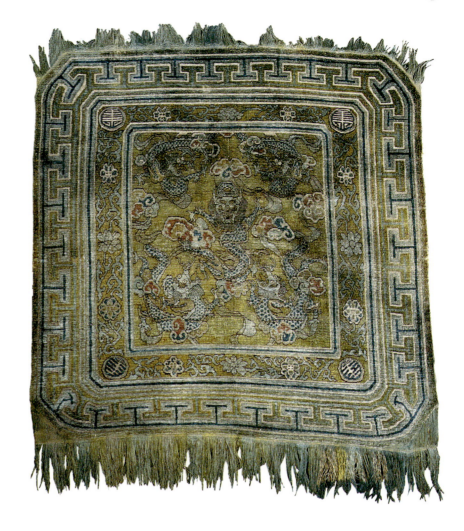

4. Table cover with five dragons, probably Xinjiang, 18th century. Silk pile with brocaded metal thread on a silk foundation, 101 x 106 cm (3'4" x 3'6"). Reputedly formerly in the collection of a monastery in northern Tibet.

5. Saddle cover with geometric interlaced design, probably Ningxia, 17th century. Silk pile on a silk and cotton foundation, 52 x 58 cm (1'8" x 1'11"). The Textile Gallery, London.

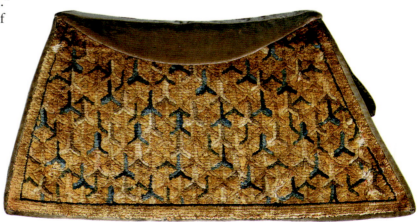

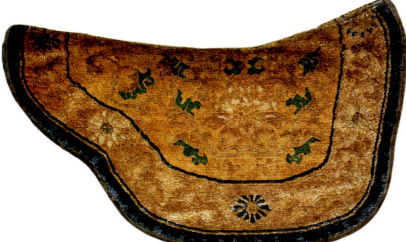

6. Saddle cover with peonies, probably Ningxia, 17th century. Silk pile on a silk and cotton foundation, 49 x 58 cm (1'7" x 1'11"). Eberhart Herrmann Collection, Emmetten.

7. Seating mat with lotuses, possibly Ningxia, 17th century or earlier. Silk pile on a cotton foundation, 96 x 99 cm (3'2" x 3'3"). Formerly private collection, USA.

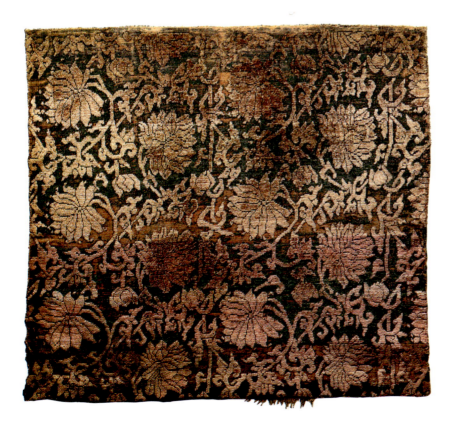

been assumed to be a later copy, and two others that are known to us were acquired in China at the beginning of this century. Two further silk covers, much smaller in size, each depict a single dragon enclosed by a cloud-head border *(yuncaitou)*.[12] One of these covers has been attributed to the Ming dynasty, although the cloudhead border is more in keeping with Xinjiang carpets from the eighteenth and nineteenth centuries, as seen below (**26**). It can reasonably be assumed, therefore, that these two are from the later period.

OTHER SILK SADDLE COVERS

Few Chinese saddle rugs and covers survive from before 1800, perhaps due to their materials and usage.[13]

However, two silk pile saddle covers found in Tibet in the early 1980s have been attributed to the seventeenth century or earlier. Both are woven in the manner of Ningxia carpets, and their edges are finished with late sixteenth or early seventeenth century Ming velvet. One of these (**5**), has a design composed of a simple motif repeated to form a lattice resembling interlaced basketry.[14] This design can also be found on wall paintings from the Yuan dynasty (1279-1368) as well as in the borders of Chinese porcelain of the sixteenth century, but this is its only known appearance on a pile carpet. Although the pattern is composed of a very simple geometric shape resembling an inverted 'Y', the arrangement of the colours is far more complex. A very few Chinese carpets, all from the sixteenth and early seventeenth centuries, employ as many as sixteen different colours, as here. The velvet binding the edges is original, but the piece that joins the two sides of the cover has been inserted recently.

The second saddle cover (**6**)[15] depicts a peony with beautifully drawn leaves. Initially it appears to be from the seventeenth century, although the use of this style of leaf and flower drawing was not confined to this period. The earliest depiction of these leaves can be seen on certain imperial carpets of the Ming dynasty (1368-1644) with camel pile as well as others with wool pile from the reign of the Kangxi emperor (1662-1723) of the succeeding Qing dynasty (1644-1911); they continued to be used in a shortened and more stylised form throughout the eighteenth century.[16] An interesting feature of this cover is that the pile is 'carved' where one colour joins another; the edges of the knots are shaved to create a raised and partially embossed effect. This is one of the earliest known examples with this feature, which can be seen on Imperial Ming carpets as well as on several later rugs attributed to the reign of the Yongzheng emperor (1723-1736). This technique, which continued to be used through to the latter part of the nineteenth and twentieth centuries, is discussed and illustrated by Lesley Pinner in her article on Chinese carpet structure.[17]

FLORAL COVERS WITHOUT BORDERS

A table cover with a peony design once in the Phoebe A. Hearst Collection (**8**) is firmly datable.[18] This silk pile cover is comparable to two of arguably the greatest surviving Chinese knotted pile carpets, which are considered masterpieces of Chinese textile art. The latter, both with lotus patterns and camel-like pile on a linen foundation, are represented now only by fragments, in the Museum für Kunsthandwerk in Frankfurt, and the Musée des Arts Décoratifs in Paris.

Stylistically the Hearst cover fits comfortably with the decoration found on late fifteenth

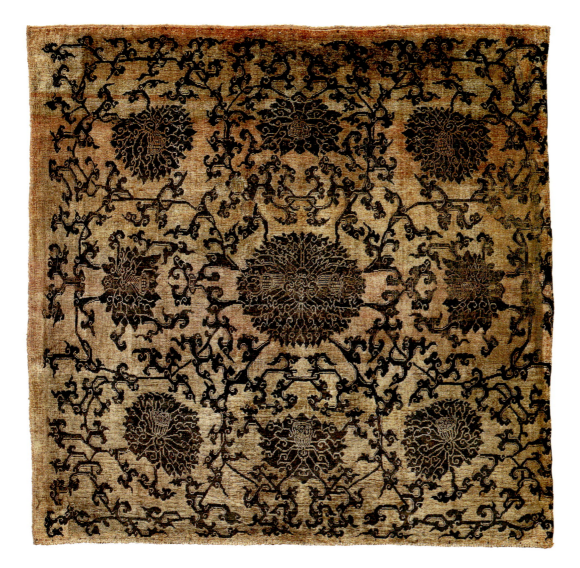

8. Table cover with peonies, probably Ningxia, C^{14} dated 1444-1666, probably late 15th century. Silk pile on a silk foundation, 113 x 116 cm (3'8" x 3'9"). Formerly Phoebe A. Hearst Collection, California.

century ceramics, although it has a wider carbon-14 date range of 1444-1666.[19] A large central peony is encircled by eight further peonies: four smaller ones in the corners and one on each axis. A network of floral stems surrounds these. The layout gives the impression that the central peony with its surrounding stems was placed over a circular table or stool, while the rest of the pattern draped over the sides. The central flower is shown as if viewed from above, the surrounding peonies point in towards the centre and appear to be climbing upwards.

It is often erroneously assumed that Chinese carpet designs were derived from ceramics. Arthur Upham Pope and Phyllis Ackerman, who wrote about this cover in the catalogue of the Hearst Collection, stated that the design was "surely taken from pottery".[20] They were also convinced that it was influenced by Persian design – but as students of Persian art they looked for its influence with particular zeal. In fact, the pattern of this cover lies at the very centre of Chinese art and any received influences have come from the east. Indeed, patterned textiles were traded across Asia from the earliest times, and it is possible that certain ceramic designs were taken from textiles. In defence of Pope and others it should be pointed out that prior to the second quarter of the twentieth century very few Chinese textiles from the Ming dynasty and earlier were widely known. Since then, the publication of Japanese and Chinese collections and, in recent decades, the addition of newly excavated discoveries as well as examples emerging from Tibetan monasteries have added greatly to the corpus now available for study. The use of more sophisticated dating criteria, employing both scientific methods and examples from dated tombs, has clarified the relative chronology of specific types. As a result, conventional opinions on the derivation of Chinese designs arrived at in the first quarter of this century should be treated with some caution.

The peony pattern decorates ceramics in the Song dynasty (960-1279) particularly on incised *ding* wares. But the peony arabesque can be traced back further into history, appearing on silver and stucco work of the Tang dynasty (618-906), the influence of which extended as far as Sogdiana in Transoxania. Patterns are easily spread via the textile medium, since textiles are readily transported, and the Silk Road was an ideal conduit for this process. Apart

9. Dais cover with octagon-and-square lattice (and detail showing the corroded black pile), Ningxia, Ming period, ca. 1600. Silk pile on a silk foundation, 380 x 365 cm (12'5" x 12'). Formerly Frank Michaelian Collection, New York.

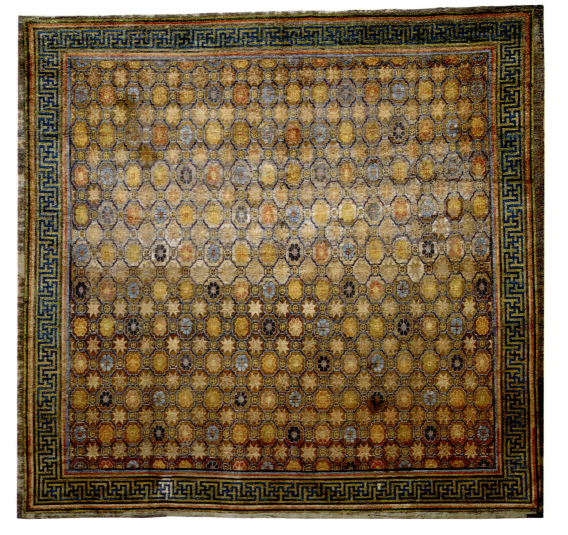

10. Opposite: Dais cover with peonies, Ningxia, 18th century. Silk pile on a cotton foundation, 247 x 392 cm (8'0" x 12'10"). Thyssen-Bornemisza Collection, Lugano.

from the famous Hearst example, we know of four other silk covers with trailing floral designs and no borders.[21] This group seems technically more closely related to wool pile weavings from Ningxia than to the silk covers that are clearly from Kashgar. The flowers used are either the lotus, whose symbolic power lies in its purity as the source of life, or the peony, the King of Flowers and an omen of good fortune. Designs may be centralised, as on the Hearst cover, or have an endless repeat, as in an example formerly in an American private collection (7) in which offset rows of peonies point alternately left and right: a similar design appears on two silk brocades recently excavated in China and dated to the Southern Song dynasty.[22]

NINGXIA DAIS COVERS

More typical of Ningxia work are two large dais covers. The oldest known Chinese dais cover with silk pile of which we are aware once belonged to Frank Michaelian in New York, and is one of the most beautiful Chinese carpets from his considerable collection (9)[23] despite the fact that the black pile has corroded. Michaelian imported Chinese carpets to America from the 1920s until the late 1970s. He spent a great deal of time in China between the two World Wars, when he had carpets made to order and assembled an outstanding collection of early Ningxia carpets. Making acquisitions in both America and China during his lifetime, he amassed the largest and certainly the finest collection of sixteenth to nineteenth century Chinese carpets, with the intention of using them as a library for new production. He was reluctant to show his carpets as he did not want anyone else to copy them, so they were kept in store in New York. After his death, his executors disposed of this remarkable collection by private treaty and public auction, and its true significance became more widely known.

The field design of the Michaelian dais cover, composed of an early version of the well-known octagon-and-square lattice, is very much in the manner of silk brocade textiles of the late Ming period. Here the octagons are somewhat curvilinear and contain eight-petalled rosettes and eight-pointed stars in alternate rows, while the lobed squares contain four-petalled rosettes. The drawing of the design falls somewhere between the octagon-and-

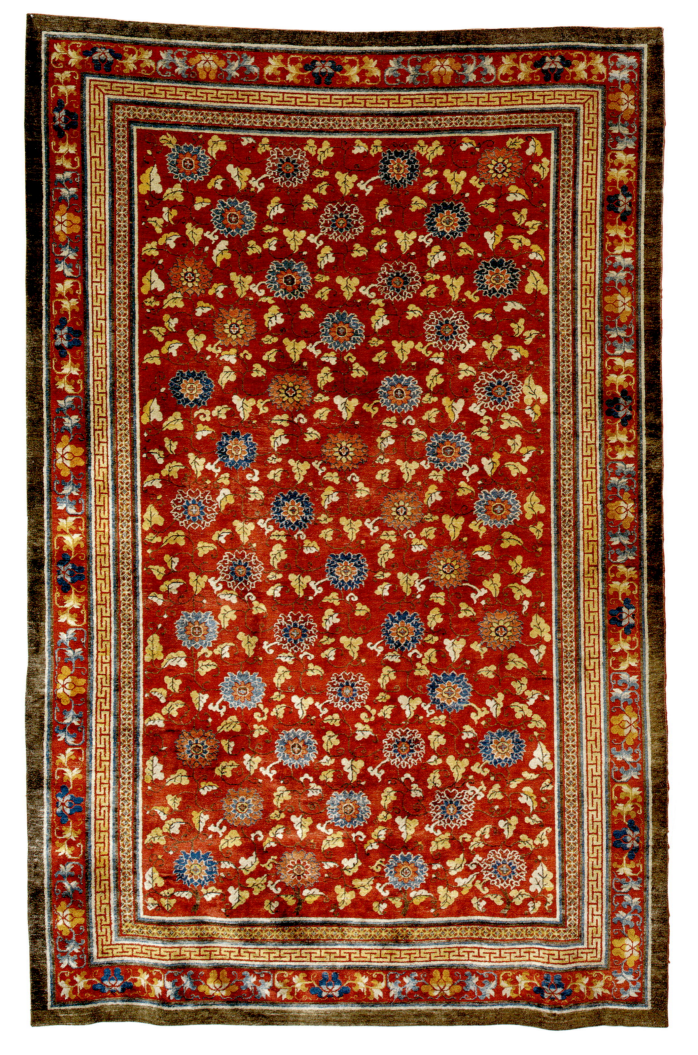

*11. Kang cover with dragons
and clouds, probably Kashgar,
ca. 1700. Silk pile on a silk foun-
dation, 91 x 142 cm (3'0" x 4'8").
The Metropolitan Museum of
Art, New York, 08.248.8.*

square and 'longevity' designs that were to become so popular during the Kangxi reign: this
curvilinear version seems to have been the precursor of the later geometricised styles. The
more angular octagon-and-square lattice field design is found on at least twenty-one known
wool pile carpets from Ningxia attributed to the Kangxi period. It was also used in other
media. One silk pile fragment from Xinjiang is known which has this design in geometric
style enclosed by a border of cartouches with *shou* signs flanked by bats, in a late eighteenth
century manner.[24]

The second Ningxia dais cover, in the Thyssen-Bornemisza Collection, Lugano, has a field
design of rows of peonies on a very delicate arabesque stem, set against a rich red ground (**10**).[25]
The beautifully detailed flowerheads are arranged by colour in a repeated series of four diag-
onal rows. Scattered between the blossoms are curling triangular leaves in yellow and white,
depicted as if blown by the wind. This form of leaf field can be related to other well-known
Chinese carpets. The primary border design, the inner interlaced 'T' guard border and
the outer grey 'frame' are common features of Ningxia rugs woven in the seventeenth and
eighteenth centuries. The lotuses in the border are typical of those used in the latter years of
the Kangxi period. The brilliance and richness of its colours, the superb quality and thick-
ness of the silk and, most remarkably, its extraordinarily fine condition make this a rug of
exceptional beauty. Furthermore, its condition allows us to see it for what it was intended to
be, an object of unashamed luxury. As such, it can only be compared with seventeenth
century Persian 'Polonaise' carpets and the seventeenth century silk carpets of Mughal India.

A fragment of a Yarkand silk pile carpet in The Textile Museum, Washington DC,[26] shows
how Ningxia designs were used further west. It has a stylised floral design with bats in the
field, very much in the eighteenth century manner, a more naturalistic version of which
appears on a fragment surviving from one of the earliest known Ningxia wool pile dais
covers, dating from the middle of the seventeenth century. This magnificent cover, formerly
in the Michaelian Collection, depicts at least four different-shaped lotuses in an overall leaf
and stem design enclosed by a wide 'key' inner border, then a wide border of large peony
blossoms and trailing leaf stems and finally a wide, plain grey-brown frame.[27]

KANG COVERS WITH SWASTIKA AND BAT BORDERS

An interesting group of small Chinese silk carpets comprises seven examples, whose format
suggests that they were probably made to be placed on a raised daybed *(kang)*. They are all
between 90 and 100 centimetres wide and 140 and 143 centimetres long, and were intended to
be viewed with the design at right angles to the warp. They share a border pattern of rows of
swastikas overlaid with bats, which was commonly used, albeit in a slightly different form, as
both a field design and a minor border design on wool pile carpets from Ningxia.[28] It is gen-
erally assumed that these covers were probably made in Kashgar, and the density of pile and

12. *Kang cover with lilies, probably Kashgar, ca. 1700. Silk pile on a silk foundation, 90 x 142 cm (3'0" x 4'8"). Thyssen-Bornemisza Collection, Lugano.*

range of colours are closely enough related to suggest that they are all from one workshop.

Three different field designs are used in this superb group of covers, the most famous of which are two related examples, one in The Metropolitan Museum of Art, New York **(11)**, the other in the Musée Historique des Tissus, Lyon. These have a field design of stylised dragons and clouds alternating in rows against a dark blue ground.[29] The Metropolitan's *kang* cover, first published in 1908 and known as the 'Magistrate's Rug', was reportedly acquired for Louis Comfort Tiffany in the early part of this century from a Chinese provincial magistrate. It was originally attributed to China and the sixteenth century, but later re-attributed, mistakenly we believe, to Khotan and the eighteenth century.[30] The field pattern can be compared to a similar border of alternating stylised dragons and clouds on a Chinese satin-weave temple hanging, also in the Metropolitan Museum, which is thought to have been made for the Tibetan market in possibly the seventeenth century.[31] We think that this group of pile *kang* covers probably dates from the middle or later years of the Kangxi reign, around 1700.

The second field design, of beautifully drawn lilies scattered across a soft pink field, is

13. *Kang cover with peonies, probably Kashgar, ca. 1700. Silk pile on a silk foundation, 92 x 140 cm (3'0" x 4'7"). Private collection. Formerly Franco Vanotti Collection, Lugano.*

shared by four of the examples, including one in the Thyssen-Bornemisza Collection **(12)**.[32] The lilies grow from stems that protrude into the field from all directions, and twist and turn as if blown by some supernatural wind.

An exceptional example of this group with the third and unique field design of peonies, was once with the well-known Chinese art collector Dr Franco Vanotti from Lugano, and survives in immaculate condition **(13)**.[33] Of the seven silk covers with the swastika and bats border design, this is the only one with four rows of swastikas rather than three.

KASHGAR COVERS WITH MUGHAL-STYLE DESIGNS

The following two groups are the first that can be directly attributed to Kashgar. Situated at a major crossroads on the Silk Road at the very heart of Central Asia, this was the principal oasis town at the western end of the Taklamakan Desert in Xinjiang (see map). East of Kashgar the Road divided into northern and southern routes skirting the treacherous Taklamakan. To the west, the Road again divided: south across the mountains to India, southwest across the Pamirs to Afghanistan, and northwest over several mountain passes and down the Ferghana Valley to Tartary and the golden city of Samarkand. Kashgar was not only a market town but also a great centre of art for the region. Given the area's geographic location and its historic mix of peoples and religions, it is not surprising that the traditional designs that evolved within its textile art were subject to many different influences and derived from several cultural sources, including India to the south, Turkestan and Persia to the west, and China to the east.

The earliest definable groups of knotted pile weavings from Kashgar are believed to date from the end of the seventeenth century and show strong Indian influence in their use of a tight floral lattice on a deep red ground of extraordinary richness. The late seventeenth and eighteenth century Muslim lords of Kashgar were related to the Mughal dynasty in India, a kinship which resulted in a distinctively Mughal style of decoration on the products of this desert city state. These covers, the subject of an essay by Hans König,[34] relate especially closely to a group of rare red-ground Mughal carpets from the mid-seventeenth to the mid-eighteenth century which can be attributed to the Deccan, either to Hyderabad or Warangal in the Kingdom of Golconda, which came under direct Mughal rule from 1687 to 1724.

Despite the obvious reliance of these 'first period' Mughal-style covers on Indian models, they manage to imbue their sources with a quality which is recognisably their own, and one which carries on into the later Chinese-inspired Kashgar silk rugs of the eighteenth century. The dense arrangement of tiny leaves and blossoms into a delicate overall pattern shows artistry of a high order. There can be little doubt that they represent Xinjiang weaving at its greatest. The luxury of these weavings indicates that they were special commissions, woven as platform covers probably for a local dignitary. This style was produced with both silk and wool pile – several examples of the latter survive.

We know of two basic field designs for the 'first period' Mughal-style covers. The first design has a floral field defined by a discreet – rather than overtly stated – ogival lattice, implied by an intricate system of fine floral

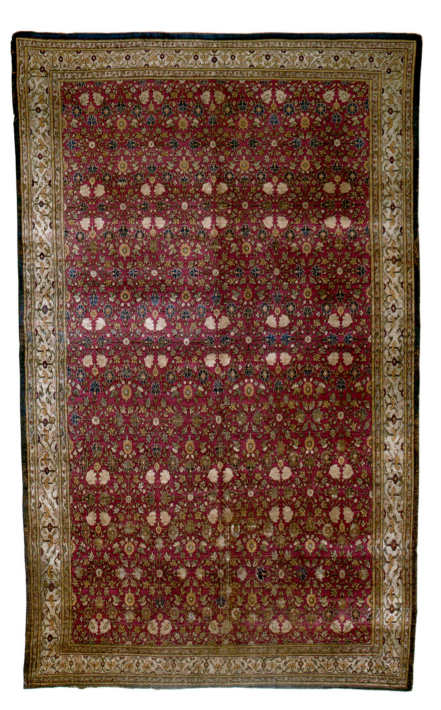

14. Dais cover with Mughal-style flowers, Kashgar, late 17th century. Silk pile on a silk foundation, 205 x 360 cm (6'9" x 11'9"). Thyssen-Bornemisza Collection, Lugano.

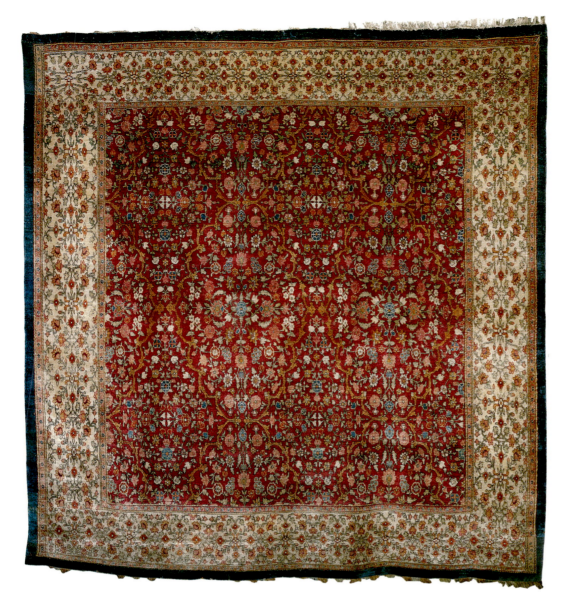

15. Dais cover with Mughal-style floral lattice, Kashgar, probably late 17th century. Silk pile on a silk foundation, 233 x 252 cm (7'7" x 8'3"), incomplete. Private collection, Switzerland. Formerly Hagop Kevorkian Collection, New York.

stem-work which is drawn in a manner suggesting a composition of rows of circles with diamond-like forms at the interstices. A very beautiful complete example is in the Thyssen-Bornemisza Collection (**14**). Another with fresh, intense colours in full pile was formerly in the Baltimore Museum of Art, but unfortunately only a section of the field is known.[35]

The second design scheme found on 'first period' Kashgar carpets with Mughal-style designs has a more distinctly defined ogival lattice with golden stems, outlined in black, that twist and curve to form large-lobed ogives. At the centre of each elegantly drawn ogive is a tiny blue flower and radiating into the four axes are stems with numerous tiny multi-coloured flowers. The ogives are completely filled, as are the large diamond-like interstices between them. The field is surrounded by a beautiful wide border decorated with fine stem-work with flowers in two-tone pink and red. The most stunning example, shortened in length, is a dais cover once in the famous Hagop Kevorkian Collection in New York (**15**); another section from the field was more recently in the Wher Collection, Switzerland. A complete cover with the same field design, less intense colours and a blue-ground border with a simpler design is in a private collection in New York. A tiny fragment of a companion piece was once in the Bernheimer Collection, Munich. The guard borders on the last two are similar to many wool pile Kashgar carpets with other field designs and must have been typical for that region. We know of two other complete Mughal-style lattice-design carpets only from photographs: one with an ivory-ground border, the other with a blue-ground border. All seem to have a plain blue band surrounding the outer edge of the border.[36]

This form of decoration seems to have reached its artistic high point in silk carpets towards the end of the seventeenth century. It was also used on wool pile carpets from the late seventeenth century onwards, although these tend to be far less colourful.[37] These patterns continued to be used for both silk and wool pile carpets in an increasingly

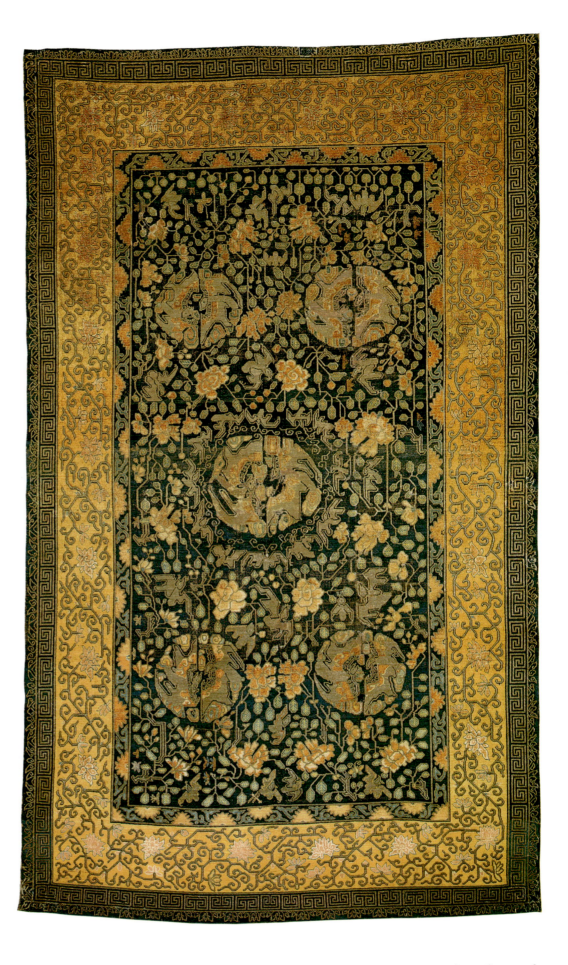

16. Dais cover with medallions and flowers, probably Kashgar, first half 18th century. Silk pile on a cotton foundation, 222 x 394 cm (7'3" x 12'11"). Thyssen-Bornemisza Collection, Lugano. Formerly J.P. Morgan Collection, New York.

debased form throughout the eighteenth and nineteenth centuries: a number of examples woven in silk can be placed into this 'second period' Mughal-style category, including a dais cover in the Metropolitan Museum.[38] Judging by the large number of later Xinjiang carpets with floral lattice designs extant, this pattern seems to have proved popular enough to influence other ateliers throughout the region.

RELATED COVERS WITH CHINESE-STYLE DESIGNS

A second group of covers, probably woven in Kashgar, have field and border patterns in a distinctly Chinese style. As their designs are in the manner of art from the reigns of the Yongzheng (1723–1736) and Qianlong (1736–1796) emperors, we believe that they date from the first half of the eighteenth century. The most important of them is a silk dais carpet, formerly belonging to the banker J.P. Morgan and now in the Thyssen-Bornemisza Collection, that was the subject of an article by the scholar-dealer Ulrich Schürmann (16).[39] Some years ago we saw a photograph of a room in the Imperial Palace in Beijing that showed an identical carpet; it is possible the two were woven as a pair.[40] The bright imperial yellow border and profusion of gold thread suggest that the cover was made for court use. The stylisation of the bats, with one wing dipped, flying freely against the dark blue background surrounding the central medallion, is typical of this period. A third, fragmented, dais cover is divided between The Textile Museum, Washington DC, and the Museum für Kunsthandwerk, Frankfurt.[41] Gold thread is used instead of pile in some areas of all three in order to highlight parts of the design.

Closely related to these three dais covers are ten small covers.[42] While they share many features, they are less bold in design and colour and may be slightly later in date as their patterns are more typical of the Qianlong period. They can be divided into three formats. Five examples, including one in the Metropolitan Museum (17), are similar in shape to the cushion faces used for chair backs, although it is possible that they, or their precursors, were saddle covers. Three are rectangular with rounded corners, as in another Metropolitan example. Initially these were assumed to be table covers, but it is possible they were intended to be placed on a horse beneath the saddle. There are also two square covers, possibly a pair, perhaps used as mats to designate the seating position of an eminent guest.

All nine have similar floral designs on a golden yellow ground. Some of the trailing floral motifs in the borders can be recognised as dragons. Their fields display a central flower, which on four of them is recognisable as a pomegranate, a symbol of fertility and prosperity often used in Xinjiang. All have a 'key fret' minor border: the 'cushion faces' have both inner and outer borders, the 'table covers' only an inner one. They were originally assigned to China because of their similarity of pattern to silk embroideries and *kesi* slit-tapestries of the Qianlong period. In handle and colour, however, they are more likely to be from Xinjiang. They vary considerably in fineness of weave. Some of the table covers are among the most finely knotted silk carpets from China, while both the seating mats and one of the cushion faces are more coarsely woven. The table covers are all knotted on a silk foundation, while the seating mat and the coarser cushion face are on cotton. It is possible that these pieces were made by Xinjiang weavers working further east inside China, or in Xinjiang for the Chinese market.

17. Cushion face with trailing flowers, probably Kashgar, Qianlong period (1736-1795). Silk pile on a silk foundation, 64 x 66 cm (2'1" x 2'2"). The Metropolitan Museum of Art, New York, 36.153.2.

18. Seating mat with octagon-and-square lattice and interlace, probably western China, 17th century. Silk pile on a cotton foundation, 84 x 81 cm (2'9" x 2'8"). Wher Collection, Switzerland.

THE INFLUENCE OF TEXTILE DESIGNS

The field pattern of two seating mats, one in the Wher Collection (18), the other once with Tiffany Studios, New York, shows how the designs of some wool pile and some silk pile carpets were influenced by woven silk textiles, and vice versa. While the Tiffany mat has been attributed to the Ming dynasty, indications suggest a date for both of the last half of the seventeenth century.[43] Both leave parts of the field unknotted and brocaded in a herringbone technique using metal thread wrapped around a silk core, as on the sixteenth century Davison saddle rug (3) and on the eighteenth century dais carpet in the Thyssen-Bornemisza Collection (16).

The design of the mats, a lattice composed

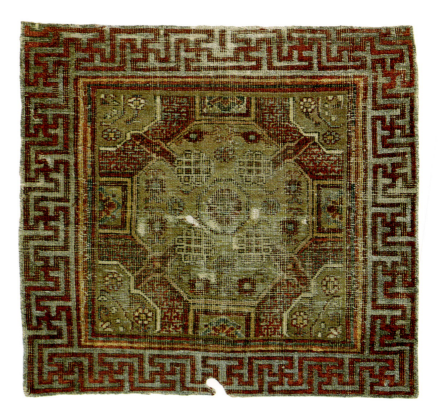

of octagons and squares with an interlace is typical of Chinese silk brocades, on which it was used profusely from the sixteenth to eighteenth century. Stylised versions can be seen on a seventeenth century Ningxia wool pile carpet as well as on several examples from the Gansu region from around 1800.[44] Even today, reproductions of the silk cloth can be seen used as covers for boxes and mounts for scroll paintings. It is possible to observe a stylistic development in this pattern. The Wher Collection mat almost certainly drew its design from a silk brocade rather than vice versa, although in handle it is similar to the Davison saddle rug.

The swastika fret border of the Wher and Tiffany silk mats can also be seen, drawn in the manner of Ningxia carpets of the seventeenth century, on a huge dais cover with silk pile and metal thread once with Vitall and Leopold Benguiat.[45] The field is covered with a small repeat

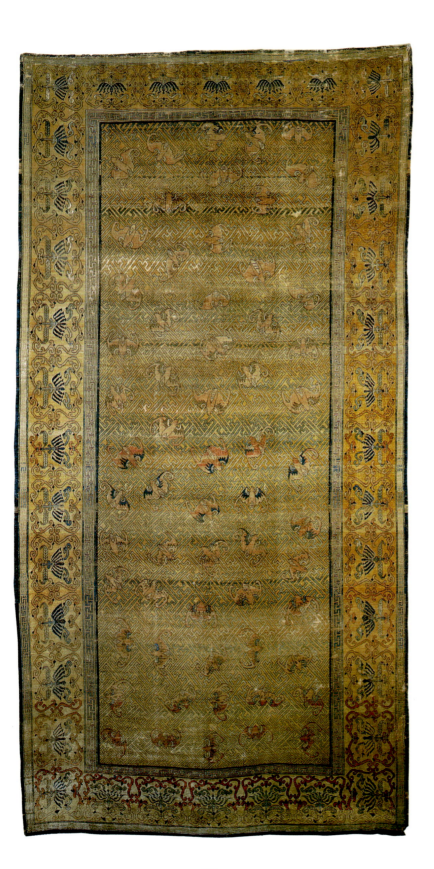

19. Dais cover with swastika trellis and overlaid bats, probably Kashgar, first half 18th century. Silk pile brocaded with metal thread, 192 x 395 cm (6'3" x 12'11"). Private collection, England. Formerly E.A. Bischoff Collection, Beijing and London.

pattern of inward- and outward-pointing palmettes drawn in a Chinese manner – a miniaturised version of the famous seventeenth century Persian Esfahan design. The background of the field is brocaded in a herringbone technique using a gilt metal thread, and that of the border in silver-like thread. This is the sole surviving example we know with this design, but as it is representative of a traditional art form we can be certain that many others once existed. The Benguiat cover has superficial stylistic similarities with the Mughal-style dais cover in the Thyssen-Bornemisza Collection (14), but without direct examination it is very difficult either to date it or link it with other known works.

Cut pile silk velvet as we know it today was woven in China from at least the fourteenth century. However, the technique clearly evolved over a long period: velvet-like material has been found in a Han dynasty tomb, although its technique more closely resembles a looped pile.[46] From the Ming dynasty onwards we find velvet used for costume, hangings and covers: a number of silk velvet carpets share field and border designs with silk and wool knotted pile carpets. The swastika fret border, for example, so prevalent on Kangxi period carpets from Ningxia, appears on velvet *kang* covers from the early eighteenth century.[47] These are often woven in three sections, and also have areas left unpiled and embellished with gold thread. Their manufacture appears to have continued through the nineteenth century. It is possible that they were intended to be more refined versions of the knotted pile examples under discussion here. One field design found on these velvets, a diagonal swastika trellis overlaid with bats with one wing dipped and the other elongated and curled at the end, can be found on a magnificent silk pile dais cover reportedly from the Imperial Palace in Beijing, which was acquired in China by E.A. Bischoff in the early part of this century (19).[48]

A number of wool pile carpets from Ningxia that have been attributed to the reign of the emperor Kangxi have a field design of either a vertical or a diagonal swastika trellis overlaid with bats.[49] In seventeenth century wool-pile versions the trellis is quite pronounced

and the bats are drawn 'face on' in a rather abstract manner. The diagonal swastika trellis continued to be used through the eighteenth and nineteenth centuries, in both wool and silk pile. A distinct change appears to have occurred in its execution in the second quarter of the eighteenth century: rather than being the main focus of pattern, it was given a secondary role and used in paler tones as a background dominated by other ornaments. A fragmented silk pile carpet from the end of the reign of the Qianlong emperor in the Victoria and Albert Museum in London is typical of this paler rendering: large flowers and bats are superimposed on the trellis, and the border has elements from the 'Hundred Antiques' design.[50] The far western regions would possibly have adopted the new style later than workshops in Ningxia.

SEATING MATS

A pair of seating mats, possibly from Yarkand, in The Textile Museum, Washington DC, have a field design of a large lotus palmette on a blue ground enclosed by a wide orange-red border with leaves, which are reminiscent of the large curling leaves on the borders of the Bischoff dais cover (19). A seating mat with an almost identical pattern, but slightly less refined, with a yellow ground in the main field and border, is in the Wher Collection (20).[51] It is similar in weave to other silk pile covers from Yarkand.

The border pattern of the Textile Museum and Wher mats is almost identical to that of a pair of early eighteenth century wool pile seating mats once in the Bernheimer Collection, which have been attributed to Kashgar but could possibly be among the oldest Yarkand examples.[52] In the field they have one of the earliest known drawings of a motif that might be termed the 'uncoffered-gül', which was originally composed of four bats facing inwards towards a small flower. This, combined with their elegant border and the crisply defined drawing of the ornaments, suggests an early eighteenth century date and helps us to place the silk pile examples.[53] The bats-and-flower motif became widely used on Xinjiang carpets from the late seventeenth or early eighteenth century, with more stylised versions were in use throughout the region by the second half of the eighteenth. Later versions have become known as the 'coffered-gül' design: the bats-and-flower motif simply resembles flowers and is encircled by stylised dragons, which in the latest examples are represented by an abstract dragon fret.[54]

A small silk pile seating mat, also once with Bischoff (21),[55] originally attributed to the Ming dynasty but probably from the seventeenth century, has what may be an even earlier rendering than the Bernheimer mats of the 'uncoffered-gül' motif, composed of more naturalistic bats. The design scheme is reminiscent of Persian Garden carpets, the central square creating L-shaped corners. In the centre are stylised dragons and in each of the corners are three groups of bats.

A beautiful seating mat has a rare design composed of a central rounded motif of one bat surrounded by four other bats joined by

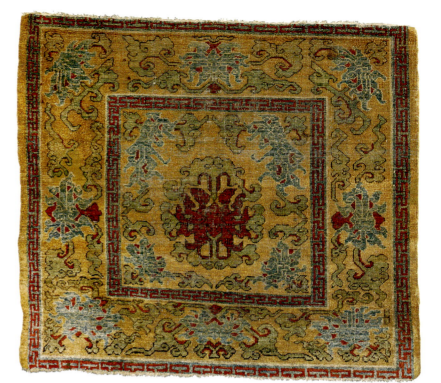

20. Seating mat with lotus palmette, probably Yarkand, 18th century. Silk pile on a cotton foundation, 93 x 100 cm (3'1" x 3'3"). Wher Collection, Switzerland.

21. Seating mat with stylised dragons and 'uncoffered-gül' motif, probably Kashgar, 17th century. Wool pile on a cotton foundation, 102 x 102 cm (3'4" x 3'4"). Private collection. Formerly E.A. Bischoff Collection, Beijing and London.

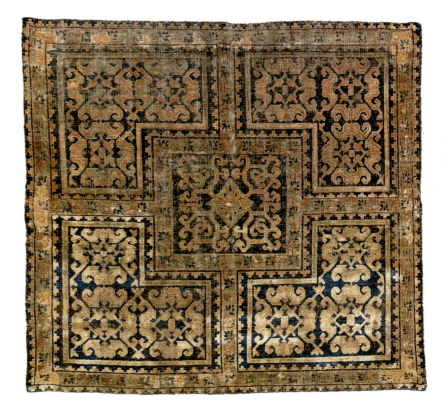

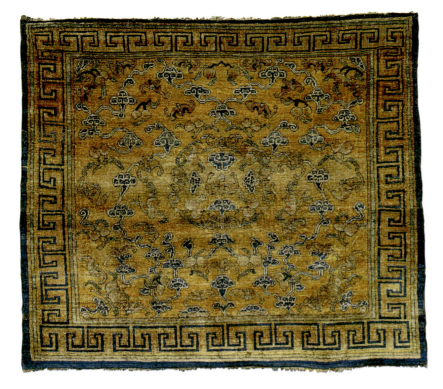

22. Seating mat with bats,
peaches and lingzhi fungus,
Xinjiang, 18th century.
Silk pile on a silk foundation,
94 x 104 cm (3'1" x 3'5").
Formerly James Herbert Boone
Collection, Baltimore.

23. Cushion face with deer
and tree, Ningxia, second quarter
18th century. Silk pile on a cotton
foundation, 76 x 81 cm (2'6" x
2'8"). Eberhart Herrmann
Collection, Emmetten.

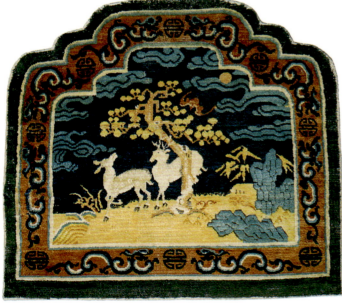

peaches and the *lingzhi* fungus (**22**).[56] Complex *lingzhi* motifs – which resemble multi-coloured mushrooms – cover the rest of the field in a regular network, interspersed with realistically drawn bats and pairs of peaches.

This design, which is purely Chinese in origin, can be seen on another silk pile seating mat from Xinjiang,[57] although there are also a number of Chinese tapestry-woven *kesi* from the Qianlong period that use it. The *lingzhi* symbolises immortality. The peach has the same meaning – according to different sources, the famous peaches of eternity ripen every one, three or nine thousand years. The subtle colour of this fruit with its characteristic leaves is superbly rendered here. Bats represent good fortune, and they are found all over the golden yellow ground. If they are grouped in fives – as in the central rounded motif – they represent the five blessings: long life, wealth, good health, love of virtue, and natural death. They can be found also on a silk pile *kang* cover, formerly on the New York art market, with a field design of hundreds of tiny bats randomly placed on a melon-coloured ground, enclosed by a swastika fret border, which is another sole surviving example of its type.[58]

SHAPED COVERS

Chinese carpets have used naturalistic and semi-naturalistic pictorial designs since the sixteenth century, if not earlier. The patterns found on the Imperial Palace carpets of the Ming period which depict scenes with dragons, phoenixes, clouds and seas can be categorised as 'pictorial', although they achieve a kind of naturalism in the widest sense of the term. One of the earliest examples with a truly pictorial scene set in a vignette is a wool pile seating mat from the Sarre Collection now in The Textile Museum, Washington DC, which depicts a crane and a butterfly among lotuses. This was first attributed to the Ming dynasty, but we have always considered it slightly later, from the middle of the seventeenth century. Several other late seventeenth century wool pile carpets with pictorial scenes set in panels survive, such as one formerly in the Michaelian Collection.[59]

The earliest surviving silk pile example that we know is a cushion face with a similar but simpler scene of deer and a tree (**23**).[60] This is thought to be from the second quarter of the eighteenth century, as the border is similar in style to other examples from this period.[61] The design of a tree and deer appears on at least two silk pile saddle rugs from the eighteenth or nineteenth century and also on Baotou wool pile saddle rugs from the end of that period.[62] A silk pile *kang* cover once in the Treitel Collection, possibly made around 1800 in Ningxia, shows a horse tethered to a tree in a landscape, surrounded by vases and other antiques.[63]

Shaped silk carpets, such as the cushion faces (**17**) and table covers discussed earlier, are rare. Another possible cushion face attributed to Yarkand (**24**) is with Dennis R. Dodds of Philadelphia: the field contains a large peony, and the borders have large waves, with bats and lotuses in the sides and upper border.[64] A second such shaped piece, on a red ground, is currently with Herrmann (**25**).[65] He attributes it to the seventeenth or eighteenth century and believes the flowers in the central field, which is enclosed by a yellow border with small red coins or *shou*-like characters, to be lotuses. We feel that it is quite likely to be from Kashgar. And while it is remarkably difficult to distinguish between lotuses, chrysanthemums and peonies, the flowers are more like the last of these (**13**).

Another panel of unfamiliar shape, in the Freer Gallery of Art in Washington DC, is also believed to be from Xinjiang.[66] The foliated medallion is typical of late seventeenth and early eighteenth century carpets, but the corner designs, reminiscent of European Renaissance designs, are unusual. A similar pattern can be seen in the medallion of an early seventeenth century Chinese wool pile carpet.[67]

XINJIANG CARPETS WITH FLORAL DESIGNS

A number of clearly recognisable types with allover floral designs can be broadly categorised as 'Kashgar': some of these have a repeated five-flower motif, others have a variety of other small floral patterns.[68] Some have metal brocading. The tonality of some of these is so much like that of Esfahan 'Polonaise' carpets that it is not difficult to believe examples of these Persian weavings might have influenced the workshops of Kashgar in the second half of the seventeenth and early eighteenth centuries.[69] The five-flower pattern was perhaps a stylisation of an allover floral design, and a silk pile carpet with a design of rows of flowers twice offered at auction in recent years – in both instances we believe incorrectly attributed to Khotan – may represent a transitional stage in the development of Kashgar designs: its border is of a type we associate with the first half of the eighteenth century.[70]

The earliest surviving carpets with the five-flower pattern have wool pile. Many of them have similar minor borders to some of the silk carpets usually attributed to Kashgar. They include an example in the Museum für Islamische Kunst, Berlin, attributed by Hans Bidder to Kashgar in the first half of the eighteenth century.[71] Bidder also attributes a silk dais cover with a similar design to Khotan and the sixteenth or seventeenth century. While agreeing with his Kashgar attribution for the Berlin example, we prefer an attribution to the eighteenth century, probably also to Kashgar, for the dais cover, where the flowers are more stiffly drawn.[72] In 1973, we assigned an unusual ivory-ground silk pile cover from the Thyssen-Bornemisza Collection, with a five-flower field design and a cloudhead primary border (**26**),[73] to Kashgar, which was also Ulrich Schürmann's designation. However, its weave is clearly different from others thought to have come from that city, so we are now not at all certain where it was made. The lack of metal thread is not really a decisive factor, as it is also absent from some of the earliest silk pile carpets with the five-flower motif that are more clearly attributable to Kashgar.

The generally more subdued tones of the carpets attributed to Kashgar contrast with the bright yellows and orange-reds that we associate with Yarkand and Khotan. Of the wool pile examples, those with a depressed foundation and cotton wefts that are often dyed blue tend to be attributed to Yarkand, and those with a flat back and cotton or sometimes wool wefts and a rather looser weave are usually assigned to Khotan. The five-flower design was used extensively through the nineteenth century on wool pile carpets from both cities,[74] albeit in a somewhat stylised manner, and a few silk carpets with this pattern are also known. One of the earliest silk examples, once in the Michaelian Collection, has a central medallion and part-medallions in the corners.[75] Its borders are very similar to the silk Kashgar published by Bidder cited above, yet its tonality, style of drawing and weave are more akin to Yarkand and Khotan carpets.[76]

There are also a number of silk pile covers with floral lattice field designs that are generally attributed to eighteenth century Kashgar.[77] They are all on a cotton foundation and

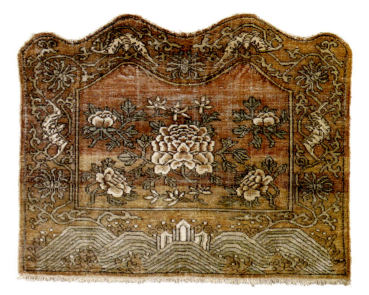

24. *Cushion face (throne back) with peony, lotuses, bats and waves, probably Yarkand, 18th century. Silk pile with cotton highlights on a cotton foundation, 79 x 66 cm (2'7" x 2'2"). Dennis R. Dodds, Philadelphia.*

25. *Cushion face with peonies and shou symbols, probably Kashgar, ca. 1700. Silk pile on a silk foundation, 92 x 88 cm (3'0" x 2'10"). Eberhart Herrmann Collection, Emmetten.*

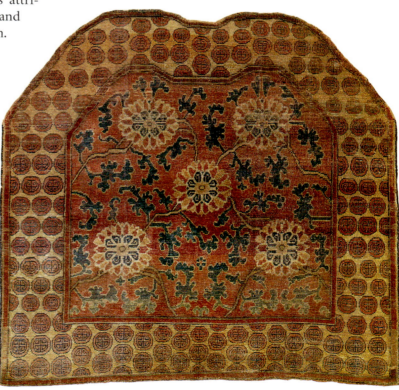

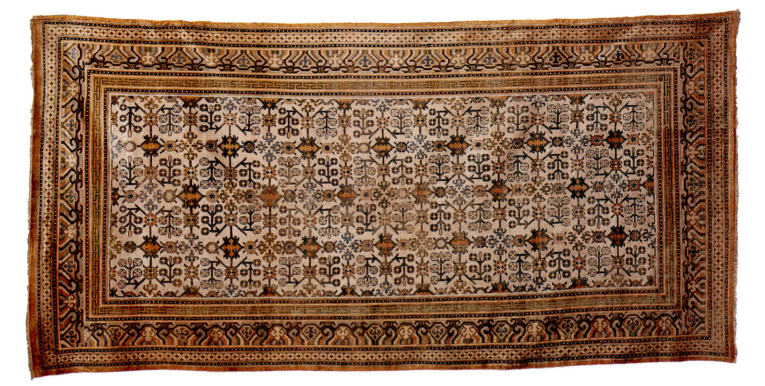

26. Dais cover with five-flower design on a white ground, western China, 18th century. Silk pile on a cotton foundation, 173 x 356 cm (5'8" x 11'8"). Thyssen-Bornemisza Collection, Lugano.

have areas left unknotted and brocaded in a herringbone technique with metal thread, in the same way as the Wher Collection (**18**) and Tiffany seating mats. Several others exist without metal thread but with similar border and guard border stripes, including one with a floral field and rows of large confronting tigers.[78] Among other types known only from one or two surviving examples is a 'unique' and very beautiful Yarkand silk dais cover, probably woven around 1800, formerly in the Kevorkian Collection (**27**).[79] While elements of its leaf and medallion design can be seen on other carpets, we know of no others with this overall composition.[80]

XINJIANG CARPETS WITH POMEGRANATE DESIGNS

The most frequently found motif on both wool and silk pile carpets from Xinjiang is the pomegranate tree. Pomegranates, with their many seeds, have always been a powerful symbol of fertility. One of the most common reasons for making carpets in Central Asia was as part of a wedding dowry, and what better symbol could there be to display for this purpose than one of fertility. Probably the earliest surviving, and one of the most beautiful, examples is a Khotan rug in the Victoria & Albert Museum, London.[81] Knotted with wool pile, it has a single red plant set against an ivory background. Since its first publication by Schürmann in 1969, this marvellous rug has acted as a standard by which all others of this design are judged. Numerous surviving examples show that the pomegranate tree was used with a background colour of blue, yellow, ivory and red. On those with a red background, the pomegranates are in two shades of blue or in yellow; on all the other field colours they are in two shades of red.

A beautiful example of the design, also illustrated by Schürmann, is an early nineteenth century rug with the most elegant proportions, now in the Thyssen-Bornemisza Collection (**28**).[82] As with most silk pile carpets from Yarkand, it utilises the archaic concept of an 'overlaid' design.[83] The emphasis is placed upon a single background colour, in this case a deep magenta, on which the border stripes are overlaid; the field design may be viewed as a large panel, here in golden yellow, which also is set upon the magenta background. In less well conceived examples the borders and field abut, so this design illusion is not created.

XINJIANG CARPETS WITH CENTRAL MEDALLION DESIGNS

In addition to the five-flower design Yarkand or Khotan carpet from the Michaelian Collection mentioned on the previous page, which has a central medallion and part-medallions in the corners, others are known with designs in which the medallion is more prominent. A number of Xinjiang wool pile carpets from the eighteenth and nineteenth centuries have one, two or three central medallions and some of these take a gül- or disc-like form. The discs may float free on an empty field, be surrounded by floral forms or placed in a square. Several silk pile carpets with this design are also known and they appear to be from a variety of different locations, made over a long period.[84]

27. Opposite: Dais cover with leaves and medallions, Yarkand, ca. 1800. Silk pile on a cotton foundation, 206 x 339 cm (6'9" x 11'0"). Formerly Hagop Kevorkian Collection, New York.

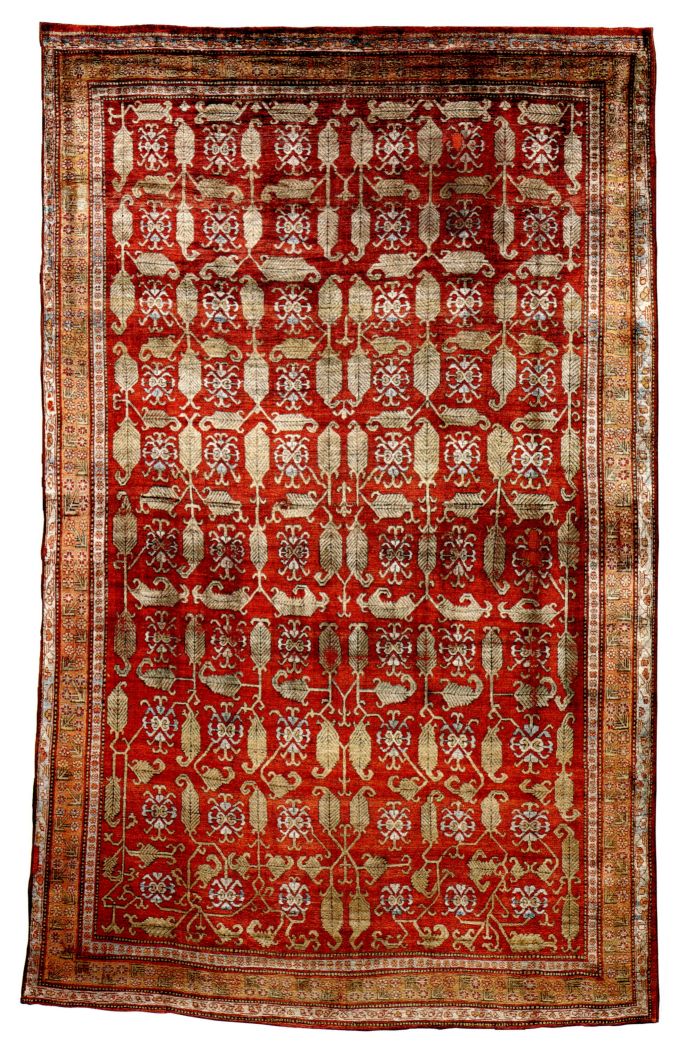

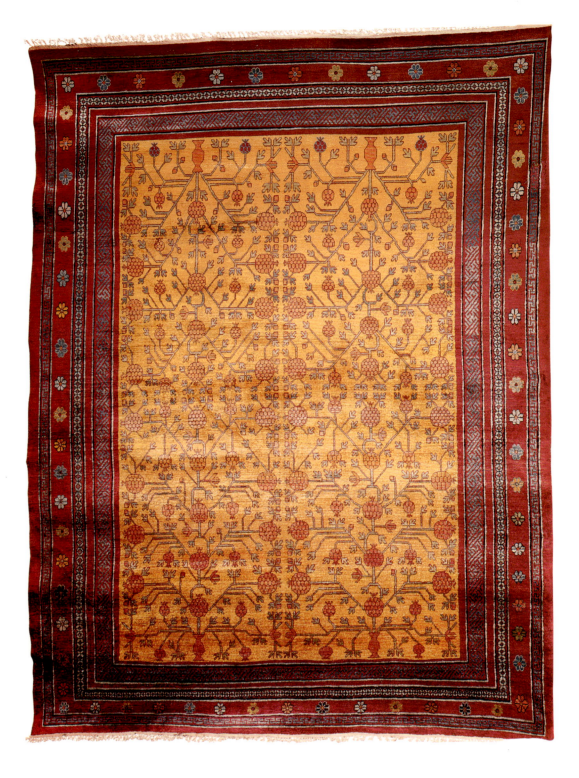

28. Dais cover with red pomegranate tree on a yellow ground, Yarkand, ca. 1800. Silk pile on a cotton foundation, 231 x 315 cm (7'7" x 10'4"). Thyssen-Bornemisza Collection, Lugano.

XINJIANG SAFS

In the fourth century AD Buddhism was widely practised throughout western China. However, by the end of the seventh century, following the Arab invasion of Sogdiana, Islam had begun spreading across Central Asia, and the vast majority of the population today, even as far east as Ningxia, are Muslims. Therefore multiple-niche prayer carpets *(safs)* were made in most of the carpet-making centres of Xinjiang. The earliest examples, in wool pile and attributed to Kashgar, tend to be less colourful and more austere than those attributed to Khotan and Yarkand. Red and blue predominate and often the designs in each niche or *mihrab* are identical.[85] Some of the safs attributed to Kashgar and knotted with silk pile have areas of metal brocading, while others are fully knotted; again the designs within each of the niches tend to be identical.[86] Remarkably few of these are known to us, probably because such items were rarely exported.

Two published silk pile safs with flowering niche designs might well be from Khotan.[87] Another, once with Victor Eskenazi in Milan, with heavily depressed silk pile and blue cotton wefts, was probably made in Yarkand around 1800 (**29**).[88] Again, the same flowering shrub

repeats within each niche, and variety is achieved by a change in colour of the background leaves and stems. The field is enclosed by a very angular form of the cloudhead border. A unique single-niche silk pile prayer rug, once with Herrmann, also has a stylised version of the cloudhead border; the long thin niche culminates in a ram's horn motif, and the field is filled with a small repeating diaper motif.[89] The very angular style of the waves on both the Eskenazi and Herrmann niche carpets can be seen again on a number of wool pile carpets dating from the first half of the seventeenth century to the early 1800s.[90] Two other Yarkand silk pile safs are almost identical to each other in design: they have four niches, one with a tiger, the second with a man, the third with a sheep and the fourth with a serpent.[91] They are both dated '1210' (perhaps 1910), but it is not known what calendar this follows.

IMPERIAL CARPETS WITH XINJIANG AND CHINESE-STYLE DESIGNS

Brief mention should be made of the group of imperial silk covers with Xinjiang and Qianlong period Chinese designs, thought to date from the end of the eighteenth through the nineteenth century. They all have four or five character inscriptions designating the rooms in the Imperial Palace for which they were made. We have not shown any of these in this essay because we feel they are mostly copies, made to order as court furnishings, and therefore not part of the indigenous textile art that is our subject. Many of them do contain silk and metal thread, but they display a crude juxtaposition of jarring colours and have derivative designs. Because many were sold off by court officials during the times of unrest at the beginning of the twentieth century, more than fifty have survived in excellent condition. This particular group was the subject of a very thorough catalogue which accompanied a special exhibition at the University Museum of Pittsburgh in 1973.[92]

CONCLUSION

We have surveyed a number of silk knotted pile carpets from western China which date from before 1800, and have attributed some of them to Ningxia and others to the three principal oasis towns of Xinjiang. Several others probably come from other regions and towns that we are presently unable to identify. Carpets regularly come to our attention that share features

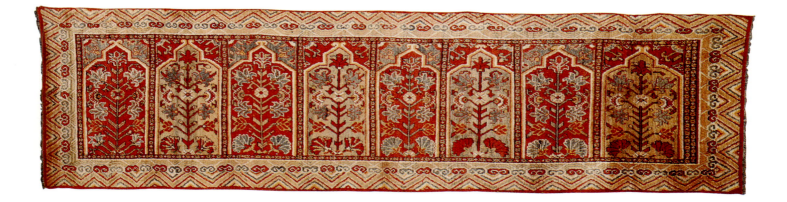

of several of the types listed here, yet do not comfortably fit into any one group; others represent types previously unknown to us. For instance, we mentioned wool pile carpets from the province of Gansu, which share features of design and technique that clearly identify the majority of examples that we attribute to that region, but no silk pile versions. But why should there not also have been silk pile rugs from Gansu province? A silk pile rug advertised by a Florentine gallery in a recent issue of *Hali*, previously unknown to us, has all the design features that one would associate with Gansu carpets, and we would therefore assume it to be probably from there too.[93]

The ideas presented here arise from examination of several thousand Chinese carpets, but still there are no clear answers. The statements made are based on comparative analysis, but we have few if any fixed points that can act as standards for place of origin or date of manufacture. One should therefore regard our conclusions as opinion rather than fact. We can ask no more than that people should look at these beautiful carpets in admiration of their elegance and beauty, and treat them simply as great works of art, the creations of unknown artisans, from cultures and traditions that have now been swept away by the tide of 'progress'.
Notes, acknowledgments and bibliography see Appendix

29. Eight-niche saf with flowers and wave or cloudhead border, probably Yarkand, ca. 1800. Silk pile on a cotton foundation, 110 x 410 cm (3'7" x 13'5"). Formerly Victor Eskenazi Collection, Milan.

7

BY THE PEN

The Art of Writing in Islamic Art

SHEILA BLAIR AND JONATHAN BLOOM

Along with geometric designs and the arabesque, writing in Arabic script is one of the most characteristic features of Islamic art. Using examples drawn from a wide variety of sources, this article considers some of the roles writing played in traditional Islamic art and the formal and aesthetic principles that governed its use.

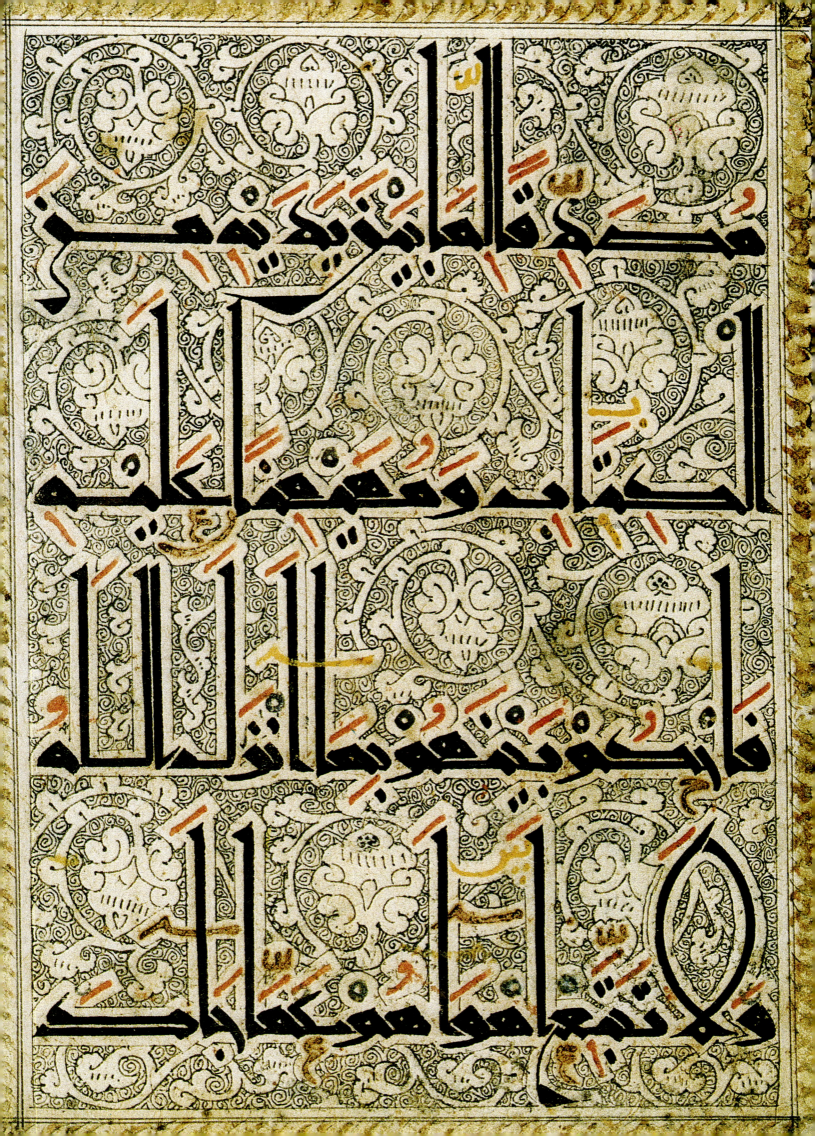

One of the most distinctive features of decoration in Islamic art, writing is found on virtually all media, from the humblest everyday objects – such as unglazed oil lamps and jars – to the fanciest accoutrements of princes, including rock crystal phials and jade jugs. Writing decorates objects and buildings made throughout the course of Islamic civilisation in almost all regions from the Maghreb (3), or western Islamic lands, to the Indian subcontinent and beyond. Despite its ubiquity, decorative writing was more important and creative in some times and places than in others. One need think only of the extraordinary styles of interlaced script that developed in the tenth century under the Samanids in northeastern Iran and Transoxania (19) or the floriated kufic that blossomed in the eleventh and twelfth centuries under the Fatimids in Egypt (22). By contrast, the writing used to decorate works produced in Nasrid Spain or the Ottoman empire, although beautiful, was often stereotyped and repetitive. But writing was never ignored totally.

Two of the most famous examples of Islamic architecture illustrate how purposefully writing was used on buildings. Writing is already an important decorative feature on the earliest example of Islamic architecture, the Dome of the Rock in Jerusalem, ordered to be built by the Umayyad caliph 'Abd al-Malik in 692. Originally both the outside and the inside of the buildings were sheathed in glass mosaic, the most ambitious programme known from

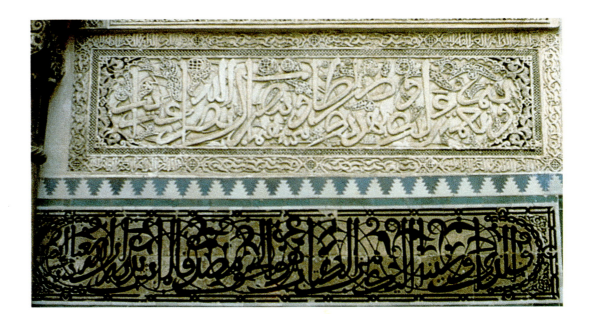

ancient or medieval times. (As the exterior mosaics suffered the effects of weathering, the Ottoman sultan Süleyman the Magnificent had them replaced with tiles in the sixteenth century, so we can say nothing about the role of inscriptions there.)

Most of the mosaic decoration on the inside, however, survives in its original aspect and shows that inscriptions were an integral feature of the decorative programme. Two long bands of inscriptions, written in gold letters that sparkle against a deep blue ground, encircle the inner and outer faces of the octagonal arcade. The inscription around the inner face (4) contains a single continuous text with Qur'anic excerpts and paraphrases and pious phrases extolling God, Muhammad and Islam, denouncing the Trinity and expounding the view of Jesus as God's servant and messenger. The inscription around the outer face contains a similar mixture of pious phrases and Qur'anic passages, but concludes with a short historical text invoking the name of the patron and the date of construction.[1]

Both inscriptions around the Dome of the Rock, like most inscriptions from early Islamic times, are written in the angular script commonly known as *kufic,* so-called because it was once thought to have originated in the city of Kufa in Iraq. Although this identification dates only from eighteenth century Europe, the name kufic is still useful in designating this script: it is characterised by simple geometric shapes, harmonious proportions and wide spacing. The juxtaposition of horizontal and vertical strokes lends the inscription a strong internal rhythm, which is subtly enhanced by the elongation of such horizontal letters as *dāl* and *kāf* (5).

To highlight the message, diacritical marks – in this case diagonal strokes – were added to the inner band to distinguish different letters with the same shape. These glittering marks

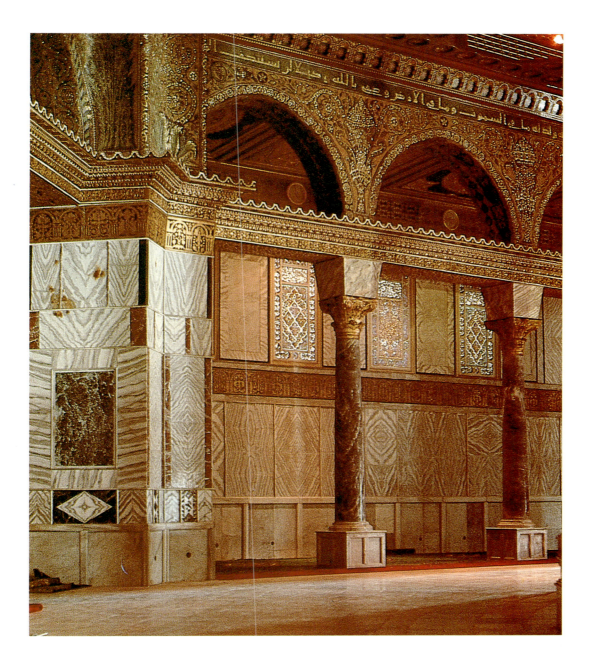

4. Part of the mosaic inscription on the inner face of the octagonal arcade, interior of the Dome of the Rock, Jerusalem, 692.

embellish the inscription band in much the same way that shimmering pieces of mother-of-pearl enhance the representational mosaics, which depict diadems, pectorals and other jewels. When the modern spotlights on the dome are extinguished, the inner inscription and the representations of jewels sparkle quite noticeably. The effect would have been even greater before the sixteenth century when the present double window grilles were added.

The inscriptions on the Dome of the Rock can be compared with those decorating an equally famous building erected a millennium later and some four thousand kilometres to the east – the Taj Mahal – the tomb that the Mughal emperor Shah Jahan ordered in memory of his favourite wife Mumtaz Mahal. Work began soon after her unexpected death in 1631,

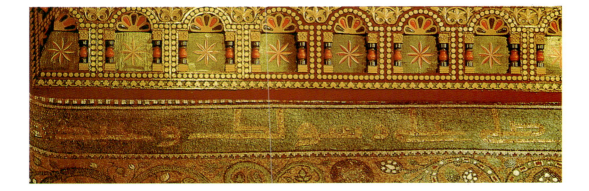

5. Detail of the kufic inscription in fig. 4.

6. Detail of the Qur'anic inscription in thuluth framing the south side of the portal, Taj Mahal, Agra, 1631-1647.

and the building was completed by 1647. As on the Dome of the Rock, inscription bands encircle the inside and outside of the building and combine Qur'anic and historical texts. Most of the inscriptions are short chapters from the Qur'an emphasising eschatological themes, particularly the Day of Judgment.

The band framing the south, or inner, side of the main gateway (6), for example, contains Chapter 89 of the Qur'an, Surat al-Fajr (The Dawn). One of the earliest suras to have been revealed by the angel Gabriel to the Prophet Muhammad, it describes the punishments in store for non-believers, culminating with the ultimate reward promised to the righteous: "Enter thou among My servants, Yea enter thou My Paradise."[2] It has been suggested that the epigraphic programme, which was designed by the famous Mughal calligrapher Amanat Khan, was meant to drive home the message implicit in the building's form and location, that the tomb was an allegorical representation of the Throne of God above the gardens of Paradise on the Day of Judgment.[3]

As on the Dome of the Rock, the use of bold colours at the Taj Mahal makes the inscriptions legible from afar. The tomb and the platform on which it is set are revetted in polished white marble, a crystalline and translucent material which contrasts with the soft and opaque red sandstone used for the outlying structures. The inscriptions are inlaid on the white marble in black hardstone, an effect like ink on paper. The effect is all the more striking when the inscribed white marble bands are inset into red sandstone frames, as on the gateway. The style of script used at the Taj Mahal, however, is quite different from that used a millennium earlier. The squat kufic has been replaced by a tall *thuluth* script, in which the ascenders of some letters are elongated so that they stretch to the top of the band. Words are piled into two registers, and the curving diagonal tails of other letters create a counterpoint to the stems that seem to march across the written space. The inscription is both stately and flowing.

These buildings are only two examples of the ubiquitous use of writing in Islamic architecture. It is easy to explain how this tradition evolved. Inscriptions that trumpet the names of rulers and patrons had marked important sites and buildings in the Ancient Near East and the classical Mediterranean world, but the word plays an especially important role in the religion of Islam. The central miracle of the faith is that in the late seventh century God sent a revelation to the Prophet Muhammad, a revelation that was later written down as the Qur'an (literally 'reading' or 'recitation'). The first words that God revealed to Muhammad are the opening five verses from Chapter 96, Surat al-'Alaq (The Blood-clot):

> Recite: In the name of thy lord who created,
> created man from a blood-clot;
> Recite: And thy Lord is the Most Generous,
> who taught by the pen,
> taught man what he knew not.

These verses underscore the central role of writing, and by extension language, in Islamic culture and art.

The central role of writing runs through the Qur'an. Chapter 68, another early revelation known as Surat al-Qalam (The Pen) or Surat al-Nun (The Letter Nun), opens with the words, "Nun. By the pen and what they inscribe…" Later commentators suggested that the pen was the first thing created by God so that he could write down events to come, and the sentence has inspired poets and mystics down through the centuries. The Qur'an puts man's whole life under the sign of writing. According to another revelation from slightly later (verses 17-18 of Chapter 50, Surat al-Qaf, or 'The Letter Qaf'), two noble angels sit on man's shoulders recording his thoughts and actions, the one on the right jotting down his good deeds and the one on the left his evil ones. On Judgment Day, man's every deed will be totted up in the Book of Reckoning for the final accounting (Chapter 69, Surat al-Haqqa, verses 18-19).

Given the importance of writing in the revelation, it is no surprise that writing became such an important feature of Islamic culture. Not only did inscriptions become a major type of decoration, but also books and book production became major art forms. Some of the earliest books were, of course, copies of the Qur'an. These manuscripts were works of art, painstakingly transcribed on parchment and embellished with gold and silver. While most early manuscripts of the Qur'an were copied in brown or black ink onto white parchment, there are examples such as a page, probably from a manuscript made in Tunisia in the tenth century, that were written in gold ink on parchment dyed blue with indigo (7). This colour

scheme was probably meant to imitate royal Byzantine manuscripts which had been dyed purple with murex, a rare dye derived from molluscs.[4] The combination of blue and gold was already seen as royal in Umayyad times, for it was the one used in the mosaic inscriptions at Jerusalem. The scribe's care in copying the page is clear from the time and effort he spent in stretching out certain letters horizontally, a technique known in Arabic as *mashq*.

Qur'an manuscripts were copied in various scripts. A page from a dispersed manuscript of the Qur'an (2), probably copied in the late eleventh century, for example, is transcribed in a distinctive and mannered script in which the angular letters are exaggerated and the contrasts between thick and thin and tall and short are accentuated. The script is known by a variety of names, ranging from 'Qarmathian kufic' (because it was once associated with the radical Qarmathian movement that sacked Mecca in the tenth century), 'broken kufic' (because of the angular breaks in the strokes), 'eastern' or 'eastern Persian kufic' (because it was thought to have originated in the eastern Islamic lands), 'western kufic' (for the opposite reason), to the 'new Abbasid style' (because it replaced traditional squat kufic and came to prominence in the tenth century when the Abbasid caliphs were the main power ruling the Islamic lands).[5] None of these names is mentioned in historical sources, and so far it has been difficult, if not impossible, to match recorded names and extant scripts. The differences of opinion are matters best left to expert quibbling. Nevertheless, there is much about the role of writing in Islamic art that can be appreciated by non-specialists, even those who do not read Arabic script.

One important aspect, already clear from the mannered script used on the Chester Beatty page (2), is the question of whether such texts were meant to be read literally or recognised visually. In the case of the Qur'an, most scribes and readers knew the text, or much of it, by heart, and visual recognition of a single word would be sufficient to trigger aural memory. Richard Ettinghausen argued that since many inscriptions on other media are almost impossible to read, they were recognised as symbolic affirmations of the faith or of the ruler's

7. Page from the so-called Blue Qur'an, probably Tunisia, 10th century. 28.3 x 37.7 cm (11" x 15"). The Nasser D. Khalili Collection.

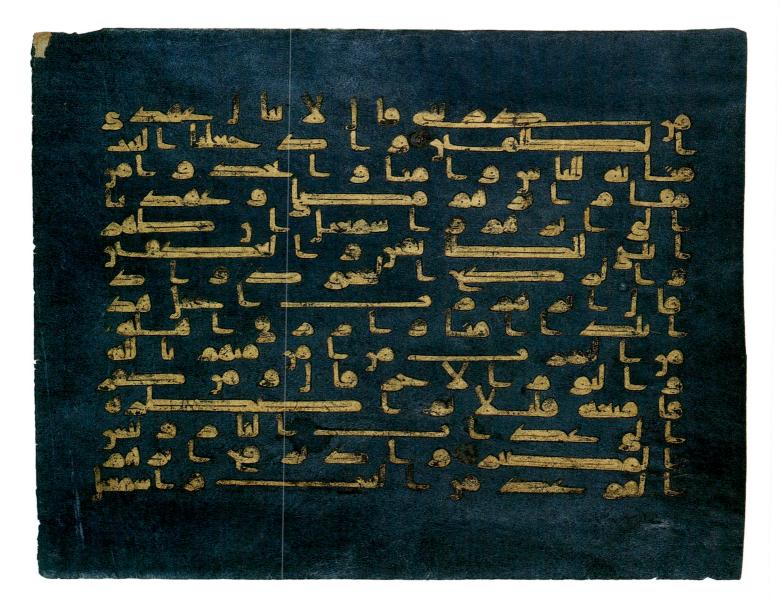

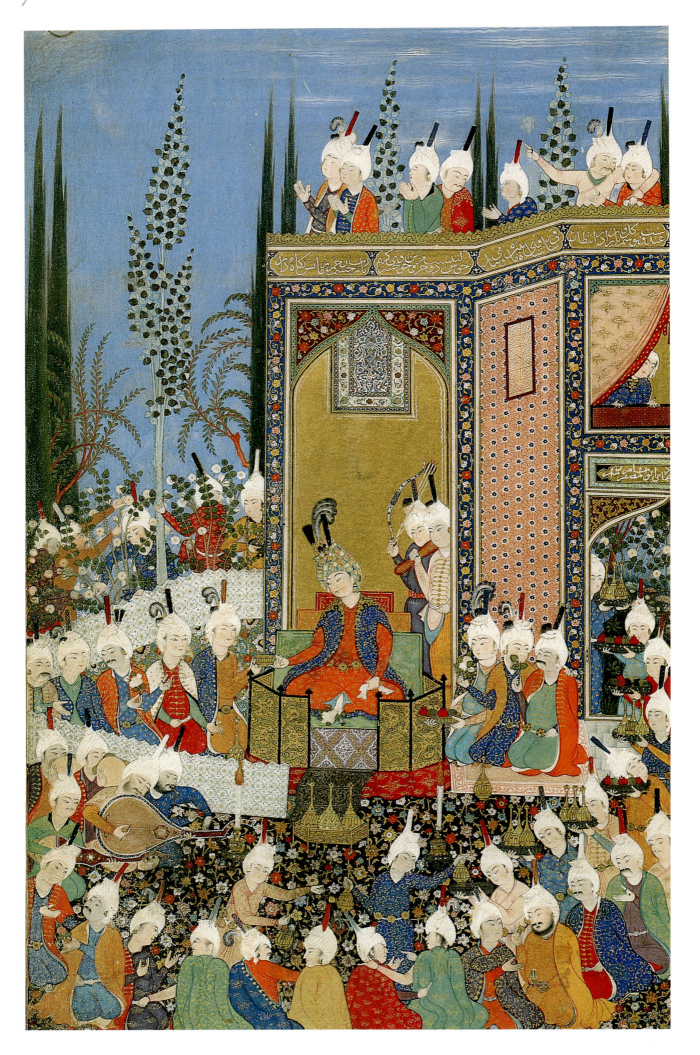

authority.[6] Regardless of their legibility, inscriptions were recognised as meaningful statements, and their general meaning could often be inferred from their context and style.

For example, it is easy to recognise the foundation inscription on a building, even if it is difficult to decipher the particular text, which normally proclaims who made what, when and sometimes why. A good example is the band decorating the façade of the tomb complex built in the late thirteenth century for the Mamluk sultan Qala'un (**1**) along the main street of Cairo.[7] The inscription begins on the right or northeastern corner of the complex under the minaret, runs along the wall of the tomb, continues across the entrance portal to the corridor linking the various parts of the complex, and finishes at the left end of the façade of the madrasa, or theological school. The long text identifies the different parts of the building (a tomb, a hospital and a madrasa) and gives the dates of inception and completion (1284 and 1286). Most of the space is given over to the names and titles of the patron, who is extolled as our lord and master, the greatest sultan, al-Malik al-Mansur, the wise, the just, the one who is aided by God, the victorious, the fighter, the triumphant, sword of the world and the faith, sultan of Islam and the Muslims, lord of kings and sultans, sultan of the earth in longitude and latitude, king of the world, sultan of the two Iraqs and the two Egypts, king of the two continents and the two seas, inheritor of royalty, king of kings of the Arabs and Persians, possessor of the two qiblas, keeper of the two noble sanctuaries, Qala'un al-Salihi, partner of the Commander of the Faithful. Clearly, eulogising the ruler and his work was the most important function of this text.

Inscriptions also give other significant information. On a painting or a ceramic, the inscription often contains the signature of the artist. This is especially true of the finest wares, where artists were particularly proud of their work. Lustred and enamelled (minai) wares were the most expensive kinds of medieval ceramics. Lustrewares were most frequently signed, and the names of some twenty potters are recorded on Persian lustrewares made in the early thirteenth century.[8] The most famous decorator is Abu Zayd, who worked in both lustre and enamel and who has recently been identified as the artist responsible for the famous plate in the Freer Gallery decorated with a scene of a sleeping groom.[9] A signature was, therefore, both a mark of quality and a sign of the artist's status.

Artist's signatures were often ingeniously positioned on the object to reflect the artist's humility with respect to the patron's majesty. Take, for example, a painting detached from a celebrated sixteenth century manuscript (**8**) containing the collected poems of Hafiz, the fourteenth century lyricist.[10] The two couplets inscribed in cartouches along the parapet of the palace describe the festivities of 'Id, the celebration marking the breaking of the fast of Ramadan. After sighting the new moon, participants are encouraged to look upon a beautiful face to ensure good luck in the month to come. In the poem, Hafiz encourages viewers to behold the new moon in the king's face, a clever conceit praising the ruler.

The painting depicts the celebration. Three courtiers on the roof await the new moon. Other courtiers below gaze upon the enthroned monarch, intended to represent the reigning Safavid Shah Tahmasp. The artist signed his work in a cartouche at the base of the throne, "the work of Sultan-Muhammad of Iraq" (**9**). Writing in 1544, the Safavid librarian and chronicler Dust Muhammad lauded Sultan-Muhammad as the master of the age and the foremost painter in Tahmasp's studio,[11] and the location of the signature is intended to underscore the artist's subservience to the ruler. He is, quite literally, under his patron's feet! Just as Hafiz's poem was a clever encomium eulogising his patron, the Muzaffarid ruler Shah-Shuja', so Sultan-Muhammad's signature on the painting is a clever visual conceit connecting the artist with his patron, Tahmasp.

This kind of symbolic signature occurred not only in paintings but also in other contemporary arts, and in this way the painting reflects the setting of Safavid times. One of the most famous carpets produced for the Safavids is a splendid medallion carpet with hunting scenes now in the Poldi Pezzoli Museum, Milan (**11**).[12] The dark blue field is filled with figures sporting the distinctive Safavid turban and fighting lions, deer and other animals. The lively hunting scene surrounds a red medallion with cranes and cloud bands. In the centre is a cartouche bearing the name of the designer, Ghiyath al-Din Jami, and the date 949 AH (1542-1543 AD). The carpet was probably intended to be placed beneath the throne, and the designer's signature would have been hidden under the throne.

Scholars and historians are most interested in the historical information contained in

8. Opposite: 'Celebration of 'Id' from a dispersed manuscript of the collected poems of Hafiz. Tabriz, ca. 1527. 20 x 15 cm (8" x 6"). Art and History Trust Collection, on loan to the Arthur M. Sackler Gallery, Smithsonian Institute, Washington DC.

9. Detail showing Sultan Muhammad's signature under the throne in the 'Celebration of 'Id' (see 8).

inscriptions, and hence this aspect of writing, its content, is fairly well studied. The decorative transformation of writing, that is, how artists transformed inscriptions into works of art, is another aspect of the inscription, but it has received less attention. Hence it will be the focus of the rest of this article.

By looking at inscriptions, several basic concepts can be formulated about the art of writing in Islamic art. One of the most elementary principles, but one that is regularly overlooked, particularly by Westerners, is that writing forces the viewer to approach a work of art in a particular way. The presence of writing gives a work of art a beginning and an end as well as directions for getting from one to the other. Words and sentences have beginnings, middles and ends, and texts can be read in only one direction. Most inscriptions on works of Islamic art are written in Arabic script, which, like Hebrew and Syriac, reads from right to left. Many inscriptions, like many actions undertaken by Muslims, begin with the *basmala* or invocation to God, "In the name of God, the Merciful and Compassionate". Finding the *basmala* shows where the inscription begins. Even without the *basmala*, most inscriptions have a specific beginning. Since the text reads from right to left, it encourages the viewer to examine the object from right to left.

This principle can be seen on a slip-painted earthenware bowl (**10**) made during the tenth century when the Samanids ruled eastern Iran and Transoxania.[13] The centre of the interior is filled with an abstracted plant which grows from a single stem and has five leaves. The major decoration on the interior is a wide band of elegant kufic script encircling the walls. Following a small decorative motif at four o'clock, the Arabic text begins with "Blessing to its owner". After a small teardrop motif at eight o'clock, the text continues with the proverb: "It is said that he who is content with his own opinion runs into danger". Assuming that the bowl was intended to be held and appreciated with the stem of the plant at the bottom, closest to the viewer, then the most important part of the inscription, the blessing to the owner, is immediately legible at the bottom. To read the following proverb, the viewer must turn the bowl completely around in a counterclockwise direction. The inscription invites the holder to handle and rotate the bowl until it is returned to its original position, thereby repeating the opening phrase "Blessing to its owner". Writing is therefore quite the opposite of the arabesque and geometric patterns, for these other two decorative features of Islamic art can be approached from any direction and are infinitely expandable. Writing, by contrast, engenders direction.

10. *Slip-covered earthenware bowl inscribed in kufic script with good wishes to the owner and a proverb, eastern Iran or Transoxania, 10th century. Diameter 39.3 cm (15¹/₂"). Freer Gallery of Art, Washington DC, no.57.24.*

Writing also encourages certain meanings and discourages others. In this way it can help us understand the meaning of other figural, vegetal or geometric decoration. Take for example a superbly carved ivory pyxis in the Louvre (**13**).[14] The kufic inscription around the base of the lid invokes God's blessing on al-Mughira, son of the caliph 'Abd al-Rahman III, in the year 357 AH (967-968 AD). The text begins to the right of the clasp (which was added later) over a medallion showing youths stealing eggs from eagles' nests. The inscription, like that on the Samanid bowl, encourages the viewer to turn the pyxis counter-clockwise. To 'read' the four figural scenes in the medallions, one must consider them in the same order. The carving on the pyxis enhances the message. The high relief underscores the object's three-dimensionality, and some surfaces, such as the hindquarters of the animals, are rounded. The viewer is invited to engage with the figures who look out obliquely from the surface. Any reading of the figural decoration on this and the other elaborately-carved ivories from Islamic Spain must therefore consider the images as they are seen in the round.

Content could be, and often was, manipulated to fit form. This was already done on the Dome of the Rock and on the Spanish ivories, where the texts were adapted to fit the available space and ensure that each inscription was a complete and intact sentence.[15] Such manipulation was even easier when the inscription was quite long, as with the foundation inscription on a major building. A good example is the Shah Mosque in Isfahan (**12**).[16] The

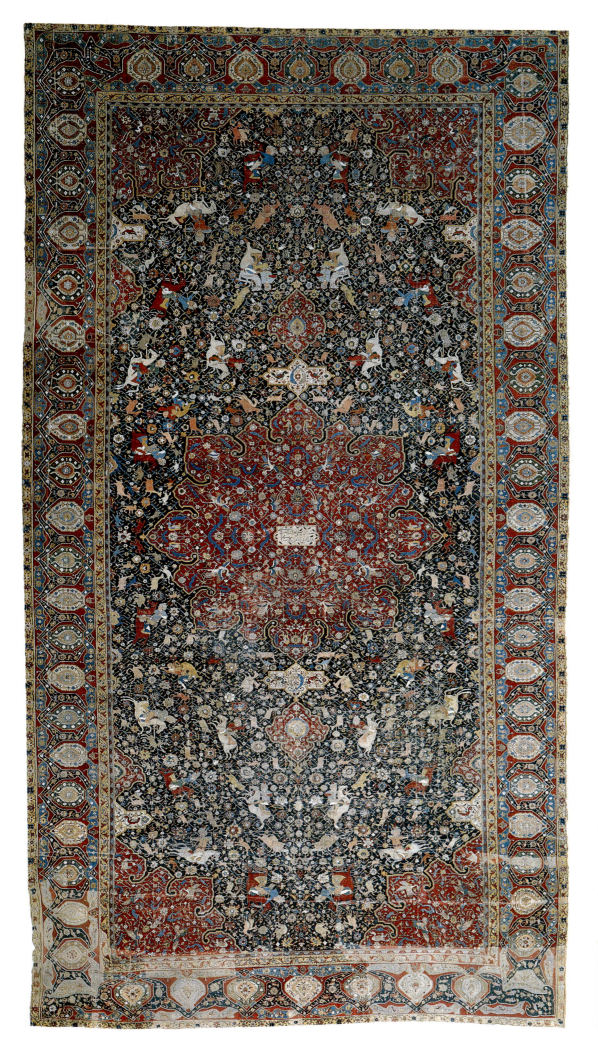

11. Silk medallion carpet, Tabriz, 1542-3. 365 x 570 cm (12'0" x 18'8"). Detail shows Ghiyath al-Din's signature in the central panel. Poldi-Pezzoli Museum, Milan, no.154.

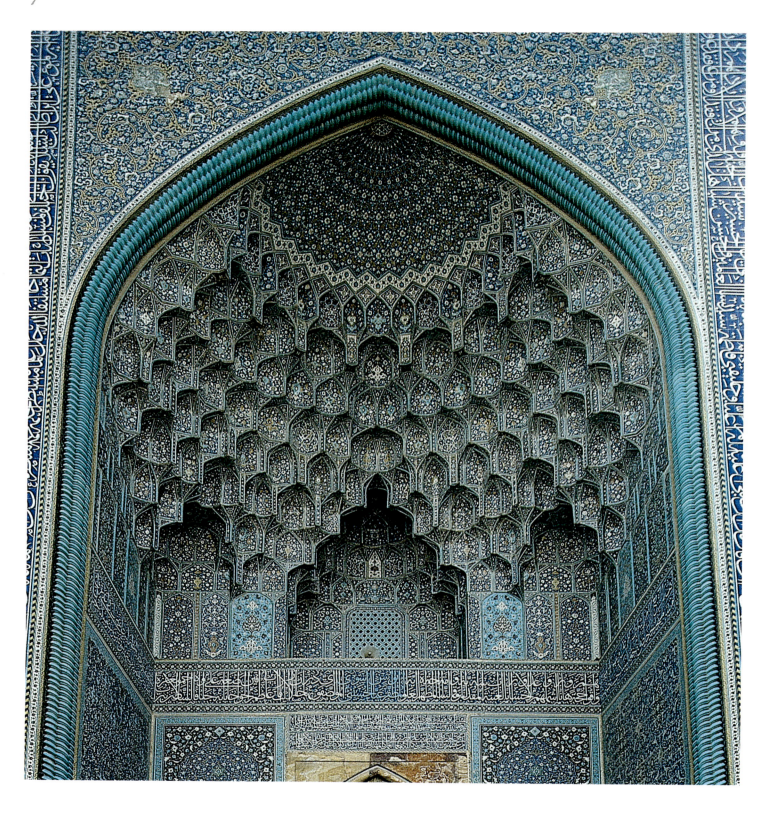

12. Foundation inscription naming Shah 'Abbas I written in thuluth script around the portal of the Shah Mosque, Isfahan, begun 1616-17.

text bears many similarities to the foundation inscription along the façade of Qala'un's tomb complex erected in Cairo three and a half centuries earlier. The inscription on the Safavid mosque is set in a prominent place on the façade, in this case around the main portal. The text says that Shah 'Abbas I ordered the construction of the congregational mosque from his personal monies, and a vertical line inserted at the end of the band gives the name of the calligrapher, 'Ali Riza, and the date 1025 AH (1616-1617 AD). As with Qala'un's inscription, most of the space is given over to 'Abbas's name and titles, for the text was meant to underscore the ruler's majesty.

The design of 'Abbas's foundation inscription is even more sophisticated than Qala'un's. The Safavid inscription is set over the doorway, at the base of the portal's curving vault **(12)**. 'Abbas's titles were clearly adapted to the occasion and mention his piety, generosity and religious authority. Colour enhances the message, and the main part of 'Abbas's name – Abu'l-Muzaffar 'Abbas al-Husayni al-Musavi al-Safavi – is in light blue letters which contrast

with the rest of the inscription written in white against a dark blue ground. Anyone entering the mosque literally passes beneath the ruler.

Varying styles of script were frequently juxtaposed on the same object to differentiate between different messages. On an inlaid brass pen box in the Freer Gallery (14), three distinct scripts are used for three discrete texts.[17] The inscription around the lid, written in a legible rounded script usually known as *naskh*, conveys the historical information, with the names and flowing titles of the owner of the pen box, Majd al-Mulk al-Muzaffar. He served as grand vizier to the penultimate Khwarazmshah ruler of Iran and Central Asia, 'Ala al-Din Muhammad (r. 1200-1220). The large inscription around the base of the pen box, also in *naskh* but with human heads at the top of the letters, contains lengthy blessings to an anonymous owner. The inscription written on the back between the hinges, although smaller and thinner, is executed in a dramatically balanced and refined human-headed kufic. It records the name of the artist, Shadhi, and the date 607 AH (1210-1211 AD). Shadhi's artistic talents are clear from his signature: the words ending his name and beginning the date are wittily arranged as two birds' heads confronting each other over the central knot.

The three texts on the pen box are written in three scripts, not only to heighten the aesthetic impact but also to convey different kinds of information. Despite their complexity, the inscriptions are still legible, with simpler scripts used for historical texts and more complicated animated ones for good wishes. Even without reading the inscriptions, someone looking at the pen box could discern that three types of information were being presented.

Gradually, inscriptions conveying good wishes became more elaborate, and sometimes figures took over and replaced the text, as on a large canteen, also in the Freer Gallery (15).[18] The canteen is the most famous of a diverse group of some twenty inlaid brasses decorated with Christian scenes, and the style and technique of decoration show that it was made in thirteenth century Syria.[19] The convex top of the canteen is decorated with two bands written in a stylised kufic script and offering good wishes to an anonymous owner. The inscriptions surround several Christian scenes. The central medallion shows the enthroned Madonna with the Christchild, and the outer ring displays three panels with scenes from the life of Christ: the Nativity, the Presentation in the Temple, and the Entry into Jerusalem. The flat back of the canteen is decorated with an arcade of twenty-five pointed arches, each enclosing a haloed figure, including an angel, a warrior saint and a praying figure.

The two pieces of the canteen are joined on the shoulder by an animated inscription band separated into thirds by roundels, each with a seated figure holding a crescent. The letters of the inscription have been transformed into revelers, and the text is almost unreadable. The inscription was tentatively deciphered only recently and seems to contain a combination of good wishes – "eternal glory and perfect prosperity, increasing good luck", and general titles – "the chief, the commander, the most illustrious, the honest, the sublime," and "the pious, the leader, the soldier, the warrior on the frontiers". To the casual viewer, the specific verbal message has been lost, although the general content of such inscriptions –

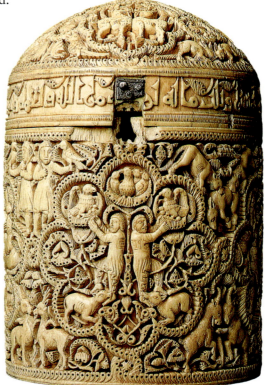

13. Ivory pyxis with kufic inscription made for al-Mughira, Spain, 967-968. Height 15 cm (6"); diameter 8 cm (3"). Musée du Louvre, Paris, MAO 4068.

14. Inlaid brass pen box with naskh inscription, made by Shadhi for the Khwarazmshah vizier Majd al-Mulk al-Muzaffar probably at Herat in 1210-11. Length 31.4 cm (12¹/₂"). Freer Gallery of Art, Washington DC, 36.7.

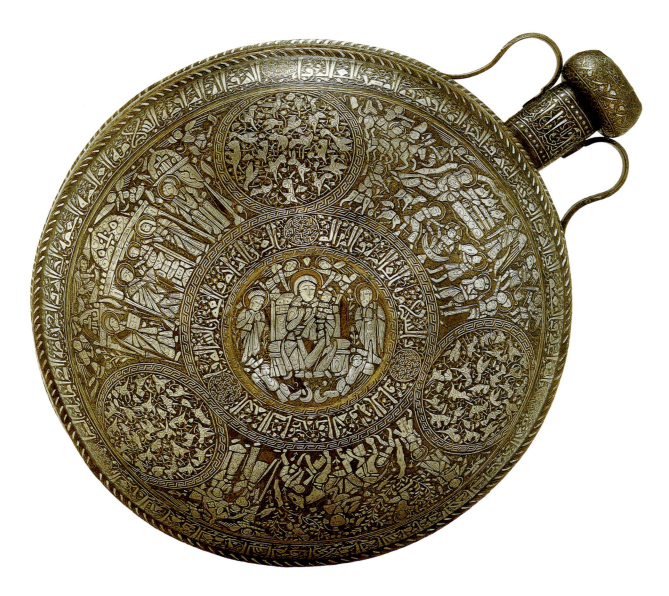

15. Inlaid brass canteen with stylised kufic inscriptions of good wishes, Syria, mid 13th century. Diameter 37 cm (14½"). Freer Gallery of Art, Washington DC, 41.10.

good wishes – would have been understood immediately. Nevertheless, legibility was important for significant information. When the text was predictable, it could be made more difficult to read, but when it was necessary to convey the name of a specific patron or owner, then the inscription was written in a more legible script. This dichotomy is clear on coins, where the name of the ruler is often in a legible round script while the rest of the legend is in stylised kufic.

The same dichotomy between decorative inscriptions with good wishes and legible texts with historical information occurs on ikat cottons produced in ninth and tenth century Yemen. Some Yemeni ikats are decorated with inscriptions embroidered in an interlaced kufic script, but many others have inscriptions painted and gilded in an elaborately plaited and foliated kufic. The painted inscriptions fall into two types.[20] Historical texts, including three with the names of imams and amirs of the Yemen active in the late tenth century, are simple. Legibility was important, so interlacing was restricted to single letters and decoration was restrained. In contrast, the inscriptions on other ikats with pious texts (**16**) are much more elaborate, with an extraordinary number of arcs, bumps, triangles, curls and other decorative devices inserted between and around the letters. Extremely laborious to read, these pious texts are legible only because of the limited repertory of phrases used.

Writing was so important that artists went to great lengths to include texts, even when the demands of the medium made it extremely difficult to do so. This is the case with textiles bearing inscriptions incorporated during the weaving itself, not added after manufacture with paint, dye or embroidery. It is comparatively easy to set up short texts that repeat in mirror reverse, but much harder to include a running text. The demand for inscribed textiles was so great, however, that silk weavers in the Islamic lands overcame the confines of the technique, and by the tenth century Persian weavers had figured out how to incorporate long bands of inscriptions on their elaborately patterned silks.

16. *Cotton ikat with painted and gilded inscription (detail), Yemen, 10th century. 35 x 34 cm (14" x 13"). Museum für islamische Kunst, Berlin, I.5563.*

One of the finest examples to be preserved is the silk known as the shroud of St Josse (**17**), re-used in medieval times to wrap the bones of St Josse in the abbey of St Josse-sur-Mer, near Caen in northern France.[21] Two fragments are preserved, and the complete piece can be reconstructed as a square measuring 1.5 metres on a side, with a carpet-like design of borders surrounding a central field. The borders contain a train of two-humped or Bactrian camels, with a cock set in each corner. The rectangular field shows two facing elephants with dragons between their feet. An inscription in kufic beneath the elephants' feet, but written upside down, invokes glory and prosperity to the commander, Abu Mansur Bakhtikin, and asks God to prolong his existence. From textual sources, Bakhtikin can be identified as a Turkish commander of the province of Khorasan in northeastern Iran. He was arrested and executed on the orders of his Samanid sovereign 'Abd al-Malik b. Nuh in 960. As the inscription on the silk asks for blessing on a living person, the piece must have been made when Bakhtikin was still alive.

This weft-faced compound twill with a complicated design in seven colours was woven on a drawloom. The drawloom was extremely time-consuming and expensive to set up, and it required two operators – the weaver and the drawboy who sat above the loom and pulled the cords that controlled the warps. Although this silk is the only example of this pattern so far known to have survived, many identical pieces must have been produced, as the cost

17. *Silk cloth with kufic inscription offering good wishes to Abu Mansur Bakhtikin, northeastern Iran, mid-10th century. 52 x 94 cm (20½" x 37"). Musée du Louvre, Paris, 7502.*

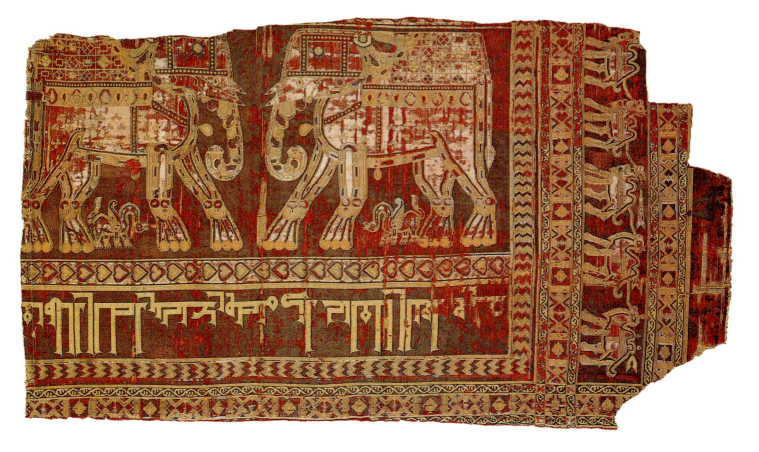

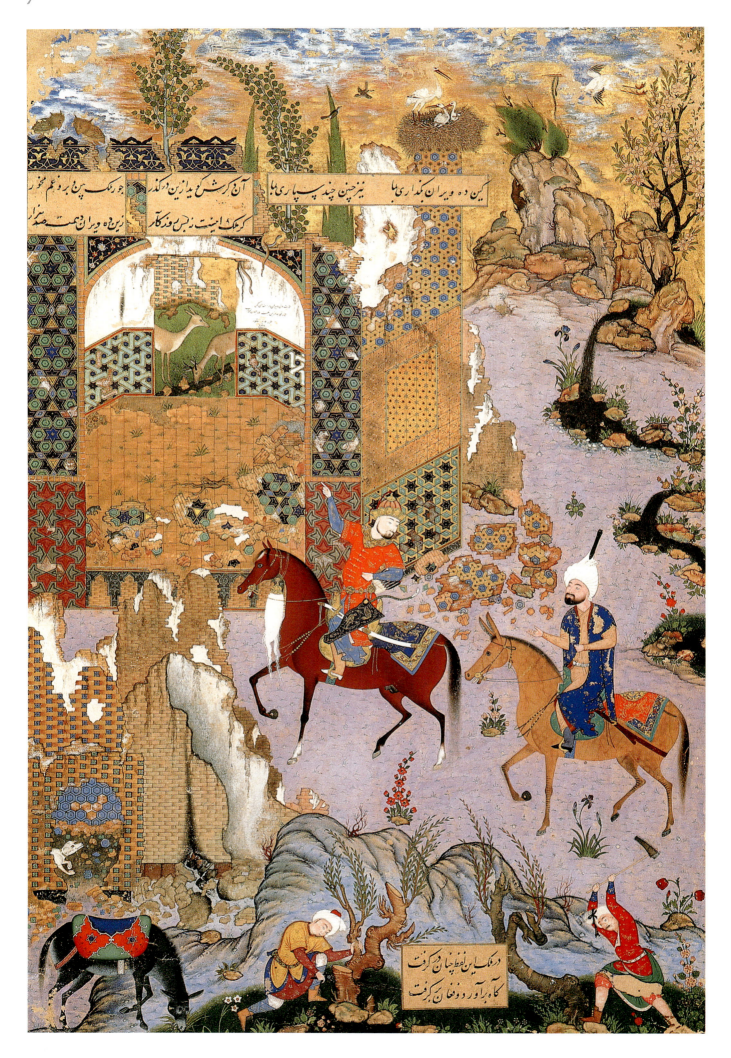

of setting up the loom would have been amortised by producing multiple examples.

The shroud of St Josse may have been intended to be a saddlecloth.[22] Nasir-i Khusraw, the Persian traveller and Isma'ili spy who journeyed from his home in northeastern Iran to the Fatimid court in mid-eleventh century Cairo, mentioned inscribed silk saddlecloths on the two thousand horses in the retinue of the Fatimid caliph during festivities for the opening of the canal in Cairo in the spring of 1048. Nasir-i Khusraw specifically comments that the saddlecloths were woven of brocaded silk that was neither cut nor sewn but woven to shape and had inscriptions with the name of the sultan along the borders. It must have been a stunning sight indeed to see the lines of horses, each bedecked with the ruler's name along its flanks. The image obviously struck a chord with the Persian traveller, who might have been familiar with similar saddlecloths at home in northeastern Iran. If we imagine that the shroud of St Josse and its siblings would have been worn by horses in Abu Mansur Bakhtikin's retinue, then the saddlecloths would have hung down over the animals' backs, with the elephants upright to viewers and the inscriptions legible to those seated on the horses.

Many inscriptions, especially those with artists' names, were intended as puns or plays on words. One example is Mir Musavvir's signature on the painting depicting Nushirvan in the ruined palace (18), from a splendid copy of Nizami's *Khamsa* made for Shah Tahmasp between 1539 and 1543.[23] The faint graffito on the wall of the iwan reads:

> *Build up the desert heart of those deprived of bliss*
> *There is no better building in this ruined world than this.*
> *Mir Musavvir penned it in the year 946.*

The date 946 corresponds to 1539-40 AD, the year that Shah-Mahmud Nishapuri began transcribing the manuscript. With this witty signature, Mir Musavvir compliments himself on a job well done. The signature also confirms the information provided by Dust Muhammad, who said that two painters, Aga Mirak and Mir Musavvir, worked on the manuscript.[24]

Such punning signatures are found in other media as well. This is the case with a group of five moulded and unglazed jugs (19) which have interlaced kufic inscriptions around the shoulder. They are signed by two artisans, Muhammad b. Ahmad and Mahmud b. Muhammad. The former bears an epithet or *nisba* that seems to read al-Sarraj. This can mean saddlemaker, but since the Arabic root *s-r-j* means to plait or braid it was probably also a pun on the style of script used.[25]

Another factor to consider when discussing the art of writing in Islamic art is the role of the medium. We tend to think of writing as a paper-based technique, but paper was only introduced after parchment and papyrus had long been in use. Writing on objects was sometimes transferred from words first written on paper, but sometimes writing was generated by the potential of the medium itself. A good example is the script popularly known as square kufic. It was generated out of bricklaying techniques, as builders exploited the spaces between bricks to spell out names or short phrases. Indeed, one of the Persian names for the script, *banna'i* ('builder's [script]') points to its origin. The first example of square kufic to survive, and probably one of the first executed, occurs on the minaret erected at Ghazna by the ruler Mas'ud III (r. 1098-1115). These square kufic inscriptions spell out the names and titles of the patron.

This technique was quickly adopted by Iranian builders to cover large wall surfaces. Instead of using the spaces between the bricks, they inserted glazed bricks so that the words were spelled out not by the dark shadows created by the recessed interstices between the bricks, but by glittering surfaces that were flush with the brick bonds and contrasted with the matte surface around them. The texts were simplified, and instead of the patron's titles, they spelled out short pious phrases or sacred names such as Allah, Muhammad or 'Ali, as on the shrine that Timur ordered for the Sufi shaykh Ahmad Yasavi on the steppe north of Samarkand (20 and 21).

Square kufic was also adapted for use in other media, particularly in the Mongol period, for it resembled the square box-like script known as *phagspa* introduced in 1269 by the great

18. Opposite: Nushirvan in the Ruined Palace, from a manuscript of the Khamsa of Nizami, Tabriz, 1539-43. The British Library, London, MS OR 2265, fol.15b.

19. Earthenware jar with knotted kufic inscription signed by Muhammad b. Ahmad al Sarraj and Mahmud b. Muhammad, eastern Iran, 10th century. Height 15 cm (6"), diameter 14 cm (5³/₄"). The Metropolitan Museum of Art, New York, 62.227.2.

20. *Shrine of Ahmad Yasavi with glazed brick inscription, Turkestan City, Kazakhstan, 1394-99.*

Mongol ruler and emperor of China, Qubilay, for writing Mongolian. Indeed the resemblance between the two scripts is so close that square kufic is sometimes called seal script and its origins are sometimes wrongly thought to derive from Chinese seals, although it was clearly used in architecture before the introduction of *phagspa* for seals.

The basic concepts that inform the making of inscriptions on Islamic art reveal several aesthetic principles which evolved from the specific qualities and limitations of the Arabic script. Many other languages have at least two distinct forms of writing: a monumental or printed form in which the letters are written separately, and a cursive or handwritten one, in which they are connected together. Arabic script, however, has only the handwritten form, although there are many styles of script. The Arabic alphabet represents twenty-eight distinctive sounds but has only eighteen letter forms, so the same form has to be used for as many as five different sounds. Dots and strokes are added above or below the form to differentiate the letters, as at the Dome of the Rock.

To complicate matters, individual letter forms change their shape depending on their position in a word. The same form can have one shape when it stands alone (independent), another at the beginning of a word (initial), another in the middle of a word (medial) and yet another at the end of a word (final). Furthermore, some letters rise above the line with vertical ascenders, while others descend below the line. When written in simple kufic, much of the writing is concentrated in the lower zone just above the flat base line, leaving the upper part of the inscription relatively bare (see 4 and 5).

To counterbalance this unevenness, artists developed various devices to fill the upper zone. One technique was to embellish the tips of the ascenders with such decorative devices as bevels, barbs and split palmettes. This foliated script evolved into a floriated one in which flowers, tendrils and scrolls seem to grow from the ends or even the middles of the letters. Floriated kufic was in full bloom by the mid-tenth century, and magnificent bands of floriated kufic sculpted in stone became a hallmark of the Fatimids, the wealthy and sophisticated rulers of Egypt from 969 to 1171. The band running across the façade of the Aqmar Mosque in Cairo (22), constructed in 1125-1126, shows how skilfully Fatimid artists sculpted these texts.[26]

Other artists, particularly in the eastern Islamic lands, developed the decorative device of interlacing to fulfil the same purpose of enlivening the upper zone of the inscription.[27] Whereas in Egypt elaboration of the stems of the letters had led from bevelling to foliation

21. Detail of the square kufic inscription on the shrine of Ahmad Yasavi.

and then to floriation, in the east the tendency towards elongation and distortion of horizontal letters led to internal modifications and superimposed ornament. The use of interlacing developed over the course of the ninth and tenth centuries and was already quite sophisticated by the early eleventh, as seen on Yemeni ikat cottons (**16**) or Samanid ceramics (**19**).

Another device, developed in fourteenth century Iran when the elongated *thuluth* script had become popular, was to add a second line of script twining among the tall ascenders in the upper zone of the inscription. The upper line could be written in a different script and contrasting colour, and thus the band would comprise two different texts written in two styles of script. The second line could also be written in the same style and comprise the second part of words that began in the lower zone. To accentuate the division of the band into two zones, the artist sometimes drew the tail of a descending letter in the upper zone back to the right across the middle of the band. Such a calligraphic tour de force can be seen on inscription bands decorating the Taj Mahal (**6**) and the Shah Mosque in Isfahan (**12**).

People have long appreciated Islamic art for its use of gorgeous colour and intricate geometric and arabesque designs, but many Westerners are baffled by the presence of inscriptions that they cannot read. Even without deciphering the particular texts, it is possible – and even fruitful – to appreciate some of the formal and aesthetic principles that make inscriptions a hallmark of Islamic art.

Notes see Appendix

22. Floriated kufic inscription on the façade of the Aqmar mosque, Cairo, 1125-1126.

THE SUBLIME IMAGE

Early Portrait Painting in Tibet

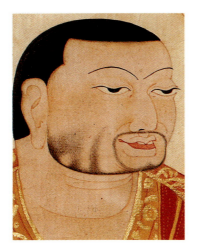

JANE CASEY SINGER

Portraiture, both of secular and religious figures, is a common theme in Tibetan paintings made between the eleventh and the fifteenth centuries, although little is known of its function and significance. Looking at portraits in murals, cloth paintings, woodblocks and even sketchbooks, the author finds that aesthetic ideals of beauty and notions of physiognomic type underlay the portrayal of historic figures. Many portraits are of religious hierarchs, and in these the artists were influenced both by the sublime ideals of the Buddhist faith and the sometimes harsh political realities within religious communities in medieval Tibet.

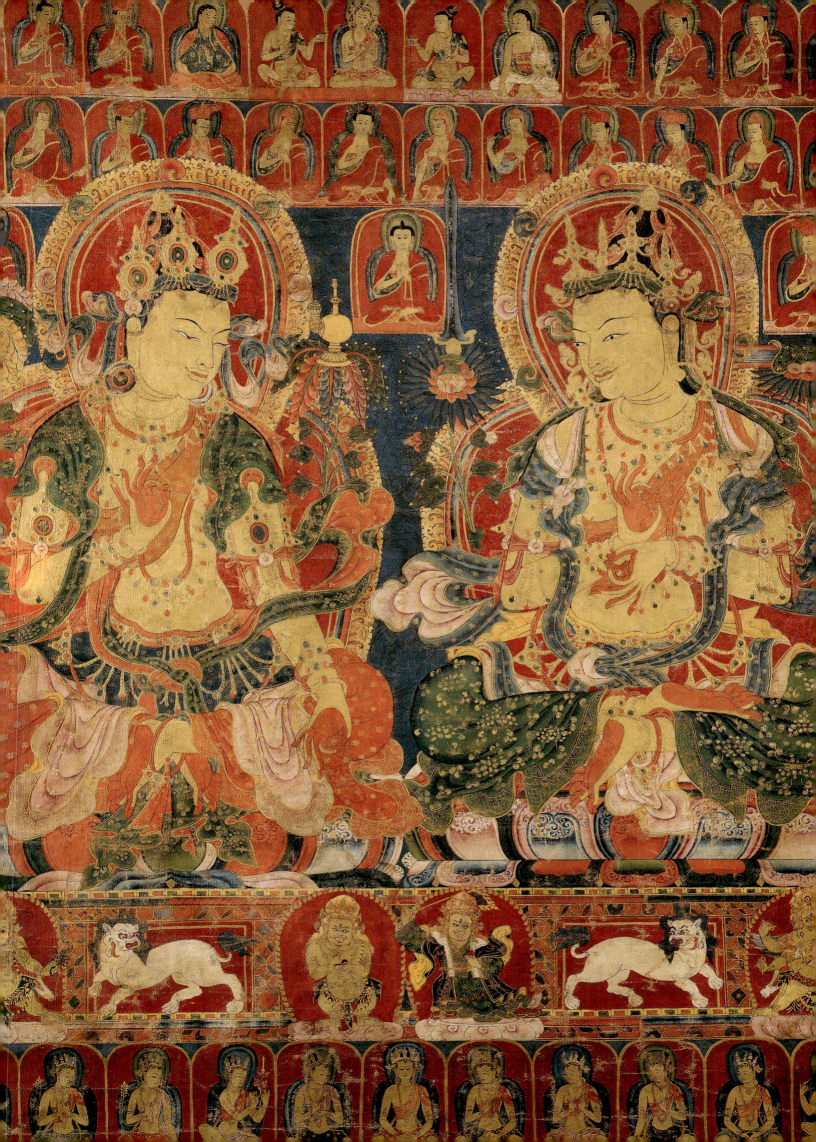

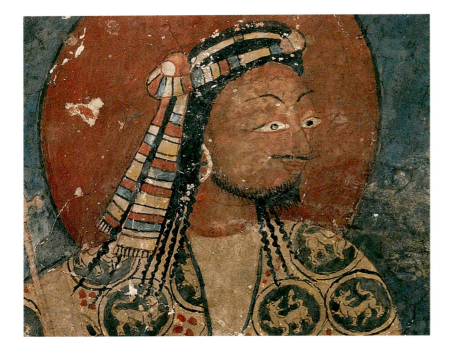

3. A haloed king from a royal drinking scene. Detail of a mural painting in the Assembly Hall, Alchi, ca. 1200. Photo courtesy Jaroslav Poncar and Roger Goepper.

1. Title page: Head of Phagmodrupa (detail of 13).

2. Previous page: Maitreya and Manjushri (detail). Painting on cloth, Central Tibet, 14th century. 85 x 68 cm (2'9¹/₂" x 2'3"). Private collection, photo courtesy John Eskenazi.

Some of Tibet's finest examples of early portraiture are still preserved at Alchi, a monastic complex along the Indus River in Ladakh, founded around 1200 AD. Two of the earliest structures at Alchi, the Assembly Hall and the Three-tiered Temple, contain numerous examples of portraiture. A narrative along the east wall of the Assembly Hall features three figures: a seated man holding an axe, a woman who faces him and offers a stemmed cup, and a young man, presumably their son. Above the three are ministers and warriors with their shields, as well as female attendants. Below, other attendants pour libations from a jug and see to the needs of the protagonists, who are clearly figures of power and authority.

What interests us here is that the two main figures are haloed, a common phenomenon in Tibetan depictions of royal, noble and saintly persons. It is likely that in this painting, the halos reflect both a pre-Buddhist Tibetan notion of divine kingship and the imported Indian notion of *cakravartin*, the divinely inspired ruler. Their names and their precise dates are not known, but an inscription below the scene identifies these figures as royalty, stating that the king (3) and queen, having given royal sanction for the temple's construction, were refreshing themselves in the region. In Tibetan portraiture, one does not usually find ordinary mental states depicted, such as pride, humility, fear or anger. Thus, in the case of this king at Alchi, one has absolutely no sense of his character as a man, although his apparel, his halo and the composition within which he appears tell us of his existence and of his importance in the social hierarchy of his time.

Other scenes of royalty appear in Alchi's Three-tiered Temple, notably a narrative found on the temple's ground floor, which features a king and two queens (4). Here the king and his queens are haloed, as are their offspring (represented as miniature persons) and various associates. One of these queens appears again in a nearby scene, her dress, coiffure and physiognomy virtually identical (5). The queen's similar portrayal in both murals – while not surprising, since the narratives are contemporaneous and produced by the same group of artists – nevertheless raises the question of the relationship between the artist's rendition of this queen and her actual likeness.

4. Royal scene. Mural painting in the Three-tiered Temple, Alchi, ca. 1200. Photo courtesy Poncar and Goepper.

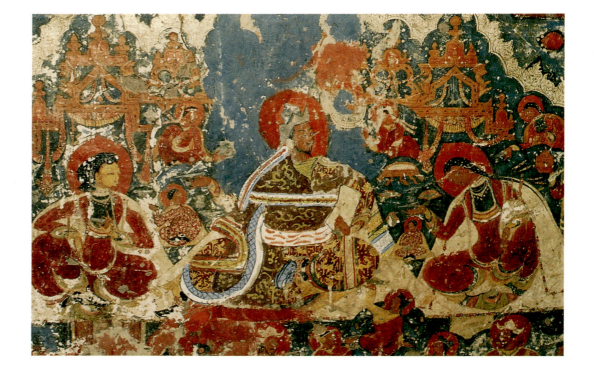

While one can never know whether the portrait was an accurate likeness, it is probable that the artist – who may never have seen her – conceived of the queen as a physiognomic type; and, being a queen, she was obliged to possess a kind of unearthly beauty. The close resemblance between this queen and the Buddhist goddess Tara, featured in another scene on the ground floor of the Three-tiered Temple, is noteworthy (**5, 6**). Despite the difference in their complexions, the queen and the goddess share fundamental elements of beauty. Their rosebud lips, their extended, pointed chins and the shape of their faces, eyes and noses are all extremely similar, as are their earrings and necklaces. The coiffures of both figures are adorned with an ornamental fabric which is affixed to the hair and falls down the back. Their close resemblance calls to mind a story from the *Vikramcarita*, a Sanskrit treatise.[1] An Indian artist, called upon to make a portrait of a queen, recognised at a glance that her beauty was of a certain type – *padmini* (likened to a lotus flower) – and painted her portrait accordingly, primarily guided not by what he observed, but by an ideal.

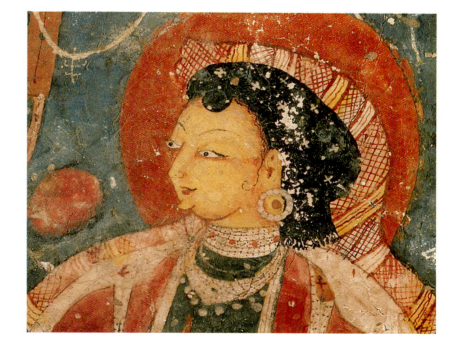

The theoretical guidelines for early Tibetan portraiture are still obscure. Indigenous literary accounts, which would greatly enhance our understanding of this genre, have not yet come to light – if, indeed, any were written. In their absence, it is instructive to look briefly at portraiture in India and China, for these cultures contributed greatly to the formation of Tibetan Buddhist art. India is not generally thought to have produced a highly developed tradition of Buddhist portraiture. Portraiture is, however, mentioned in Sanskrit texts from the Gupta period (ca. 320-486 AD) onwards, and there is evidence that some form of religious portraiture was practised at medieval Buddhist monasteries such as Vikramashila, whose ruins lie near the modern city of Antichak in Bhaglapur district, Bihar.

Tibetan translations of Indian treatises, such as the *Citralakshana* and the *Manjushri-mulakalpa*, as well as Sanskrit texts including the *Vishnudharmottara* and the *Vikramacarita*, briefly describe portraiture in India. The *Vishnudharmottara*, a work of the seventh century or earlier, describes resemblance *(sadrshya)* to the subject as one of the five important features of painting.[2] But, as Ananda Coomaraswamy stresses in his commentary, 'resemblance'

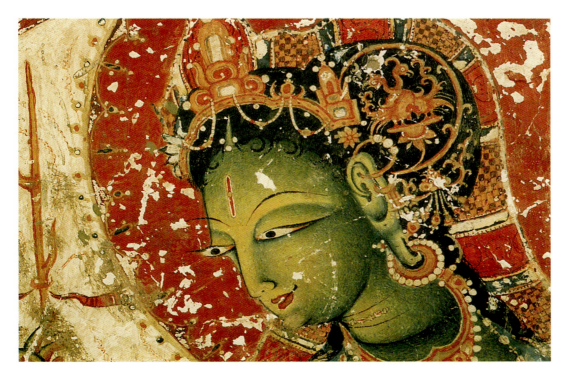

7. Scene showing Shakyamuni Buddha and attendants (detail of 8).

in this instance should not be understood as accurate physical likeness; rather, a reminiscence of the subject's qualities beyond mere physical appearance.[3]

The *Vishnudharmottara* discusses portraiture within the context of five types of men: *hamsa, bhadra, malavya, ruchaka* and *shashaka*.[4] Each type possesses a unique physiognomy, its corresponding mentality and – when rendered in art – specific iconometric proportions. The text describes the five in colourful, if imprecise terms. Of the *shashaka* it is said:

> …[he] will have somewhat projecting, otherwise fine teeth, fine nails…a swift pace; he takes delight in science, mining and trade; has full cheeks, is…a good general; fond of love's sport and partial to other men's wives; restless, valorous, obedient to his mother, and attached to woods, hills, rivers and wildernesses.[5]

The implication is that the subject of a portrait would have been cast as one of these five types and painted accordingly, concessions also having been made to the individual's caste.[6] There were, however, instances when the portrait artist's powers of observation were called upon. The *Manjushrimulakalpa* states that the sacrificiant, who appears in the painting's lower corner, should be drawn "after nature."[7]

Of particular interest are the pronouncements on portraiture which appear in the *Citralakshana*, a text no longer surviving in Sanskrit but extant in its Tibetan translation.[8] The text describes the portrayal of various categories of gods and men. It is clear, however, that in portraying the various physiognomic types, an artist was expected to 'improve' upon nature. "How should one proceed in the matters of proportions, if a body is not possessed of perfect beauty? It is for this reason that the definition of the [bodily] proportions… has been imparted."[9] Elsewhere, the text states that these iconometric rules, based upon "worship of all the Gods", exist "because emphasis must be laid on what appears agreeable to our eyes…"[10]

Among the human types to be represented are sages, *siddhas* (yogic adepts) and the universal monarch *(cakravartin)*. The universal monarch's appearance is described in detail:

> The face should be made squarish in form, sharply delineated, beautifully full and endowed with brilliant and pleasing marks. It shall not be made triangular, nor sloping; it shall not be made angry nor round…the cheeks should be made to the measurement of five digits, and the jaw bones to that of four digits. One should know that the measurements of the contour of the cheeks amount to four digits…[11]

Despite these prescriptions, some leeway was permitted the artist. Regarding the sage *(pandita)*, it is said, "…everyone should have his measurements according to his own digits."[12] Later, regarding proportions of 'normal' human beings, the artist is cautioned: "…in the case of those born of woman, one should exercise one's own judgement…"[13] Thus, as the Indian art historian Ananda Coomaraswamy has noted, Indian portraiture observed two apparently contradictory approaches: on the one hand informed by observation of the subject, on the other purely imaginative, following the prescriptions for ideal types.[14]

Portraiture has a long history in China. A tradition of portraying Buddhist hierarchs existed from the Tang period (618-907) onwards, often exhibiting a high degree of realism and appearing in a functional context quite similar to that in Tibet. Chinese artists often placed great emphasis upon close observation of an individual, for accurate depiction of the subject's physiognomy as well as his mind or 'spirit' were both considered fundamental to proper portraiture.

Along these lines, Chen Shidao (1053-1101) wrote: "A loss of formal likeness and spiritual harmony alike would produce a painting like a shadow silhouette, which would not be a portrait."[15] Consider a passage from Wang yi (active ca. 1360):

> Whoever paints a portrait must be thoroughly familiar with the rules of physiognomy, for the disposition of the parts of people's faces is like that of the Five Mountains or Four Rivers, each element being different…I begin with the left side of the nose, and then go to its right side. Then follows the tip of the nose…If the bridge of the nose is high, I start from its point of concentration and go downward in one stroke; if it is low, I start from the side of the eye and go downward in one stroke. If it is neither high nor low, then I start from a point eight-tenths or nine-tenths in distance [from the tip] and go downward in one stroke at each side. Then follow the part between nose and mouth, the mouth, the sides of the eyes…It is necessary to proceed like this from one part to another so that not even a hair will be omitted or incorrect.[16]

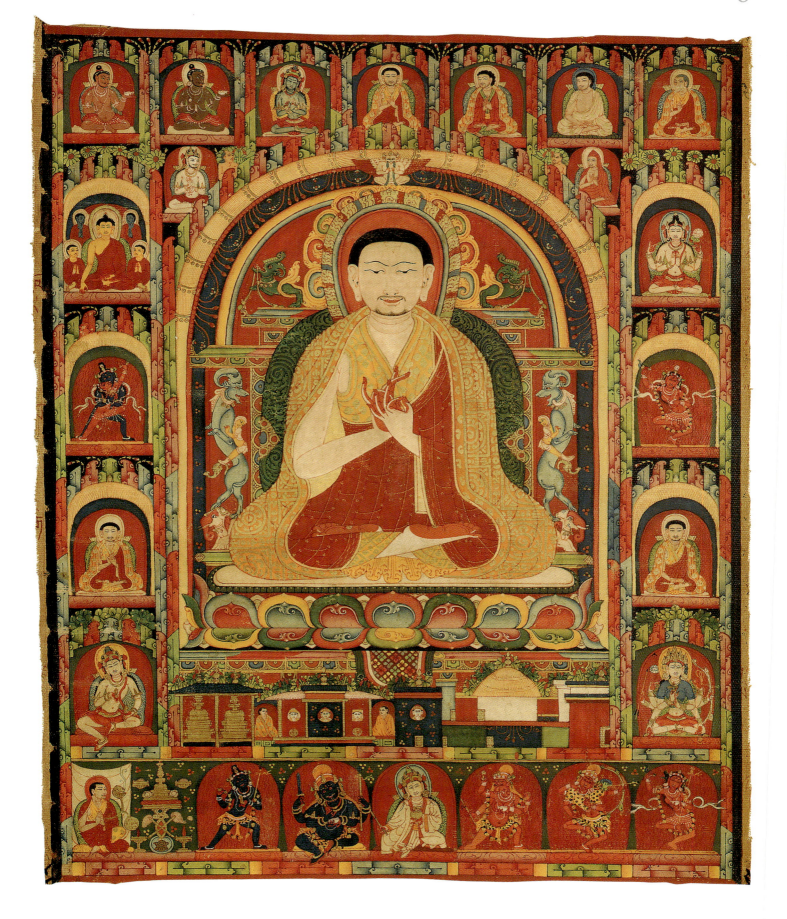

This Chinese artist's painstaking effort to capture minute details of the subject's particular physiognomy contrasts sharply with Indian portraiture and with aspects of early Tibetan portraiture, as will be explained below. To what extent the traditions of Indian and Chinese portraiture influenced Tibetan portraiture remains to be seen. Future studies will put these questions into perspective, once the salient characteristics of Tibetan portraiture are more clearly defined.

A special genre within Tibetan portraiture is that of the Buddhist hierarch or spiritual

8. Portrait of Taglung Thangpa Chenpo. Painting on cloth, Central Tibet, 13th century. 32 x 25 cm (14" x 10"). Michael McCormick Collection, New York.

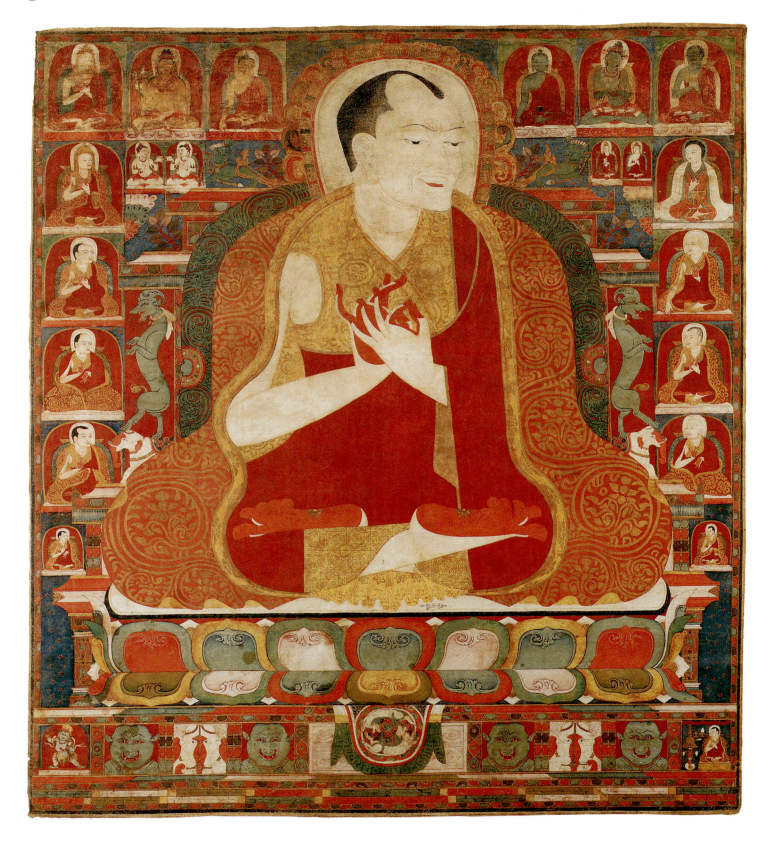

9. Portrait of Shangton Chögyi Lama. Painting on cloth, Central Tibet, ca. mid-13th century. 130 x 114 cm (4'3" x 3'9"). Private collection.

leader. Most surviving hierarch portraits were not created during the lifetime of their subjects, and one wonders what guided Tibetan artists when the subject of their portrait was not available (**8**).[17] Sketchbooks, such as that once belonging to the Nepalese artist Jivarama and dated 1435, undoubtedly provided some assistance. Jivarama's drawings include idiosyncratic sketches of Tibetan people, each identified by Nepalese or Tibetan inscriptions, some of which suggest that a number of the sketches may have been made during a journey to Central Tibet. Among Jivarama's sketches is a depiction of the prominent Tibetan Buddhist hierarch, Phagmodrupa (1110-1170), seen in (**11**) as the middle figure in the top row, wearing a hat. Phagmodrupa also appears in the Three-tiered Temple at Alchi, where he is again identified by inscription (**10**). It is interesting to compare the two portrayals, one dated 1435, the other ca. 1200, for there is little resemblance between them. This and other similar com-

parisons lead one to conclude that accurate physiognomic likeness was not crucial to Tibetan portraiture of this period. But if strict rules of verisimilitude did not guide portrait artists, then what aesthetic and theoretical guides did artists observe in creating hierarch portraits? In some cases, portraits of religious hierarchs are hardly distinguishable from divine images. This principle is illustrated in the frontispiece from a woodblock edition of the Chinese *Qi sha Tripitaka*, dated 1301, now in the British Library, London (**12**). On the left is a seated Tibetan monk attended by two standing monks, on the right is Shakyamuni Buddha, flanked by an Indian monk and an *arhat* (Buddhist elder). It is interesting to observe the many iconographic parallels between these representations of the sacred founder of the Buddhist faith and – it could be said – a mere monk. The Tibetan monk and Shakyamuni present the same teaching gesture, and they are similarly dressed, although the Tibetan monk wears the peculiarly Tibetan sleeveless undershirt *(chöko)* beneath his robe, while the Buddha is bare-chested, wearing only the traditional Indian robe.

10. Phagmodrupa. Detail of a mural painting in the Three-tiered Temple, Alchi, ca. 1200.

Both figures are seated on identical thrones, the sides of which are constructed from an elephant, *vyalaka* (leogriff), *makara* (mythological crocodile), and *kirttimukha* ('face of glory'), familiar to anyone acquainted with South Asian art. This throne originated in India, where it signifies the assemblage of natural and supernatural forces and their obeisance to him (or her) who sits upon it.[18] In Indian art, it is reserved for the rare universal monarch *(cakravartin)* and for Buddhas, bodhisattvas and other deities. In short, this is not merely a seat, but a setting of great symbolic significance. The figures differ chiefly in that the Buddha, following traditional iconography, exhibits peculiar physiognomic characteristics known in India as *lakshana* or the physical signs of his full enlightenment: elongated earlobes, the *urna* (mark between the brows), and the *ushnisha* (cranial protruberance).[19]

There is considerable evidence that Tibetan artists borrowed iconographic conventions originally developed for the depiction of Buddhas and bodhisattvas in their renditions of Buddhist hierarchs. This can be seen in a mid-thirteenth century portrait of Shangton Chögyi Lama, now in a private collection (**9**). Shangton Chögyi Lama was the fifth abbot of Narthang monastery, Central Tibet, between 1234 and his death in 1244. In rendering his subject, the artist has observed iconographic rules for depicting an enlightened being: the temple-throne setting, *lakshana* (here, wheels on the soles of his feet), and the gesture of religious instruction *(dharmachakra pravartana mudra)*. And yet, one is struck by the sensitive portrayal of his features. The artist has taken care to show lines around his mouth and between his brows, the stubble of his chin, a faint moustache and a receding hairline – all suggesting a unique individual.

11. Portraits of Tibetan monks. Detail of a page from Jivarama's sketchbook, dated 1435. Neotia Collection, Calcutta. After Lowry 1977, A4.

However, the painting's apparent realism is put into perspective when one considers a remarkable *kesi* now in the Potala, Lhasa (**13**). This textile portrait depicting the Shang Lama (1123-1194) bears a strong resemblance to the painted portrait of Shangton Chögyi Lama. They are extremely similar not only in body type and physiognomy (e.g. eyes, nose and mouth), but also in details such as hairline and facial lines. The Shang Lama wears a small goatee, but little else distinguishes them. One cannot know how closely these portraits resembled their subjects, but the close resemblance between these portrayals of different men suggests that the artists relied on physiognomic types, perhaps adapted to reflect physiognomic peculiarities of the subject, or possibly of a purely imaginative nature.

A thirteenth century painting portraying two enthroned monks, now in the Cleveland Museum, underscores this point (**14**). The figures, probably Phagmodrupa on the left and his disciple Taglung Thangpa Chenpo (1142-1210) or Tashipel (about whom more will be said below), are distinctive in their physiognomies: Phagmodrupa possesses a broader face, more bulbous nose, larger teeth, and a different pattern of facial hair. But the regularity of their features and the near-perfect pattern of their beards and moustaches suggest that their portrayal, even if informed by the subjects' actual physiognomy, is nevertheless idealised. It is instructive to compare the Cleveland double portrait with a fourteenth century painting depicting the bodhisattvas Maitreya and Manjushri, now in a private collection (**2**).

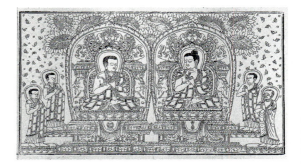

12. Shakyamuni Buddha and a Tibetan monk, dated 1301. Woodblock print, 30 x 12 cm (12" x 5"). British Library, London.

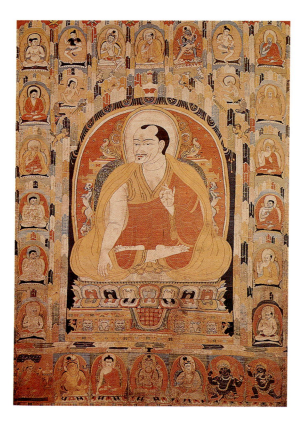

13. *Shang Lama (1123-1194). Silk kesi, Tibet, 12th century. 84 x 54 cm (2'9" x 1'9"). Potala Collection, Lhasa. After Dorji, Chaogui and Wangchu, n.d., pl. 62.*

The physiognomies of these celestial figures are only slightly less distinctive than those in the Cleveland work, with Manjushri, on the right in this painting, possessing more widely opened eyes and a sharper nose and thinner lips than Maitreya on the left.

A fifteenth century double portrait also presents idiosyncratic renditions of Buddhist hierarchs, in this case very possibly based on the subjects' actual physiognomic traits. This silk painting, now in a private collection, features two hierarchs of the Sakya Order, probably Sonam Tsemo (1142-1182) and his younger brother Drakpa Gyaltsen (1147-1217). Sons of Kunga Nyingpo (1092-1158), third abbot of Sakya monastery, they were distinguished theologians and revered teachers of their day. Sonam Tsemo's hands are in the gesture of religious discourse *(dharmachakra pravartana mudra)* while, in the detail illustrated, Drakpa Gyaltsen holds the thunderbolt sceptre *(vajra)* and bell, symbols of wisdom and compassion **(16)**.

The painting is remarkable for its idiosyncratic treatment of the subjects. Their distinctive features and detailed, lavish robes show a degree of realism unusual in early Tibetan portraiture. But is it realism or, like most of the portraits considered thus far, merely realistic technique? Drakpa Gyaltsen's curly red hair, evident upon close inspection of the painting, bears particular mention. To my knowledge, this physiognomic feature – which has no known iconological significance – does not appear in later portraits, where he is usually shown with short white hair. However, another ca. fifteenth century painting may also depict Drakpa Gyaltsen with red hair.[20] While extremely unusual, red hair is not genetically impossible for a Tibetan. Some of Tibet's medieval Central and Inner Asian neighbours are known to have had red hair, as do some Afghans today.[21] It is unlikely that an artist would have fabricated this element in his portrayal, which may still have been familiar to Sakya historians of the fifteenth century.

It would seem that the most critical factor in religious portraiture was to present the subject as an accomplished Buddhist. The apotheosised portrait did not need to reflect the man's physiognomy, so long as it conveyed his spiritual accomplishments. These were conveyed by iconographic conventions such as posture, gesture, associated ritual symbols and by other iconographic codes which suggest the subject's inner life. And yet, not all portraits were purely imaginary; elements of individual appearance such as facial shape and features, hair colour, hair line and facial hair may have informed some portraits. Even in these cases, however, the portrayal appears to have been based on the notion of physiognomic types.

If Tibetan artists borrowed iconographic conventions developed for the depiction of Buddhas and bodhisattvas in their renditions of cherished hierarchs, they did so because they often perceived their hierarchs as divinities. This is evident in a painting now in the Cleveland Museum of Art dating to the late twelfth or early thirteenth century which features Vairocana Buddha **(15)**. Most interesting for the present discussion is the diminutive seated monk who appears in Vairocana's tiara.

While it is not uncommon for an Esoteric Buddhist deity to bear an image of his spiritual superior in his crown, it is rare for a deity to bear a *human* image in this superior position. The Tibetan cultural historian R.A. Stein notes the particular reverence with which Tibetans imbued their religious masters, stating that "it is typical of [Tibetan Buddhism]…that one's Lama (guru) is superior to all 'deities', even the most prominent."[22] Moreover, "the Lama's dominant position, higher even than the buddhas, is common to all orders [of Tibetan Buddhism]."[23] Stein offers insight into the possible iconologic significance of this image:

> …the disciple conjures up the tutelary deity *(yi-dam)* chosen for him by his Lama, with whom the deity is closely fused; then he himself merges with the Lama, who has absorbed, as it were, the deity. From him he draws the desired state of purification.[24]

Gö Lotsawa (1392-1481) in his early fifteenth century history, *The Blue Annals (deb-ther sngon-po)*, frequently describes religious hierarchs in terms of the deities whom they are said to embody. The venerable Ling (1128-1188) is attributed with the statement, "My body, speech, and mind do not differ from the Body, Speech, and Mind of all the Tathagatas [Buddhas]…Whoever will pray to me with devotion, will realise all his wishes…"[25] One of Drigungpa's disciples "…did not abandon even for a single moment the notion that the

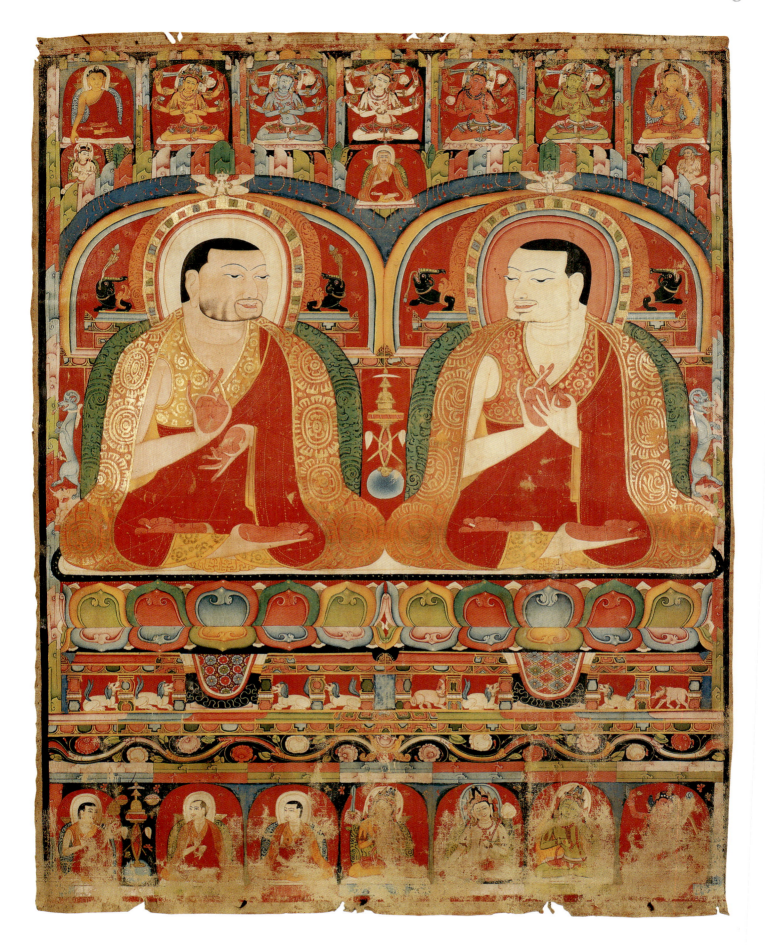

Dharmasvamin [Drigungpa] was a Buddha."[26] Gö Lotsawa also describes a disciple who chastised himself for thinking of his master as merely a "tenth *bhumi*" bodhisattva: "From then on, he did not differentiate his Teacher from the notion of Buddhahood…"[27] Near death, Taglung Thangpa Chenpo (1142-1210) is said to have uttered: "I am the Sugata [Buddha] Himself."[28] Of Taglung Thangpa Chenpo's successor Kuyal Rinchengon (1191-1236),

14. Portrait of two Buddhist hierarchs. Painting on cloth, Central Tibet, ca. 1300. 51 x 39.5 cm (1'8" x 1'3½"). Cleveland Museum of Art, 87.146.

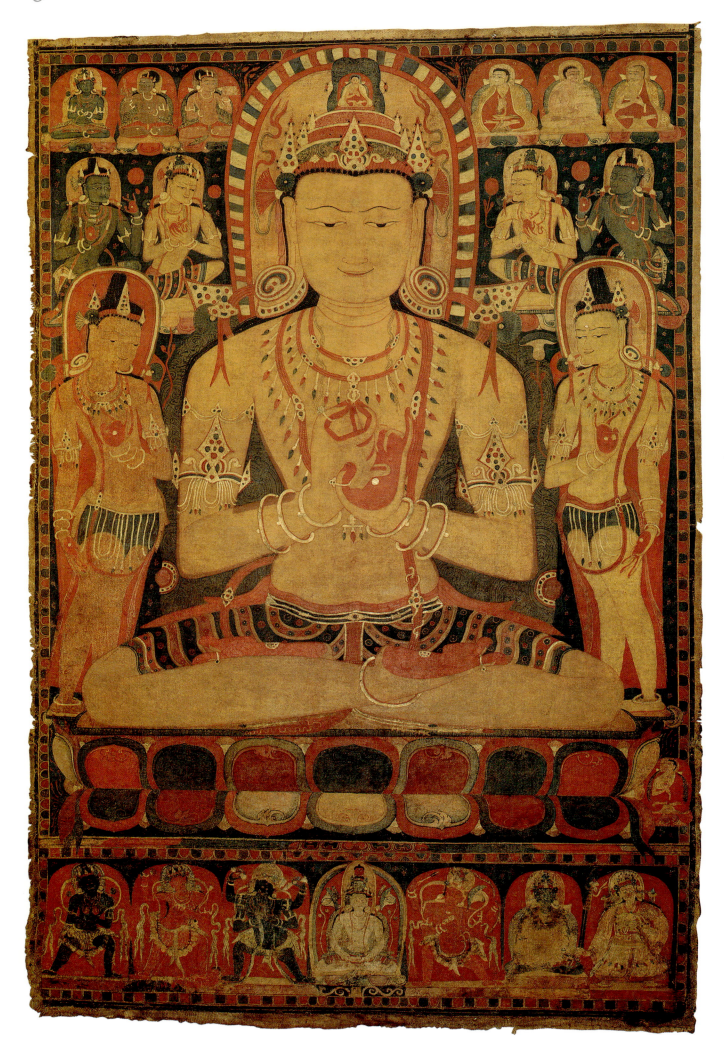

it was said: "On many occasions...he exhibited different manifestations of his physical form. Further, many saw him as Shakyamuni, Samvara and other divine beings."[29]

Who was the diminutive monk depicted in the Cleveland painting? Analysis of the figures along the painting's top register provides some clues. They illustrate a now well-documented early Kagyu lineage, seen in dozens of paintings from Central Tibet, and at Alchi.[30] Thus, from left to right are: Dorje Chang (Skt. Vajradhara), the Indian yogin Tilopa (active late tenth, early eleventh century), his Indian disciple Naropa (956-1040), followed by his Tibetan disciple Marpa (1012-1096). Next to Marpa is his Tibetan disciple Milarepa (1040-1123), followed by Gampopa (1079-1153), the latter's chief disciple. Gampopa's greatest disciple was Phagmodrupa (1110-1170, whose portrait has already been noted at Alchi and in Jivarama's sketchbook), perhaps the diminutive figure in Vairocana's crown.

Despite Gö Lotsawa's typically hagiographic prose, Phagmodrupa stands out as a particularly remarkable teacher. Gö describes him as the "second Buddha."[31] Phagmodrupa apparently shared this view when he "openly proclaimed that he was the Buddha of the Past and Future, as well as the Shakyendra of the Present Age."[32] The notion of a teacher's pivotal role in the spiritual development of his disciples was familiar to Phagmodrupa and his predecessors. Naropa, Indian progenitor of Phagmodrupa's spiritual teachings, is recorded as saying, "as long as there is no Lama, there is not even the word *buddha*; even the buddhas of a thousand kalpas appear on the basis of Lamas...these gods are only forms of myself."[33] With its privileged placement of the spiritual teacher, this painting may have been made by one of Phagmodrupa's disciples, for whom this Buddhist teacher was greater than all the Buddhas. The full iconological significance of this remarkable work awaits further study.

One wonders why hierarch portraits were made and what purposes they served. *The Blue Annals* states that portrait paintings were sometimes made when a great religious figure died and were then distributed to monasteries and chapels frequented by the hierarch. Such portraits may have served both public and private commemorations. That portraits were thought to transmit a spiritual presence is suggested by Gö Lotsawa's description of how Taglung Thangpa Chenpo was introduced to Phagmodrupa by seeing his portrait. Immediately afterwards, Taglung Thangpa Chenpo "felt in himself that he must go and meet his teacher."[34] Some portraits acted as the focus of rituals in which an individual 'absorbed' teachings from the painted image.[35] One is reminded of the tale in the *Mahabharata* of Ekalavya who, wishing to study archery with Drona but repudiated by the peerless master, fashioned a clay image of Drona and, worshipping it, miraculously acquired the desired skills. This practice relates to the phenomenon known in India as *darshan*, 'seeing' the deity.[36]

Traditionally, all consecrated Tibetan paintings are thought to be the reflection *(gzugs-brnyan;* Skt. *pratima* or *pratibimba)* of transcendent spheres, the 'physical support' *(rten)* of a deity. In the final stages of consecration, the deity is invited to 'inhabit' the work of art. In his religious history, the Second Pawo Rimpoche (1504-1566), Tsuklak Trhengwa, recorded the request made in Tibet by the famous Indian Buddhist master Atisha (982-1054) that, after his death, his followers should paint a life-size *(lus tshad-du)* portrait *(gzugs-brnyan)* of him. Atisha promised to return from the Tushita heaven to consecrate it. He also promised to fulfil the request of his Tibetan disciple Ngok that after his death the lama would "come into his own [painted] portrait image."[37] These remarks indicate that at least some hierarch portraits served as icons, although this aspect of portraiture has yet to be fully examined.

Perhaps a quarter of the surviving pre-fifteenth century cloth paintings represent hierarch portraits. To explore the reasons for this genre's popularity, one must look to the social and political factors surrounding the creation of hierarch portraits in pre-fifteenth century Tibet. Religious hierarchs were always highly revered in Tibetan society. Lamas *(bla-ma)*, or 'superior persons', were important in Tibet even before the introduction of Buddhism, a phenomenon which helps to explain why the Indian notion of religious master (Skt. *guru)* was so easily adapted by Tibetans. King Trisong Detsen (ca. 756-797) had leading religious figures sit in a position superior to that of his political ministers, on the same level as the king himself. And the Sakya hierarch Phakpa (1235-80), First Imperial Preceptor

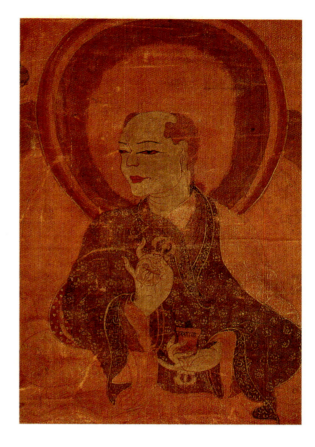

16. *Drakpa Gyaltsen (1147-1217). Detail from a portrait of two Sakya Order Buddhist hierarchs. Painting on silk, Tibet, 15th century. 90 x 65 cm (3'0" x 2'1½"). Private collection, photo courtesy Robert Bruce-Gardner.*

15. *Vairocana Buddha and acolytes. Painting on cloth, Central Tibet, ca. late 12th century. 111 x 73 cm (3'8" x 2'5"). The Cleveland Museum of Art, 87.146.*

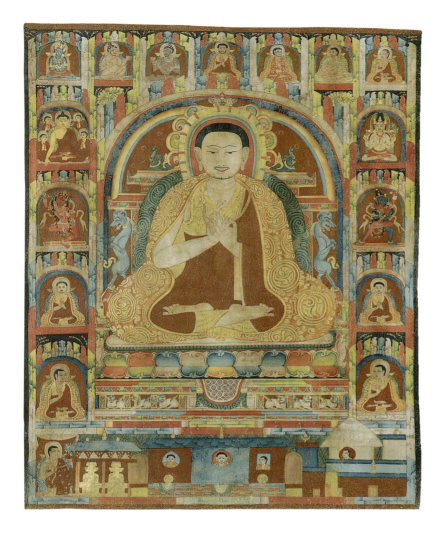

17. Portrait of Taglung Thangpa Chenpo. Painting on cloth, Central Tibet, Taglung monastery, early 13th century. 47 x 37 cm (1'6¹/₂" x 1'2¹/₂"). Private collection.

(Chinese *dishi*) to the Yuan rulers, is said to have insisted that his seat be even higher than that of Kubilai Khan (1215-1294).

After the demise of the Tibetan monarchy in 846, Tibet reverted to an essentially feudal social structure, with local aristocrats controlling the land and its resources. During the second introduction of Buddhism (mostly from India) beginning around the mid-tenth century, no central ruling authority monitored the growth of Buddhist institutions. Religious communities evolved rapidly, but somewhat haphazardly. Aspirants journeyed great distances to meet anyone who might claim to possess knowledge of Buddhism. Such individuals sometimes met dozens of teachers before they met one with whom they could commit themselves for prolonged study. Some masters charged high fees for their initiations and teachings. When the would-be disciple Ngok Chödor (1036-1102) brought Marpa a horse, he was told: "If this is your offering…for instruction in the Doctrine, it is too small, but if this is your offering…for an interview, it is too large!"[38] Ngok returned to present Marpa with seventy black female yaks, a black tent, a dog, a butterchurn and a pitcher. He later remarked that it seemed that the master's teachings were just as plentiful as his disciples' material resources.[39]

During the eleventh and twelfth centuries, many small religious communities came into being, each led by a charismatic figure. Such individuals were the driving force behind Buddhism and its institutions. They founded monasteries, attracted disciples and propagated their own version of the faith. The future of their religious institutions depended upon the charismatic strength of the founder, the extent of the material resources at his disposal and the manifold skills of his successors. There arose what might be described as a 'cult of personalism', with great emphasis placed not upon schools or institutions but upon individual teachers as repositories of the faith. Perhaps the relatively large number of hierarch portraits from this period reflects the special prominence of Buddhist leaders in Tibet at this time.

An important element in a hierarch's portrayal, already touched upon but not yet analysed, is that of his spiritual lineage. Many early portraits prominently feature the hierarch's spiritual lineage, typically along the top and side borders. The purpose of this series of teachers was to demonstrate the hierarch's association with a reliable, respected lineage of *dharma* masters, extending in unbroken succession from his own teacher to the much revered Indian masters. Such concerns preoccupied Tibetan religious communities particularly before the reforms of Tsong Khapa (1357-1419) and other leading theologians in the late fourteenth century. Although the notion of spiritual lineage is inherent within Buddhism, the prominence of these lineages in paintings – particularly in thirteenth century hierarch portraits – probably reflects the struggles to establish and legitimise spiritual authority which characterised many Tibetan religious communities at this time.

Personal jealousies and rivalries between groups were common. An elderly monk in Central Tibet admonished a young novice around the turn of the thirteenth century: "The followers of the Mahamudra [i.e. Drigungpas, a sub-sect of the Kagyupa Order] are great liars. It is better…to visit the seat of the dKa'-gdams-pas [the Kadampa Order]."[40] There were also rivalries within groups, especially acute during the aftermath of a teacher's death. Most groups had no clear pattern for succession of religious authority, so that when a charismatic leader died, his disciples usually dispersed, many subsequently founding their own institutions. This pattern of bifurcation, quite innocent at first, became so acute in the thirteenth century that it threatened the foundations of Buddhism in Tibet.

The bitter struggle within religious institutions for the right to succeed a common

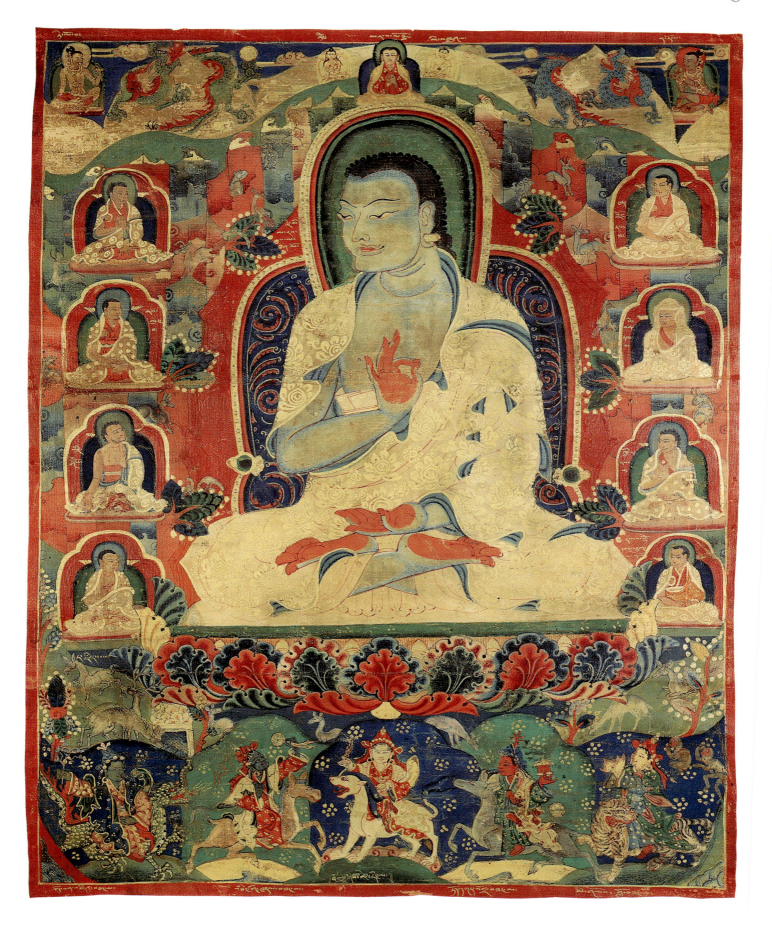

18. Portrait of Milarepa. Painting on cloth, Eastern Tibet, Riwoche monastery (?), 14th century. 37.5 x 30 cm (1'3" x 12"). Private collection, photo courtesy John Eskenazi.

spiritual teacher is exemplified by the life of Taglung Thangpa Chenpo, or Tashipel (1142-1210), the subject of an early thirteenth century portrait, now in a private collection (17). The traditional Kagyu lineage, noted above, appears in the painting's top register: Vajradhara, progenitor of Kagyu teachings, is flanked by the Indian Buddhist master Tilopa and his disciple Naropa. Skipping the figure directly above Taglung Thangpa Chenpo, one finds the Tibetans who inherited the Indian teachings: Marpa, his disciple Milarepa, and his disciple

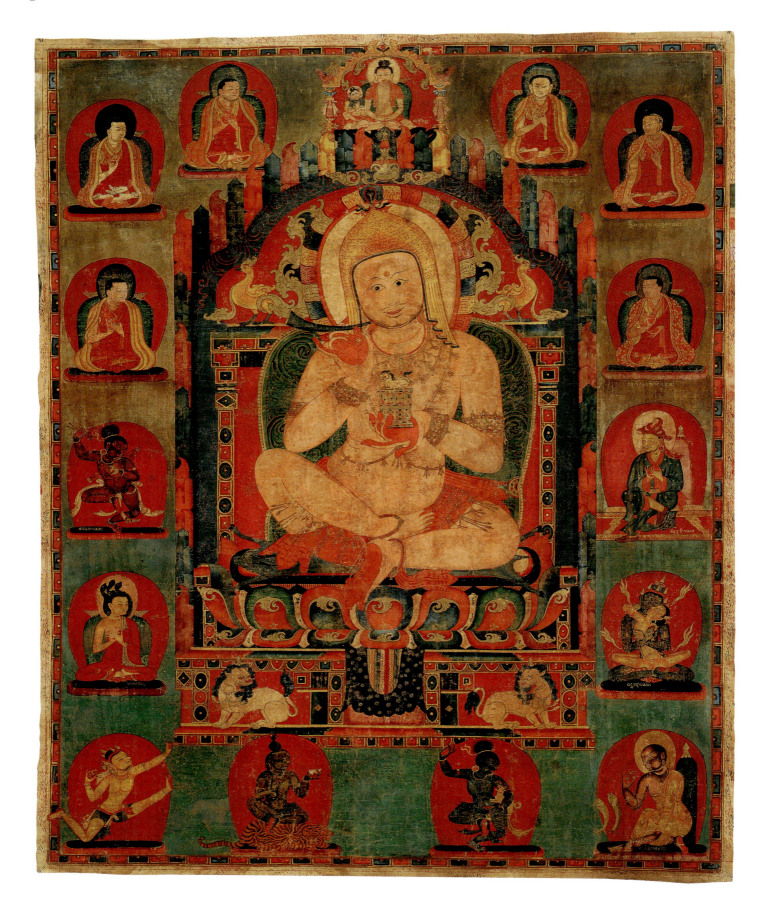

19. *Portrait of Jñanatapa.*
Painting on cloth, Eastern Tibet,
Riwoche monastery, 14th century.
68.5 x 54.6 cm (2'3" x 1'9½").
The Metropolitan Museum of
Art, New York, 1987.144.

Gampopa. Taglung Thangpa Chenpo's teacher Phagmodrupa – in a gesture of *dharma* instruction – appears just above his head.

While this lineage is not incorrect, it is somewhat misleading because its apparent linear transmission of religious instruction masks a more complex historical truth. Other teachers had played crucial roles in the religious education of Taglung Thangpa Chenpo. Moreover, Taglung Thangpa Chenpo was among hundreds of disciples who received Phagmodrupa's teachings. The painting's simplified lineage underscored a historical perspective which best

served Taglung Thangpa Chenpo and his disciples: it was meant to signify that he and his community were the rightful inheritors of the spiritual mantle from the great Phagmodrupa.

In fact, Phagmodrupa had not identified a successor and, when he died, his lineage splintered: competing disciples fought to legitimise themselves as his prime successor. Two almost identical lineage paintings illustrate this rivalry. In 1180, Taglung Thangpa Chenpo founded Taglung monastery just north of Lhasa, the seat of his sub-branch of the Kagyu Order. One of his greatest rivals was Drigungpa, whose portrait appears in a mural at Alchi which illustrates his competing branch of the Kagyu lineage.[41] This was painted about the same time as the Taglung Thangpa Chenpo portrait shown earlier (17). The Alchi mural shows essentially the same lineage, except that Drigungpa, not Taglung Thangpa Chenpo, is shown as Phagmodrupa's successor.

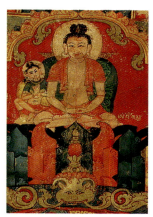

20. *Detail of 19. Identified by inscription as 'Avagarbha', this figure is placed directly above the central figure, implying that his relationship to Jñanatapa is that of teacher.*

Although Phagmodrupa had not appointed a successor, Drigungpa seized the abbot's chair at Densatil, Phagmodrupa's monastic centre, where both the rival claimants had studied. Drigungpa left under duress in 1179, having served as abbot for only two years. Subsequently, the monastery was often without an abbot. When local people threatened to raid Densatil for its valuables just after the turn of the thirteenth century, Drigungpa took much of the wealth and its famed library to his own monastery in Gampo. Taglung Thangpa Chenpo experienced anguish over the desecration of his master's establishment. Early historians suggest that the incident, which brought their rivalry to a head, led to Taglung Thangpa Chenpo's premature death.

The inherently unstable charismatic authority which shaped Tibet's monastic establishments during the eleventh, twelfth and thirteenth centuries gradually gave way to a more stable, institutionalised process of spiritual succession. This, in turn, made different iconographic demands on painting. Later portraiture is more likely to depict the progenitors of a school or monastery, rather than the current abbot – whose role in a spiritual lineage would have been relatively well defined. One such example is a late fourteenth century painting of the Kagyu hierarch Milarepa (1040-1123), probably made for Riwoche monastery in eastern Tibet (18).

Another example of this phenomenon and a fascinating aspect of Tibetan portraiture can be seen in a fourteenth century painting produced for Riwoche monastery, now in The Metropolitan Museum of Art (19). All but the central figure are identified by inscription, and it is clear that the painting illustrates the spiritual lineage associated with Riwoche, which was founded in 1276 by Önpo Lama Rimpoche (1251-1296), formerly the fourth abbot at Taglung monastery. Until recently, the identity of the central figure was a mystery despite some intriguing clues. Before the painting arrived at The Metropolitan Museum, a silk cloth was attached to it, inscribed with the Sanskrit name 'Jñanatapa'. The figure depicted under an arch, directly above the central figure and thus in the position where one might expect his teacher to be, is identified by inscription as 'Avagarbha' (20).

Both names were at first unknown to the author, but the identity of the central figure was later made clear in a history of the Taglung school by the Tibetan historian Ngawang Namgyel (1571-1626). A chapter on Önpo Lama Rimpoche includes a tale about one of Önpo's previous lives in India. It states that, in his Indian incarnation, Önpo's name was Jñanatapa and his Buddhist teacher was Avagarbha, a highly accomplished yogi (*mahasiddha*). Remarkably, The Metropolitan Museum's painting illustrates the spiritual lineage of Riwoche monastery, featuring at its centre a portrait of its founder, Önpo Lama Rimpoche, in one of his Indian incarnations. Why Önpo should have been depicted in such a guise is unclear, but one recalls the Tibetan concern for the purity of its spiritual lineages, often judged by their unbroken links with respected Indian masters, discussed above.

In conclusion, it is clear that some degree of observation may have informed portraits made close to the lifetime of the subject, but an artist's primary guide seems to have been the notion of physiognomic types. Sectarian tensions also found their way into paintings: as competing groups sought to legitimise their own authority, their paintings featured spiritual lineages and abbot portraits, designed to show their own contemporary leader as the rightful successor of acknowledged spiritual authorities. In rendering Buddhist hierarchs, artists frequently relied on iconography already established for the portrayal of Buddhas, bodhisattvas and other deities, an observance justified by the Tibetan perception of their religious leaders as living Buddhas and bodhisattvas. Tibetan painting has never aspired to create an accurate record of the visual world, choosing instead to depict transcendental forces and ideal worlds. It should be no surprise, then, that portraiture also sought to represent not the surface of a man, but his profound qualities as an enlightened being.

Notes see Appendix

THE QUIET WAY

Korean Celadons of the Koryo Dynasty

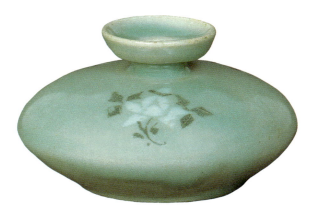

ROBERT D. MOWRY

At their best, Korean celadons are the equal of their Chinese precursors, both technically and aesthetically. Celadon-glazed ware evolved in Korea during the Koryo dynasty (918-1392). Early experimental examples gave way to the celebrated classic wares of the twelfth and thirteenth centuries, while later celadons paved the way for the rustic *punch'ong* style of the Choson dynasty (1392-1910). Korean potters were the first to develop techniques such as the use of inlay, while at the same time drawing inspiration from Chinese silver, lacquer and ceramics.

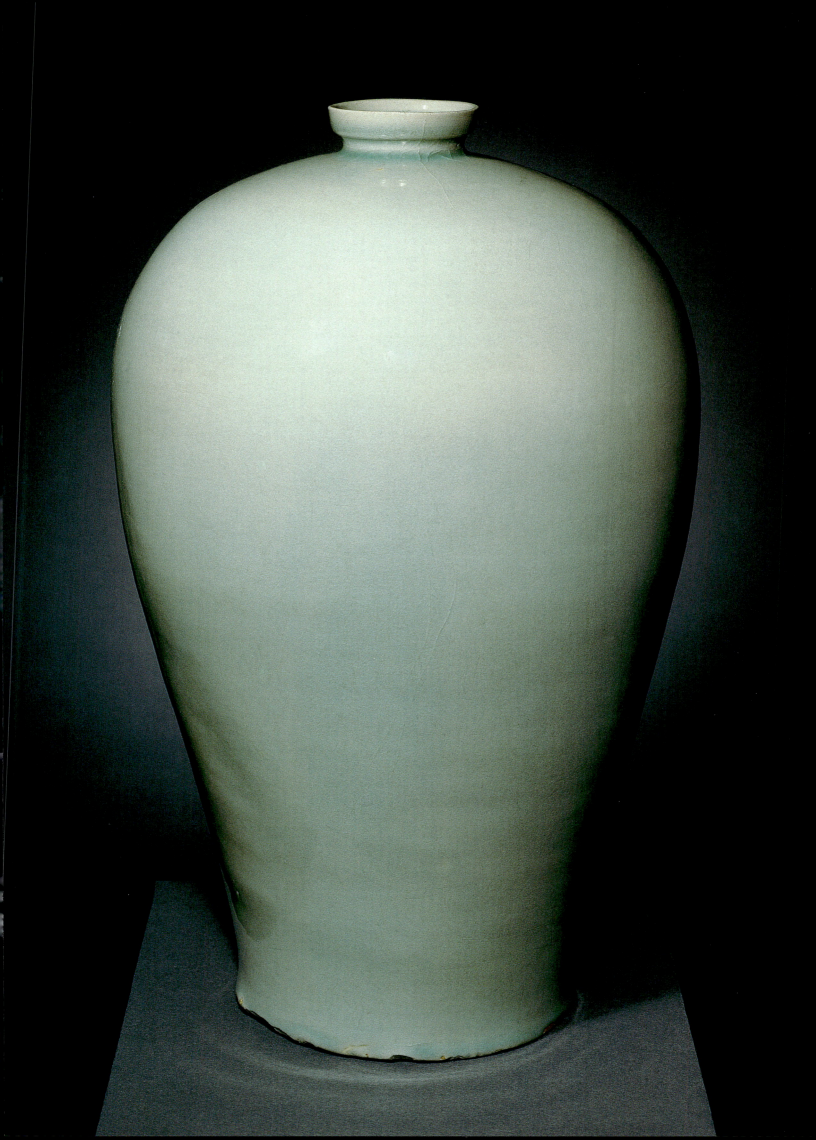

1. *Title page: Oil bottle with stylised peony design, second half 12th century. Stoneware inlaid in black and white slips under celadon glaze, 5 x 8.1 cm (2" x 3"). Harvard University Art Museums, Cambridge MA, 1991.554.*

2. *Previous page: Maebyong bottle, late 11th century. Stoneware with celadon glaze, 38.4 x 24.1 cm (1'3" x 9½"). The Asia Society, New York, 1979.192.*

3. *Maebyong bottle with floral design, early/mid 12th century. Stoneware with incised and carved decoration under celadon glaze, height 40.6 cm (1'4"). Philadelphia Museum of Art, 1974-133-1.*

The books of the Academy, the wines of the Palace, the inkstones of Duanxi, the peonies of Luoyang, the tea of Fujian, the brocades of Sichuan, the porcelains of Dingzhou, the celadons of Korea...all are first under Heaven.
(From *Xiuzhongjin*, Taiping Laoren)

With the expression 'first under Heaven', the twelfth to thirteenth century Chinese author Taiping Laoren ranked the classic bluish-green glazed Korean celadons among the most prized possessions of his country. The only non-Chinese items on the list, Korean celadons are grouped with articles that would have been available only to connoisseurs of abundant wealth and discerning taste. Since China was, and is, known the world over for the quality and diversity of its ceramics – including celadon wares – mention in that select company is high praise indeed.

Through their many millennia of cultural development, Korean artists have produced world-class examples of painting, calligraphy, sculpture and lacquerware, but it is their ceramics for which they have gained renown in both historical and modern times. Not only did the Chinese treasure Korean celadons, importing them during the Yuan dynasty (1279-1368), but the Japanese, too, prized Korean ceramics and imported them in quantity, especially in the Momoyama (1568-1614) and Edo (1614-1868) periods, when they were favoured for the tea ceremony. Nonetheless, from a Western viewpoint Korea has been overshadowed by its powerful neighbours, China and Japan, and largely escaped the attention of Europeans and Americans until the twentieth century, with the result that its ceramic tradition is only now gaining recognition in the West.

Although the blue-and-white porcelains produced during the Choson dynasty (1392-1910) command the highest prices in today's market, the celadon-glazed stonewares made during the Koryo dynasty (918-1392) best reflect Korea's artistic achievements. At their best, Koryo period celadons are every bit the equal of the very finest Chinese ceramic wares, both technically and aesthetically; Korean ceramics of other periods cannot claim that distinction, nor can ceramics from many other places in the world. This article will introduce Korean celadons and briefly trace their history.

Even though Chinese, Koreans and Japanese refer to such ceramics as 'pale bluish-green wares', they are generally known by the more romantic if less precise 'celadon wares' in English.[1] The exact origin of this term remains unclear but a number of theories offer possible explanations. Some scholars believe it came from Céladon, the name of a shepherd in a seventeenth century French play who always wore greyish-green clothing. Another opinion is that 'celadon' is a corruption of the name Saladin, Sultan of Egypt and Syria (1138-1193), who reputedly admired and collected such wares. Others have, however, pointed to the mention of a River Celadon in Homer's *Iliad*, contending that the term has always been associated with water and its sea-green colour.

Whatever the exact origin of the term, 'celadon' is now generally understood to describe ceramics with a glaze that is light bluish-green or greyish-green. The colour, which varies in hue from kiln to kiln, results from the presence of iron compounds in the glaze clay.[2] When fired in a reducing atmosphere – one free of oxygen-bearing fresh air but rich in smoke-laden air bearing carbon monoxide – chemical reactions take place and bring about the beautiful green colours. As iron occurs naturally in most clays, the secrets of producing celadon wares were perhaps discovered with relative ease.

The first evidence of the use of celadon glazes occurs in China during the Shang dynasty (circa 1600-1028 BC). There has been an almost continuous history of production of celadon ware from approximately the fifth to third century BC in the succeeding Zhou

period (circa 1028-221 BC), proving these wares the most persistent of all Chinese ceramics; indeed, they are often said to be the backbone of the Chinese ceramics tradition. In the centuries before the Song dynasty (960-1279 AD), when the Chinese celadon tradition reached full maturity, most celadon wares were produced along the central China coast, not far from modern Hangzhou, in the region once known as Wu-Yue, from which came the name of the most famous and influential of China's early celadons, Yue ware.[3] Already in the third and fourth centuries AD, potters of this area were creating stately vessels with thin, olive-green glazes, which were highly valued by China's rulers and elite. By the ninth century, the artistically mature potters had perfected the use of celadon glazes and extant examples bear eloquent testimony to their genius. These masterly designed wares were the most prized imperial and aristocratic wares in the eighth, ninth and tenth centuries. Indeed, they were the most sophisticated ceramics then being produced anywhere in the world.

The manufacture of ceramics began very early in Korea, with some pieces dating at least as early as 5000 BC. By the Three Kingdoms period (traditionally 57 BC-668 AD), the Koreans were producing unglazed but highly sophisticated grey-bodied stonewares esteemed for their austere but imposing shapes.[4] Considering that by the fifth century AD, only two peoples, the Chinese and the Koreans, possessed sufficient technological sophistication to produce stoneware, Korea unquestionably qualifies for a place high on the list of technologically sophisticated cultures.[5] Although other early peoples made ceramics – one thinks, for example, of Greek painted vases or so-called *haniwa* figures from Kofun-period (258-646 AD) Japan – their products were earthenwares with low-fired glazes. Like China and Korea, those cultures possessed abundant artistic talent in the decoration of their ceramic wares, but unlike China and Korea, they did not possess the same high degree of technological prowess that would enable them to create the more durable and refined high-fired clay bodies of stonewares and the specific chemical reactions necessary to create jewel-like glazes such as celadon. For Korea, this point assumes cardinal importance vis-à-vis Koryo period ceramics, as the ability to manufacture stoneware was a prerequisite for the production of celadon ware.

Celadon-glazed wares were used by people of various socio-economic classes during the Koryo period. The very finest examples went to the court – then located in Kaesong, along the west coast of Korea, near the thirty-eighth parallel, and now in North Korea – to wealthy nobles, or to members of the powerful Buddhist clergy, but other pieces were available to households of lesser means. Celadon wares were produced at a number of kilns along Korea's southwest coast, but the finest came from Puan and Kang-jin, in present day North and South Cholla provinces, respectively.

Korea historically had maintained close trade and cultural ties with China's Wu-Yue area, and when Korean potters began to experiment with celadon glazes in the ninth and tenth centuries, they took the high-quality, sophisticated Yue wares as their model. Few Korean celadons remain from the ninth century, but those from the tenth indicate that this was a period of learning and experimentation. By the eleventh century, the Koreans had mastered the techniques of celadon manufacture and were producing wares of great sophistication. Many works of this period are undecorated, relying on tautness of form and beauty of glaze for their aesthetic appeal (2). Others reveal bold, spontaneous floral designs lightly incised into the moist body clay before the glaze was applied (4). Such patterns find close parallels in Yue wares, as do the light grey, fine-grained stoneware bodies and the glaze hues.

By the first half of the twelfth century, Korean potters had abandoned the spontaneous designs of the eleventh century for delicate, meticulously incised motifs, as revealed by a refined lobed

4. Bowl with notched rim and floral design, late 11th/early 12th century. Stoneware with incised decoration under celadon glaze, 6.4 x 18.4 cm (2¹/₂" x 7"). The Asia Society, New York, 1979.194.

5. Lobed maebyong bottle with design of alternating blossoming and fruiting branches, early/mid-12th century. Stoneware with incised decoration under celadon glaze, 21.3 x 14.2 cm (8" x 5¹/₂"). Harvard University Art Museums, Cambridge MA, 1919.205.

6. Cupstand with foliate lip, early/mid 12th century. Stoneware with carved decoration under celadon glaze, diameter 18.4 cm (7"). Honolulu Academy of Arts, 3434.1.

7. Covered globular ewer with lotus petal design, mid-12th century. Stoneware with incised, carved and slip-dotted decoration under celadon glaze, height 17.8 cm (7"). The Brooklyn Museum, New York, 56.138-1.

bottle with decoration of alternating blossoming and fruiting branches in the collection of the Harvard University Art Museums (5). Even more than their Chinese counterparts, celadons of the Koryo dynasty were shaped to resemble such natural forms as flowers, gourds and melons, and they typically feature flowers, fruits and flying cranes as decorative motifs; the segmenting indentations, for example, cause the Harvard bottle to resemble a ripe melon. Probably used for storing wine, broad-shouldered, narrow-footed, bottles of this type are called *maebyong*, the Korean pronunciation of two characters reading *meiping* in Chinese. The term denotes a tall bottle with a small mouth, short neck, broad shoulders and constricted waist. As the *meiping/ maebyong* (literally, 'plum bottle', or 'plum vase') implies their use as vases for cut branches of blossoming plum, the name is anachronistic since in Song China and Koryo Korea such bottles were actually used for storing wine, vinegar, soy sauce and other liquids.[6] These bottles would therefore originally have sported small, bell-shaped covers that not only protected the contents but reversed and complemented the vessels' strong curves.

Some Korean celadons from the first half of the twelfth century have subtly carved decoration, such as a *maebyong* bottle now in the collection of the Philadelphia Museum of Art (3)[7] or a delicate cupstand in the Honolulu Academy of Arts (6). On the Philadelphia vase, aquatic birds dart between the flowering lotus and mallow plants that embellish its exterior; overlapping lotus petals border the bottom of the exquisitely carved decorative frieze, while six ogival panels with a scrolling floral decoration frame its top. The designs on vessels with carved decoration find parallels both in Chinese textiles of the Song dynasty and in contemporaneous Chinese and Korean paintings.

A spectacular ewer in the Brooklyn Museum combines incised and carved decoration (7). Resting on an everted foot, which bespeaks influence from the Yue wares, the globular ewer simulates a lotus bud, its overlapping petals carved, their interior veining incised. Touched in with a brush, dots of white slip emphasise details of the design on both ewer and cover. Unlike incised decoration, which is achieved with a pointed stylus, carved decoration is created with a small scalpel, usually of bamboo rather than metal. The effect of incised decoration might be compared to a pencil drawing, whereas carved decoration is more closely akin to bas-relief sculpture.

Another group of early twelfth century celadons were created with moulds, such as a rectangular censer in the collection of the Museum of Fine Arts, Boston (9). Such pieces occasionally reveal a taste for both sculptural forms and relief ornamentation. The crisply moulded decoration on the Boston censer features lotuses and reeds growing in a pond. The cloud scrolls and floral diapers that border the pictorial panels reflect the influence of Song dynasty bronzes, as does the form of the censer itself, a relationship that has not previously been explored.[8]

In the first half of the twelfth century – an exceptionally fertile period in the development of Korean ceramics – Koryo potters began to seek inspiration in a variety of wares from northern Chinese kilns, some imitating Ding ware designs, others mimicking imperial Ru ware. Two foliate bowls and saucers in the Rockefeller Collection at The Asia Society in New York (8) – four pieces remaining from a large set of matched pieces – reflect the influence of Ru ware from Henan province, the most revered of all Chinese ceramics; in fact, the bowls are direct copies of a celebrated Ru ware foliate bowl now in the National Palace Museum in Taipei.[9] Like their Ru prototypes, these exquisite Koryo bowls and saucers were made in the early decades of the twelfth century.[10]

So perfect were these bowls and saucers that the potters of the Ru kilns would doubtless have been proud to claim them as their own. As close as they are to their prototypes, however, a trained eye would not mistake them for Ru ware. Their glaze is not only more transparent than the slightly clouded Ru glaze, but it exhibits the distinctive Koryo celadon green, a hue that at one moment seems bluish-green and at the next, greyish-green; the Ru glaze, by contrast, usually appears more bluish green. The glaze crackle, with its long, single lines, differs significantly from the 'shattered ice' and 'fish net' crackle that typically occurs on Ru ware.

If Korea's genius lay in the ability to adopt and perfect an idealised model and then to transform it to suit native tastes, this phenomenon is nowhere more apparent than in Koryo ceramics. With the Asia Society bowls and saucers, Korean potters achieved perfection in emulating an idealised Chinese model. In succeeding decades of the twelfth century, they turned their attention toward the creation of new designs and techniques of decoration that expressed the native aesthetic vision.

The most dramatic invention of Korean potters was inlaid decoration, which they had perfected by the mid-twelfth century. The origin of this technique is unclear, but it was doubtless inspired by underglaze painting in white slip, by bronze vessels decorated with linear designs inlaid in silver wire and by contemporaneous lacquer pieces inlaid with mother-of-pearl (a type of decoration that the Koreans adopted from the Chinese lacquer workers of Hangzhou). In a small cosmetic-oil bottle in the Harvard University Art Museums (1) and a *maebyong* bottle in the Newark Museum (10), the Koryo potters carved the designs out of the moist clay without actually piercing the walls of the vessels. The hollowed areas were then filled with fine clays, or slips, that fired black and white. The oil bottle reveals that inlaid celadons from the second half of the twelfth century have sparse decorative schemes that maintain a happy balance between decorated and undecorated areas; the thirteenth century *maebyong* shows that in succeeding decades, decorative schemes not only became more pictorial but expanded to occupy a larger proportion of the vessel surface.

Koryo potters experimented with a variety of other decorative techniques. On the surpassing ewer in the collection of the Freer Gallery of Art in Washington DC, for example, the potter tinted the edges of the lotus petals with a copper compound (11); in the heat of the kiln, those areas that received the copper fired red, adding a note of local colour. Scholars hotly debate the date of the first use of copper in the decoration of Korean celadons. Some authorities argue that because it is virtually identical to one excavated from a tomb dated to

8. One of a pair of foliate bowls and dishes, early/mid 12th century. Stoneware with celadon glaze, bowls: 9.2 x 14.6 cm (3½" x 6"), dishes: 2.9 x 15.9 cm (1" x 6½"). The Asia Society, New York, 1979.193.1-4.

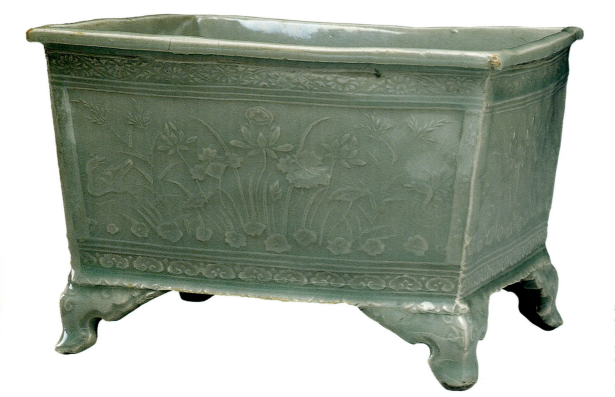

9. Rectangular censer with design of lotuses and reeds in a pond, mid-12th century. Stoneware with moulded decoration under celadon glaze, length 16.2 cm (6½"). Museum of Fine Arts, Boston, 19.678.

1257, this ewer must date to the mid-thirteenth century. Other authorities contend that this ewer must date to the mid-twelfth century, citing as evidence the similarity of its carved and incised lotus petals to those of the Brooklyn Museum ewer discussed above (7); they maintain that the excavated ewer must have been old – perhaps a treasured antique – at the time it was buried. Whatever the date of its introduction, copper seems to have been used for the decoration of high-fired ceramics in Korea before it was used in China; the Chinese only

10. *Maebyong bottle with design of cranes wading in a pond under willow, banana and flowering trees, late 12th/early 13th century. Stoneware with decoration inlaid in black and white slips under celadon glaze, height 41.3 cm (1'4"). The Newark Museum, Newark, New Jersey, 49.488.*

10. *Lotus-bud shaped ewer with moulded figures of two crouching boys, mid-12th century. Stoneware with incised, carved, and slip-dotted decoration under celadon glaze, the edges of the petals painted with underglaze copper red, height 30.5 cm (12"). Freer Gallery of Art, Washington DC, F15.50.*

11. *Maebyong bottle with ginseng-leaf design, 13th century. Stoneware with decoration painted in white slip against a ground coated with black slip, all under celadon glaze, height 28.9 cm (11¹/₂"). The Cleveland Museum of Art, 61.270.*

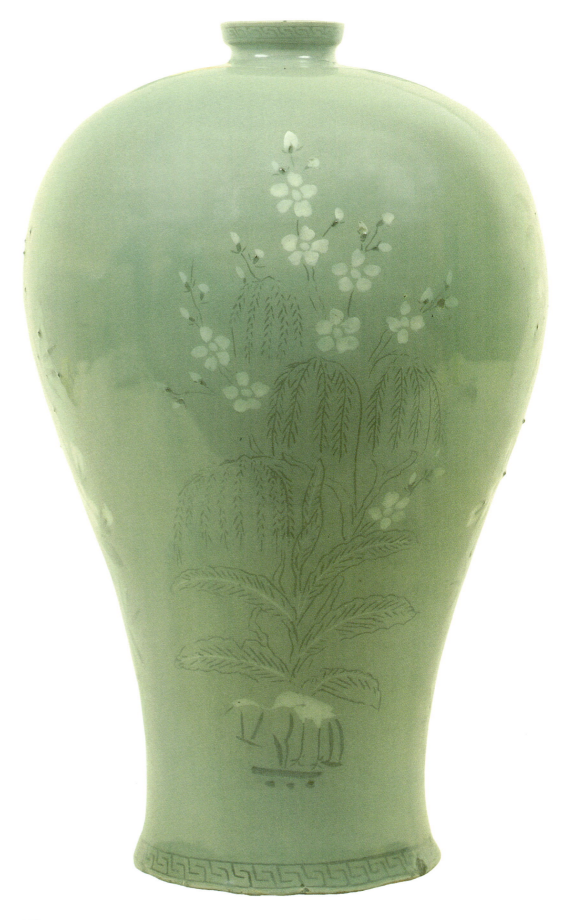

came to use copper with any frequency in the fourteenth century, when potters at Jingdezhen, in Jiangxi province, applied it to their porcelains to create red-and-white wares.

Although it appears to be covered with a black glaze, a *mae-byong* bottle from the Cleveland Museum of Art (12) actually has a celadon glaze. In this case, the light grey stoneware body was first covered all over with black slip, on the top of which the delicate ginseng-leaf decoration was painted in white slip. After the clays had dried, the bottle was covered with a celadon glaze and fired. One's immediate impression is that the glaze is black due to the coating of black slip underneath, but the white ginseng leaf design reveals the covering glaze indeed to be a bluish-green celadon. Pieces of this type also defy a ready periodisation, but the proportions suggest a date of manufacture in the thirteenth century. Fully mature Koryo period *maebyong* vessels characteristically exhibit a profile with a decided 'S' curve imparted by broad shoulders, attenuated body, constricted waist and lightly flaring foot. Earlier manifestations of the shape (2 and 3) relate more closely to their Chinese prototypes with their straight but rapidly expanding sides.

Of all the peoples in the world, only the potters of China and Korea were able to produce high-fired glazed stonewares, such as the much celebrated celadons, during the several centuries from the eleventh to the fourteenth century, attesting to the technological sophistication of both countries. The world is better acquainted with Chinese celadons of the Song dynasty than with their Koryo period counterparts only because China, a huge country, produced far more ceramics than were needed for the home market, with the result that the excess was exported – to Japan, the Philippines, Southeast Asia and even as far afield as India, Persia and Egypt – producing a favourable balance of trade for China (a concern already in early times). Although history records Korea exporting a few high-quality celadons to China, their ceramic output was not enough to permit large-scale export, so the world remained ignorant of Korea's contributions until the twentieth century.

Korean ceramics were made as functional objects – some for use in ceremonies and rituals now long forgotten; others for use in the elegant surroundings of a royal palace or Buddhist temple; and yet others for use in the scholar's studio. Though some pieces may have been treasured as works of art from the beginning, all were intended as articles of use, rather than as mere decorative items to grace a shelf or table.

High quality, inventiveness and perfection characterise Korean ceramics of all periods. This ceramic tradition came to life more than two millennia ago; by the fifth century AD, Korean potters were producing high-fired grey stoneware, the basic foundation upon which the Koryo celadon tradition would be built. Not only were Korean potters of the eleventh and twelfth centuries able to replicate the finest Chinese celadons, they were soon able to transcend mere imitation to produce beautiful wares imbued with a uniquely Korean aesthetic vision. Descendants of those same potters invented new techniques of decoration, such as slip-inlaid designs and underglaze painting in copper red, that would later be used by potters in other countries and cultures. The attention not only to form and glaze but to decoration and detail is another distinguishing mark that collectors of all periods have prized in Korean ceramics.

More than anything else, though, it is the subtleties that draw one to Korean celadons. Their shapes are inventive but natural and pleasing, neither mechanically perfect (in the Chinese mode) nor consciously awkward (in the native Japanese taste). Their colours are delicate, particularly those of the celadons, which range from bluish-green to greyish-green, the misfired piece occasionally displaying olive undercurrents. While the intense red glaze of a Chinese vase or the brilliant and varied palette of a Japanese polychrome bowl might exert a more immediate and compelling appeal, that very same assertiveness is likely to lessen the impact of the piece through repeated exposure. The subtle Korean wares, by contrast, are like introverted friends whose personalities come to be appreciated through repeated contact, their quiet ways and sterling characters making them ever more appealing.
Notes and bibliography see Appendix

COURT LADIES MONKS AND MONSTERS

Yamato-e Painting of the Sixteenth to Eighteenth Centuries

STEPHAN VON DER SCHULENBURG

An exploration of the lively and jewel-like images of Japanese *Yamato-e* painting, focusing on the collections of the Frankfurt Museum für Kunsthandwerk. Whether they tell of princes and their ladies, mythical monsters or miraculous events, these book illustrations and paintings reflect the images and aspirations of a changing society, in which power was passing from the feudal overlords who had long held sway to the emerging mercantile classes.

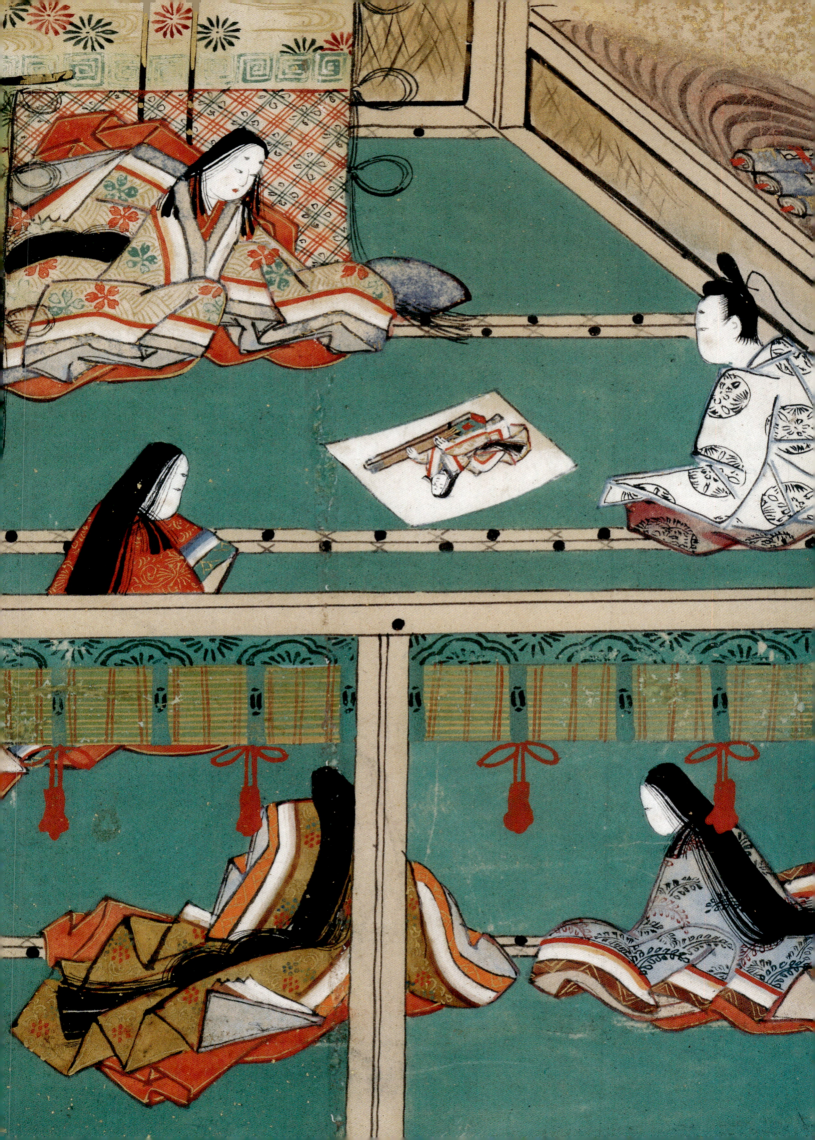

A glance at the collection of *Yamato-e* style Japanese paintings in Frankfurt's Museum für Kunsthandwerk instantly evokes images of court life of the Heian period (794-1185). The atmosphere of this "World of the Shining Prince"[1] is known to us above all through one of the greatest pieces of world literature, the *Tale of Genji (Genji monogatari),* and it is this novel that became the most famous literary subject for *Yamato-e* painting. Up to the present, no other literary work has had such an impact on Japanese writers, artists and the general public. Written between 1001 and 1015, in the late Heian period, by the court lady Murasaki Shikibu, the *Genji monogatari* requires the reader to surrender to a particular atmosphere of bittersweet melancholy characteristic of the late Heian imperial court. As one dives into the life and loves of Genji, the 'Shining Prince' (1), one enters a world that is a kind of golden cage with blinds that rarely allow more than a glimpse of the outside world.

Yamato-e (painting from Yamato) is a term that probably came into use in the early Heian period as a definition for a genuinely Japanese style of painting, as opposed to painting styles dominated by Chinese and Korean influences, called *kara-e* (Chinese style painting). Yamato refers to the region around Nara – the imperial capital in the eighth century – and more broadly to old Japan as a whole. The oldest and most typical format used for painting in this style is the handscroll *(emaki),* but elements of the style can equally be found in albums, painted fans, hanging scrolls, large-size folding screens, wall paintings and illustrated books.[2] Typical subjects include *shiki-e* (four seasons painting), *tsukinami-e* (activities of the twelve months) and *meisho-e* (pictures of famous places), the last rendering important mythical, historical or scenic places of Japan, such as the Tatsuta river, praised for the beautiful autumn colours of the maple trees along its banks. However, another very important subject of *Yamato-e* is the depiction of scenes from literature, and particularly in the format of illustrated books.

Japanese men of letters from the father of the No theatre Zeami (1363-1443) to the modern author Tanizaki Junichiro (1886-1965) have shown their veneration for Murasaki Shikibu's masterwork *The Tale of Genji,* which so deeply expresses *yugen,* an untranslatable but nevertheless crucial term in Japanese culture meaning something between mystery, solemnity and melancholy. The illustrations in the *Yamato-e* style of the *Genji monogatari* have been just as important as the text itself in transmitting to posterity the spirit of this aristocratic world of idleness. The earliest known of these illustrations are the remains of a set of ten scrolls with scenes from the fifty-four chapters of the novel. Painted in the first half of the twelfth century, the brightly-coloured, elegant images have lost little of their original charm (3). During later centuries countless artists followed in the tradition of illustrating the novel in the *Yamato-e* style, and not surprisingly the fascination of the story has not been limited to Japan. It has been said that in writing *A la recherche du temps perdu* early this century, Marcel Proust drew not only on memories of his own youth, but on images from Lady Murasaki's novel.

It is not recorded whether the Irish mining entrepreneur Sir Alfred Chester Beatty (1875-1968) shared Proust's sentiments for court life in ancient Japan. But, given his love for Persian and Indian miniatures, it was natural that he should succumb to the beauty of Japanese scrolls and books such as the mid-seventeenth century hand-written and illustrated fifty-four volume edition of the *Genji monogatari* now preserved in Dublin's Chester Beatty Library. An illustration from this book (4) reproduces the same scene from the novel as does the composition of a fan painting from Frankfurt's Museum für Kunsthandwerk (5). Taken

3. Scene from the Genji monogatari, section of the Kashiwagi scroll of the Genji monogatari emaki. Late Heian period, early 12th century. Handscroll, ink and colour on paper, entire Kashiwagi scroll 21.8 x 48.2 cm (8 ¹/₂" x 19"). Tokugawa Art Museum, Nagoya.

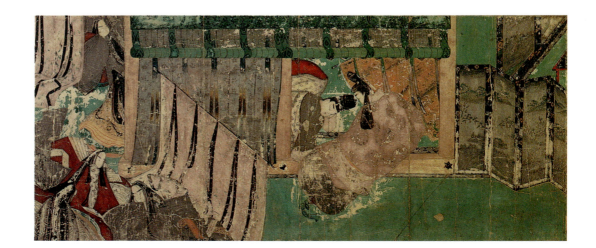

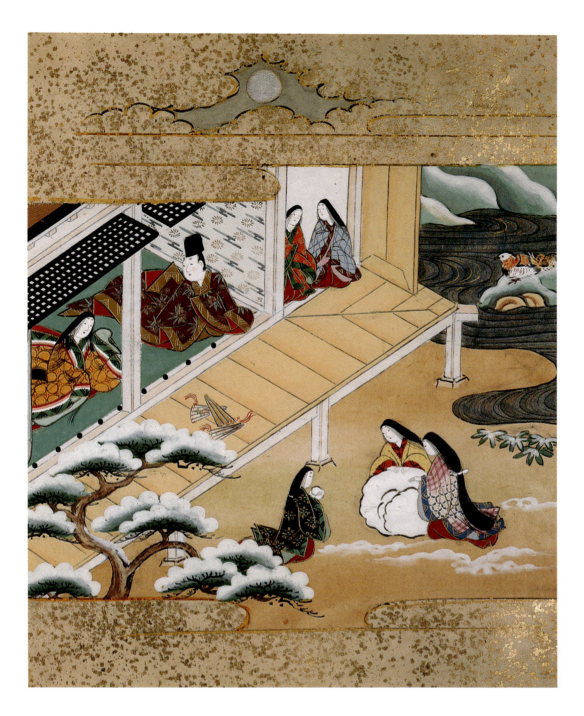

4. *Prince Genji and Lady Murasaki in conversation, from 'Asagao' (The Morning Glory), Chapter 20 of the Genji mono-gatari. Edo period, mid-17th century. Illustration from a 54-volume Nara ehon, ink and colour on paper, 23.5 x 17 cm (9" x 6½"). Chester Beatty Library, Dublin, CBJ No. 1038 (31).*

from the novel's twentieth chapter, 'Asagao' (The Morning Glory), the scene depicts Prince Genji and his consort Lady Murasaki conversing in a room while three young girls roll a snowball outside. The basic composition in the Frankfurt and Dublin illustrations is very similar: a diagonal placement of the open house where the couple sits, the three children around the snowball, the curving waterfront with a male and a female duck, and the tree to the left in the foreground – all shrouded in golden mist.

In the late sixteenth century, and increasingly in the Edo period (1603-1868), people from the newly affluent merchant class began to rival the aristocracy as patrons of the arts, and particularly of narrative painting in the *Yamato-e* style. In addition to such courtly novels as the *Genji monogatari*, they were also interested in tales from foreign lands and fantastic tales from the world of dragon kings and monsters, as well as legends involving ordinary people. It was primarily these kinds of subjects that fascinated Beatty when he discovered his love for Japan. During a visit to the country in 1917, the Irishman bought a large part of his superb collection of Japanese painting from antiques dealers in Kyoto.

These same dealers may also have made the acquaintance of Dr Ernst Arthur Voretzsch (1868-1965), German ambassador to Tokyo between 1928 and 1933. Voretzsch had a long career in Asia behind him when he arrived in Tokyo, having served as consul general in Calcutta, Hong Kong, Shanghai and Hankou. During these years in the East, he travelled extensively in India, China, Siam and Japan. Apart from his diplomatic mission, he developed a distinc-

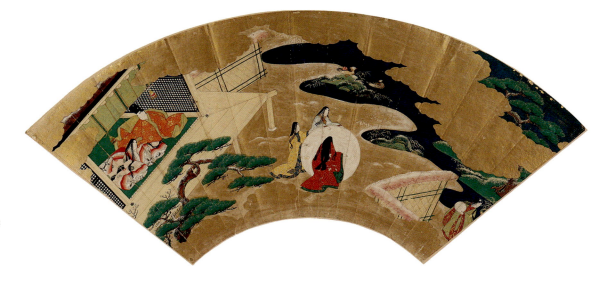

5. *Prince Genji and Lady Murasaki in conversation (compare with 4). Momoyama period, late 16th century. Fan painting, ink, colour, and gold on paper, 23.5 x 50.3 cm (9" x 20"). Museum für Kunsthandwerk, Frankfurt-am-Main, 13618.*

6. *Servant carrying a spear (detail). Edo period, circa 1685. Otsu-e, ink and colour on paper, 32.5 x 24 cm (13" x 9¹/₂"). Private collection, Germany.*

tive interest in Asian history and art, the result of which were various publications, among them his 1926 German translation with commentary of the *Historia do Japao* (1549-78) by the Jesuit father P. Luis Frois. Moreover, while posted in India and China he had joined various archaeological campaigns. Beyond these scholarly activities, however, Voretzsch became one of the most dedicated German collectors of Asian art of his day. Among the artworks he amassed are early Chinese ceramics and bronzes, magnificent Buddhist sculptures from China and Thailand, as well as lacquers from China, the Ryukyu Islands and Japan. It must have been during his six years in Japan that he acquired a total of twenty-five hand-written and illustrated books.

Only four years after the retired ambassador had returned to Germany from Tokyo, Max Loehr proudly announced the opening of a new museum of Asian art in the northern wing of the 'Neue Residenz' in Bamberg in July 1937, due to Dr Voretzsch's generous loan of a large part of his collection.[3] This promising enterprise did not last long, however, and in the aftermath of World War II the Bamberg authorities decided to remove the Asian artworks from the 'Neue Residenz', citing "construction necessities".[4] Fortunately, in 1959, Professor P.W. Meister, then director of Frankfurt's Museum für Kunsthandwerk, persuaded the city of Frankfurt to purchase the collection formerly exhibited in Bamberg, as well as a number of pieces that had remained in Voretzsch's residence, Colmberg castle in Franconia. The city paid Voretzsch what at that time seemed the extraordinary sum of DM250,000 – we know now, however, that it was in fact a very moderate price for a collection of this quality. It appears surprising today to see in the 1959 acquisition list the collection's twenty-five illustrated books (nearly sixty volumes) valued in total at DM1,000 – followed by a 'lacquer chest' at DM2,000.[5]

Why did these books attract so little attention in the 1950s, or earlier, when Voretzsch had bought them for presumably an even more modest price? The answer is simple. Art historians in Japan, as well as scholars in the field of Asian art in the West, have until recently treated narrative scrolls and books dating to after the 'classical' era of the Heian and Kamakura (1185-1333) as minor and crude forms of art. Surprisingly, they were even overlooked by the *mingei* (folk art) movement initiated by Yanagi Soetsu (1889-1961) in the 1920s. Yanagi and his followers had the highest esteem for *Otsu-e* (6), pictures of a simple beauty that were sold by peasant painters outside the city of Otsu (not far from Kyoto) along the ancient Tokaido highway. Compared to these charming, and utterly naive compositions, books illustrated with *Yamato-e* paintings showed a much higher level of sophistication, and perhaps did not therefore qualify as *mingei*. On the other hand, as serial products of workshops they were clearly distinct from the elegant handscrolls, albums and fan paintings produced by the masters of schools patronised by the imperial court and government, such as the Kano and the Tosa, not to speak of the painting of masters working in the literati style. Compare once again the Frankfurt fan painting (5) and the Dublin book illustration (4). Details such as faces, garments, or snow-covered trees and plants are painted much more carefully on the fan than in the book, although the latter is a book illustration of the finest quality. This difference cannot be explained only by the later date of the book, but is also due to the fact that such illustrations generally reveal less careful brushwork in comparison to scrolls, fan or screen painting in the *Yamato-e* style. It is this peculiar position – not rustic enough to be *mingei*, yet not elegant

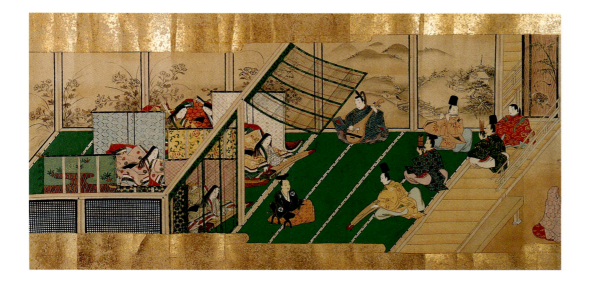

7. Court nobles playing music in Bunsho's house, from Bunsho soshi. Edo period, mid-17th century. Illustration from a pair of Nara ehon scrolls, ink, colour, gold and silver on paper, 33 x 1400 cm (13" x 45'11"). Chester Beatty Library, Dublin, CBJ No. 1186 (9).

enough to be considered as fine art – that led connoisseurs of Japanese art to neglect this genre.

The earliest known occurrence of the term *Nara ehon* (Nara picture books) for books illustrated in the *Yamato-e* style is in a Japanese National Diet Library catalogue of holdings dated 1899.[6] There is no evidence at all that the city of Nara was of specific importance in the production of these books, although there are some indications that they were especially popular in the ancient heartland of Japan, primarily in the old imperial capital of Kyoto, but also in nearby Nara and Sakai. There is a type of painted handscroll sometimes referred to as *Nara emaki* (Nara picture scroll), but the term *Nara ehon* (*ehon* literally meaning picture book) is usually used for this style of painting in both formats.[7] Indeed, the same range of stories and the same types of pictures appear in either form, as seen by the comparison of an illustration in a scroll of the *Bunsho soshi (Tale of Bunsho)* in the Chester Beatty Library (7) and the same scene found in a three-volume set of the *Bunsho soshi* in the Frankfurt Museum (8). Both the book and the scroll show the interior of an aristocratic home – the status of the residence clearly indicated in the Dublin version by the back wall and the wooden blinds in the corridor to the right which are elegantly painted with plants, a landscape and a tiger with bamboo. Further indications are the elegant cloth panels hanging from the lacquer stands to the left where the ladies are sitting. These details are missing from the Frankfurt book, but the painter may have decided to exclude them as they had already been included in an illustration a few pages earlier (9). The view into the interior is in both cases made possible by an artistic conceit known as *fukinuki yatai* ('blown-off roof' style), which had been used in *Yamato-e* since the Heian period (3).

One important difference is that the painter of the Frankfurt book chose to compose the

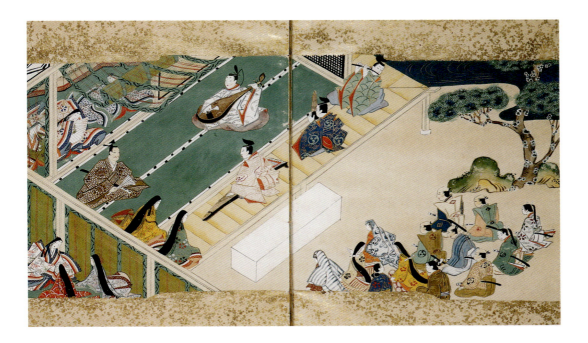

8. Court nobles playing music in Bunsho's house. Edo period, late 17th/early 18th century. Illustration from a three-volume Nara ehon, ink, colour and gold on paper, 24 x 35.5 cm (9½" x 14"). Museum für Kunsthandwerk, Frankfurt, 12792.

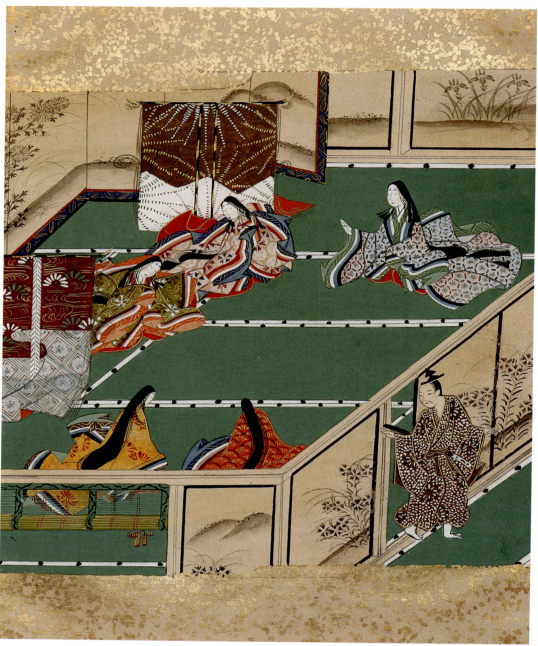

9. *Interior scene of Bunsho's residence in Kashima, from Bunsho soshi. Edo period, late 17th/early 18th century. Illustration from a three-volume Nara ehon, ink, colour and gold on paper, 24 x 18 cm (9¹/₂" x 7"). Museum für Kunsthandwerk, Frankfurt, 12792.*

image on a diagonal, thus moving the depicted subject of the musical performance much closer to the viewer. Another detail underlining the dramatic appeal of the scene is the way the bamboo blind separating the men and the women is raised by a sudden gust of wind. While in the Dublin scroll it is moved up in an almost straight, rather stiff line, in the Frankfurt book it flutters in a dramatic, S-shaped curve. Apart from these differences, the scroll and the book share the device of using elegant garments and the cloth curtains hanging on lacquered stands as a means of structuring and decorating the interior space. Another common feature is the banks of gold clouds or mist above and below the scene, which are formed by scattered small particles of gold leaf. This is, in fact, nothing more than a framing device which, with its cloud-like curves, gives a rhythmic, lively atmosphere to the illustrations. The faces of the men and women in these pictures are depicted in the standard *kagihana hikime* (hook nose and single line eyes) manner familiar from classical *Yamato-e* works like the Heian period *Genji monogatari* scroll illustrations (3). Their expressions betray little emotion. Nevertheless, a closer examination of the Dublin scroll and the Frankfurt book shows slight but important differences. In the Dublin scroll, the faces have a very calm, solemn expression that is in perfect harmony with the elegance and rectangular setting of the room (7A). Even the flute player and the two men blowing the *sho* (a Japanese mouth organ) show very little strain in their faces. In contrast, although seen from behind, the *sho* player in the Frankfurt book has rounded cheeks, giving the impression of strong exhalation, and similarly the courtier with the flute seems to blow so vigorously that the instrument bends like a bow (8A).

An effect of the book's more lively rendering of faces is a touch of naiveté in comparison to the scroll – a hint at the different rank of the artists of each work and their closer or lesser affiliation to the leading schools of *Yamato-e*. The more elegant *Nara ehon* handscrolls such as the Chester Beatty example may have been painted by freelance 'town painters' *(machi eshi)*, artists with closer links to the Tosa School, the most important and powerful institution in the field of *Yamato-e*. The illustrated books generally reveal a sloppier, spontaneous style, which may therefore suggest they were produced in the workshops of painters of low rank. Of course, there must have been close relations between these groups as there is no clearly defined difference between a *machi eshi* and a painter of lower rank. The more carefully painted scrolls may even be the product of the same painting workshop as the rather carelessly executed picture books, the only difference being that the master of the workshop left less of the work on the scroll to his staff because his customer had ordered a more refined work for a higher price. To make things even more complicated, one of the Frankfurt illustrated books could possibly be the work of a well-known master of the Tosa School **(15, 16)**. However, most of these works bear no indication of authorship, and it is therefore very difficult to draw any firm conclusions.

The Dublin *Bunsho soshi* scroll has been dated by scholars to the middle of the seventeenth century,[8] and, bearing in mind the slight differences in style described above, one could venture to date the Frankfurt book to the late seventeenth or early eighteenth century.[9] A set of three *Bunsho soshi* handscrolls recently sold at Sotheby's New York **(10)** helps to shed further light on the date of these works.[10] At first glance they are strikingly similar to the Dublin scrolls, but on closer examination a rather different, slightly rustic appearance to the faces can be seen. The man sitting in the upper centre, with a fan in his hand, has an exaggerated, wide-mouthed facial expression, bearing some resemblance to the facial characterisation found in *ukiyo-e* ('floating world' painting) – a popular style of genre painting that emerged in the latter half of the seventeenth century and is perhaps best known through coloured woodblock prints. Also, less care has been taken in the Sotheby's scroll with the sizes of the figures in respect to each other and the setting – note the woman shown from behind in the lower centre of the scene! Another difference is how clumsily the landscape painting on the sliding doors in the background is executed in comparison to the same detail in the Dublin scrolls **(7)**. One could assume that, as a consequence of this, the Sotheby's scrolls were painted by a minor workshop, but it also seems justified to give them a later, eighteenth century date as the authors of the Sotheby's catalogue have done.

The *Bunsho soshi* is one of the most popular subjects in *Nara ehon*, and is the story of Bunsho, an impoverished attendant at the Shinto shrine of Kashima in the province of Hitachi, near present-day Tokyo.[11] To test Bunsho's piety, the high priest orders him to leave the shrine and work on his own, whereupon Bunsho becomes a saltmaker **(11)** and, thanks to his diligence and unfailing devotion to the god of the Kashima shrine, soon manages to become a wealthy man. To his great distress, however, he and his wife do not succeed in

7A. *Formal and restrained depiction of the serenading nobles (detail of 7).*

8A. *The same scene as above shown with greater animation in the Frankfurt Nara ehon (detail of 8).*

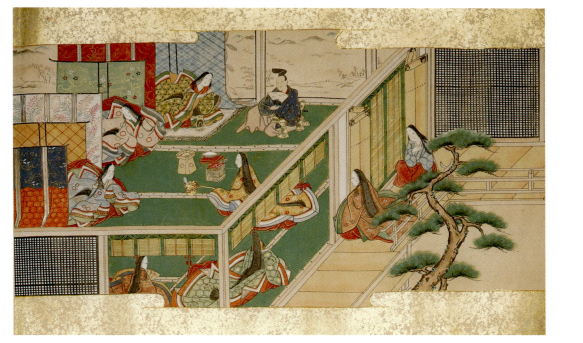

10. *Scene from Bunsho soshi. Edo period, 18th century. Illustration from Nara ehon of three scrolls, ink, colour and gold on paper, 33 x 1187 cm (13" x 38'11"). Private collection, Japan.*

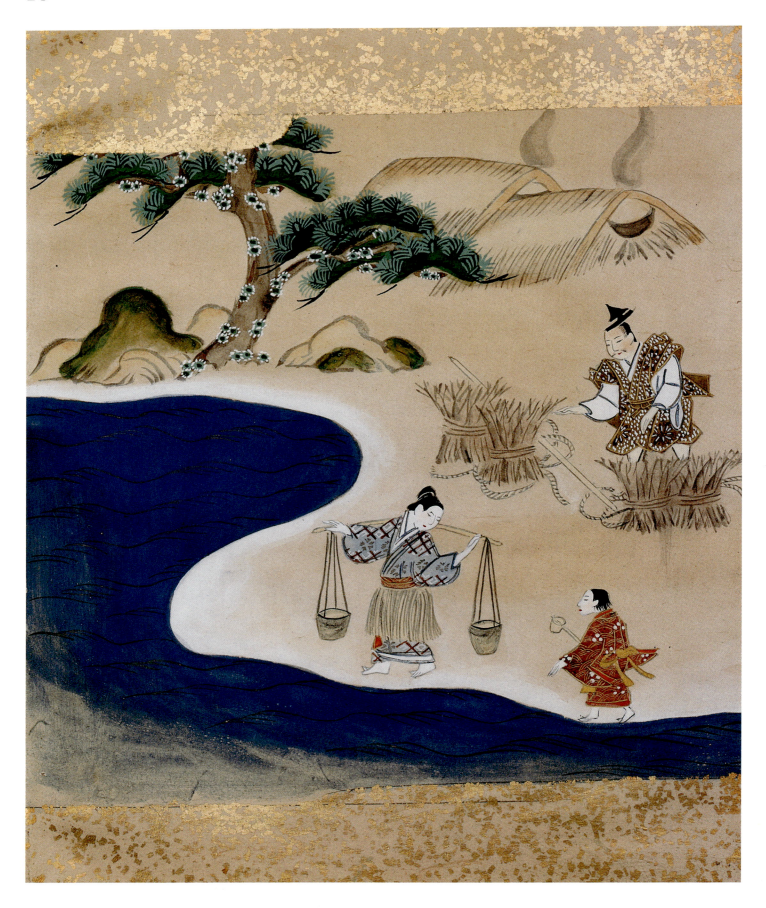

11. *Salt manufacturing in Kashima, from Bunsho soshi. Edo period, late 17th/early 18th century. Illustration from a three-volume Nara ehon, ink, colour and gold on paper, 24 x 18 cm (9½" x 7"). Museum für Kunst-handwerk, Frankfurt, 12792.*

having children. On approaching the god of the Kashima shrine with their wish, however, the couple are blessed with two beautiful daughters. As the girls reach marriageable age, the fame of their beauty spreads. Many honourable young men, among them feudal lords, come to ask Bunsho for his daughters in marriage. All are rejected. Unless they are wooed by a man from the imperial court in Kyoto, the proud ladies declare, they will stay unmarried and become Buddhist nuns.

One day, a court noble who has heard of the beautiful daughters disguises himself and his

three attendants as travelling merchants and visits Bunsho's house. To please the young ladies, they perform music (7, 8; the court noble is the energetic flautist discussed earlier), and from the refinement of their play, their true identities become apparent to the daughters. The young courtier and the elder daughter instantly fall in love, and, with Bunsho's approval, the young couple leave for Kyoto, soon followed by the rest of the family. The emperor himself succumbs to the beauty of the younger daughter and takes her as one of his secondary consorts. Bunsho is appointed a minister of state, and further promoted to senior councillor.

This legend of a poor man's dream come true can be seen as a literary example of the rising power of the merchant class in the Edo period. It also sheds light on the paradoxical situation in which merchants traditionally ranked below all others in society but, with the prosperity engendered by the long period of peace from the seventeenth to the middle of the nineteenth century, became the de facto ruling class in economic terms. In contrast, the ruling classes, despite their high rank, became increasingly impoverished. Bunsho's career thus represents every merchant's ideal: commercial success through his own hard labour, and social success through the marriages of his daughters into the imperial court.

It is no small wonder, therefore, that the *Bunsho soshi* became one of the most popular subjects for *Nara ehon*. Handscrolls or books of the story were highly esteemed parts of the wedding dowries of wealthy merchants' daughters. Among the *Nara ehon* in the Voretzsch Collection, there are no less than six different editions of this story, and there seems to have been some intention in compiling these examples to show the various forms it took in the history of the genre. This unique variety in a single collection provides an excellent opportunity to compare the different levels of execution in these books and thus brings us closer to answering the difficult question of dating *Nara ehon*.

We have already discussed several of the illustrations (8, 9 and 11) in the most elegant of the *Bunsho soshi* editions in the Voretzsch Collection, which is a set of three volumes of vertical, rectangular shape. The text and illustrations are on comparatively high quality, strong and glossy paper, with the text written on both sides. The book is bound in the so-called 'open-sheet binding' *(detchoso)*, which is particularly common in vertically-shaped books, as opposed to the 'covered binding' *(fukuro-toji)* popular with horizontal, rectangular books where single sheets of paper are folded in the middle to form sleeve-like double-pages bound together by thread at the two loose ends. Apart from the delicate illustrations and elegant calligraphy it contains, the Voretzsch *detchoso Bunsho soshi* already fascinates the viewer as a closed book. The outside is covered with a fine silk brocade fabric with a pattern of *tsubaki* (camellia) blossoms in gold and *karakusa* ('Chinese grasses' – stylised leaves and tendrils) in grey-green on a mustard-coloured ground (12). The paper title strip in the upper centre is carefully decorated with pigment and particles of reddish and whitish gold, forming a delicate background for the calligraphy in rich black ink. Opening the book, the reader finds the inside cover shining with applied gold leaf, embossed with a pattern created by pressing it against a fabric ground.

Another version of the *Bunsho soshi* in the Frankfurt collection gives a very different impression. The cover of this horizontal, rectangular two-volume book is made of waxed, dark-blue paper covered with scattered square gold and silver particles; on the inside cover the book binder has affixed a sheet of light green paper with a dense irregular pattern of gold and silver particles of different sizes – from larger strips to fine dust. However, this is not the book's original cover as it is slightly smaller than the originally *fukuro-toji*-bound pages inside, which still have the holes for the thread binding.[12] The text of the book is written carefully in an unusually dense sequence of seventeen lines per page – ordinary *Nara ehon* of this size have only thirteen to fifteen lines a page. Another feature of this book is that when approaching the interspersed pages of illustration the sequence of lines does not, as in most *Nara ehon*, reduce the number of characters in a line with increasing distance between each line in order that the flow of text continues smoothly up to the illustration. In contrast, in this edition, the copyist has left sometimes more than a page completely empty to preserve the even spacing between the lines of text.

Furthermore, the style of painting of the illustrations of this *Nara ehon* has a particularly

12. *Cover from Bunsho soshi. Edo period, late 17th/early 18th century. Silk brocade on paper with paper title strip, 24 x 18 cm (9¹/₂" x 7"). Museum für Kunsthandwerk, Frankfurt, 12792.*

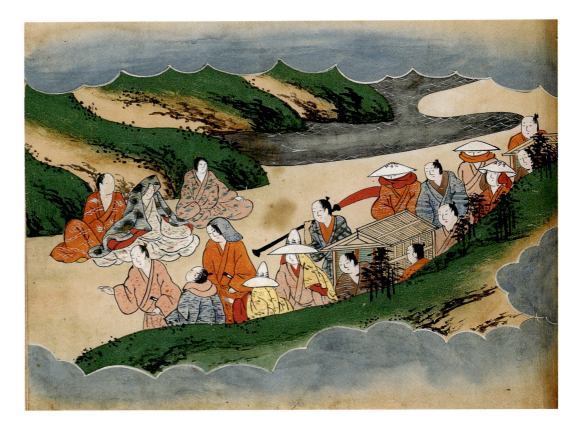

13. Bunsho's daughter and her bridegroom travel to Kyoto, from Bunsho soshi. Edo period, mid-17th century. Illustration from a two-volume Nara ehon, ink, colour and gold on paper, 18 x 24.5 cm (7" x 10"). Museum für Kunsthandwerk, Frankfurt, 12804.

'folkish' touch about it. The image illustrated (13) depicts the journey to Kyoto of Bunsho's eldest daughter and her betrothed courtier. Partly hidden between rolling hills, the party of travellers makes its way, with porters carrying two wooden palanquins containing the nobleman and his bride. The faces are painted in the *Yamato-e* 'hook nose, single line eyes' manner, but compared to the Dublin scroll (7A) and the first Frankfurt *Bunsho soshi* (8A), the painting is more coarsely executed. The garments are rendered in bright colours, with gold in some places, but not with the same attention to detail as the above-mentioned handscroll and *detchoso* edition. The most significant indication in this painting of a folk aesthetic is the anti-naturalistic size of the figures in relation to the landscape around them: the trees on the hill in the foreground are less than half the height of the figures behind them. Furthermore, the proportions of faces vary widely in the illustration – compare the wide, frog-like faces of the two figures on the right, partly disguised by a shawl and a straw hat, to the tiny head on top of a large body of the rightmost of the three figures seated by the roadside in the left part of the illustration.

Another difference to the more refined editions of the *Bunsho soshi* is the form of the framing banks of clouds or mist. Instead of gold, they are painted in light blue with a white strip at the edge – a common feature in less luxurious editions of *Nara ehon*. However, where these blue clouds with a white lining are normally depicted as stylised strips of mist (15, 16 and 17), those in this edition have an irregular, bubbling shape. In spite of their rather naive and rustic execution, however, the illustrations of this *fukuro-toji* edition have a particular atmosphere of calm beauty and lyrical expression (13), and therefore would appear to be earlier in date than those of the elegant *detchoso* edition, but of comparable date to the Beatty handscroll – the middle of the seventeenth century.[13]

A third edition of the Frankfurt *Bunsho soshi*, and the last to be discussed here, is one of two over-sized editions in the collection (14).[14] With a cover of *kumo-gami* – white paper decorated with two double rows of stylised clouds in the shape of wavy lines in light blue on the top and purple at the bottom – this edition's illustrations have a similar folk aesthetic to the edition just discussed, but are even more quickly and carelessly drawn. This is particularly apparent in the coarsely and summarily painted garments of the large figures, the folding screen to the right and the brushwood fences framing the scene in the lower section. The stylised banks of mist or clouds have the double outlines familiar in the more simple *Nara ehon*, but the painter has forgotten to fill the blank space with blue. Indeed, only in five of the eleven illustrations in these two volumes have the mists and clouds been painted blue. An even more unusual feature is the division of the illustration into an upper and a lower scene, both including short explanatory texts within the composition. One reason for this may be

three attendants as travelling merchants and visits Bunsho's house. To please the young ladies, they perform music (7, 8; the court noble is the energetic flautist discussed earlier), and from the refinement of their play, their true identities become apparent to the daughters. The young courtier and the elder daughter instantly fall in love, and, with Bunsho's approval, the young couple leave for Kyoto, soon followed by the rest of the family. The emperor himself succumbs to the beauty of the younger daughter and takes her as one of his secondary consorts. Bunsho is appointed a minister of state, and further promoted to senior councillor.

This legend of a poor man's dream come true can be seen as a literary example of the rising power of the merchant class in the Edo period. It also sheds light on the paradoxical situation in which merchants traditionally ranked below all others in society but, with the prosperity engendered by the long period of peace from the seventeenth to the middle of the nineteenth century, became the de facto ruling class in economic terms. In contrast, the ruling classes, despite their high rank, became increasingly impoverished. Bunsho's career thus represents every merchant's ideal: commercial success through his own hard labour, and social success through the marriages of his daughters into the imperial court.

It is no small wonder, therefore, that the *Bunsho soshi* became one of the most popular subjects for *Nara ehon*. Handscrolls or books of the story were highly esteemed parts of the wedding dowries of wealthy merchants' daughters. Among the *Nara ehon* in the Voretzsch Collection, there are no less than six different editions of this story, and there seems to have been some intention in compiling these examples to show the various forms it took in the history of the genre. This unique variety in a single collection provides an excellent opportunity to compare the different levels of execution in these books and thus brings us closer to answering the difficult question of dating *Nara ehon*.

We have already discussed several of the illustrations (8, 9 and 11) in the most elegant of the *Bunsho soshi* editions in the Voretzsch Collection, which is a set of three volumes of vertical, rectangular shape. The text and illustrations are on comparatively high quality, strong and glossy paper, with the text written on both sides. The book is bound in the so-called 'open-sheet binding' *(detchoso)*, which is particularly common in vertically-shaped books, as opposed to the 'covered binding' *(fukuro-toji)* popular with horizontal, rectangular books where single sheets of paper are folded in the middle to form sleeve-like double-pages bound together by thread at the two loose ends. Apart from the delicate illustrations and elegant calligraphy it contains, the Voretzsch *detchoso Bunsho soshi* already fascinates the viewer as a closed book. The outside is covered with a fine silk brocade fabric with a pattern of *tsubaki* (camellia) blossoms in gold and *karakusa* ('Chinese grasses' – stylised leaves and tendrils) in grey-green on a mustard-coloured ground (12). The paper title strip in the upper centre is carefully decorated with pigment and particles of reddish and whitish gold, forming a delicate background for the calligraphy in rich black ink. Opening the book, the reader finds the inside cover shining with applied gold leaf, embossed with a pattern created by pressing it against a fabric ground.

Another version of the *Bunsho soshi* in the Frankfurt collection gives a very different impression. The cover of this horizontal, rectangular two-volume book is made of waxed, dark-blue paper covered with scattered square gold and silver particles; on the inside cover the book binder has affixed a sheet of light green paper with a dense irregular pattern of gold and silver particles of different sizes – from larger strips to fine dust. However, this is not the book's original cover as it is slightly smaller than the originally *fukuro-toji*-bound pages inside, which still have the holes for the thread binding.[12] The text of the book is written carefully in an unusually dense sequence of seventeen lines per page – ordinary *Nara ehon* of this size have only thirteen to fifteen lines a page. Another feature of this book is that when approaching the interspersed pages of illustration the sequence of lines does not, as in most *Nara ehon*, reduce the number of characters in a line with increasing distance between each line in order that the flow of text continues smoothly up to the illustration. In contrast, in this edition, the copyist has left sometimes more than a page completely empty to preserve the even spacing between the lines of text.

Furthermore, the style of painting of the illustrations of this *Nara ehon* has a particularly

12. *Cover from Bunsho soshi. Edo period, late 17th/early 18th century. Silk brocade on paper with paper title strip, 24 x 18 cm (9¹/₂" x 7"). Museum für Kunsthandwerk, Frankfurt, 12792.*

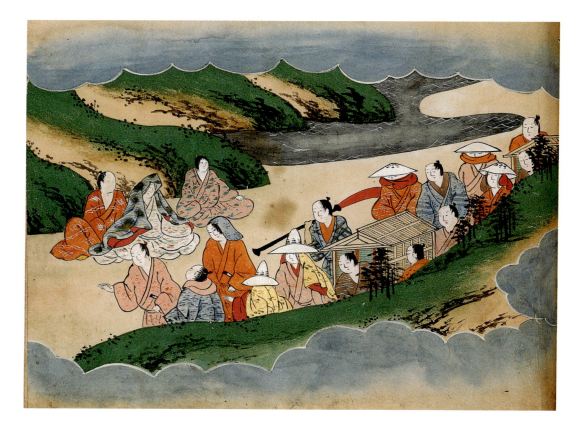

13. *Bunsho's daughter and her bridegroom travel to Kyoto, from Bunsho soshi. Edo period, mid-17th century. Illustration from a two-volume Nara ehon, ink, colour and gold on paper, 18 x 24.5 cm (7" x 10"). Museum für Kunsthandwerk, Frankfurt, 12804.*

'folkish' touch about it. The image illustrated (13) depicts the journey to Kyoto of Bunsho's eldest daughter and her betrothed courtier. Partly hidden between rolling hills, the party of travellers makes its way, with porters carrying two wooden palanquins containing the nobleman and his bride. The faces are painted in the *Yamato-e* 'hook nose, single line eyes' manner, but compared to the Dublin scroll (7A) and the first Frankfurt *Bunsho soshi* (8A), the painting is more coarsely executed. The garments are rendered in bright colours, with gold in some places, but not with the same attention to detail as the above-mentioned handscroll and *detchoso* edition. The most significant indication in this painting of a folk aesthetic is the anti-naturalistic size of the figures in relation to the landscape around them: the trees on the hill in the foreground are less than half the height of the figures behind them. Furthermore, the proportions of faces vary widely in the illustration – compare the wide, frog-like faces of the two figures on the right, partly disguised by a shawl and a straw hat, to the tiny head on top of a large body of the rightmost of the three figures seated by the roadside in the left part of the illustration.

Another difference to the more refined editions of the *Bunsho soshi* is the form of the framing banks of clouds or mist. Instead of gold, they are painted in light blue with a white strip at the edge – a common feature in less luxurious editions of *Nara ehon*. However, where these blue clouds with a white lining are normally depicted as stylised strips of mist (15, 16 and 17), those in this edition have an irregular, bubbling shape. In spite of their rather naive and rustic execution, however, the illustrations of this *fukuro-toji* edition have a particular atmosphere of calm beauty and lyrical expression (13), and therefore would appear to be earlier in date than those of the elegant *detchoso* edition, but of comparable date to the Beatty handscroll – the middle of the seventeenth century.[13]

A third edition of the Frankfurt *Bunsho soshi*, and the last to be discussed here, is one of two over-sized editions in the collection (14).[14] With a cover of *kumo-gami* – white paper decorated with two double rows of stylised clouds in the shape of wavy lines in light blue on the top and purple at the bottom – this edition's illustrations have a similar folk aesthetic to the edition just discussed, but are even more quickly and carelessly drawn. This is particularly apparent in the coarsely and summarily painted garments of the large figures, the folding screen to the right and the brushwood fences framing the scene in the lower section. The stylised banks of mist or clouds have the double outlines familiar in the more simple *Nara ehon*, but the painter has forgotten to fill the blank space with blue. Indeed, only in five of the eleven illustrations in these two volumes have the mists and clouds been painted blue. An even more unusual feature is the division of the illustration into an upper and a lower scene, both including short explanatory texts within the composition. One reason for this may be

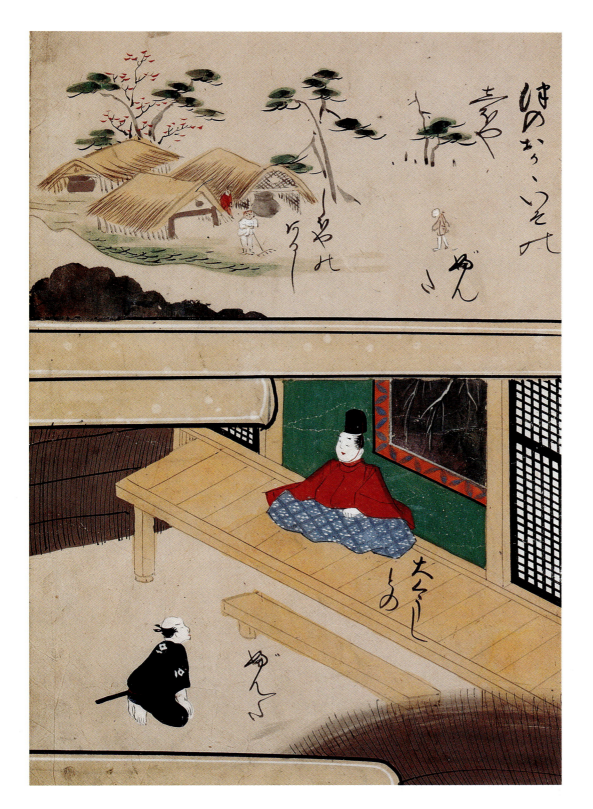

14. Bunsho's saltmaking enterprise and Bunsho's house, from Bunsho soshi. Edo period, first half of 18th century. Illustration from a two-volume Nara ehon, ink, colour and silver on paper, 33 x 22.5 cm (13" x 9"). Museum für Kunsthandwerk, Frankfurt, 12790.

that the painter was using a horizontal format sourcebook, and decided to combine two scenes to fill the vertical form of this book. Although this is the only illustration in the book so divided, other images in this edition suggest that the artist had problems filling the vertical format appropriately. In some cases, he squeezed in figures up to the very far left and right of the page, and in others he painted oddly high-rising banks of cloud or mist at the top and the bottom, so the space between them would approach the horizontal format. Compared to the mid-seventeenth century Frankfurt *Nara ehon*, therefore, this edition is of somewhat lesser quality. The calligraphy is even less delicate, as is the cover, and the illustrations are flatter and more stereotyped. All this indicates that the book is of considerably later date, probably from the first half of the eighteenth century, the last period of production of *Nara ehon*.

Although the six different versions of the *Bunsho soshi* in the Voretzsch Collection are unique in their variety, as a single book the collection's edition of *Kumano no honji* is even more important.[15] Like the *Bunsho soshi*, this legend was a very popular subject of hand-

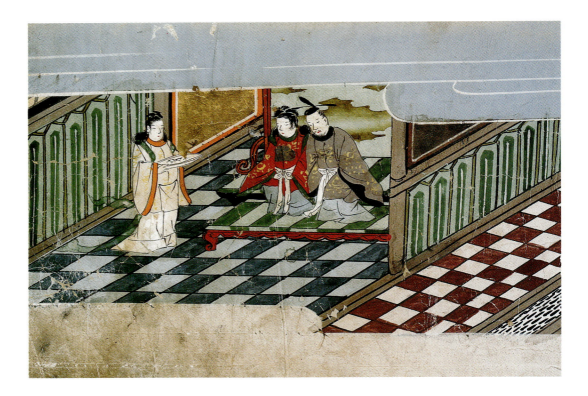

15. *The maharaja and the wife who later bore the royal heir, from* Kumano no honji, *signed Tosa no kami Mitsumoto (active 1530-69). Illustration from a single volume Nara ehon, ink, colour, gold and silver on paper, 17.5 x 26 cm (7" x 10"). Museum für Kunsthandwerk, Frankfurt, 12782.*

scrolls, *Nara ehon* and early block-printed books with hand-coloured illustrations *(tan-rokubon)*.[16] Based on a Buddhist sutra, the story reached Japan in the fourteenth century, where it was adapted into the founding legend of the three shrines of Kumano in Kii province. According to the tale, the maharaja of Magadha in ancient India was in great despair as none of the thousand wives in his harem could provide him with an heir. The last among the wives was a humble woman who lived in a detached palace. After she prayed to Avalokiteshvara, the *bodhisattva* particularly revered for his mercy, she finally became pregnant after a visit from the maharaja (15). However, the other wives in their jealousy conspired against her, and eventually, with an army of hags disguised as devils, forced the maharaja to flee her palace. Then, through a false royal order, the poor lady was taken to the mountains by the maharaja's soldiers to be killed. Just before her execution, she gave birth to the royal heir who was miraculously kept nourished by the unending flow of milk from the dead mother's breast (16). Living among the wild beasts, the boy was eventually found by a holy man who made the child his pupil. One day, the young monk met his father, and the maharaja finally discovered

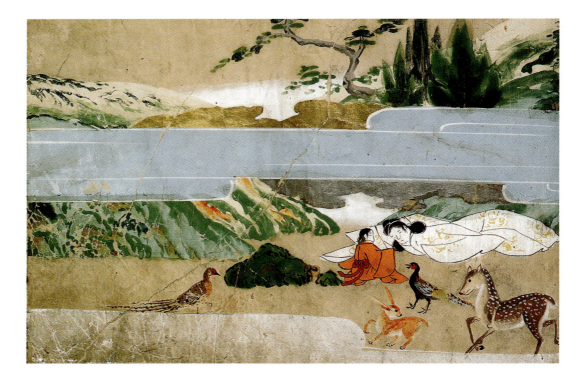

16. *The murdered wife and her infant son, from* Kumano no honji, *signed Tosa no kami Mitsumoto (active 1530-69). Momoyama period (1573-1600). Illustration from a single volume Nara ehon, ink, colour, gold and silver on paper, 17.5 x 26 cm (7" x 10"). Museum für Kunsthandwerk, Frankfurt, 12782.*

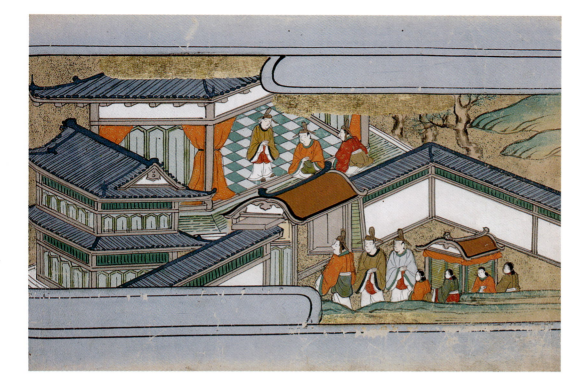

17. *The bride arrives at Emperor Taizong's palace, from Taishokan. Edo period, mid-17th century. Illustration from fragments of a three-volume Nara ehon, ink, colour and gold on paper, 16.5 x 23 cm (6½" x 9"). Museum für Kunsthandwerk, Frankfurt, 12799.*

the atrocities perpetrated against the son and mother. The bones of the dead woman were gathered and the holy man brought her back to life. The maharaja was, however, so disgusted with what had happened that he, his wife, his son and the holy man mounted a flying palanquin to go east to Japan, where they settled down as the deities of the Kumano shrine.

What is remarkable about the Kumano manuscript in the Voretzsch Collection is that it bears the signature "Tosa no kami Mitsumoto". Mitsumoto (active 1530-69) was the elder son and pupil of Tosa Mitsushige, whom he followed as *edokoro azukari* (superintendent of the imperial painting bureau in Kyoto), a position the Tosa School had held since the days of Fujiwara no Yukimitsu (fl. 1352-89). Only a few of Mitsumoto's works are known today, which may be partly due to his untimely death in battle in 1569. His signature on the Frankfurt *Kumano no honji* is rare proof of the direct involvement of a leading Tosa master in the production of *Nara ehon*. There are several other *Nara ehon* with illustrations painted in a style obviously linked to that of the Tosa School, but as they do not bear an artist's signature, none of them can with any certainty be attributed to a Tosa artist, much less a Tosa master.

Presuming the signature as well as the whole book are not copies by a later artist, this would make the work dateable to the middle of the sixteenth century, and therefore one of the earliest known *Nara ehon* in book form.[17] Certainly, the painting style of the illustrations fits a sixteenth century date. The cloud or fog banks are once again an unusual feature in this book. Rendered as solid horizontal strips, they have the white outlines common to the simpler type of *Nara ehon* in which gold is not used, but the painter has made a clear distinction between the upper cloud bank in light blue and the lower in white. An indicator for the early date of the book is that, in two of the illustrations, the upper bank is not placed at the very top as a framing device, but instead is used within the composition (16). In the example illustrated, the upper cloud bank, placed midway in the composition, underlines the steepness of the snow-covered peaks, which literally transcend the clouds, thus giving dramatic expression to the more intimate scene below of the infant beside his dead mother, surrounded by the wild beasts of the forest. Another uncommon feature in this book is a second layer of clouds in gold and silver running parallel to the blue and white clouds. Although the framing cloud forms can be explained physically as clouds opening to allow a view of the scene depicted, they are nevertheless usually highly stylised, as a decorative pattern. If, as in the Kumano book, there is a painted layer of clouds and another one in gold and silver leaf, this is a further step toward stylisation, going beyond the more or less naturalistic rendering of the landscape or people in the picture. One may also interpret the clouds, which separate the picture proper from the viewer and give the scene a dreamy, super-naturalistic atmosphere, as a symbol or an indicator for the supernatural content of the story depicted.

In the illustration of the maharaja visiting his wife in her detached palace (15), the painter

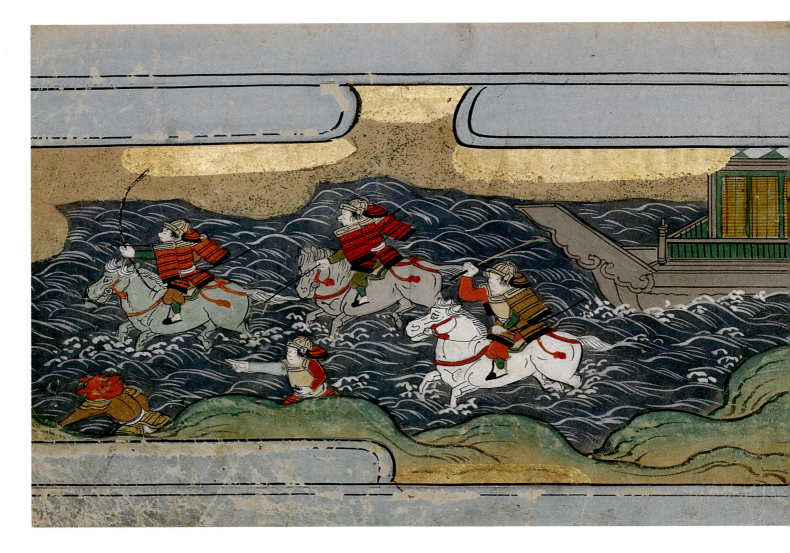

18. *The army of the dragon kings attacks the Chinese ships, from Taishokan. Edo period, mid-17th century. Illustration from fragments of a three-volume Nara ehon, ink, colour and gold on paper, 16.5 x 45.5 cm (6 ½" x 1'6"). Museum für Kunsthandwerk, Frankfurt, 12799.*

depicts a scene in India, and for this purpose uses various devices that also appear in other *Nara ehon* in which foreign lands or even the supernatural world of dragons and demons are represented. The garments and hair styles are reminiscent of Tang dynasty (618-907) China, and other typical features are the chequer-patterned floor and the green vertical wall panels in the shape of a wooden fence. It is interesting to note that the same pictorial device of rendering foreign architecture can be found in *Nanban byobu* ('Southern Barbarians' folding screens) depicting the life of the Portuguese who were the first Europeans to enter Japan in the middle of the sixteenth century.[18]

All these characteristics reveal the hand of a rather distinguished painter with a very personal style of painting. However, the very simple brushwork of the trees in comparison to the rather finely painted central scene around the dead mother (16) is a clear indication that this book, like all *Nara ehon*, is the product of a workshop. There were not only specialists for the calligraphy, the painting and the book-binding, but the painting work itself was obviously subdivided between the workshop master, who would determine the general composition and often paint the central scenes and figures, and his staff, who would specialise in executing the background, such as the depiction of architecture, landscape and cloud banks. It is very likely that, even within the figure painting, subordinate specialists were responsible for rendering the often very diligently executed patterns of garments. Thus, if we assume that Tosa Mitsumoto's signature is authentic, we must still bear in mind that the master himself can only be called the general supervisor of the work and probably the painter of the central parts of the illustrations.

Among the *Nara ehon* introduced so far, there have been fundamentally different types of stories: the classical Heian period courtly novel of the *Genji monogatari*, the worldly aspirations of the nouveau-riche merchant class of the *Bunsho soshi*, and the fantastic tales from foreign lands of the *Kumano no honji*. The last *Nara ehon* to be introduced tells a tale in which one enters the fairy-tale world of dragon kings under the sea. This legend, *Taishokan*, has been illustrated by artists of all ranks, as it was the most popular of all subjects in *kowakamai* performances – text recitations accompanied by music and dance popular in six-

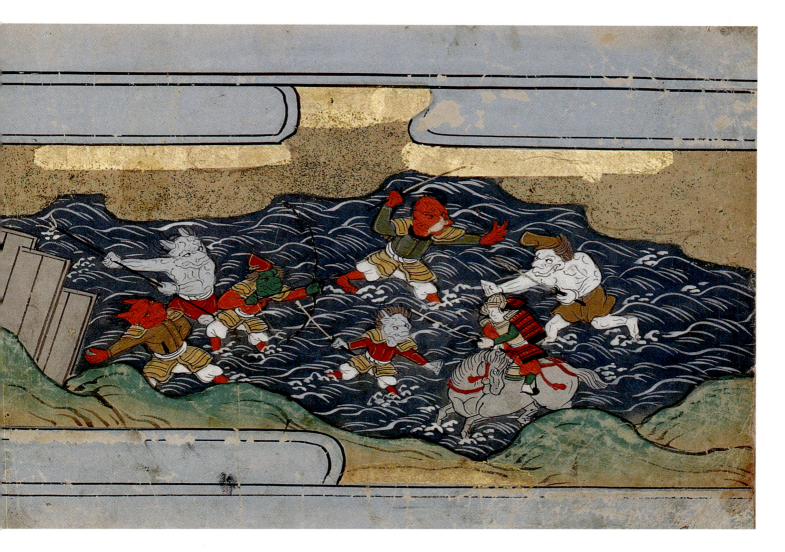

teenth and seventeenth century Japan.[19] It is a dramatic story reflecting the dangers of sailing across the treacherous sea separating Japan from the continent. These were very real threats in the seventh century when the story is set.

Taishokan, the powerful statesman Fujiwara no Kamatari (614-669),[20] had a daughter famous all across the 'Three Empires' of India, China and Japan for her beauty. With Taishokan's approval, she became the wife of the Chinese Tang emperor Taizong (r. 626-49). The image illustrated here depicts the moment the bride's palanquin arrives at the Tang imperial court (17). A devoted Buddhist, Taishokan's daughter sends treasures to her home country for the foundation of the Kofuku-ji temple in Nara, among them a jewel with magical power. However, eager to acquire the jewel themselves, the eight dragon kings send their army to attack the Chinese ships bringing the treasures to Japan (18). The Chinese soldiers successfully ward off the demons, but near the southern coast of Japan's Shikoku island, a dragon princess disguised as a beautiful girl seduces the Chinese general and manages to steal the jewel. Taishokan, therefore, determines to regain the jewel himself and sets out to Shikoku where he wins the friendship of a woman pearl diver (19). On the third birthday of their son, Fusasaki, he confesses to her that he needs her help to recover the jewel. On condition that their son Fusasaki will become the heir of the Fujiwara clan, the woman agrees to Taishokan's plan and dives down to the bottom of the sea, where the dragon kings have their palace. While a band of musicians on the shore distract the monsters, the pearl diver obtains the jewel. However, while making her escape, she is detected by one of the dragons and killed. When the dead body is washed to the shore, the villagers find a deep wound in her breast in which the dying woman has secreted the jewel. Thus the precious stone is rescued and taken to Nara to be set in the forehead of the Great Buddha of Kofuku-ji. A story of the female virtue of self-sacrifice, *Taishokan* as a *Nara ehon* was a popular wedding gift, and in this respect, the tale is the melodramatic counterpart of *Bunsho soshi*. The 'happy ending' in *Taishokan* is 'happy' only for the poor pearl diver's son, who, following Taishokan's promise, becomes heir of the Fujiwara.

The Frankfurt edition of *Taishokan* is a fragmented set of three volumes of relatively early

date, probably the mid-seventeenth century, and has a horizontal format. The cover is of dark blue paper delicately painted with a seascape: fishing nets and weir baskets in front, with three triangular sails hidden behind the waves in the background. The title strip is of crimson red paper and the inside cover has a slightly embossed geometric pattern of scattered *mon* – circular family crests, in this case the pair of stylised turtles of the Suharu family.[21]

An indication for the relatively early date of the book is the repetition of the framing fog-banks, which are composed of small strips of gold leaf, reminiscent of the gold and silver strips in the *Kumano no honji* (**15** and **16**), which probably dates some seventy years earlier. Compared to elegant later *Nara ehon* like the three-volume *detchoso Bunsho soshi* (**8, 9, 11** and **12**), the manner of painting figures and landscape appears somewhat less elaborate. The expression however is more naive, spontaneous and natural. This can be observed especially in the poetic scene by the sea in which Taishokan meets the pearl diver (**19**). This illustration shows a particular sensitivity for the relation of humans and nature: the woman in the boat and Taishokan, approaching her from the land, are echoed by two rocks on the upper left, two pairs of trees and the two golden strips of mist at the top. Both of the human figures seem to have their eyes lowered in shyness, their facial features only indicated by simple lines in the 'hook nose and single line eyes' style. However, the woman's left and the man's right hand raised towards each other are a clear indication of their affections. Furthermore, it is remarkable that the pearl diver is, as in all other illustrations showing her, rendered in plain white with a black contour. This can only be interpreted as an omen of her imminent death (white being the colour of death and mourning in East Asia).

The collection of *Yamato-e* in the Museum für Kunsthandwerk has been further enriched in the past two decades by the acquisition of a group of twelve fan paintings. The fans, now mounted in passe-partout, have been cut from an earlier mounting on paper decorated irregularly with small square gold particles, which probably once formed the surface of a nineteenth century folding screen. The fans themselves, however, date from the late sixteenth century and while rather similar in style are not all by the same artist. Of extremely fine quality, they surpass even the very best of the *Nara ehon*. We have already discussed one of the fans with the scene of 'Asagao' from the *Genji monogatari* (**5**) in its comparison to a *Nara ehon* with the same scene in the Chester Beatty Library (**4**).

Another recent acquisition of *Yamato-e* is a set of thirteen illustrations and five sheets of poems representing episodes from Fujiwara no Sada'ie's compilation of poetry, the *Mono-gatari hyakuban uta'awase*, which is variously dated to 1196 or 1206.[22] This late seventeenth century set has selected poems from the *Genji monogatari* and the *Sagoromo monogatari*. A detail from one of these shows Sagoromo presenting to the lady of his heart, Genji no Miya, a portrait of her which he has drawn himself while she was playing the *koto* (zither) (**2** and **20**). In the

19. Taishokan and the pearl diver, from Taishokan. Edo period, mid-17th century. Illustration from fragments of a three-volume Nara ehon, ink, colour and gold on paper, 16.5 x 23 cm (6 ½" x 9"). Museum für Kunsthandwerk, Frankfurt, 12799.

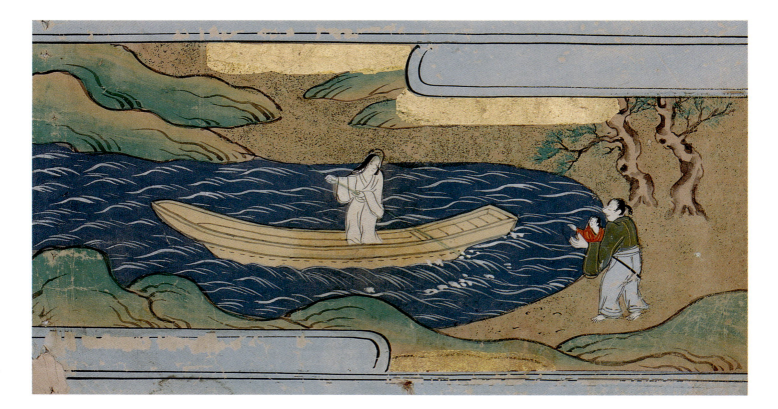

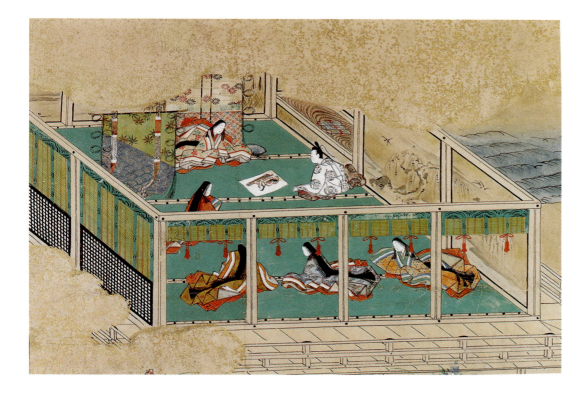

20. *Sagoromo offers a portrait to the lady of his heart, from* Monogatari hyakuban uta'awase. *Edo period, late 17th century. Detail from an album leaf, ink, colour and gold on paper, 32.5 x 50.5 cm (1' x 1'8"). Museum für Kunsthandwerk, Frankfurt, 16114.*

alcove above Sagoromo are three rolled-up scrolls, possibly illustrated narrative scrolls. This scene raises the question of how illustrated literature was read and how painting was viewed in ancient Japan. A detail from the early twelfth century *Genji monogatari* scroll shows a lady reciting a tale from a textbook while another is glancing at a separate volume containing the illustrations (**21**), indicating that it was not until sometime later that texts and illustrations were combined to form books, whether bound or in scroll form, of the *Nara ehon* type.

The Museum für Kunsthandwerk is presently preparing an extensive catalogue of its collection of *Yamato-e* books and paintings scheduled to be published in early 1998, possibly in conjunction with a travelling exhibition. We hope this project will deepen the understanding of one of the most fascinating chapters of Japanese art history in which there are still many secrets to be unveiled.

Notes see Appendix

21. *Section from the Azuma scroll of the* Genji monogatari emaki. *Late Heian period, early 12th century. Handscroll, ink and colour on paper, height 22 cm (8¹⁄₂"). Tokugawa Art Museum, Nagoya.*

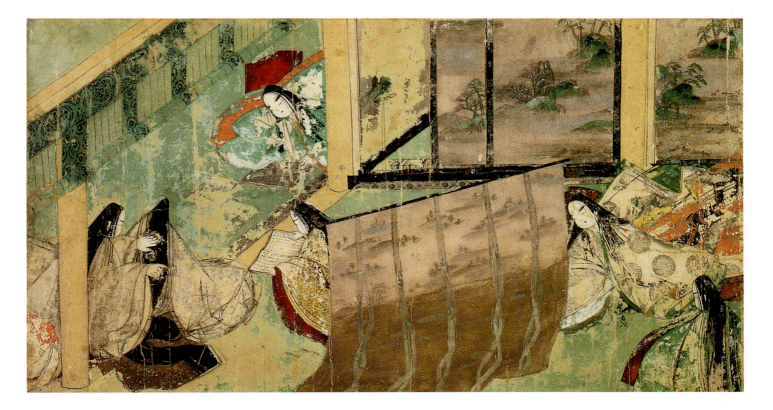

GLAMOUR AND RESTRAINT

Silver, Gold and Bronze from Mughal India

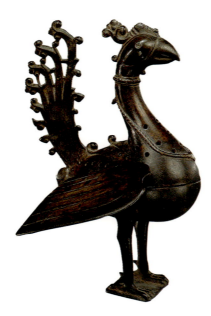

MARK ZEBROWSKI

In the sixteenth century the Mughal emperors, descendants of the great Timur, established a powerful and influential empire in the Indian subcontinent that would last for three centuries. They also helped to create a vibrant culture that has produced some of the most beautiful works of art the world has ever seen. Their metalwork has a jewel-like fineness and an exuberance that has yet to be matched, but, in contrast to the scholarly attention given to media such as miniature painting, it has received scant attention. The author's recently published *Gold, Silver and Bronze from Mughal India* is the first substantial study to deal exclusively with metalwork of the period.

1. *Title page: Incense burner in the shape of a peacock, Deccan, late 15th/early l6th century. Copper alloy, height 30 cm (12¹/₂"). Private collection.*

2. *Previous page: Dish with design of carnations around a central lotus blossom, North India, 17th century. Enamelled gold, diameter 19 cm (8"). The Hermitage Museum, St Petersburg, V3-705.*

Metalwork has always been to India what ceramics is to China, with the startling difference that until recently there had never been a major book or exhibition devoted to it. Although the subject is therefore largely unknown to the general public, Mughal silver, gold and bronze include some of the most exuberant, poetic and technologically refined objects produced anywhere. Glamour and restraint are forged into a unique blend that reflects the influence of Persian refinement on Indian taste during the reigns of the Mughal emperors from the sixteenth to the eighteenth century.

3. *Dish with design of a single lotus blossom, North India, 17th century. Enamelled gold, diameter 19.5 cm (8"). The Hermitage Museum, St Petersburg, V3-288.*

Even before this period, however, Persian influences had already reached India during the rule of the Turkish Sultans (1192-1526) – called the Sultanate Period. This long age of quiet gestation, when Islamic culture slowly sunk sturdy roots into Indian soil, was a necessary prelude to the brilliant Mughal epoch which followed close on its heels. Only a handful of outstanding objects have survived from Sultanate rule: among them two remarkable incense burners, both extremely sculptural, one in the shape of a peacock (1), the other a lion with an upraised paw (4).

The last and most important Muslim invaders of India were the Mughals, Central Asian Turks – descendants of Timur and Chinghiz Khan. In 1526, they established the richest and largest empire in nearly two thousand years, swiftly transforming both the conquered and the conquerors. For the first time in an Islamic state, Hindus were invited to join in government. Mughal kings married Hindu princesses. Religious tolerance was established. A new civilisation was born which in large part has determined present-day India. The empire's fortunes soared. Its coffers overflowed; commerce prospered. The Mughal treasury became the richest the world had known till then, and an opulent, cultured class arose not only at court but in all the cities of the realm. Patronage of the arts intensified. Most importantly, the Mughal rulers themselves, who had already been highly cultured as provincial Central Asian potentates, opened up profoundly to the outside world through contacts with European travellers and their own Hindu subjects, blossoming into patrons of art and literature of unique breadth, and far more international than any of their brother Muslim kings. Their example informed patronage throughout the empire.

In fact, during the reigns of the emperors Akbar (1556-1605), Jahangir (1605-1627) and Shah Jahan (1627-1658), India can be seen as entering a period of true renaissance comparable to the renewal which had just taken place in Europe. Great innovations occurred in painting with Indian artists incorporating influences from Iran and Europe. In the early decades of the seventeenth century, the arts passed into a classic phase, which, like all classical periods, was the epitome of poise, restraint and power. Suddenly, after the scarcity of objects from the Sultanate years, there is a relative abundance, not only in metal but in hardstone, glass, wood and mother-of-pearl. Metalwork, however, was pre-eminent. Hindus preferred metal objects, which they believed did not carry ritual pollution when passed through the hands of the country's myriad castes. The Mughals inherited this preference without realising its origins.

The mingling of Hindu and Muslim sensibilities gave Mughal silver, gold and bronze a rare, enduring power and the ability to delight us still today, just as religious tolerance gave political strength to Akbar and his successors. There is the attenuated, ethereal elegance of Islam married to the feeling for weight and volume that ultimately derives from India's great tradition of pre-Islamic Hindu sculpture. The latter was cut short by the Mughal invasion, but this taste for mass came to enrich the decorative arts. When all is said and done, it is the gravitas of Mughal objects which grips us so – a rich solemnity, a stillness, a simplicity and, strangely, a kind of glamour (2 and 3). It is the quality we hear in Indian classical music; we see it in the great pictures painted for the emperors Jahangir and Shah Jahan; we feel it in the sobriety of Mughal tombs and palaces. It is the mood of classical Gupta sculpture miraculously reborn after a thousand years.

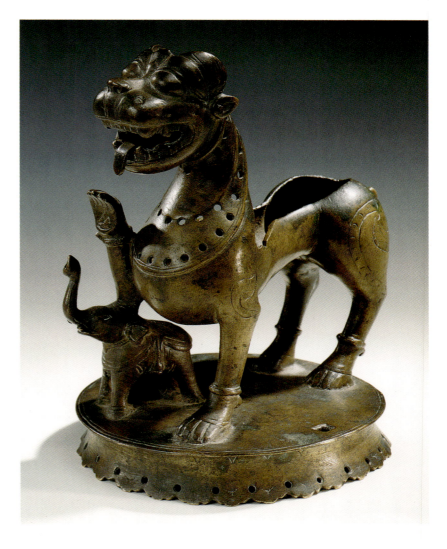

4. Incense burner in the shape of a lion, Deccan, 15th/early 16th century. Copper alloy, 17 x 15 cm (7" x 6"). Freer Gallery of Art, Washington DC, 1991.12.

As in India, objects made in the West during the Renaissance, and before, had a great emotional appeal and aesthetic originality. However, after the sixteenth century, they disappoint with their merely decorative appeal and limited aesthetic content. Attention shifted to oil paintings and sculpture, and a distinction was made between the 'fine arts' and the 'minor arts'. Hardstones, metalwork, ceramics and textiles became, quite simply, 'minor'. The largely abstract objects of India and Islam embodied in their day the same strong emotions which paintings do (or did until recently) in the West. They were prized among princes, and they caused sensations outside their own cultures, both in Europe and China. How else can we account for the number and quality of Mughal pieces in the ducal col-

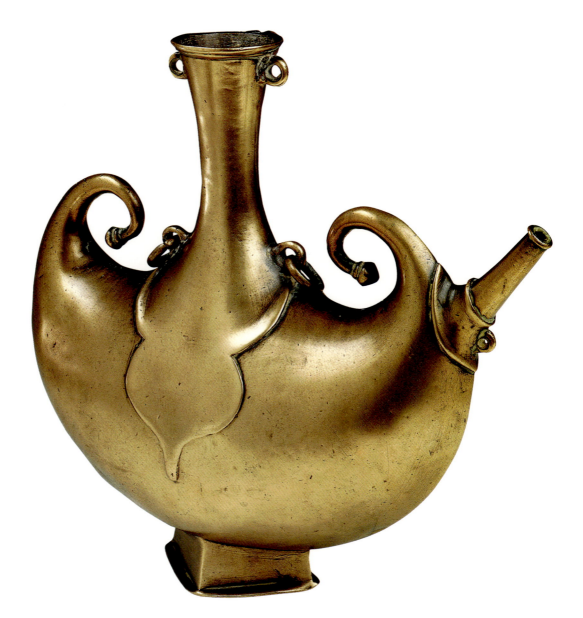

5. *Pilgrim flask, North India, 16th/17th century. Copper alloy, 25.5 x 27 cm (10¹/₂″ x 11″). David Collection, Copenhagen, 18/1992.*

lections of the Bargello and the Pitti Palace in Medici Florence, the treasury of the Kings of Saxony in Dresden, or the superb paper thin jades from India owned by the Chinese emperors now largely preserved in Taipei, the Mughal textiles and carpets so perfectly preserved in Japanese temples that they look new, and the mother-of-pearl furniture of Indian manufacture in the Topkapı Saray and the Santa Sophia treasury in Istanbul?

It is significant that in the eighteenth century, after prolonged contact with the West, the grave and grandiose qualities of decorative arts in Mughal India also declined, to be replaced by seductive glitter and flimsy elegance, a charge that can still be put against Indian objects made today. Compare an eighteenth century domed box for betel nut *(pandan)* or water pipe *(huqqa)* with one from a century before: both the size of the object and the scale of its ornament have shrivelled! The decorative arts, as in the West, were quite literally becoming the *minor* arts.

The majority of the objects discussed here, and even the styles they represent, have never

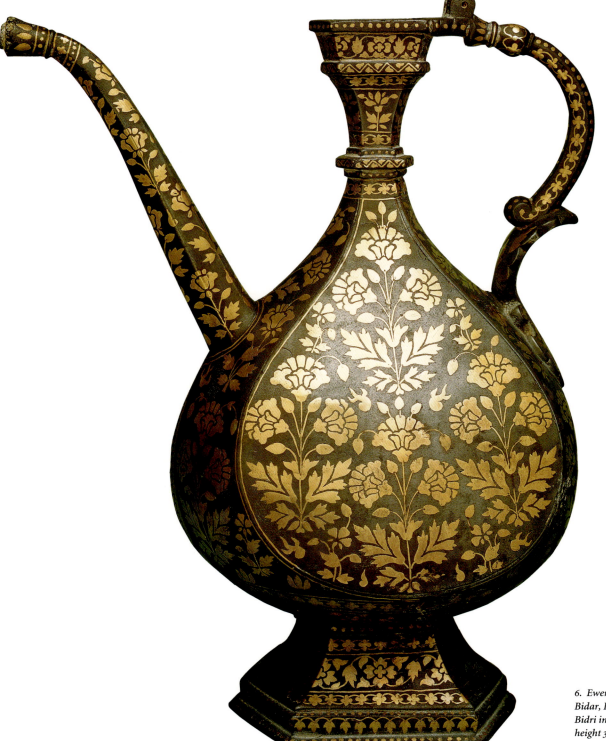

6. *Ewer with design of poppies,*
Bidar, Deccan, 17th century.
Bidri inlaid with brass,
height 30 cm (12¹/₂"). Spink
and Son Ltd., London.

before been published. So many rites, customs, habits and pastimes filled life to the brim in this super-refined age; and miraculously, just as many beautiful objects evolved for the stylish functioning of these activities. To wash one's hands before meal time or before Muslim prayer, behold the myriad kinds of ewer, each one pure elegance materialised (**5** and **6**). In the early seventeenth century, the smoking of tobacco suddenly caught on and opulent round *huqqas* at once sprang forth from the ancient water vase *(lota)* shape to hold scented water for cooling and perfuming hot smoke. After a little more than a century, all fashionable gentlemen and ladies switched *en masse* to bell-shaped *huqqas* (**7**). The ancient Indian practice of chewing rolled, stuffed betel-leaf *(pan)*, rages unabated till today. For this, the Mughal craftsmen devised the domed container called the *pandan* – resuscitating in miniature the ancient Buddhist stupa shape which had lain dormant in their dreams for a thousand years (**8**, **11** and **12**). To sweeten the air and to protect against the evil eye, incense burned in the *ud dan*, or incense burner, some of which were splendidly architectural, shaped like little domed

7. Bell-shaped huqqa base,
North India, late 18th century.
Silver gilt with multi-coloured
enamels, 20 x 22 cm (8½" x 9").
Private collection.

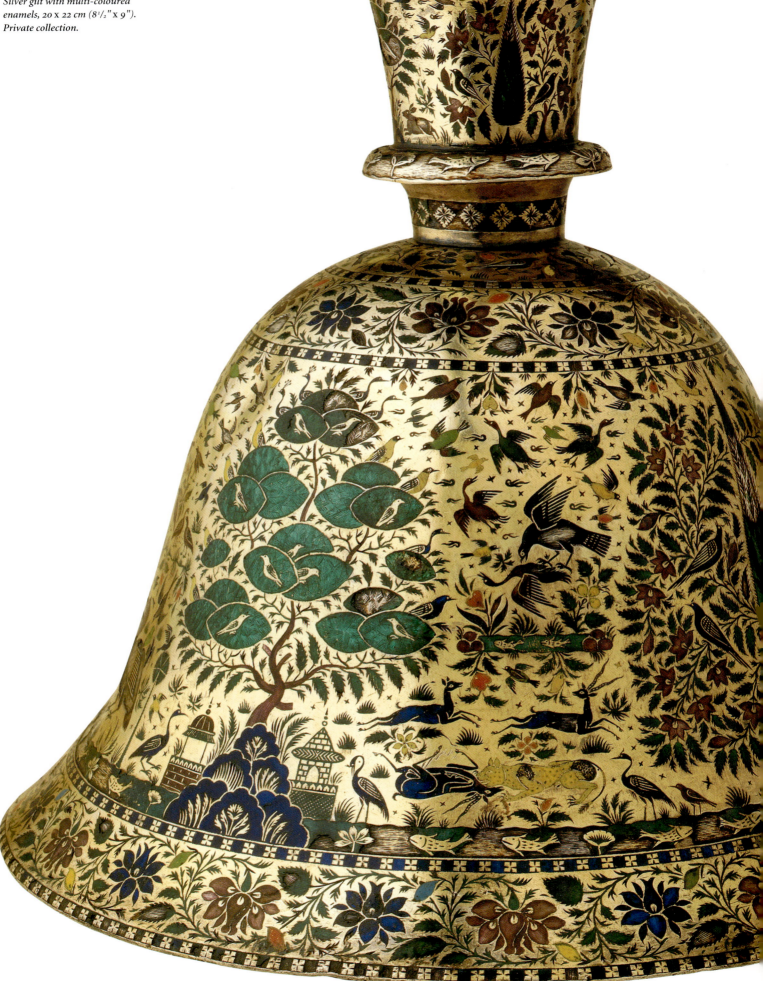

mausolea. Others, hitherto completely unrecorded, have the shape of birds (**1**) or animals (**4**), related to Middle Eastern tradition but with a more developed Indian plasticity. They represent almost the only free-standing, secular, zoomorphic sculpture of the period. One of the most striking of these bronze birds, and the one closest to Middle Eastern styles, is a great bronze dove with unfurled tail (**10**), which is not a vessel at all, but is said to have been the finial of a dovecote in the province of Gujarat.

This great diversity of shapes is matched by an equal diversity of techniques and materials. Many of the items which have survived are of various copper alloys, what is popularly known as 'brass' or 'bronze', brass containing some zinc, and bronze containing more tin. As zinc is much more common in India than tin, except in the far south, most pieces are probably of brass. The true bronze to be found in the south is often termed 'bell-metal' because it has such extraordinary resonance. In the absence of a detailed analysis of the metal content of the pieces under discussion, however, I have used the less precise term 'copper alloy'. Another unique feature of Mughal metalwork is *bidri*, the black alloy composed mainly of zinc from Bidar in the region of the Deccan. When inlaid with copper, brass and silver, it has the sombre yet fabulous air present also in early Deccani painting. It was developed to rival the opulently inlaid metal wares of the medieval Middle East. Outstanding examples of *bidri* are a sharp-edged ewer inlaid with brass poppies (**6**), the domed gadrooned *pandan* in the Salar Jang Museum in Hyderabad (**12**) and the great tray, with eye-catching chevron ornament, probably made to support a spherical *huqqa*, also in the Salar Jang Museum (**13**).

Most Indian silver has long since been melted down, and only a handful of pieces can be dated to the seventeenth or eighteenth centuries. The vast majority of surviving objects are nineteenth or twentieth century. A rose-water sprinkler in the Virginia Museum of Fine Arts in Richmond, with designs of squirrels leaping through a leafy meander, and a tall spire like an elegant minaret, can be dated to the seventeenth century on stylistic grounds (**14**). A second rose-water sprinkler in the Freer Gallery of Art in Washington DC, has the shape of the baluster pillars found in seventeenth century Mughal palaces. However, the baroque rather than streamlined character of the ornament, consisting mainly of irises, acanthus leaves and peacocks, inclines me to place it in the eighteenth century (**16**). Traces of gilding survive on both pieces.

A few gilt copper items have recently come to light, usually cast and sometimes open-work, like the pierced stone *jali* screens which function as windows in Indian palaces. Unknown in Iran, Indian gilt copper gleams with the honey-coloured hues of the *tombak* wares of Ottoman Turkey to which they are technically similar and for which they are usually mistaken. A gilt copper open-work *pandan* sitting on a matching tray in the possession of Spink and Son, London, has the stately, ornate flowers of the classical period of Mughal art (**11**). In fact, the inspiration for each floral panel is architectural, recalling the windows in Mughal palaces and tombs. Like pierced windows which permit the passage of cool breezes into the interior of a building without the entrance of harsh sunlight, the pierced walls of this *pandan* permitted the air to enter the vessel and to keep the *pan* leaves inside fresh and cool. The stylised flowering plants have that slow and heavy grace which characterised the arts of the reign of the emperor Shah Jahan (1627-1658) when Hindu plasticity blended happily with Islamic and Italianate taste.

A large proportion of the vessels actually used by the emperor, his family and their households were either of jade or of solid gold, the latter usually enamelled and set with gems. In India, most metal objects, from the earliest bourgeois bronze to the most royal gold, were melted down once they had incurred the slightest damage or simply if fashions changed. This relentless consignment to the fire is the reason for the rarity of such items from millennia of recorded Indian history, compared to the abundance of analogous pieces from neighbouring Iran. Gold objects

8. Pandan and tray with design of flowering rose bushes, North India, 17th century. Enamelled gold, pandan: diameter 15 cm (6 ¹/₂"), tray 33 cm (14"). The Hermitage Museum, St Petersburg, V3.706,707.

9. A Mughal Prince at his Bath (detail), ca. 1700, colours and gold on paper. Private collection.

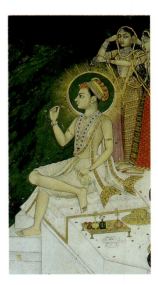

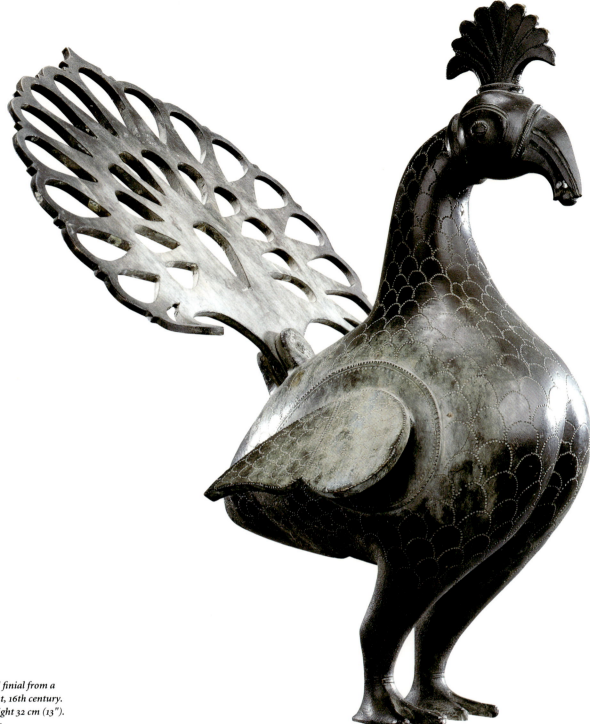

10. Dove-shaped finial from a dovecote, Gujarat, 16th century. Copper alloy, height 32 cm (13"). Private collection.

were, of course, especially at risk because of their higher intrinsic value, and therefore constitute the rarest group of metalwork.

Because of these practices, no imperial Mughal gold objects survive in India itself – at least they are not recorded. A few pieces of probable royal origin are in the Khalili Collection in London, the al-Sabah Collection in Kuwait, the Topkapı Saray in Istanbul, and some British and American museums; the whole number not amounting to more than a handful. But by far the most significant group of gold pieces survives in the Hermitage Museum in St Petersburg. Consisting of seventeen pieces and one ring, they represent an infinitesimally small portion of the booty which the Persian conqueror Nadir Shah looted from the imperial Mughal treasury when he invaded India in 1739. I certainly cannot condone pillage and plunder, but because of such violent actions, an important number of truly wonderful objects left Delhi and were almost immediately checked into a royal collection which has been saved for posterity. They can still be admired in the northern metropolis of Russia. Nothing comparable remains in India, and nothing in its original state survives in Iran, although gems removed from other Mughal pieces looted by Nadir Shah were probably reworked into

the Iranian crown jewels, now kept in Tehran.

But how did such extraordinary treasures destined for Iran find their way to relative safety in far-off Russia? Nadir Shah was a man of such astounding energy that had he ruled a few centuries earlier, he might have blazed along the glorious paths of such world conquerors as Chinghiz Khan or Timur. He expelled the Russians and the Ottoman Turks from Iran, conquered Central Asia and Oman, and marched towards India, officially to quell the troublesome Afghans along the border. On February 13, 1739, he defeated the indolent Mughal emperor Muhammad Shah (1719-1748), took him prisoner and then entered Delhi, the hitherto undisturbed repository for the vast loot accumulated by the Mughals from all their conquests since the days of Akbar in the sixteenth century. The palace vaults were opened, and Nadir spent two months in the capital

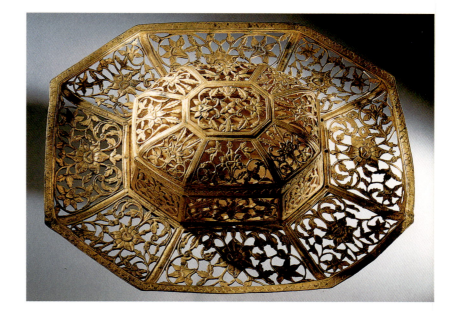

collecting an official indemnity of eighty crores. The crore, an old Persian measure, still used in India, equals ten million rupees. Eighty crores in the eighteenth century was an unheard of sum, the rough equivalent today of many billions of dollars or pounds, and easily the largest fortune ever amassed till then. In addition, the Persian army squeezed even more – and that is of course immeasurable – from the nobility and populace at large.

Departure for Iran laden down with so much baggage, cash and objects proved much more difficult than Nadir Shah's arrival in India. The five rivers of the Punjab had to be forded. Much was lost during the first months of the retreat, either jettisoned by the wayside or stolen by the peasantry of the area. However, Nadir managed to get so much back to Iran that he excused his Persian subjects from taxes for three years. Included in the booty that made it back to Iran were, of course, innumerable famous jewels, for example the Koh-i-Nur diamond, and jewelled objects like the Peacock Throne of Shah Jahan which alone had cost nearly three crores to manufacture. Some sources mention nine other bejewelled, gold thrones belonging to previous emperors; others say sixteen. Nearly seven hundred elephants carried away the un-itemised loads, in addition to countless camels, mules, horses and oxen.

Just before crossing the last great obstacle of the Punjab, the Indus river itself, a singular event occurred. Nadir decided to send embassies to 'Rus' and 'Rum' (Russia and Turkey), the enemies he had just expelled from Iran. According to some sources, the purpose of these embassies was to inform Tsar and Sultan of the conquest of India and of the return of the 'world-conquering' army back to Iran and closer to their borders, thus a thinly veiled threat. However, according to other sources the threats were more direct: Nadir Shah announced, with these embassies, his resolve to conquer both Turkey and Russia and to warn both countries to prepare for war!

It was these very embassies which carried the important pieces of Mughal gold to Istanbul and to St Petersburg, thus ensuring their survival. Presents of equivalent value (12,000 *tumans*) were sent to each destination, including jewels, bejewelled vessels and elephants. Court historian Mirza Khan Astarabadi recorded: "[Nadir Shah] had it in his mind…to send …choice goods from this country [India]." The ambassadors with large retinues bearing the gifts left India in October 1739. A list surviving in the Russian archives, written when the embassy arrived in St Petersburg in October 1741, mentions twenty two objects, fifteen rings and four-

11. Pandan and tray with openwork floral decoration, North India, 17th century. Gilt copper, 26.5 x 23.5 cm (11" x 10"). Spink and Son Ltd., London.

12. Pandan, Bidar, Deccan, 17th century. Bidri inlaid with brass and silver, diameter 14 cm (5½"). Salar Jang Museum, Hyderabad.

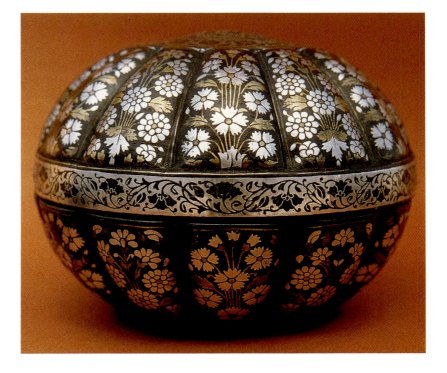

13. *Tray with chevron design,
Bidar, Deccan, 17th century.
Bidri inlaid with brass and silver,
diameter 33 cm (14"). Salar Jang
Museum, Hyderabad.*

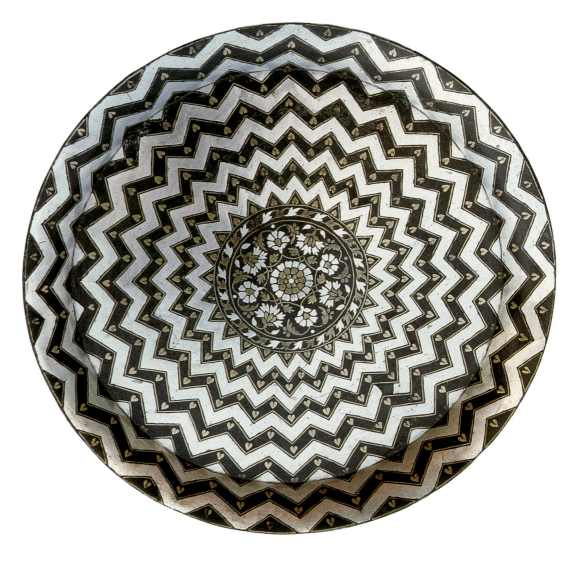

14. *Rose-water sprinkler with
design of squirrels in a leafy
meander, North India, second
quarter 17th century. Silver gilt,
height 33 cm (14"). Virginia
Museum of Fine Arts, Richmond.*

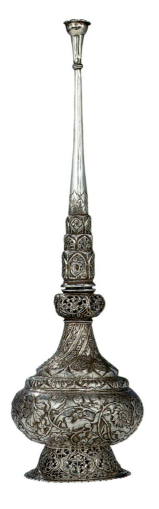

teen elephants, of which only seventeen objects and one ring are now accountable. It took two years for the embassy to arrive in Russia, probably because of the problems involved in marching fourteen elephants over such a vast distance!

Three gold enamelled dishes of modest size in the Hermitage's Nadir Shah group (their average size slightly more than nineteen centimetres in diameter) are costlier versions of the dramatic *bidri* tray we have already admired **(13)**. One is strewn with concentric rows of red carnations against a plain gold ground **(2)**. The effect is dramatic, opulent and – in terms of design – extremely serious and restrained. The red, green and white enamelling is confined to the flowers, the central lotus and an elegant meander round the edge. The second dish is the most dramatic of all: a single, giant, full-blown lotus fills the entire field and, except for the central roundel, enamelling covers the whole piece so that the gold of the base does not show at all **(3)**. This favourite Indian flower brings to mind the monumental stone lotus roundels at the ancient Buddhist stupas of Sanchi and Amaravati in India from nearly two thousand years before. These flowers were symbols of *bodhisattvas*, pure beings who, unsullied by the filth of this world, choose to remain in it to inspire less advanced creatures. Similarly, lotus flowers have a beauty undimmed by the mud of the swamp in which they grow. Such Hindu and Buddhist motifs were still very much alive in Mughal India though we can hardly suppose their ancient meanings had survived.

A slightly larger gold dish in the same collection far surpasses the impact of the others **(15)**. Against pure white enamel, spinels and emeralds form flower heads of convincing weight and volume, contrasting with the un-enamelled gold surface of the centre. These gem-studded poppy plants, seeming to sway to subtle rhythms, give an effect of such potent and severe classicism that one is tempted to see this plate in the old Indian tradition of a great abstract *mandala*, a tool, if not for meditation, than at least for the most profound reverie. Its amazing quality puts it into a class well above most other Mughal objects, more akin to the finest carved marble dados of pietra-dura work in Mughal palaces. In fact the plate's milky white enamel is analogous to the fashion for white marble architecture popularised by the emperor Shah Jahan in the mid-seventeenth century and must fall within his reign and circle.

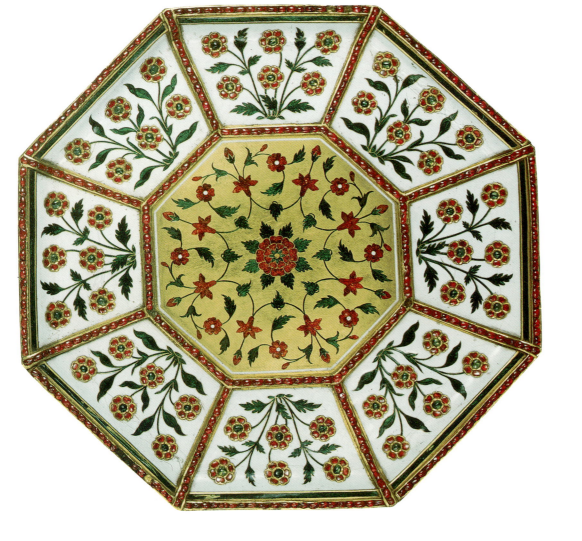

15. Octagonal dish with design
of poppies, North India,
17th century. Enamelled gold,
diameter 31 cm (13"").
The Hermitage Museum,
St Petersburg, V3-724.

16. Rose-water sprinkler with
design of irises, acanthus leaves
and peacocks, North India, first
half 18th century. Silver gilt,
height 28 cm (11 ¹/₂""). Freer Gallery
of Art, Washington DC, F.1990.1.

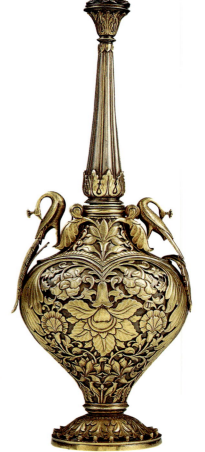

Less serene is the gold *pandan* and matching tray in the same collection which combines
the techniques of champlevé and cloisonné enamel (**8**). Again the milky white enamelled
background recalls the white marble walls inlaid with designs of flowering plants in the
palaces of Shah Jahan. The piece superficially resembles a *pandan* and tray of circa 1700 in
the Khalili Collection, but the former's ornament of red rose bushes with carefully serrated
leaves is so much closer to nature, unlike the repetitive decoration of the other, that an
earlier, mid-seventeenth century date is likely.

A similarly conceived polygonal gold *pandan* on a tray is depicted in a painting where it
lies at the feet of a young Mughal prince enjoying a cooling bath at the side of a well (**9**). His
radiance is enhanced by a Timurid halo exactly like the one often favoured by Jahangir in his
portraits: an effulgent solar disk combined with a crescent moon at bottom. He may be a son
or a grandson of the emperor Aurangzeb (r. 1658-1707). As beautiful country girls serenade
him, and shower him with gems – a compliment no doubt to his charms – we note within
his reach a round blue-and-white ceramic *huqqa* on a ring, a small blue-and-white spittoon,
a low table, perfume bottles, a lidded cup and various rose water sprinklers.

Recently, a gold enamelled covered bowl and dish appeared on the London art market
from the collection of the 6th Marquis of Bute (**19**). The very dense design of sensitively
observed red crocus flower heads, depicted just at the moment when the first petal has
separated itself from the bud – a motif found in printed and painted cotton textiles –
suggests a date of about 1700. The quality of the white enamelling derives from the taste
of Shah Jahan, but unlike the other pieces we have discussed, the enamel here is applied
in such a way to the gold base that the latter appears through the enamel in elegantly
undulating parallel lines giving the feeling of waves of water supporting the blossoms. Along
the rim of the cover is the Ottoman Turkish motif of *çintamani*, probably inspired by
Ottoman textiles exported to the Mughal court. The qualities of opulence joined to great
restraint in colour and design place these pieces amongst the most satisfying objects to have
survived from the Mughal court.

The comparable items sent by Nadir Shah to the court at Istanbul, the 'Sublime Porte',

17. *Durbar of the Mughal Emperor Muhammad Shah (1719-48), Mughal or Kishangarh, ca. 1730. Colours and gold on paper, 33 x 24 cm (14" x 10"). Private collection.*

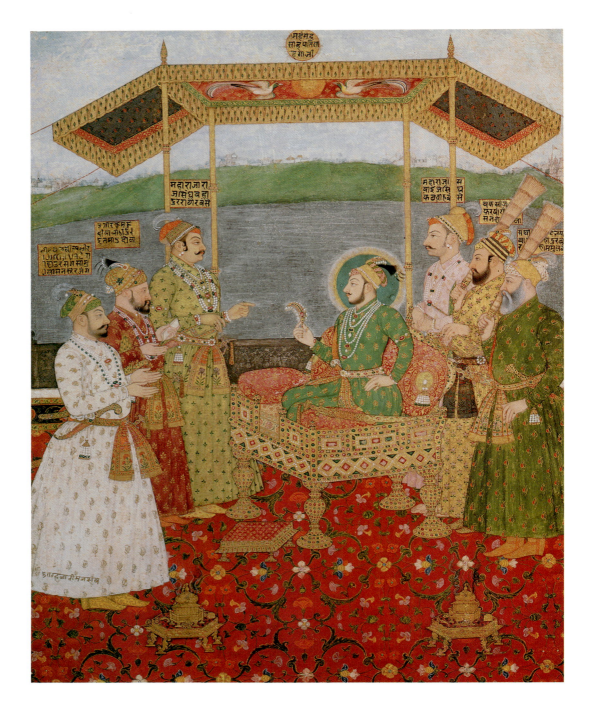

cannot be so easily accounted for. The only significant early Mughal piece – and this is of utmost significance – is the magnificent throne of Muhammad Shah (**18**). Lists of items presented in 1741 and 1746 by Nadir Shah to the Sultan of Turkey have been published and include, respectively, an "octagonal box of gold, covered with white enamel" – perhaps like the *pandan* with matching tray in St Petersburg (**8**) – and a "golden Indian throne inlaid with rubies and pearls", which is perhaps the very Indian throne preserved in the Topkapı. This throne is undoubtedly the largest and most important vestige of Mughal India. It is of the bed-like, platform type favoured in the subcontinent, with a back in the elegantly cusped 'Chinese' form. Its low parapets resemble the low walls of Indian palace terraces with horizontal panels alternating with upright posts crowned with fruit-like finials, here all rubies set in gold. The panels themselves bear extraordinary enamelling in red, dark green and a wonderfully delicate shade of chartreuse, set with jewelled plants and arabesque. The feet are splendidly robust versions of the Mughal baluster pillar, akin to the shape of the silver rose-water sprinkler in the Freer Gallery (**16**). The whole is of such impeccable quality, costliness of materials and harmony of design that there can be no doubt that this throne is one of the royal pieces sent to Istanbul by Nadir Shah. However, despite its typically Mughal style and the published lists of Nadir Shah's gifts which include "a golden Indian throne inlaid with rubies and pearls", both its Indian origins and its high quality have recently been placed in doubt by the catalogue entry for the Topkapı Saray Museum Treasury:

...set with pearls, rubies and emeralds, some in Ottoman mounts [!]. Unlike the fine Mughal enamels which are polychrome and generally basse-taille...The history and provenance are obscure, but the tradition that this throne was presented by Nadir Shah, the conqueror of India,...is entirely without foundation...The workmanship is difficult to date, but is provincial in quality and very probably no earlier than 1800.

This is simply not the case: this throne vies with the Hermitage enamels as the finest imperial Mughal objects in existence. And the published lists of Nadir's gifts suggest that this is the very throne sent in 1746. Furthermore, a portrait of the conquered Mughal emperor Muhammad Shah, whose thrones and treasures provided Nadir Shah's gifts, depicts the indolent ruler sitting upon a throne nearly identical to this one (**17**). Allowing for the distortions of poetic licence – a few details of ornament vary – we can safely assume that this picture depicts either the Istanbul throne itself or one just like it.

The jewel-studded vessels in St Petersburg and the throne of Muhammad Shah in Istanbul exhibit the same nonchalance in regard to the intrinsic worth of the gems from which they are constructed. Similar royal objects from the Ottoman court in the Topkapı Saray – analogous Safavid objects have not survived – display profound differences. They shout their preciousness through a different aesthetic and a different technique. Complicated gold settings raise each stone well above the surface of the vessel, lending it great prominence as well as isolating it from its neighbours. So with relatively few stones Turkish craftsmen were able to create a dramatic effect, like that of a heap of jewels, but they failed to produce harmonious patterns in colour or line. In the Indian pieces (**2**, **3**, **8**, **15** and **19**) the opposite is true. As in all great Indian art, serenity is sought and artistic values prevail over brash displays of wealth. The surface of each item is so densely packed with stones in such narrow, masterfully worked settings that baroque tendencies are minimalised. Instead fluidity and calm predominate. The surfaces of these gem-set vessels are usually so flat – like a perfectly joined mosaic – that we can hardly believe at first that we are dealing with so many precious individual stones.

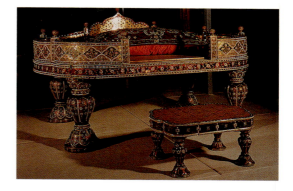

18. Throne of the Mughal Emperor Muhammad Shah (1719-1748), North India, 17th/ early 18th century. Enamelled gold, 155 x 120 x 95 cm (5'4¹/₂" x 4'2" x 3'3¹/₂"). Topkapı Saray Museum, Istanbul, 735.

19. Covered bowl and dish, North India, c. 1700. Enamelled gold, 8 x 13 cm (3" x 5¹/₂"). Formerly Collection of the 6th Marquis of Bute. Courtesy Christie's, London.

APPENDIX

Acknowledgments, notes, bibliographies

1 THE WORLD IS A GARDEN
Pages 8-25

I should like to express my thanks to Robert Skelton and Ralph Pinder-Wilson who helped to obtain colour photographs of some of the objects here published.

NOTES

1. For Timurid architecture see Lisa Golombek and Donald N. Wilber, *The Timurid Architecture of Iran and Turan*, Princeton, 1988, 2 volumes, and Bernard O'Kane, *Timurid Architecture in Khurasan*, Costa Mesa, 1987.

2. For Timurid painting see Ivan Stchoukine, *Les Peintures des manuscrits timurides*, Paris, 1954, and Basil Gray (ed.) *The Art of the Book in Central Asia*, Paris and London, 1979; see also Thomas W. Lentz and Glenn D. Lowry, *Timur and the Princely Vision, Persian Art and Culture in the Fifteenth Century*, exhibition catalogue, Washington DC, 1989, for a large number of colour illustrations of architecture, architectural decoration, paintings and objects of Timurid art. On Timurid bookbindings see Oktay Aslanapa in Gray (1979), cit., pp.59-91, and Mehmet Aga-Oglu, *Persian Bookbindings in the Fifteenth Century*, Ann Arbor, 1935.

3. See Linda Komaroff, *The Golden Disk of Heaven: Metalwork of Timurid Iran*, Costa Mesa and New York, 1992, and Assadullah Souren Melikian-Chirvani, *Islamic metalwork from the Iranian World, 8th-18th Centuries*, Victoria and Albert Museum catalogue, London, 1982, Chapter IV.

4. See Ernst J. Grube, 'Notes on the Decorative Arts of the Timurid period', *Gururajamanjarika, Studi in onore di Giuseppe Tucci*, Naples, 1974, pp.233-279, pls.24-111 [*Tim. Dec. Arts, I*]; id., 'Notes on the Decorative Arts of the Timurid Period, II', *Islamic Art*, III, 1988-1989, pp.175-208, and pls.11-12 [*Tim. Dec. Arts, II*], and id., 'Notes on the Decorative Arts of the Timurid Period, III: Timurid Pottery', ibid., V, 1997 [*Tim. Dec. Arts, III*] [in press].

5. See Beatrice Forbes Manz, *The rise and rule of Tamerlane*, Cambridge, 1989.

6. For the manuscripts made for and attributable to Iskandar Sultan see Stchoukine, op. cit., pp.40-42; also Eleanor Sims, 'The Timurid Imperial Style: Its Origin and Diffusion', *Art and Archaeology Research Papers*, 6, 1974, pp.56-67, and Priscilla Soucek, 'The Manuscripts of Iskandar Sultan: Structure and Content', *Timurid Art and Culture: Iran and Central Asia in the Fifteenth Century*, Lisa Golombek and Maria Subtelny (eds), Leiden, 1992, pp.116-131 (*Studies in Islamic Art and Architecture*, Supplement to *Muqarnas, VI*).

7. For the general history of this period see the various chapters by H.R. Roemer in *The Cambridge History of Iran*, Volume 6, 1968; for the Turkmans see also Faruk Sümer, *Oğuzlar (Türkmenler)*, Ankara, 1972, and John E. Woods, *The Aqquyunlu, Clan, Confederation, Empire, A Study in 15th/9th Century Turko-Iranian Politics*, Minneapolis and Chicago, 1976. See also *A Century of Princes, Sources on Timurid History and Art*, Selected and Translated by W.M. Thackston, Cambridge, MA, 1989.

8. For the crucial position of Timurid painting in the history of painting in the eastern Islamic world see Ernst J. Grube, *The Classical Style in Islamic Painting, The early school of Herat and its impact on Islamic Painting in the later 15th, the 16th and 17th centuries*, Lugano, 1968 (a revised edition will appear in the author's *Studies in Islamic Painting and the Decorative Arts*, London, 1997); for a similar approach concerning the pottery of the period see the author's forthcoming article in *Islamic Art V*, cit.

9. See E. Bretschneider, *Mediaeval Researches from Eastern Asiatic Sources*, II, London, 1967, Part IV: 'Chinese intercourse with the countries of Central and Western Asia during the fifteenth and sixteenth centuries'. See also id., 'Notes on Chinese Mediaeval Travellers to the West, II: Record of an Embassy to the Regions of the West', *The Chinese Recorder and Missionary Journal*, V, 1874, pp.305-327, and ibid., VI, 1875, pp.1-22. For Chinese trade with 'the West', see Paul Pelliot, 'Les grands voyages maritimes chinois au début du XVe siècle', *T'oung-Pao*, XXIX, 1932, pp.237-452; id., 'Encore à propos des voyages de Tcheng Houo', ibid., XXXI, 1935, pp.210-222; and id., 'Notes additionelles sur Tcheng Houo et sur ses voyages', ibid., XXXI, 1935, pp.274-314; see also J.J.L. Duyvendak, 'The true dates of the Chinese maritime expeditions in the early fifteenth century', *T'oung Pao*, XXXIV, 1938, pp.341-412. For Timurid embassies to China see *A Century of Princes*, cit., pp.279-297; see also *A Persian Embassy to China, Being an Extract from Zubdatu't Tawarikh of Hafiz Abru*, trans. K.M. Maitra, New York, 1970 (originally published Lahore, 1934), on the 1419 mission.

10. See Grube, *Tim. Dec. Arts, I*, figs.40-41, and 142; id., *Tim. Dec. Arts, II*, figs.33-36.

11. See Aga-Oglu, op. cit., pls.I, IV, XII, and Aslanapa, op. cit., pl.XVII, and figs.34, 39, 41-43, 51.

12. See Grube, *Tim. Dec. Arts , I*, figs.104-114, cit., and id.,*Tim. Dec. Arts, II*, figs. 9-11, cit. Also Ralph Pinder-Wilson, 'Jades from the Islamic World', *The World of Jade*, Stephen Markel (ed.), Bombay, 1992, pp.35-48.

13. For this group see Grube, *Tim. Dec. Arts, II*, figs.2, 7-8, 12-14, 18-19.

14. Grube, *Tim. Dec. Arts, I*, figs.80-81, and id., *Tim. Dec. Arts, II*, fig.17 and Komaroff, op. cit., nos.4-5, 7.

15. See Grube, *Tim. Dec. Arts, II*, figs.42-47, 52, 55-57.

16. For Timurid textiles see Lentz and Lowry, op. cit., and Louise Mackie, 'A Piece of the Puzzle, A 14th-15th Century Persian Carpet Fragment Revealed', *Hali* 47, 1989, pp.16-23. For the so-called 'cloud-collar', see Schuyler V.R. Cammann, 'The Symbolism of the Cloud Collar Motif', *Art Bulletin*, 33, 1951, pp.1-7, and John E. Vollmer, 'Technical and Ethnic Considerations of Costume Depictions in the Istanbul Albums H. 2153 and 2160', *Islamic Art*, I, 1981, pp.136-144. For depictions of this motif in paintings of the 14th century see ibid., figs.40, 42, and 44E, for examples of the beginning of the 15th century ibid., figs.128-130, 132. See also the painting in a *Shah-nameh* manuscript, dated 1370 AD in which the cloud-collar already appears, see Basil Gray, *Persian Painting*, Geneva, 1961, p.63.

17. Moscow, Kremlin Treasury, TK-3117, see Lentz and Lowry, op. cit., pp.216-217, and pp.354-355, cat.no. 116. The piece was first published by F.R. Martin, *Figurale persische Stoffe aus dem Zeitraum 1550-1650*, Stockholm, 1899, p.15, and pl.X; it was shown in the *Ausstellung von Meisterwerken muhammedanischer Kunst in München 1910* (cat.no. 2349), Munich, 1912, pl.206, in both cases it is attributed to Persia and dated to the 16th century; an attribution and date also suggested in the *Survey of Persian Art*, Oxford,

1939, pl.1017. Friedrich Spuhler, in *The Cambridge History of Iran*, 6, 1986, p.721, was perhaps the first to suggest a Timurid date for the object.

18. For a brass jug made for Sultan Hussayn by Shams al-Din al-Ghuri in 903/1498, in the British Museum, 1962-7-18.1, see Komaroff, op. cit., pp.179-1180, no.12.

19. For the Shrine of Khwaja Ahmad Yasavi in Yasi (Turkestan), built between 1397 and 1399, see Hagim-Bek Nurmukhammedov, *Mavzolei Khozhi Akhmeda Yasevi* (The Mausoleum of Hodja Ahmed Yasevi), Alma-Alta, 1980, and Golombek and Wilber, cat.no. 53, pp.284-288; for the metal objects see Komaroff, op. cit., pp.17-49, and pp.240ff., but see also A.A. Ivanov, 'O bronzovykh isteliyakh kontsa XIV v. iz Mavzoleya Khodzha Akhmeda Yasevi' (14th century bronze objects in the Mausoleum of Ahmad Yasavi), *Srednyaya Aziya i ee Sosedi v drevnosti i srednevekov'e (istoriya i kult'tura)*, Moscow, 1981, pp.68-84, where some of the engraved inscriptions are questioned.

20. Komaroff, op. cit., pp.160-161, no.5.

21. For manuscript illumination of the period see Oleg F. Akimushkin and Anatol A. Ivanov, in *The Art of the Book in Central Asia*, cit., pp.35-57.

22. Istanbul, TKS, H.676; for the manuscript see Zeren Akalay, 'Emir Hüsrev Dehlevi'nin 1496 yilinda min-yatürlenmis Heşt Bihişti', *Sanat Tarihi Yıllığı*, VI, Istanbul, 1976, pp.347-373; the binding was first published by Grube, *Tim. Dec. Arts, I*, figs.141 and 141b; see also Aslanapa, op. cit., pls.XVII-XVIII.

23. Istanbul, TKS, Treasury, 2/1846; the piece was first published by Grube, *Tim. Dec. Arts, I*, figs.144-145; also id., *Tim. Dec. Arts, II*, figs.21-26, 31, 37-38; and Lentz and Lowry, p.142, 207, and p.339, cat.no. 49.

24. Serai Mulk Khanum was the daughter of Kazan Sultan Khan of Turkestan and Maverannahr, a direct descendant of Chinghiz. Timur had, in fact, adopted this title himself; see for this Bretschneider, op. cit., p.256, note 1059.

25. Calouste Gulbenkian Museum, 328. The piece was first published in *L'Art de l'Orient islamique/Oriental Islamic Art, Collection of the Calouste Gulbenkian Foundation*, exhibition catalogue, Museu Nacional de Arte Antiga, Lisbon, May 1963, no.28, illustrated in black and white. Pinder-Wilson, who wrote the entry for this object, read the inscription and established its date and place of origin. The jug is illustrated in colour in *Persian Art, Calouste Gulbenkian Collection*, Lisbon, 1972, no.13. See also Grube, *Tim. Dec. Arts, I*, pl.XXXIII, fig.107, and p.254, and id., *Tim. Dec. Arts, II*, p.189, fig.9, and p.178; it was included in the London exhibition *The Arts of Islam*, 1976, p.129, no.114, with a black-and-white illustration and a transliteration and translation of the inscriptions; Lentz and Lowry; p.144, fig.46; Robert Skelton, 'Islamic and Mughal Jades', in Roger Keverne, *Jade*, London, 1991, pp.274-295, p.276, fig.7 (colour), and Pinder-Wilson (1992), op. cit., p.38, fig.4 (colour).

26. For Timur's tombstone see A.A. Semenov, in *Epigrafika Vostoka*, I, 1947, pp.23-26, and III, 1949, pp.45-54; Pinder-Wilson, p.37, fig.2; for a colour illustration Lentz and Lowry, op. cit., p.28, fig.3, and Skelton, 'Jades', in Keverne, op. cit., p.275, fig.3.

27. William Watson, 'A jade cup in the British Museum inscribed with the name of Ulugh Beg', *Trudy Dvadtsa' Pyatogo Mezhdunarodnogo Kongressa Vostokobedov, Moskwa, 9-16 avgusta 1960*, III, Moscow, 1963, pp.124-125; Ralph Pinder-Wilson and William Watson, 'An inscribed cup from Samar-qand', *The British Museum Quarterly*, XXIII, 1960, pp.19-22, and pl.XI, attribute the piece to a Central Asian workshop. Teng Shu-ping, 'Jades believed to have been bestowed and transmitted to foreign lands', (in Chinese), *National Palace Museum Monthly of Chinese Art*, no.47, February 1987, pp.3-8, attributes the piece to a Chinese atelier, identifying the cup's form as that of a *cheng* (water reservoir), used for grinding ink in a scholar's study. Lentz and

Lowry, op. cit., p.354, no.124, refer to Shu-ping's attribution to China but state that "there is no reason at present...to reject the suggestion, when the cup was first published, that it was possibly made at a provincial Central Asian jade-carving center in imitation of a Chinese example." Illustrated in colour on p.224. Pinder-Wilson, op. cit., p.35, fig.1, and p.36, where he suggests that the object may have been a gift to Ulugh Beg from the Chinese envoys that visited his court in Samarkand in 1445, among the gifts brought jade vessels being explicitly mentioned. See for this Bret-schneider, op. cit., p.263. Yolande Crowe's statement (in *Silk & Stone, The Art of Asia, The Third Hali Annual*, London, 1996, p.64) that Shah Rukh sent Ulugh Beg with a delegation to Beijing is erroneous. For the 1419 embassy, reported on by Ghiyath al-Din *naqqash*, a painter especially commissioned by Baysungur to record the event, see *A Century of Princes*, cit., pp.279-297; Crowe is obviously confused by the fact that Ulgh Beg had sent a delegation of his own to China at the same time. The two delegations met and took part of the return trip together; see Bretschneider, op. cit., pp.262-263, note 1069.

28. Bharat Kala Bhavan, 8860: Grube, *Tim. Dec. Arts, I*, figs.110-112; id., *Tim. Dec. Arts, II* (1989), p.197, fig.38B; Skelton, 'Jades', in Keverne (1991), op. cit., p.282, fig.15 (colour); Pinder-Wilson, op. cit., p.35, fig.1.

29. Grube, *Tim. Dec. Arts, I*, figs.104-108, 110-111; id., *Tim. Dec. Arts, II*, figs.9-11; Skelton, 'Jades', in Keverne, op. cit., figs.6-8.

30. New York, The Metropolitan Museum of Art, The Heber R. Bishop Collection; 02.18.765, 51 x 102 mm, first published as Chinese in *Catalogue of the Bishop Jade Collection*, New York, 1902. An attribution to the Timurid period was first suggested by Grube, *Tim. Dec. Arts, I*, pl.LXXXIV, fig.109, and p.254, which is accepted by Lentz and Lowry, op.cit., p.142 (colour illustration), and p.340, cat.no. 51; and by David Alexander in *The Metropolitan Museum of Art: The Islamic World*, New York, 1987, p.88, fig.67 (colour). Very similar quillons appear on two 15th century swords in the Armoury in the Topkapı Palace, see *Survey of Persian Art*, Oxford, 1939, pl.1428, C & E, one of which (1-220) is illustrated in colour in Lentz and Lowry, op. cit., p.222, cat.no. 121.

31. (Ruy Gonzalez de Clavijo), *Embajada a Tamorlan, Estudio y edicion de un manuscrito del siglo XV por Francisco Lopez Estrada*, Madrid, 1943, p.160; the translation quoted after Clavijo, *Embassy to Tamer-lane, 1403-1406*, translated from the Spanish by Guy Le Strange, London, 1928, pp.224-225.

32. See Jean Soustiel, *La Céramique islamique*, Fribourg, 1985, p.239, fig.274.

33. For the Abu Sa'id building-inscription tiles see Lentz and Lowry, op. cit., cat.no. 113.

34. The piece was first published in Grube, *Tim. Dec. Arts, I*, p.235, (where the Arab numeral 4 is mis-printed as a 3) and pl.XXIV, figs.1-2.

35. For the Kilwa pottery see Neville Chittick, *Kilwa: An Islamic Trading City on the East African Coast*, Nairobi, 1974, II, pp.306-308, and pls.113-128.

36. See G. A. Pugachenkova, 'Samarkandskaya keramika XV veka', (Samarkand ceramics of the XVth century), *Trudy Sredneaziatskogo Gosudarstvennogo Universiteta*, XI, Tashkent, 1950, pp.91-120; and E.Iu. Buryakova, 'Novye dannye k stratigrafii tsitadeli srednevekovogo Samarkanda' (New findings toward a stratigraphy of the medieval citadel of Samarkand), *Arkheologicheskie raboty na novostroikakh Uzbekistana*, Tashkent, 1990, pp.65-91. See also I.A. Sukharev, 'Dva blyuda XV v. iz Samarkanda', (Two 15th-century dishes from Samarkand), *Trudy Istituta istorii i arkheologii Akademia Nauk UzbekskoiSSR*, I, Tashkent, 1948, pp.47-64.

37. See A. Ivanov, 'Fayansovoye blyudo XV veka iz Mashkhada (A faience dish of the fifteenth century from Mashhad)', *Soobshcheniya Gosurdarstvennogo*

Ermitazha, 45, 1980, pp.64-66.

38. A.L.B. Ashton, 'Early Blue-and-White in Persian Manuscripts', *Transactions of the Oriental Ceramic Society*, 1934-1935, London, 1936, pp.21-25; Basil Gray, 'Blue and white vessels in Persian miniatures of the 14th and 15th centuries re-examined', ibid., 24, 1948-49, pp.23-30; see also Margaret Medley, 'Chinese Porcelain in the Istanbul Album Paintings', *Islamic Art*, I, 1981, pp.157-159, who addresses the questions which of the blue-and-white pieces in these paintings are Chinese rather than local imitations, and how they should be dated.

39. There is another *lajvardina* bowl in Berlin (Museum für islamische Kunst, I.24/66) which is dated *rajab* 776/December 1374; see *Islamische Keramik*, exhibition catalogue, Hetjens-Museum, Dusseldorf, 1973, p.161, no.222, and J.M. Rogers, in Ronald Ferrier (ed.), *The Art of Persia*, London and New Haven, 1989, p.262, fig.16.

40. See G.A. Bailey, 'The Dynamics of Chinoiserie in Timurid and Early Safavid Ceramics', in *Timurid Art and Culture*, cit., pp.179-190.

41. Published in Ivanov (1980). op. cit.

42. Both pieces in Grube, *Tim. Dec. Arts, I*, figs.42-43.

43. For the group see ibid., figs.44-50, and id., *Tim. Dec. Arts, II*, pp.48-49, and pl.XII.

44. For examples see Grube, *Tim. Dec. Arts, I*, figs.58-60, and id., *Eredità dell'Islam, Arte islamica in Italia*, exhibition catalogue, Venice, 1993, Milan, 1993, nos.212-213.

45. See Louise Mackie's article quoted in note 16. Also Lentz and Lowry, op. cit., p.220, cat.no. 119. See also Barbara Brend in *Oriental Art*, n.s., XXX, no.25, summer 1984, pp.178-188, who deals with some material possibly deriving from carpets made in Timurid Samarkand.

46. A detail of this rug was first illustrated in *Hali* 89, 1996, p.137. The same detail and the 'chess-board' are illustrated in the invitation by Jeremy Pine Fine Art to a viewing of the rug at the 8th International Conference on Oriental Carpets, Philadelphia, 31 October - 4 November 1996; the complete rug has now been published in Ken Whyld's 'The Magic Carpet', *Chess*, 61, no.8, 1996, pp.46-47.

47. Lentz and Lowry, op. cit., p.218, cat.no. 49; a very similar patterned silk in The Textile Museum, Washington, 1934.3.214, is illustrated and attributed there to the mid 15th century, as is another, of a different pattern, in the Hermitage Museum, St Petersburg, inv.no. 1175.

48. See Amy Briggs' studies 'Timurid Carpets, I: Geometric Carpets', *Ars Islamica*, VII, 1940, pp.20-54, and 'Timurid Carpets, II: Arabesque and Flower Carpets', ibid., XI-XII, 1946, pp.146-158, which are entirely based on the analysis of representations in Timurid paintings. Briggs does not pose the problem of the documentary value of these paintings; she also did not have sufficient access to paintings of the period to realise that what she calls "arabesque and flower carpets" appear much earlier than she assumes.

49. See A. Adamova, 'Repetition of Compositions in Manuscripts: The Khamsa of Nizami in Leningrad', *Timurid Art and Culture*, cit., pp.67-75.

50. Istanbul, TKS, H. 362, see for the manuscript Ernst J. Grube, 'Two *Kalilah wa Dimnah* codices made for Baysunghur Mirza', *Quaderni del Seminario di Iranistica, Uralo-Altaistica e Caucasologia dell'Università degli Studi di Venezia*, 8, 1980, pp.115-122, and i-xi, and id., 'Prolegomena for a Corpus Publication of Illustrated *Kalilah wa Dimnah* Manuscripts', *Islamic Art*, IV, 1990-1991, pp.301-481, p.382, MS 16.

51. See Melikian-Chirvani, op. cit., p.384, for the term, which appears already in a 12th century technical encyclopaedia, but examples of which do not seem to have survived before the later 14th or early 15th century, ibid., fig.71; see also Grube, *Tim. Dec. Arts, I*, figs.94 and 96; id., *Tim. Dec. Arts, II*, p.188, fig.4; Komaroff, op. cit., figs.19-20, and 22.

52. For this piece see Assadullah Souren Melikian-Chirvani, 'The Lights of Sufi Shrines', *Islamic Art*, II, 1987, pp.117-147.

53. See Briggs (1946), op. cit., p.158.

54. Istanbul, TKS, H. 781, for the manuscript see Ivan Stchoukine, 'Une Khamseh de Nizami de la fin du règne de Shah Rokh', *Arts Asiatiques*, XVII, 1968, pp.45-58, and id., *Les Peintures des manuscrits de la "Khamseh" de Nizami au Topkapı Sarayı Müzesi d'Istanbul*, Paris, 1977, pp.44-49, and pls.XVII-XX.

55. See Note 17 for details. It should perhaps be mentioned that some remains of Ulugh Beg's clothing were found when his tomb was opened in 1941, although they can hardly give an idea of courtly dress; see Mikhail Gerasimov, *The Face Finder*, London, 1971, p.143: "The skeleton had upon it a delicate piece of woven stuff, apparently the remains of an unrolled turban. On the torso were fragments of a kind of shirt made of silk, which behind and on the sides were tucked into trousers of traditional Uzbek cut. Around the waist these were held in place with a broad silk band ornamented with a checker pattern of white and light blue squares. The front of the shirt fell in a wide gusset almost to the knees." The fabrics are preserved in the Navoi Literature Museum of the Uzbek Academy of Sciences in Tashkent.

2 HYBRID TEMPLES IN KARNATAKA

Pages 26-43

GLOSSARY

aedicule – image or representation of a building (of a shrine) used as an architectural element.

aedicular component – compositional unit of a composite temple form, consisting of an aedicule or a related image such as a *kuta-stambha*.

alpa vimana – minor *vimana* (uni-aedicular).

amalaka – 'myrobolan fruit'; ribbed crowning member in Nagara shrines.

Bhumija – one of the later, composite modes of Nagara temple.

chaitya hall – Buddhist barrel-roofed hall of worship (*chaitya* = sacred place).

dome – in Dravida architecture, term used here for the square, circular or octagonal roof element (*shikhara*) of a *kuta*, or crowning the whole *vimana*.

Dravida – 'Southern' language of temple architecture.

garbha-griha – 'womb-house', sanctum, holy of holies.

gavaksha – ('cow eye') horseshoe arch gable motif in Nagara architecture.

griva – 'neck'; recess under *kuta* dome, *shala* roof or other roof element.

jala – net, grille, grille pattern.

kapota – eave-like 'cornice' moulding used at top of wall zone, and in plinths, in Dravida temples.

kuta – representation of a square (occasionally circular, octagonal or stellate) pavilion, with domical roof; generally constituting the superstructure of an *alpa vimana* or *kuta*-aedicule.

kuta-aedicule – aedicule with a *kuta* as the superstructure; the most common form for an *alpa vimana*.

kuta-stambha – pillar form (usually embedded, as a pilaster) crowned in Dravida architecture by a Dravida *kuta*, or in Nagara architecture by a small *shikhara* form.

Latina – the basic, unitary mode of Nagara shrine.

mandapa – hall, especially the pillared hall of a temple.

mula-prasada – main shrine of a Nagara temple.

Nagara – 'Northern' language of temple architecture.

nasi – horseshoe arch gable motif in Dravida temple architecture.

panjara – 'cage'; representation of a pavilion with a *nasi* as its roofing element, often constituting the superstructure of a *panjara*-aedicule.

panjara-aedicule – aedicule with a *panjara* as the superstructure.

plinth – used here to denote a moulded base.

prasada – palace, mansion; shrine (Nagara).

shala – in Dravida architecture, representation of a 'barrel-roofed' ('barrel-vaulted', 'wagon-roofed') pavilion; generally constituting the superstructure of a *shala*-aedicule.

shala-aedicule – aedicule with a *shala* as the superstructure

Shekhari – one of the later, composite modes of Nagara temple.

shikhara – in Nagara temples, whole superstructure or

'spire' of a shrine; representation of a Latina superstructure constituting or crowning an aedicular component in a composite shrine form.

staggered – stepping forward to create two or more vertical planes.

stambha – pillar.

urah-shringa – half *shikhara* form on the 'chest' (*urah*) of a Shekhari superstructure; conceptually an embedded, emergent *shikhara*.

vimana – shrine proper, or one of a number of such, in a Dravida temple.

vyalamala – band of *vyalas* (leonine monsters) and other figures; moulding used in parapet and plinth, representing joist ends.

wall-shrine – secondary aedicular component, in wall zone of a temple; may or may not contain a niche for a sculpted image or icon.

3 PATTERNS OF LIFE
Pages 44-59

NOTES

1. In a modified form in Niessen, 1985.
2. See also Heide Leigh-Theisen and Reinhold Mittersakschmöller, *Lebensmuster. Textilien in Indonesien*, Vienna, 1995.
3. Cf. Holmgren and Spertus in Völger and von Welck, 1991, pp.59-80, pls.I-VIII.
4. Kartiwa,, 1993, pp.26-29.
5. Khan-Majlis, 1991, p.79.
6. Sanday and Kartiwa in Völger and von Welck, 1991, p.87.
7. Ibid.
8. Cf. Hauser-Schäublin et al., 1991 p.15f.
9. Ibid., pp.128f.
10. Cf. Djoemena, 1990, p.44, fig.130.
11. Ibid., p.33.
12. Ibid., p.56, fig.92.
13. Ibid., p.33.
14. See Maxwell, 1990, p.398, fig.570.
15. Cf. Holmgren and Spertus, 1989, p.72.
16. Ibid, p.72.
17. Ibid, p.96ff.
18. Khan-Majlis, 1984, p.97; cf. M.J. Adams, 'System and meaning in East Sumba textile design: a study in traditional Indonesian art', in *Southeast Asian Studies Cultural Report*, Series 16, New Haven, 1969, pp.95 and 130f.
19. Cf. Kartiwa, op. cit., p.81.
20. Ibid., p.81.
21. Jager Gerlings, 1952, p.110f.
22. Holmgren and Spertus, 1989, p.51.
23. Ibid, p.66.

SELECT BIBLIOGRAPHY

Adams, M.J., 'System and meaning in East Sumba textile design: a study in traditional Indonesian art', in *Southeast Asian Studies Cultural Report*, Series 16, New Haven, 1969.

Djoemena, Nian S., *Batik. Its Mystery and Meaning*, Jakarta, 1990.

Gittinger, Mattiebelle (ed), *Splendid Symbols. Textiles and Traditions in Indonesia*, Washington DC, 1979.

Hauser-Schäublin, B., Nabholz-Kartaschoff, M-L., and Ramseyer, U. (eds), *Textilien in Bali*, Basel, 1991.

Holmgren, Robert J. and Spertus, Anita E., *Early Indonesian Textiles from Three Island Cultures*, New York, 1989.

Holmgren, Robert J. and Spertus, Anita E., 'Is Geringsing really Balinese?', in Völger and von Welck, 1991, pp.59-80, pls.I-VIII.

Jager Gerlings, J.H., *Sprekende Weefsels*, Amsterdam, 1952.

Kartiwa, Suwati, *Tenun Ikat/Indonesian Ikats*, Jakarta, 1993.

Khan-Majlis, Brigitte, *Indonesiche Textilien. Wege zu Göttern und Ahnen*, Cologne, 1984.

Khan-Majlis, Brigitte, *Gewebte Botschaften. Indonesische Traditionen im Wandel*, Hildesheim, 1991.

Maxwell, Robyn, *Textiles of Southeast Asia. Tradition, Trade and Transformation*, Melbourne, 1990.

Niessen, Sandra, *Motifs of Life in Toba Batak Texts and Textiles*, Dordrecht, 1985.

Sanday, Peggy R. and Kartiwa, Suwati, 'Value in and of Minangkabau songket', in Völger and von Welck, 1991, pp.87-91.

Völger, Gisela and von Welck, Karin (eds), *Indonesian Textiles. Symposium 1985*, Cologne, 1991.

ADDITIONAL TECHNICAL INFORMATION
Fig. no.

1. See 19 below.
2. Ceremonial cloth (146.385). Silk and natural dyestuffs; tabby weave, double ikat.
3. Ceremonial shoulder cloth (56.821). Hand-spun cotton and primarily natural dyestuffs; warp-dominated tabby weave, twill weave, brocaded and floated supplementary weft (also *sungkit* type), weaving, supplementary warp, wrapped outside edge, weft twining.
4. Man's wrap (73.352). Hand-spun cotton and natural dyes; warp-dominated tabby weave, warp ikat, weft twining and twisted fringing.
5. Ceremonial hip or shoulder cloth (87.460). Silk, probably natural dyes, and metal sequins; weft ikat, embroidery, and appliqué.
6. Ceremonial cloth (175.363). Hand-spun cotton and natural dyestuffs; reserved design painted and drawn in two processes with a partial application of mordant, and blue and red pigmentation.
7. Shoulder cloth and shawl (146.470). Silk, dyestuffs and gold thread; plangi, tritik, painting, and bobbinlace trimming.
8. Man's upper hip cloth (73.566). Silk, pigments, and paper gold and paper silver thread; tabby weave, brocaded and floated supplementary weft.
9. Shoulder cloth (131.125). Silk, probably natural pigment, and paper gold thread; tabby weave, floated and brocaded supplementary weft.
10. Hip cloth (17.985). Commercial cotton; tabby weave, *batik tulis*.
11. Man's upper hip cloth (73.562). Silk, dyes, and paper gold and paper silver thread; weft-dominated tabby weave, weft ikat (*endek*), brocaded and floated supplementary weft.
12. Batik cloth (176.002). Commercial cotton and natural dyestuff; *batik tulis*.
13. Batik cloth (175.196). Commercial cotton, natural dyestuff, and gold thread; *batik tulis* and bobbin-lace trimming.
14. Hip cloth (175.035). Commercial cotton; *batik tulis*.

15. Sarong (175.427). Commercial cotton and dyes; *batik cap.*

16. Ceremonial cloth (175.184). Hand-spun cotton, silk, and natural dyes; tabby weave and floated supplementary weft.

17. Ceremonial cloth (30.376 and 30.377). Cloth: Hand-spun cotton, natural dyestuffs; tabby weave and floated supplementary weft. Beadwork: plaited palm-leaf, cotton, glass beads, nassa shells.

18. Strip of pattern from a ceremonial sarong (142.372). Cotton, silk, and natural dyes; tabby weave and embroidery.

19. Woman's ceremonial sarong (83.272). Primarily hand-spun cotton and mainly natural dyes; warp-

dominated tabby weave, supplementary warp, and painting.

20. Ceremonial cloth 98.273. Hand-spun cotton, natural dyes, and commercial cotton material (trimmed selvedge); warp-dominated tabby weave, warp ikat.

21. Ceremonial cloth 175.362. Commercial cotton and primarily natural dyes; warp-dominated tabby weave, warp ikat and twisted fringing.

22. Woman's ceremonial sarong 167.476. Hand-spun cotton and natural dyes; warp-dominated tabby weave and warp ikat.

23. Warrior's jacket 5.322. Bast fibre (ramie?) and natural dyes; weft twining and painting.

6 FENGRUAN RUTAN
Pages 84-107

I would like to thank the following owners for generously allowing us to illustrate their carpets: Dennis R. Dodds, Philadelphia, fig.24; John Eskenazi, London, fig.4; Christopher Gibbs, London, fig.19; Eberhart Herrmann, Emmetten, figs.3, 5, 6, 7, 22, 23, 25; Metropolitan Museum of Art, New York, figs.11, 17; Thyssen-Bornemisza Collection, Lugano, figs.10, 12, 14, 16, 26, 28; Wher Collection, Switzerland, figs.18, 20; anonymous private collections, figs.13, 15, 21, 27, 29. Figs.3, 4, 5, 7, 8, 9, 22 are with The Textile Gallery, London. For their help in compiling this essay, I would like to thank: Romolo and Maurizio Battilossi; Clara and Marino Dall'Oglio; Dennis R. Dodds; the late Charles Grant Ellis; John Eskenazi; Elizabeth Duley; Christopher Gibbs; Michael Goedhuis; Carlos Gonçalves and Fami Gonçalves; Eberhart Herrmann; Hedy and Gerhard Käbisch; Marion and Hans König; Ronnie Newman; Robert Pinner; the late Ulrich Schürmann; Jacqueline Simcox; Baron and Baroness Heinrich Thyssen; Daniel Walker. Thanks are also due to Roderick Whitfield for arranging the calligraphy used at the beginning of the essay, to Rupert Waterhouse for his extensive editorial help, and to past and present members of Longevity Textile Conservation for photography and conservation of many of the carpets illustrated.

NOTES
Lists of analogues known to us are cited in their entirety except where indicated otherwise. Where many examples of a particular type survive, a representative few are listed.

1. Known as the 'Spring of Khosrow' because its Paradise garden design represented the miracle of flowering spring, according to the *Historical Annals* of the Arab chronicler al-Tabari. Apparently inlaid with crystal, gold and precious stones, and measuring 7.8m², it was cut up and distributed as booty when the Arabs captured Ctesiphon in 637 AD. See Edwards, 1953, p.2.

2. Ten mentions can be found in various European and Near Eastern records between 1341 and 1589, referring to silk carpets from Cairo, the Mamluk Empire, Granada, Edirne, the Levant and Persia. See Pinner & Denny, 1986.

3. *Dais cover with 'chess garden' design.* Samarkand?, C¹⁴ dated to ca. 1400. 168 x 368 cm, silk pile on a silk foundation. Jeremy Pine, et al., London. Pub. *Hali* 89, 1996, p.137.

4. Österreichisches Museum für angewandte Kunst, Vienna. 290 x 540 cm. Pub. Sarre & Trenkwald, 1926, vol.I, pls.44-46, *Hali* 31, 1986, pp.8-9.

5. See Erdmann, 1970, pp.61-65.

6. We have examined more than ninety of these.

7. *Saddle rug with dragon design.* 79 x 158 cm, silk pile with brocaded silver thread on a cotton foundation. Textile Gallery, London, and Eberhart Herrmann, Emmetten. Formerly: J. Davison, London; Giuseppe Eskenazi, London. Pub. Sotheby's, London, 12 December 1978, lot 250; Pinner, 1978, pp.317–318, 391, pl.IX; Herrmann, 1988, pp.8–9, pl.1 (structural analysis). C¹⁴ dating: 1530–1610 (68% probability)

and 1490–1650 (95% probability).

8. Bidder, 1964, p.24.

9. A small group of large Chinese dais carpets knotted with camel-like pile, specifically made for the throne platforms in the Imperial Palace in Beijing, probably during the Wanli period (1573–1620), have patterns – such as the foliated dragon with a flaming pearl and cloud scrolls, and the scrolling meander border – that relate stylistically to the Davison saddle rug.

10. *Table cover with design of five dragons.* 101 x 106 cm, silk pile with brocaded metal thread on a silk foundation. Textile Gallery, London, and John Eskenazi, London. Formerly: reportedly a monastery in northern Tibet; Fred Cagan, Nepal; Textile Gallery, London; J.D. Burns, Seattle. Pub. Sotheby's, NY, 20 January 1990, lot 45; *Hali* 50, 1990, p.169.

11. *Imperial silk pile* kang *wedding covers:* i) Design of dragon, phoenix and 'conjugal happiness' signs. Possibly 17th century. 216 x 272 cm, cotton foundation. MMA, NY, no.29.100.158. Formerly: Mrs H.O. Havemeyer, NY. Pub. Dimand & Mailey, 1973, pp.326-327, fig.302 and p.347, cat.no.228 (structural analysis; 19th century); Lorentz, 1972, pp.78-79, fig.30 (17th century). ii) Dragon and phoenix design. Possibly 17th century. 272 x 361 cm. Royal Ontario Museum, Toronto. Pub. Lorentz, 1972, pp.78, 80, fig.31 (19th century copy of Ming carpet). iii) Dragon and phoenix design enclosed by a border with repeating *shou* motifs. 256 x 350 cm. Formerly: Dr Ludwig Treitel. Pub. Augustus W. Clarke, NY, 11-12 April 1913, lot 352 (cited). iv) Design of dragon, phoenix and 'conjugal happiness' signs. 259 x 358 cm. Formerly: Dr Ludwig Treitel. Pub. Augustus W. Clarke, NY, 11-12 April 1913, lot 348 (cited).

12. *Silk pile covers with dragon designs attributed to the Ming dynasty but probably* ca. 1800: i) Imperial *kang* cover with dragon design and wave or cloudhead border. 114 x 198 cm. Formerly: Dr Ludwig Treitel. Pub. Augustus W. Clarke, NY, 11-12 April 1913, lot 340 (cited). ii) Seating mat with dragon design and cloudhead border. 90 x 175 cm. Rietberg Museum, Zurich. Formerly: R. Akeret, Zurich. Pub. Lorentz, 1972, pp.78, 80, fig.31 (possibly 17th century). Exhibited: London 1935-36, cat.no.1825 (perhaps Ming).

13. *Some other silk pile saddle rugs:* i) Lotus design. Yarkand, 18th century. 66 x 145 cm, cotton foundation. Textile Gallery, London. Pub. *Hali* 69, 1993, p.157. ii) Saddle rug with design of Buddhist symbols, enclosed by a border with bats and key minor borders. 18th century. 74 x 138 cm, silk foundation. Textile Gallery, London. iii) Saddle rug with design of Buddhist symbols enclosed by a border with bats and scrollwork and swastika minor borders. 19th century. 77 x 148 cm, cotton foundation. Formerly: Hans König, Cologne; Eberhart Herrmann, Munich. Pub. Herrmann, 1983, pp.190-191 (structural analysis). iv) Saddle rug with rounded ends, geometric lattice design. Ronnie Newman, Ridgewood, NJ.

14. *Saddle cover with geometric design.* 52 x 58 cm, silk pile on a silk and cotton foundation. Textile Gallery, London. Formerly: Lisbet Holmes, London. Pub. ICOC, 1990, p.67. Warp: silk, gold, Z2S; weft: cotton, white, S2Z, 2 shoots; pile: silk, stranded, Z2S, some Z1S, 15 strands per knot, AS open left, half knots and packing knots used regularly, 1092/dm²; colours: 16.

15. *Saddle cover with floral design.* 49 x 58 cm, silk pile on a silk and cotton foundation. Eberhart Herrmann, Emmetten. Formerly: Lisbet Holmes, London; Textile Gallery, London. Pub. Herrmann, 1990, pp.174–176, no.83 (structural analysis).

16. *Chinese carpets with leaf designs:* Examples include: i) a. Section of a large cover with design of lotuses among a trailing stem and long leaves against a golden beige background. Western China, 16th century. 110 x 211 cm, camel-like pile on a cotton foundation? Museum für Kunst und Gewerbe, Frankfurt, no.4173. Pub. Lorentz, 1972, p.107, fig.20; Franses, 1982, p.136, fig.6. b. Section of a large cover with design of lotuses among a trailing stem and long leaves against a golden beige background. Western China, 16th century. Musée des Arts Décoratifs, Paris, no.19267. Pub. Gilles et al., 1989, pp.170-1. ii) *Kang* cover with design of peonies and large leaves on a beige background enclosed by a key border. Ningxia, ca. 1700. Wool pile on a cotton foundation. TM, Washington DC, inv.no.R.51.1.3. Pub. Ellis, 1968, p.36. iii) Section of a *kang* cover with design of foliated dragon medallion and part-medallion corners on large leaves. 18th century. 224 x 193 cm, wool pile on a cotton foundation. MMA, NY, no.45.174.47. Formerly: George D. Pratt, NY. Pub. Dimand & Mailey, 1973, pp.325-326, fig.301, cat.no.227 (structural analysis); Ellis, 1968, p.39.

17. Pinner, 1983, p.273.

18. *Table cover with peony design.* 113 x 116 cm, silk pile on a silk foundation. Textile Gallery, London. Formerly: Phoebe A. Hearst, California (who reportedly acquired several of her carpets from Grace Nicholson, Pasadena, and Ephraim Benguiat, New York); C. John, London. Pub. Pope, 1917, no.569, facing p.141, and pp.150–151.

19. 1494–1640 (68% probability) and 1444–1666 (95% probability).

20. Pope, 1917, p.150.

21. *Floral design silk pile covers without borders:* i) Seating mat with endless repeat design of lotuses. 96 x 99 cm, cotton foundation. Textile Gallery, London, and Eberhart Herrmann, Emmetten. Formerly: Private collection, USA. Pub. Sotheby's, NY, 3 December 1988, lot 103 (structural analysis); Herrmann, 1990, pp.156-157, pl.74 (structural analysis). ii) Cover with endless repeat design of diagonal rows of peonies. Freer Gallery of Art, Washington DC, neg.no.16.358. iii) Cover with centralised design of a large peony surrounded by eight smaller peonies. 51 x 102 cm, only the right side survives, silk foundation. Private collection, London. Formerly: Dikran Kelekian, NY; Textile Gallery, London. Pub. Thompson, 1988, p.49, pl.46. iv) Table cover with endless repeat floral design. 91 x 66 cm, fragmented and joined, silk foundation. Textile Gallery, London. Pub. Sotheby's, NY, 13 December 1996, lot 22 (cited).

22. One with peonies and lotuses, the other with peonies. Attributed to the Southern Song. Both 59 x 102 cm, brown silk gauze. Fujian Provincial Museum. Excavated from the tomb of Huang Sheng, dated 1243 AD, in Fucangshan, a northern suburb of Fuzhou, in 1975. Pub. Huang, 1990, pp.60-61, 182, 184-185, pls.176, 178.

23. *Dais cover with octagon-and-square lattice field design.* 380 x 365 cm, silk pile on a silk foundation. Textile Gallery, London. Formerly: Michaelian, NY; Bausback, Mannheim. Pub. *Hali* 43, 1993, p.96.

24. *Section of a kang cover with octagon-and-square lattice field design.* Xinjiang, 18th century. 137 x 152 cm, silk pile on cotton foundation. Formerly: Bernheimer, Munich. Pub. Christie's, London, 14 February 1996, lot 185 (structural analysis).

25. *Dais cover with design of peonies.* 247 x 392 cm, silk pile on a cotton foundation. Thyssen-Bornemisza Collection, Lugano. Formerly: Textile Gallery, London, and Battilossi, Turin; Private collection, Switzerland; Textile Gallery, London. Pub. *Hali* 33, 1987, p.91; Thompson, 1988, p.47, no.44.

26. *Section of a dais cover with an allover floral and leaf design and bats.* Yarkand, 18th century. 133 x 86 cm, incomplete, silk pile on a cotton foundation. TM, Washington DC, no.R56.1.1. Pub. Schürmann, 1969, p.144, pl.68; Rostov & Jia, 1983, pp.200-201, pl.124; *Hali* 77, 1994, p.118.

27. *Section of a dais cover with an allover floral and leaf design and bats.* Ningxia, 17th century. 231 x 160 cm, incomplete, wool pile on a cotton foundation. Private collection, Switzerland. Formerly: Michaelian, NY; Textile Gallery, London. Pub. Franses, 1982, p.133.

28. The swastika border was widely used in Roman decoration, but first appears on a pile carpet in Egyptian Coptic loop-pile examples, which were also influenced by Roman art. Coptic textiles were traded along the Silk Road from at least the 3rd century AD. An example of a looped-pile Coptic textile in a Roman style is in the Abegg-Stiftung, Riggisberg (*Hali* 70, p.110).

29. *Silk pile covers with dragon and cloud field designs within a swastika fret border overlaid with bats:* i) Small *kang* cover. 91 x 142 cm, silk foundation. MMA, NY, no.08.248.8. Formerly: a Chinese provincial magistrate; Tiffany, NY. Pub. Tiffany, 1908, p.38, pl.X, no.4389; Lorentz, 1972, p.29; Dimand & Mailey, 1973, cat.no.234, fig.309 (structural analysis); Rostov & Jia, 1983, p.33, pl.11. ii) Small *kang* cover. 100 x 143 cm, silk foundation. Musée des Tissus, Lyons, no.27.596. Formerly: Madame Langweil. Pub. Bennett, 1987, p.42 (structural analysis).

30. Jean Mailey reattributed the rug to 18th century Khotan (Dimand & Mailey, 1973). No evidence was offered to substantiate this, and the weave and colours are quite different from those of any of the rugs attributed to Khotan by Bidder.

31. MMA, NY, no.15.95.154. Pub. Dimand & Mailey, 1973, pp.332–333, fig.310.

32. *Silk pile covers with lily field designs within a swastika fret border overlaid with bats:* i) Small *kang* cover. 90 x 142 cm, silk foundation. Thyssen-Bornemisza Collection, Lugano. Formerly: Yale University, New Haven, no.679; Textile Gallery, London; David Thomson, Toronto. Pub. Sotheby's, NY, 31 May 1986, lot 86; Herrmann, 1986, pp.224–225, no.114 (structural analysis). ii) Small *kang* cover. 95 x 143 cm, silk foundation. Private collection, Germany. Formerly: F. Brandt, Berlin; G. Venzke, Berlin; Herrmann, Munich. Pub. Berlin, 1929, p.404, fig.1114. iii) Small *kang* cover. 96 x 141 cm, silk foundation. Wher Collection, Switzerland. Formerly: Private collection, New England; Textile Gallery, London. Pub. Sotheby's, NY, 20 Jan. 1990, lot 8 (structural analysis); *Hali* 50, 1990, p.170. iv) Small *kang* cover. 99 x 143 cm. Rietberg Museum, Zurich. Formerly: Istanbul art trade (Samarkand); Robert Akeret, Zurich. Pub. Lorentz, 1972, pl.53 (Chinese).

33. *Small kang cover with peony field designs enclosed by a swastika fret border overlaid with bats.* 92 x 140 cm, silk pile on a silk foundation. Private collection, Lisbon. Formerly: Dr Franco Vannotti, Lugano; Wher Collection, Switzerland; Textile Gallery, London. Pub. Thompson, 1983, p.128.

34. König, 1975.

35. *First period Kashgar silk pile covers with Mughal-style floral field designs (scheme 1, implied lattice):* i) Dais cover. 205 x 360 cm. Thyssen-Bornemisza Collection, Lugano. Formerly: Textile Gallery, London. Pub. *Burlington Magazine*. ii) Section of *kang* cover. 117 x 198 cm, section of the field, silk foundation. Textile Gallery, London, and Eberhart Herrmann, Emmetten. Formerly: Baltimore Museum of Art.

Pub. Sotheby's, NY, 5 December 1987, lot 120;
Herrmann, 1988, p.228, pl.108.

36. *First period Kashgar silk pile covers with Mughal-style
floral lattice field designs (scheme 2, visible lattice):*
i) a. Dais cover. 233 x 252 cm, incomplete in length,
silk foundation. Private collection, Switzerland.
Formerly: Hagop Kevorkian, NY; French & Co, NY;
Ulrich Schürmann, Cologne. Pub. AAA, 1928, lot
460; König, 1975, p.36, fig.6 (structural analysis);
Schürmann, 1976, p.207; Herrmann, 1985, p.254,
no.112; Thompson, 1988, p.56, pl.55. b. *Kang* cover?
188 cm square, section of field, silk foundation. Wher
Collection, Switzerland. Formerly: Textile Gallery,
London, and Herrmann, Munich. Pub. Sotheby's,
NY, 31 May 1986, lot 127 (Kashgar, withdrawn in a
dispute over attribution); Sotheby's, NY, 5 December
1987, lot 121 (provincial Mughal); *Hali* 38, 1988, p.91.
ii) Dais cover? 252 x 277 cm. Private collection.
iii) a. Dais cover? 61 x 157 cm, fragment, silk founda-
tion. Formerly: Bernheimer, Munich. Pub. König,
1975, p.35, fig.5 (structural analysis); Christie's,
London, 14 February 1996, lot 95 (structural analy-
sis). b. Dais cover? 56 x 94 cm, fragment, silk founda-
tion. Formerly: Bernheimer, Munich. Pub. Christie's,
London, 14 February 1996, lot 96 (structural analy-
sis). iv) *Kang* cover. Formerly: Phoebe A. Hearst,
San Francisco. Pub. Pope, 1917, no.567. v) *Kang*
cover. Palace Museum, Beijing.

37. *Kashgar wool pile covers with Mughal-style floral lat-
tice field.* Examples include: i) Dais cover. 216 x 410
cm, cotton foundation. 18th century. Private collec-
tion, Italy. Formerly: Private collection, Switzerland;
Textile Gallery, London, and Eskenazi, Milan.
Pub. *Hali* 62, 1992, pp.52-53; Taylor & Hoffmeister,
1986, p.95. ii) *Kang.* 18th century. 297 x 188 cm.
Pub. Sotheby's, NY, 15 April 1993, lot 29; *Hali* 69,
1993, p.152.

38. *Second period Kashgar silk pile covers with Mughal-
style floral lattice field designs:* i) Dais cover. 178 x
275 cm, silk foundation. MMA, NY, no.22.100.49.
Formerly: James F. Ballard, St. Louis. Pub. MMA
(Ballard), 1923, no.117; Dimand & Mailey, 1973,
cat.no.230, p.347, fig.304 (structural analysis).
ii) *Kang* cover. 206 x 381 cm. Jean Pincket, Brussels.
Formerly: Benjamin Benguiat. Pub. AAA, 1925,
lot 54; *Hali* 3/1, 1980, p.9. iii) *Kang* cover. 213 x 423 cm.
Private collection, Switzerland. Formerly: Hans
Bidder. Pub. Schürmann, 1969, p.148, pl.72; König,
1975, p.34, pl.3. iv) *Kang* cover. 213 x 492 cm. Imperial
Palace, Beijing. (Five others known to us.)

39. Schürmann, 1975.

40. This is not the only J.P. Morgan carpet that may have
come from the Imperial Palace in Beijing. Morgan
made countless thousands of art purchases, many of
which were still in their packing cases when he died.
In 1994, while trying to trace some of his purchases,
we were shown a file in the Morgan Library, New
York, which revealed that he was offered the con-
tents of three Chinese palaces, including the Imperial
Palace. Negotiations had reached their final stages at
the time of his death.

41. *Silk pile dais covers with Chinese-style floral field
designs and 'T' borders:* i) Dais cover. 222 x 394 cm,
cotton foundation. Thyssen-Bornemisza Collection,
Lugano. Formerly: J.P. Morgan, NY; French & Co,
NY; Ulrich Schürmann, Cologne. Pub. Schürmann,
1975, pl.1 (structural analysis). ii) Dais cover.
Imperial Palace, Beijing. iii) a. Fragment. TM,
Washington DC, no.1979.29. Formerly: Erskine;
Arpad, Georgetown; Pub. Kendrick & Tattersall,
1922, vol.2, pl.65. b. Fragment, 46 x 120 cm. Museum
für Kunsthandwerk, Frankfurt. Formerly: Karl
Bader. Pub. Helbing, 1932, cat.no.35. c. Fragment,
46 x 120 cm. Museum für Kunsthandwerk,
Frankfurt. Pub. Schürmann, 1975, p.49, pl.5.

42. *Silk pile covers with floral field designs and key borders:*
i) Cushion face. 64 x 66 cm, silk foundation. MMA,

NY, no.36.153.2. Formerly: Baroness Clemens von
Ketteler. Pub. Dimand & Mailey, 1973, p.333, cat.no.
235, fig.312 (structural analysis); Textile Museum,
1967, p.46, fig.49. ii) Cushion face. 51 x 66 cm. Wher
Collection, Switzerland. Formerly: Spink & Son,
London; Textile Gallery, London. Pub. Thompson,
1988, p.50, pl.47. iii) Cushion face. 68 x 72 cm, cotton
foundation. Textile Gallery, London, and John
Eskenazi, London. iv) Cushion face. 64 x 66 cm.
Pub. Lee, 1980, p.58, pl.17. v) Cushion face. 65 x 61 cm,
silk foundation. Eberhart Herrmann, Emmetten.
Pub. Herrmann, 1990, pp.154–155, pl.73 (structural
analysis). vi) Table cover. 127 x 99 cm, silk founda-
tion. MMA, NY, no.36.153.1. Formerly: Baroness
Clemens von Ketteler. Pub. Dimand & Mailey, 1973,
cat.no.236, fig.313 (structural analysis). vii) Table
cover. 96 x 121 cm, silk foundation. V&A, London,
no.T556-1919. Pub. Schürmann, 1969, p.145, pl.69
(structural analysis). viii) Table cover. 99 x 127 cm,
silk foundation. Textile Gallery, London, and
Eberhart Herrmann, Emmetten. Pub. Sotheby's, NY,
22 September 1993, lot 76 (structural analysis); *Hali*
72, 1993-94, p.129. ix) Seating mat. 104 x 107 cm,
cotton foundation. Private collection, Germany.
Formerly: James R. Herbert Boone, Baltimore;
Textile Gallery, London, and Herrmann, Munich.
Pub. Sotheby's, NY, 3 December 1988, lot 98 (struc-
tural analysis); *Hali* 43, 1989, p.96; Herrmann, 1989,
pp.132–133, pl.62 (structural analysis). x) Seating mat.
104 x 103cm, cotton foundation, frayed and missing
part of both end borders. Whereabouts unknown.
Formerly: private collection, France? Pub. Rippon
Boswell, Wiesbaden, 24 May 1997, lot 104.

43. *Silk pile seating mats with a Chinese silk brocade design:*
i) Seating mat with design of octagon-and-square
lattice and interlace. 84 x 81 cm, missing areas around
sides and ends, metal thread, cotton foundation.
Wher Collection, Switzerland. Formerly: Textile
Gallery, London. ii) Seating mat with design of octa-
gon-and-square lattice and interlace. 91 cm square,
with metal thread. Formerly: Tiffany Studios, NY,
cat.no.3659. Pub. Tiffany, 1906, pp.89, facing p.90.

44. *Gansu wool pile dais covers with a Chinese silk brocade
design.* Examples include: i) 113 x 203 cm. Pub.
Rippon Boswell, Wiesbaden, 16 November 1985,
lot 99. ii) 180 x 308 cm. Pub. Christie's East, NY,
19 November 1985, lot 18.

45. *Dais carpet with palmette design.* 360 x 556 cm, silk
pile, metal thread. Formerly: Vitall & Leopold Ben-
guiat, NY. Pub. AAA, 1930, lot 740 (Khotan ca. 1700).

46. The twelve pieces of Han dynasty cloth found at
Mawangdui in 1972 – which show features of both
brocade and velvet and are figured with rectangles
formed by loops – are possibly contemporaneous
with looped pile textiles from Coptic Egypt that were
imported into China around this time; this draws
one to speculate further upon the origins of the
technique. A large variety of velvet is recorded in the
historical writings of ancient China, including Song
dynasty velvet brocade made by the Uighurs in Xin-
jiang and types of cut pile velvet from the Yuan and
Ming dynasties. Some examples of Yuan velvet have
been seen by Jacqueline Simcox, and we have noted
two examples probably dating from the early years
of the Ming dynasty. We are grateful to Jacqueline
Simcox and Roderick Whitfield for bringing these
early traces of Chinese velvet to our attention. See
also Cheng, 1990, pp.348, 406-411, 425-426, 439-443.

47. *Silk velvet covers from the Yongzheng or Qianlong
periods:* i) Velvet cover with diagonal swastika fret
and bat design. John Eskenazi, London. Pub. *Hali* 61,
1992, p.173. ii) Velvet table cover with diagonal swas-
tika fret and bat design. 58 x 118 cm, half only, metal
thread. Galerie Sailer, Salzburg. Pub. Thompson,
1988, p.52, no.49. (Seven others known to us.)

48. *Dais cover with design of swastika trellis overlaid with
bats.* 192 x 395 cm, silk pile brocaded with metal

thread. Formerly: reportedly Imperial Palace, Beijing; E.A. Bischoff, Beijing and London; Audrey Sheldon, USA; Christopher Gibbs, London. Pub. AAA, 1919, lot 265; Christie's East, NY, 3 March 1981, lot 29; Sotheby's, London, 18 April 1984, lot 213 (unsold).

49. *17th century wool pile carpets from Ningxia with field designs of diagonal swastika lattice overlaid with bats:* Examples include: i) *Kang* cover with design of diagonal swastika trellis in blue overlaid with bats on a beige background. Ningxia, 17th century. 130 x 188 cm, cotton foundation. Formerly: NY art market; Textile Gallery, London. Pub. *Weltkunst*, vol.57, no.4, 1987, p.354. ii) *Kang* cover with design of diagonal swastika trellis overlaid with bats. Ningxia, 17th century. 147 x 230 cm, cotton foundation. Formerly: Michon. Pub. Musée des Gobelins, 1936, no.205.

50. *Dais cover with swastika lattice overlaid with floral motifs.* 122 x 175 cm, incomplete, silk pile. V&A, London, no.T.27-1970. Pub. Franses & Pinner, 1982, fig.11.

51. *Silk pile seating mats from Yarkand with designs of a central lotus palmette enclosed by a lotus border:* i) a. 102 x 107 cm. TM, Washington DC, no.51.4. Pub. Textile Museum, 1967, no.82; Ellis, 1968, p.51; Schürmann, 1969, pl.77 (Yarkand); Rostov & Jia, 1983, p.94, pl.57. b. 102 x 107 cm. TM, Washington DC, no.51.4. Exhibited: Washington DC, 1967. ii) 93 x 100 cm, missing parts of upper and lower outer guard, cotton foundation. Wher Collection, Switzerland. Formerly: Private collection, Sweden; Textile Gallery, London; Herrmann, Munich. Pub. Herrmann, 1987, pp.206–207, pl.95 (structural analysis); *Hali* 40, 1988, p.66.

52. *Wool pile seating mats with 'uncoffered'-gül field designs:* i) a. Attributed to Kashgar but possibly early Yarkand. 102 x 102 cm, cotton foundation. Wher Collection, Switzerland. Formerly: Bernheimer, Munich (Kashgar). Pub. *Hali* 86, 1996, p.133. b. 99 x 192 cm, cotton foundation. Formerly: Bernheimer, Munich (Kashgar). Pub. Taylor & Hoffmeister, 1986, p.89, fig.2. ii) Kashgar. 99 x 94 cm, cotton foundation. Ronnie Newman, Ridgewood. Pub. *Hali* 71, p.137. Notes: another early rendering of the 'uncoffered'-gül motif that clearly shows its derivation from four confronting bats can be seen in the border.

53. Patterns seen on wool pile carpets also appear on silk pile carpets. E.g.: i) Saddle cover with floral design. 17th century or earlier. 57 x 124 cm, wool pile on a wool foundation. Wher Collection, Switzerland. Formerly: Joseph V. McMullan, NY; Fogg Museum of Art, Cambridge MA; Textile Gallery, London. Pub. McMullan, 1965, pp.372-373, pl.135. ii) See note 16, ii.

54. *Early renderings of the coffered-gül motif:* i) Seating mat with design of four coffered-güls. Kashgar. 102 x 112 cm, wool pile. Formerly: Ostler, Munich. Pub. *Hali* 38, 1988, p.11. ii) Seating mat with design of four coffered-güls. Possibly Kashgar. 92 x 89 cm, wool pile on a cotton foundation. Hoffmeister Collection, Dörfles-Esbach. Pub. Hoffmeister, 1980, pl.41 (structural analysis, Khotan). *Yarkand silk pile carpets with the coffered-gül design:* i) *Kang* cover. ca. 1800. 117 x 234 cm, corner section, cotton foundation. Formerly: Bernheimer, Munich. Pub. Christie's, London, 14 February 1996, lot 14 (structural analysis). ii) Dais cover. 196 x 412 cm. Formerly: Stephen Porter, London. Pub. *Hali* 42, 1988, p.80, 1988. (Three others known to us.) See also Bidder, 1964, pp.57–64, for variations of the design.

55. *Seating mat with 'uncoffered'-gül design.* 102 cm square, silk pile on a wool and cotton foundation. Private collection. Formerly: E.A. Bischoff, Beijing & London; Prince Giovanni del Drago; Vincent Milligan, NY; Textile Gallery, London, and Herrmann, Munich. Pub. AAA, 1919, lot 236; Sotheby's, NY, 5 December 1987, lot 119; Herrmann, 1988, pp.232–233, no.110 (structural analysis).

56. *Seating mat with design of bats, peaches and mushrooms or clouds.* 94 x 104 cm, silk pile on a silk foundation. Textile Gallery, London, and Eberhart Herrmann, Emmetten. Formerly: probably Grace Nicholson, Pasadena; James Herbert Boone, Baltimore. Pub. Sotheby's, NY, 3 December 1988, lot 102 (structural analysis); *Hali* 43, 1989, p.96; Herrmann, 1989, pp.134-135, pl.63 (structural analysis).

57. *Seating mat with design of bats, peaches and mushrooms or clouds.* 100 x 103 cm, silk pile on a silk foundation. Formerly: Dennis Ford, London. Pub. Sotheby's, London, 16 October 1996, lot 78 (structural analysis).

58. *Kang cover with design of many randomly placed tiny bats against a melon coloured ground, within a swastika fret border.* 257 x 356 cm, silk pile. Pub. Christie's, NY, 27 May 1987, lot 60.

59. *Pictorial design wool pile carpets from Ningxia:* i) Seating mat with design of crane, butterfly and lotus. 17th century. 107 x 102 cm, cotton foundation. TM, Washington DC, no.R51.1.1. Formerly: Friedrich Sarre, Berlin. Pub. *Hali* 77, 1994, p.116. ii) Dais cover with lotus and chrysanthemum field and pictorial medallion design. Late 17th century. 196 x 409 cm, cotton foundation. Private collection, Switzerland. Formerly: Thomas B. Clarke, Southampton; Frank Michaelian, NY; Textile Gallery, London. Pub. Edelmann, NY, 26 September 1979, lot 189. iii) Dais cover with lotus field and pictorial medallion design. ca. 1700. 188 x 364 cm, cotton foundation. TM, Washington DC, no.R.51.1.4. Formerly: E.A. Bischoff, Beijing & London. Pub. Eiland, 1979, p.35, fig.17. iv) *Kang* cover with lotus field and pictorial medallion design. c. 1700. 194 x 394 cm. Musée des Arts Décoratifs, Lyons, no.27.177. Pub. Franses, 1982, p.135.

60. *Cushion face with deer and tree design.* 76 x 81 cm, silk pile on a cotton foundation. Eberhart Herrmann, Emmetten. Pub. Sotheby's, NY, 22 September 1993, lot 112; *Hali* 74, 1994, p.150.

61. *Kang cover with five lotus blossoms in discs on a pattern of chrysanthemums.* 160 x 262 cm, wool pile on a wool foundation. Thyssen-Bornemisza Collection, Lugano. Formerly: Victor Geloubewi, Paris; Textile Gallery, London; Cittone, Milan; Private collection, Milan; Textile Gallery, London. Pub. *Hali* 5/2, 1982, pp.218-219.

62. *Silk pile saddle rugs with pictorial designs, Yarkand?, first half 19th century:* i) Saddle rug with design of monkey, bird and deer under tree. 72 x 156 cm, cotton and silk foundation. Herrmann, Emmetten. Pub. Herrmann, 1988, p.245, pl.116 (structural analysis). ii) Saddle rug with design of monkey, bird and deer under tree. Cotton foundation. Formerly: Textile Gallery, London; Kossow, London. *Later Chinese wool pile covers with pictorial designs:* i) saddle rug with tree, deer and bird design. Baotou, ca. 1890. 53 x 142 cm, cotton foundation. Formerly: Textile Gallery/Hugh Moss Ltd., London. Pub. [Franses], 1973, pp.92–93, no.51. ii) *Kang* cover with tree, deer and bird design. Baotou, ca. 1890. 125 x 160 cm, cotton foundation. Formerly: Textile Gallery/Hugh Moss Ltd., London. Pub. [Franses], 1973, pp.92–3, no.50.

63. *Kang cover with a design of a tethered horse surrounded by antiques, within a diagonal swastika fret inner border overlaid with coins.* 203 x 305 cm, silk pile. Formerly: Dr Ludwig Treitel. Pub. Augustus W. Clarke, NY, 11-12 April 1913, lot 349.

64. *Cushion face with design of peonies.* 79 x 66 cm, silk pile with cotton highlights. Maqam/Dennis R. Dodds, Philadelphia. Pub. Edelmann, NY, 18 June 1982, lot 149; *Hali* 41, 1988, p.80.

65. *Cushion face with design of peonies and cash/shou symbols.* 92 x 88 cm, silk pile on a silk foundation. Eberhart Herrmann, Emmetten. Pub. Herrmann, 1988, pp.234-5, no.111 (structural analysis).

66. *Cover with medallion design and corner motifs.* 71.5 x 77.5 cm, silk pile with metal thread on a cotton foundation. Freer Gallery, Washington DC, no.15.260. Formerly: Yamanaka & Co., NY. This example was brought to my attention by the late Charles Ellis, who attributed it to Xinjiang/Mongolia, early to mid 19th

century. In 1974, Dr Esin Atıl suggested that it might be a bag for posts of a yurt. However, the direction of the pile, orientated down from the crenellated end, makes this unlikely. Information courtesy of Elizabeth Duley of The Textile Museum.

67. *Dais carpet with floral design.* 420 x 425 cm, wool pile on a cotton foundation. Private collection, Switzerland. Formerly: Hadjer, Paris; Textile Gallery, London.

68. *Kashgar silk pile carpets with other floral designs:* i) Dais cover with a small floral design around a square grid. Probably 19th century. 198 x 376 cm, with metal thread. Formerly: Tapis Antique Rugs, San Francisco. Pub. *Hali* 3/1, 1980, p.14. ii) *Kang* cover with floral lattice design. Kashgar?, 19th century. 158 x 115 cm, with metal brocading. Formerly: Mehdi, London; Ulrich Schürmann, Cologne; Textile Gallery, London. Pub. Schürmann, 1969, p.152, pl.76. (Eleven others known to us.)

69. *Section of a dais cover with rows of rosettes and small floral design.* Kashgar, early 18th century. 173 x 95 cm, incomplete, silk pile and metal thread. Pub. Christie's, London, 12 October 1989, lot 17. The tones are not unlike those of a Persian Esfahan 'Polonaise' carpet.

70. *Dais cover with design of rows of small flowers.* Kashgar, 18th century. 287 x 556 cm, silk pile. Pub. Edelmann, NY, 29 October 1983, lot 28; Sotheby's, NY, 19 October 1993, lot 141.

71. *Two joined fragments from the end of a carpet.* 101 x 171 cm and 103 x 172 cm, giving a complete width of 204 cm, wool pile. Museum für Islamische Kunst, Berlin, nos.J.21/73 a,b. Pub. Bidder, 1964, pl.XVII, no.2 (200 x 345 cm, possibly complete at that time; first half 18th century); Taylor & Hoffmeister, 1996, p.95.

72. *Kashgar silk pile carpets with the five-flower design:* i) Dais cover. Probably 18th century. 217 x 425 cm. Pub. Bidder, 1964, pl.XVIII (Khotan, 16th or 17th century). ii) Dais cover. Probably early 19th century. 145 x 254 cm. V&A, London. Pub. Schürmann, 1969, p.146, pl.70. (Eleven others known to us.)

73. *Dais cover with five-flower design on a white ground.* 173 x 356 cm, silk pile on a cotton foundation. Thyssen-Bornemisza Collection, Lugano. Formerly: French & Co., NY; Ulrich Schürmann, Cologne; Textile Gallery/Hugh Moss Ltd., London. Pub. Schürmann, 1969, p.150, pl.74; London 1973, pp.84-85, no.46 (Kashgar).

74. *Dais cover with three-flower design and cloudhead border.* Khotan, early 19th century. 175 x 340 cm, wool pile on cotton warps. Joseph Lavian, London. Pub. *Hali* 64, 1992, p.17.

75. *Dais carpet with medallion design.* Khotan or Yarkand, possibly late 18th century. 168 x 320 cm, silk pile with metal thread on a cotton foundation. Formerly: Frank Michaelian, NY. Pub. Edelmann, NY, 29 September 1979, lot 188 (Yarkand); *Hali* 2/3, 1979, p.260; Sotheby's, NY, 15 April 1993, lot 50 (structural analysis; Khotan).

76. *Yarkand/Khotan silk pile carpets with the five-flower design:* i) Dais cover. Probably Yarkand, ca. 1800. 173 x 343 cm. Formerly: Thornborough Galleries, Cirencester. Pub. *Hali* 6/4, 1984, p.80. ii) Dais cover. Possibly Khotan, 19th century. 260 x 264 cm, with metal thread. Pub. Sotheby's, London, 19 October 1994, lot 65. (Three others known to us.)

77. *Lattice design covers with silk pile and metal thread attributed to Kashgar:* i) Dais cover with floral lattice design. 203 x 400 cm. Bernheimer, Munich, cat.no. 46652. Pub. Bernheimer, 1959, pl.98 (Samarkand). ii) Seating mat with floral lattice design. 116 x 118 cm. Yves Mikaeloff, Paris. Pub. Eiland, 1986, p.100, fig.20; Sotheby's, London, 20 October 1993, lot 81; *Hali* 72, 1993-94, p.129. (Three others known to us.)

78. *Kang cover with design of flowers and tigers.* 132 x 187 cm, silk pile. Pub. Lefevre, London, 27 November 1981, lot 27.

79. *Dais cover with design of leaves and medallions.*

206 x 339 cm, silk pile on a cotton foundation. Formerly: Hagop Kevorkian, NY; Y. & B. Bolour, London; Textile Gallery, London; Michael Goedhuis, London. Pub. Anderson Galleries, 1926, lot 309 (Mongolian); Thompson, 1988, p.51, pl.48.

80. *Silk covers with 'unique' designs but related design elements:* i) Dais cover with design of offset rows of circular hexagonal medallions. 182 x 390 cm, cotton foundation. Battilossi, Turin. Formerly: Andrew R. Dole, NY. Pub. Battilossi, 1986, pl.16; *Hali* 35, 1987, p.94. The design within each medallion is similar to the field motif of fig.27. ii) Dais cover with design of tiny flowers. Pub. Sotheby's. The flowers alternate in colour diagonally against an orange-red field. The principal border is composed of stylised pomegranates and leaves similar to those on the Battilossi carpet. This is flanked by a swastika fret lattice set on different multi-coloured backgrounds; a larger version of this is used as the primary border on the Battilossi carpet. iii) Section of dais cover with elongated longevity lattice with flowers. Yarkand, ca. 1800. 59 x 97 cm, fragment, cotton foundation. Formerly: Bernheimer, Munich. Pub. Christie's, London, 14 February 1996, lot 9 (structural analysis).

81. *Khotan wool pile covers with the pomegranate tree design.* Examples include: i) *Kang* cover. 102 x 158 cm. V&A, London. Pub. Schürmann, 1969, frontispiece and p.164, pl.88. ii) Seating mat with blue pomegranate tree on an ivory ground. ca. 1800. 65 x 70 cm, cotton warps. Ronnie Newman, Ridgewood, NJ. Pub. *Hali* 55, 1991, p.137.

82. *Dais cover with red pomegranate tree on a yellow ground.* 231 x 315 cm, silk pile on a cotton foundation. Thyssen-Bornemisza Collection, Lugano. Formerly: Ulrich Schürmann, Cologne; Elio Cittone, Milan; Textile Gallery, London. Pub. Schürmann, 1969, p.157, pl.81; [Franses], 1973, pp.80-81, fig.44.

83. This concept can be found on Anatolian carpets, for example, dating from before 1700. *Yarkand/Khotan silk pile carpets with the pomegranate tree design:* Type 1, with rosette and/or 'T'/swastika borders: i) Dais cover with red pomegranates on a blue ground. Yarkand. 210 x 430 cm, cotton foundation. Pub. Bidder, 1964, pl.I, following p.52. ii) Dais cover on a blue ground. Yarkand, ca. 1800. 180 x 365 cm, cotton foundation. Formerly: Eskenazi, Milan. Pub. *Hali* 1/1, 1978, p.25. (Nine others known to us.) Type 2, with trefoil border: i) Dais cover with red pomegranates on a blue ground. Yarkand. 191 x 350 cm, cotton foundation. Pub. Sotheby's, NY, 5 December 1987, lot 63 (structural analysis); *Hali* 38, p.92, 1988. ii) Dais cover with red pomegranates on a blue ground. Yarkand. 158 x 366 cm. Pub. Sotheby's, NY, 4 June 1988, lot 85; *Hali* 40, p.84, 1988. (Three others known to us.) Type 3, with three-flower border: i) Cover with blue pomegranate tree on a red ground. Khotan or Yarkand, ca. 1880. 122 x 216 cm, cotton foundation. Museum für angewandte Kunst, Vienna, no.OR 330. Pub. Lorentz, 1972, pl.7b; Natschläger & Volker, 1986, p.46, no.37 and p.73 (structural analysis).

84. *18th/19th century silk pile Xinjiang carpets with disc- or gül-like medallions:* i) Dais cover with medallion design on red. 218 x 110 cm, section, cotton foundation. Museum für angewandte Kunst, Vienna, no.OR 318. Pub. *Hali* 31, 1986, pp.53, 103 (structural analysis). ii) Dais cover with disc-medallion design. Xinjiang, dated AH 1314 (1896 AD). 330 x 175 cm. Pub. *Hali* 47, 1989, p.91. iii) Dais cover with design of ten disc-medallions in two columns and a rosette border. Khotan. 188 x 368 cm, cotton foundation. Formerly: Victor Franses Gallery, London. Pub. *Hali* 5/3, 1983, 'Hali Gallery Focus', no.1. Possibly similar workshop to fig.28. iv) Dais cover with tile-like design. Possibly Khotan, late 19th century. 195 x 333 cm, cotton foundation. Formerly: Daniele Sevi, Milan. Pub. *Hali* 48, 1989, p.62. (Seven others known to us.)

85. *Kashgar wool pile safs:* i) Five-niche saf with flowers. 99 x 341 cm, cotton foundation. Formerly: Bernheimer, Munich. Pub. Christie's, London, 14 February 1996, lot 182 (structural analysis). ii) Twelve-niche saf with flowers. 18th century. 103 x 611 cm, cotton foundation. Meschoulam, Genoa. Pub. Eiland, 1986, pp.102-3, fig.23. (Three others known to us.)

86. *Kashgar silk pile safs:* i) Five-niche saf. 18th century. 112 x 183 cm. Private collection, Switzerland. Formerly: C. John, London. Pub. Schürmann, 1969, p.146, pl.70; Thompson, 1988, p.54, pl.53. ii) Three-niche saf with flowers. 18th century. 112 x 550 cm, with metal thread. Formerly: Lady Cunliffe. Pub. Thomson, 1925, p.159. iii) Six-niche saf with flowering trees. ca. 1800. 120 x 344 cm, with metal brocading on a cotton foundation. Museum für angewandte Kunst, Vienna, no.307. Formerly: Theodor Graf, Vienna. Pub. [Bennett], 1986, pp.53, 103 (structural analysis); Natschläger & Volker, 1986, pp.52-3, no.41, cover and pp.73-4 (structural analysis). *Some plain field Yarkand silk pile safs, circa 1800:* i) Seven-niche saf. 109 x 404 cm. Formerly: Vigo Art Gallery, London. Pub. Phillips, Midlands, 6 May 1987, lot 410; *Hali* 35, 1987, p.86; *Hali* 36, 1987, p.59. ii) Six-niche saf on green. 100 x 300 cm, probably incomplete, cotton foundation. Museum für angewandte Kunst, Vienna, no.T.4292. Pub. Lorentz, 1972, p.10 and 12, pl.10; Natschläger & Volker, 1986, pp.44-45, no.35 and p.72 (structural analysis); Taylor & Hoffmeister, 1996, pp.88-89, fig.1. iii) Three-niche saf on green. 112 x 180 cm, incomplete, cotton foundation. Formerly: Michaelian, NY. Pub. Edelmann, NY, 26 September 1979, lot 142; *Hali* 2/1, 1979, p.65; *Hali* 2/3, 1979, p.260. iv) Multi-niche saf on green. 111 x 400 cm. Pub. Phillips, London, 26 April 1994, lot 27; *Hali* 75, 1994, p.134.

87. *Silk pile safs probably from Khotan:* i) Five-niche saf with flowers. 131 x 322 cm. Pub. Phillips, London, 24 February 1987, lot 24; *Hali* 34, 1987, p.86. ii) Seven-niche saf with flowers. 131 x 322 cm, cotton foundation. Eberhart Herrmann, Emmetten. Formerly: Editha Leppich. Pub. Herrmann, 1986, pl.113 (structural analysis).

88. *Eight-niche saf with flowers.* 110 x 410 cm. Formerly: Victor Eskenazi, Milan; Textile Gallery, London; Bausback, Mannheim.

89. *Single-niche rug with diaper field, ram's horn niche and cloudhead border.* Yarkand, ca. 1800. 95 x 187 cm, silk pile on a cotton foundation. Private collection. Formerly: Herrmann, Munich. Pub. Herrmann, 1988, p.230, pl.109 (structural analysis); *Hali* 41, 1988, p.97.

90. *Wool pile carpets with designs of large angular waves:* i) *Kang* cover or wall hanging with design of a single dragon and angular waves at the base of the field. Ningxia, first half 17th century. 215 x 260 cm, cotton foundation. Textile Gallery, London, and John Eskenazi, London. Pub. Eskenazi, 1995, no.14. ii) Dais cover with diagonal swastika lattice design overlaid with coins enclosed by angular waves. Ningxia, ca. 1800. 300 cm square, cotton foundation. Formerly: Michaelian, NY; Herrmann, Munich. Pub. Herrmann, 1980, no.119 (structural analysis). iii) Dais cover with diagonal swastika lattice design and cloudhead border. China, ca. 1800. 305 x 275 cm. Formerly: Reinhold Herrmann. Pub. *Weltkunst*, 18 October 1976, p.1973. (Two others known to us.)

91. *Pictorial Yarkand silk pile safs:* i) Four-niche pictorial saf. Dated 1210?. 166 x 408 cm. Pub. *Hali* 88, 1996, p.49; Nagel, 15 November 1996, lot 6. ii) Four-niche pictorial saf. Dated 1210?. 166 x 408 cm. Parviz Tanavoli, Vancouver. Pub. *Hali* 6/2, 1984, p.189; Tanavoli, 1988, pp.14-15.

92. Pittsburgh, 1973.

93. *Kang cover with a disc-medallion in the centre and quartered discs in the corners, vases of flowers at each end of the field and floral sprays.* Probably Gansu, early 19th century. 95 x 230 cm. Arad Gallery, Florence. Pub. *Hali* 75, 1994, p.110.

WORKS CITED

AAA, *An Extraordinary Collection of Rare and Beautiful Antique and Modern Rugs and Carpets*, American Art Association, auction catalogue, New York, 6-8 March 1919.

AAA, *The V. and L. Benguiat Private Collection of Rare Old Rugs*, American Art Association, auction catalogue, New York, 4-5 December 1925.

AAA, *The Kevorkian Collection*, American Art Association, auction catalogue, New York, 20 January 1928.

Anderson Galleries, *The Hagop Kevorkian Collection Part Two*, auction catalogue, New York, 8-9 January 1926.

Battilossi, Maurizio (ed.), *Battilossi Tappeti d'Antiquariato 2*, exhib.catalogue, Turin, 1986.

[Bennett, Ian], 'History of a Saf', *Hali* 31, 1986, pp.53-4.

Bennett, Ian, 'Splendours in the City of Silk, part 4', *Hali* 35, 1987, pp.32-43.

Berlin, *Ausstellung Chinesischer Kunst*, exhib. catalogue, Berlin 1929.

Bernheimer, Otto, *Alte Teppiche des 16. bis 18. Jahrhunderts der Firma L. Bernheimer*, Munich, 1959.

Bidder, Hans, *Carpets from Eastern Turkestan*, Tübingen, 1964.

Cheng Weiji, *History of Textile Technology of Ancient China*, New York, 1990.

Dimand, M.S. & Jean Mailey, *Oriental Rugs in the Metropolitan Museum of Art*, New York, 1973.

Eiland, Murray L., *Chinese and Exotic Rugs*, London, 1979.

Eiland, Murray, 'East Turkestan Rugs Revisited', *Hali* 85, 1996, pp.99-103.

Ellis, Charles Grant, 'Chinese Rugs', *The Textile Museum Journal*, vol.II, no.3, Washington DC, 1968, pp.35-52.

Erdmann, Kurt, *Seven Hundred Years of Oriental Carpets*, London, 1970.

Eskenazi, John, *Images of Faith*, exhib. catalogue, London, 1995.

[Franses, Michael], The Textile Gallery/Hugh Moss, *An Introduction to the World of Rugs,* exhib. catalogue, London, 1973.

Franses, Michael, 'Early Ninghsia Carpets', *Hali* 5/2, 1982, pp.132-140.

Franses, Michael, & Robert Pinner, 'Mughal Floral Lattice Carpet', *Hali* 4/4, 1982, pp.232-233.

Gilles, Roland, et al., *Tapis, Présent de L'Orient à l'Occident*, exhibition catalogue, Institut du Monde Arabe, Paris, 1989.

Helbing, Hugo, Frankfurt, *Versteigerung der Sammlung Karl Bader*, auction catalogue, 8 December 1932.

Herrmann, Eberhart, *Asiatische Teppich- und Textilkunst 1*, exhib. catalogue, Munich, 1989.

Herrmann, Eberhart, *Asiatische Teppich- und Textilkunst 2*, exhib. catalogue, Munich, 1990.

Herrmann, Eberhart, *Seltene Orientteppiche V*, exhib. catalogue, Munich, 1983.

Herrmann, Eberhart, *Seltene Orientteppiche VII*, exhib. catalogue, Munich, 1985.

Herrmann, Eberhart, *Seltene Orientteppiche VIII*, exhib. catalogue, Munich, 1986.

Herrmann, Eberhart, *Seltene Orientteppiche IX*, exhib. catalogue, Munich, 1987.

Herrmann, Eberhart, *Seltene Orientteppiche X*, exhib. catalogue, Munich, 1988.

Herrmann, Eberhart, *Von Konya bis Kokand, Seltene Orientteppiche*, exhib.catalogue, Munich, 1980.

Hoffmeister, Peter, *Turkoman carpets in Franconia*, Edinburgh, 1980.

Huang Nengfu (ed.), *The Great Treasury of Chinese Fine Arts, Arts and Crafts, no.6, Printing Dying Weaving and Embroidery*, vol.1, Beijing, 1990.

ICOC, Programme of the 6th International Conference on Oriental Carpets, San Francisco, 1990.

ICOC, Programme of the 8th International Conference on Oriental Carpets, Philadelphia, 1996.

Kendrick, A.F. & C.E.C. Tattersall, *Hand-Woven Carpets, Oriental and European*, 2 vols., London, 1922.

König, Hans, 'Beziehungen zwischen den Teppichen Ostturkestans und Moghulindiens', *Festschrift für*

Peter Wilhelm Meister, Hamburg, 1975, pp.32-40.

Lee Yu-Kuan, *Art Rugs from Silk Route and Great Wall Areas*, Tokyo, 1980.

Lorentz, H.A., *A View of Chinese Rugs from the Seventeenth to the Twentieth Century*, London, 1972.

McMullan, Joseph V., *Islamic Carpets*, New York, 1965.

MMA, *The James F. Ballard Collection of Oriental Rugs*, exhib. catalogue, Metropolitan Museum of Art, New York, 1923, Joseph Breck & Frances Morris.

Musée des Gobelins, *Exposition des Tapisseries et Tapis de la Chine du VIIe au XIXe Siècle*, exhib. cat., Paris 1936, text by François Carnot & Bernard Vuilleumier.

Natschläger, Helga & Angela Völker, *Knüpfteppiche aus China und Ostturkestan*, exhib. catalogue, Österreichisches Museum für angewandte Kunst, Vienna, 1986.

Pinner, Lesley, 'The Structure of Some Chinese Carpets and the Use of Packing and Warp-Sharing Knots', *Hali* 5/3, 1983, pp.272-275.

Pinner, Robert, 'A Ming Dynasty Saddle Rug', *Hali* 1/4, 1978, p.391.

Pinner, Robert, & Walter B. Denny (eds.), *Oriental Carpet & Textile Studies II, Carpets of the Mediterranean Countries 1400-1600*, London, 1986.

Pittsburgh University Art Gallery, *Imperial Carpets from Peking*, exhib. catalogue, 1973, text by John F. Haskins & Pamela Bardo.

Pope, Arthur Upham, 'Rugs', *Catalogue Mrs Phoebe A. Hearst Loan Collection*, San Francisco, 1917.

Rostov, C.I., & Jia Guanyan, *Chinese Carpets*, New York, 1983.

Royal Academy of Arts, *An Exhibition of Chinese Arts*, exhib. catalogue, London, 1935-36.

Sarre, Friedrich, & Hermann Trenkwald, *Old Oriental Carpets*, Leipzig, 1926-29.

Schürmann, Ulrich, *Central-Asian Rugs*, London, 1969.

Schürmann, Ulrich, 'Ein Bedeutender Ostturkestanischer seidener knüpfteppich des 17. Jahrhunderts, 222 x 394 cm., früher Sammlung J.P. Morgan', *Festschrift für Peter Wilhelm Meister*, Hamburg, 1975.

Schürmann, Ulrich, *Teppiche aus dem Orient*, Wiesbaden, 1976.

Tanavoli, Parviz, 'Samarkand Pictorial Saf', *Hali* 40, 1988, pp.14-15.

Taylor, John & Peter Hoffmeister, 'Xinjiang Rugs', *Hali* 85, 1996, pp.88-98.

The Textile Museum, *East of Turkestan*, exhib. catalogue, Washington DC, 1967.

Thompson, Jon, *Carpet Magic*, exhib. cat., London, 1983.

Thompson, Jon, *Silk Carpets and the Silk Road*, exhib. catalogue, Tokyo, 1988.

Thomson, W.G., 'Chinese Carpets', *Apollo*, II, 1925, pp.159-65.

Tiffany Studios, *The Tiffany Studios Collection of Notable Antique Oriental Rugs, Antique Chinese Rugs*, New York, 1906.

Tiffany Studios, *The Tiffany Studios Collection of Antique Chinese Rugs*, New York, 1908, text by M.C. Ripley.

7 BY THE PEN

Pages 108-125

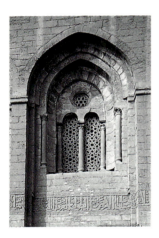

NOTES

1. Sheila S. Blair, 'What is the Date of the Dome of the Rock', in *Bayt al-Maqdis, Abd al-Malik's Jerusalem*, part one, Julian Raby and Jeremy Johns (eds.), *Oxford Studies in Islamic Art IX*, Oxford, 1992, pp.59-88.

2. Translations from the Qur'an are a modified version of those given by A.J. Arberry, *The Koran Interpreted*, New York, 1955.

3. Wayne E. Begley, 'The myth of the Taj Mahal and a new theory of its symbolic meaning', *Art Bulletin*, 56/1, 1979, pp.7-37.

4. François Déroche, *The Nasser D. Khalili Collection of Islamic Art vol.I: The Abbasid Tradition: Qur'ans of the 8th to the 10th centuries*, London, 1992, no.42. For the attribution to tenth century Tunisia, see Jonathan M. Bloom, 'The Early Fatimid Blue Koran Manuscript', *Les Manuscrits du Moyen-orient: essais de codicologie et paléographie*, François Déroche (ed.), Istanbul/Paris, 1989, pp.95-99.

5. For a summary of the various names, see Déroche, op. cit., 1992, p.132. On this manuscript see Beatrice St Laurent, 'The Identification of a Magnificent Koran Manuscript', *Les Manuscrits du Moyen-orient*, cit., pp.115-124.

6. Richard Ettinghausen, 'Arabic Epigraphy: Communication or Symbolic Affirmation', *Near Eastern Numismatics, Iconography, Epigraphy and History: Studies in Honor of George C. Miles*, Dikran Kouymjian (ed.), Beirut, 1974, pp.297-317.

7. The building is described in K.A.C. Creswell, *Muslim Architecture of Egypt*, London, 1952-59, vol.2, pp.190-212. The inscription is recorded in Etienne Combe, Jean Sauvaget and Gaston Wiet (eds.), *Repertoire chronologique d'épigraphie arabe,* (hereafter RCEA), Cairo, 1931-, no.4852.

8. Oliver Watson, *Persian Lustre Ware*, London, 1985. See also Alan Caiger-Smith, 'A Kind of Alchemy: Persian Ceramics of the Twelfth & Thirteenth Centuries', *Asian Art: The Second Hali Annual*, 1995, pp.138-53.

9. The plate is illustrated in Watson, op. cit., fig.63 and Caiger-Smith, op. cit., fig.11; the inscription is RCEA 3672. Abdollah Ghouchani, *Persian Pottery on the*

Tiles of Takht-i Sulayman, Tehran, 1992, p.5, suggested that the two short words at the end of the name of the potter should be read not as a mistaken and extra *fi shahr* but as Abi Zayd, thereby making the potter's full name Sayyid Shams al-Din al-Hasani Abu Zayd. The stylised way of writing *zayd* certainly corresponds with the potter's signature elsewhere.

10. Once in the Cartier collection, this magnificent manuscript has recently been cut up and the pages dispersed. This page in the Art and History Trust Collection is on loan to the Freer-Sackler Gallery. See Abolala Soudavar, *Art of the Persian Courts: Selections from the Art and History Trust Collection*, New York, 1992, no.59.

11. Dust-Muhammad's celebrated account of past and present scribes and painters, written as the preface to the album he prepared for Tahmasp's brother Bahram Mirza (Istanbul, Tokapı Palace Library, H2154) has been translated by Wheeler M. Thackston, *A Century of Princes: Sources on Timurid History and Art*, Cambridge, MA, 1989, pp.335-350.

12. For recent bibliography, see the catalogue of the exhibition held at the Hayward Gallery 8 April-4 July 1976, *Arts of Islam*, London, 1976, no.58 and colour plate 60.

13. Esin Atıl, *Ceramics from the World of Islam*, Washington DC, 1973, no.12.

14. For recent bibliography, see Jerrilynn D. Dodds (ed.), *Al-Andalus: The Art of Islamic Spain*, New York, 1992, no.3.

15. The inscriptions on these ivories are given in Ernst Kühnel's magisterial study, *Die islamischen Elfenbeinskulpturen VII-XIII Jahrhundert*, Berlin, 1971.

16. Lutfallah Hunarfar, *Ganjina-yi athar-yi tarikhi-yi isfahan* (A treasury of the historical monuments of Isfahan), Isfahan, 1346/1968, pp.427-64.

17. Esin Atıl, W.T. Chase, and Paul Jett, *Islamic Metalwork in the Freer Gallery of Art*, Washington DC, 1985, no.14.

18. Ibid., no.17.

19. Eva Baer, *Ayyubid Metalwork with Christian Images*, Leiden, 1989.

20. Sheila S. Blair, 'Legibility versus Decoration in Islamic Epigraphy: The Case of Interlacing', *World Art: Themes of Unity in Diversity*, Acts of the XXVIth International Congress of the History of Art, Irving Lavin (ed.), University Park, PA, 1989, pp.329-31.

21. *Arts of Islam*, no.4.

22. *Nasir-i Khusraw's Book of Travels*, trans. Wheeler M. Thackston, Persian Heritage Series no.36, Albany, 1986, p.48.

23. Sheila S. Blair and Jonathan M. Bloom, *The Art and Architecture of Islam 1250-1800*, London and New Haven, 1994, pp.170-71 and fig.213.

24. Thackston, op. cit., p.348.

25. Lisa Volov [Golombek], 'Plaited Kufic on Samanid Epigraphic Pottery', *Ars Orientalis* VI, 1966, p.128, note 21 and fig.11.

26. The classic study of the development of floriated Kufic script is Adolf Grohman's article, 'The Origin and Development of Floriated Kufic', *Ars Orientalis* II, 1957, pp.183-214.

27. Similarly, for the development of interlaced Kufic, see Volov, op. cit.

8 THE SUBLIME IMAGE
Pages 126-141

This article is adapted from 'Early Portrait Painting in Tibet', which appeared in *Function and Meaning in Buddhist Art*, edited by K.R. van Kooij and H. van der Veere (Groningen: Egbert Forsten, 1995). Full references and Sanskrit diacritics can be found in this earlier publication.

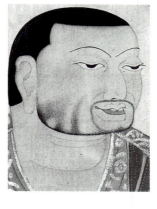

NOTES

1. Ananda Coomaraswamy, 'Visnudharmottara Chapter XLI', *Journal of the American Oriental Society* 52, no.1 (1932), p.21.

2. Coomaraswamy, 'Visnudharmottara', p.14. The others are pose (*sthana*), ideal proportion (*pramana*), extent of background (*bhulambha*), sweetness or flavour (*madhurya*) and foreshortening (*pakshavrddhi*).

3. Ibid., pp.20-21.

4. See Stella Kramrisch, 'Introduction to the *Visnudharmottara*', in *Exploring India's Sacred Art*, ed. Barbara Miller, Philadelphia, 1983, pp.267-268, 339-340.

5. Ibid., pp.339-340.

6. Ibid., pp.267-268.

7. Marcelle Lalou, *Iconographie des étoffes peintes (pata) dans le Mañjusrimulakalpa*, Paris, 1930, p.15. According to Lalou, this text was translated into Tibetan in the eleventh century. Ibid., p.4, n.2.

8. B.N. Goswamy and A.L. Dahmen-Dallapiccola, trans., *An Early Document of Indian Art: The 'Citralaksana of Nagnajit*, New Delhi, 1976, xiii. The precise date of its translation into Tibetan is not known, but one can confidently argue for a date not later than the early medieval period (ca. twelfth century), ibid. Goswamy dates the original Sanskrit text to the early Gupta period.

9. Ibid., pp.105-106.

10. Ibid., p.79.

11. Ibid., pp.85-86.

12. Finger breadth being one of the units of measurement in iconometric texts. Ibid., p.103.

13. Ibid., p.107.

14. Ananda K. Coomaraswamy, 'The Traditional Conception of Ideal Portraiture', in *Why Exhibit Works of Art?*, London, 1943, pp.111-18. See also Kramrisch, 'Visnudharmottara', pp.268, 271.

15. Translated in Susan Bush and Hsio-yan Shi, comp. and ed., *Early Chinese Texts on Painting*, Cambridge, 1985, p.227.

16. Ibid., p.272.

17. In 1949 Giuseppe Tucci wrote that – at least from the fourteenth century onwards – portraits done during a hierarch's lifetime served as models for all later portraits. There is insufficient evidence as yet to know whether this hypothesis was generally true during the period under consideration. One notes the remarkable similarities between different depictions of Taglung Thangpa Chenpo (see figs 8 and 17), a frequent subject in Taglung painting. Phagmodrupa also appears frequently in Taglung paintings, usually bearing the distinctive physiognomic traits apparent in figs 1 and 14.

18. Jeannine Auboyer, *Le trône et son symbolisme dans l'Inde ancienne*, Paris, 1949, pp.105-168.

19. Indian treatises on iconography, such as the *Maha vastu*, describe thirty-two great marks (*mahapurushalakshana*) of the enlightened being, as well as an additional eighty lesser marks (*anuvyañjanalakshana*).

20. Published in S.K. Pathak, *The Album of the Tibetan Art Collections*, Patna, 1986, pl.33. Although the painting is reproduced in black and white, the grey tone of Drakpa Gyaltsen's hair matches that of his robe, and must be red or orange in the original.

21. E.g. the Tokharians. See Denis Sinor (ed.), *The Cambridge History of Early Inner Asia*, Cambridge, 1990, chapter 6; and Otto Mänchen-Helfen, *Journey to Tuva*, Los Angeles, 1992, p.168. I am grateful to Jeremy Pine for these bibliographic references.

22. Stein, *Tibetan Civilization*, p.176.

23. Ibid.

24. Ibid.

25. George Roerich (trans.), *The Blue Annals*, 2 parts, Delhi, 1949-53, 2nd edn. Delhi, 1979, p.664.

26. Ibid., p.574. Drigungpa was a disciple of Phagmodrupa and a rival of Taglung Thangpa Chenpo, see below.

27. Ibid., p.683. In traditional Indian theology, the distinction between a tenth *bhumi* bodhisattva and a Buddha is slight. In the *Prajñaparamita* literature, including the *Suramgamasamadhi sutra* and the *Mahavastu*, there are descriptions of the ten stages (*bhumi*) through which a bodhisattva progresses in his or her career, the last stage being the tenth *bhumi*. Tenth *bhumi* bodhisattvas have already perfected the *paramita*s (virtues such as patience and charity) and have mastered the ten powers of the *tathagata*. According to the literature, they are tied to the phenomenal world only by their great compassion for sentient beings. See Etienne LaMotte, 'Mañjusri', *T'oung Pao* 48, 1960, pp.10-26.

28. Roerich, *The Blue Annals*, p.620.

29. Ibid., p.624.

30. E.g. a thirteenth century Vajravarahi mandala, published in Gilles Béguin, *Art ésotérique de l'Himalaya. Catalogue de la donation Lionel Fournier*, Paris, 1990, pl.c. The Alchi lineage is published in Goepper and Poncar, *Alchi*, p.216.

31. Roerich, *The Blue Annals*, p.563.

32. Ibid, p.552.

33. Stein, *Tibetan Civilization*, p.176.

34. Roerich, *The Blue Annals*, p.612.

35. Ibid., and *passim*.

36. See Diana L. Eck, *Darsan: Seeing the Divine Image in India*, Chambersburg, PA, 1985, 2nd rev. edn.

37. bla-ma nyid-sku'i gzugs-brnyan du 'byon-pa. chos-'byung mkhas-pa'i dga'-ston [Scholar's Feast of Religious History], Lokesh Chandra (ed.), New Delhi, 1961, part 2: 'da-pa', p.316.

38. Roerich, *The Blue Annals*, p.403.

39. Ibid., pp.403-4. This was not uncommon among the Kagyus as a whole: Gö's chapter on this school is replete with stories of disciples unable to make sufficient offerings to their masters and thus unable to obtain teachings.

40. Roerich, *The Blue Annals*, p.600.

41. Published in Goepper and Poncar, *Alchi*, p.216.

SELECT BIBLIOGRAPHY

Goepper, Roger, 'Clues for a Dating of the Three-storeyed Temple (Sumtsek) in Alchi, Ladakh', *Asiatische Studien* 44, no.2 (1990).

Goepper, Roger, and Jaroslav Poncar, *Alchi*, London, 1996.

Lowry, John, 'A Fifteenth Century Sketchbook (Preliminary Study)', in *Essais sur l'Art du Tibet*, MacDonald, Ariane, and Yoshiro Imaeda (eds.), Paris, 1977.

Pal, Pratapaditya, and Lionel Fournier, *A Buddhist Paradise: The Murals of Alchi, Western Himalayas*, Hong Kong, 1982.

Snellgrove, David, and Tadeusz Skorupski, *The Cultural Heritage of Ladakh*, 2 vols., New Delhi, 1977-80.

Tucci, Giuseppe, *Tibetan Painted Scrolls*, 3 vols., Rome, 1949.

9 THE QUIET WAY
Pages 142-149

NOTES

1. Celadons are called *qingci* in Chinese, *ch'ongja* in Korean, and *seiji* in Japanese; despite differences in pronunciation, all three names are written with the same two Chinese characters. The first syllable of the compound means 'light bluish green', and the second 'high-fired ceramic ware'; the term is correctly translated as 'light bluish green-glazed stoneware' or 'celadon-glazed stoneware'. Believing they are using a term more closely related to the East Asian one, a number of Western scholars have recently begun to translate *qingci* as 'green-glazed ware'; such usage is to be lamented, as it refers neither to the body's high-fired nature nor to the bluish component of the bluish green glaze. In fact, 'green-glazed' is the proper translation of the Chinese *lüyou*, which refers to the lead-fluxed emerald green glaze of Han (206 BC- 220 AD) and Tang (618-907) earthenwares made for funerary use. The mistaken translation of *qingci* as 'green-glazed ware' has led some beginning students and novice collectors to confuse the celadon and lead-fluxed green-glaze traditions, mistakenly assuming that the former evolved from the latter. The old term 'celadon', if properly explained, remains the better translation, as it readily distinguishes the traditions.

2. In the proper kiln atmosphere, a pale, bluish-green colour – like that of window glass – appears when concentrations of iron oxide reach 0.8 per cent. As the amount of iron oxide increases, the colour deepens, with concentrations of one to three per cent yielding celadon glazes. Additional iron oxide results in brown glazes; those with concentrations of five per cent or more turn dark brown, appearing black to the naked eye when sufficiently thick. Celadon wares are thus closely related to clear-glazed wares and to brown- and black-glazed wares. Robert D. Mowry, *Hare's Fur, Tortoiseshell, and Partridge Feathers: Chinese Brown- and Black-Glazed Ceramics, 400-1400*, exhibition catalogue, Harvard University Art Museums, Cambridge, Massachusetts, 1996, pp.23 and 106.

3. For examples of Yue ware, see Basil Gray, *Sung Porcelain and Stoneware*, Faber and Faber, London and Boston, 1984, pp.27-36, pls.1-12; Shelagh J. Vainker, *Chinese Pottery and Porcelain From Prehistory to the Present*, George Braziller, New York, 1991, pp.70-72, pls.50-52; Yutaka Mino and Katherine R. Tsiang, *Ice and Green Clouds: Traditions of Chinese Celadon*, exhibition catalogue, Indianapolis Museum of Art, Indianapolis, 1986, pp.122-135, nos.44-50.

4. For examples of such stonewares, see Robert P. Griffing, Jr., *The Art of the Korean Potter: Silla, Koryo, Yi*, exhibition catalogue, Asia House Gallery, The Asia Society, New York, 1968, pp.57-63, nos.1-11; René-Yvon Lefebvre d'Argencé (ed), *5,000 Years of Korean Art*, exhibition catalogue, Asian Art Museum of San Francisco, San Francisco, 1979, p.21, pl. VIII, pp.71-80, pls. 39-51, 53-54, 61-68; Sarah Milledge Nelson, *The Archaeology of Korea*, Cambridge World Archaeology series, Cambridge, New York, and Victoria, 1993, pp.206-61.

5. Robert D. Mowry, 'Korean Technical Sophistication Mirrored in the Korean Ceramic Heritage', *Korea Magazine*, March 1993, pp.26-27.

6. In fact, the term *meiping* does not appear in Chinese texts before the Qing dynasty (1644-1911). The Qing dynasty treatise *Yinliuzhai shuo ci (A Discussion of Ceramics [by the Master of the] Yinliu Studio)* states that such bottles were called *meiping* because the mouth was as small as a slender plum branch. The name gradually gained currency and has remained in use throughout East Asia to this day. Mowry, *Hare's Fur, Tortoiseshell, and Partridge Feathers*, p.253, no.103.

7. This bottle was in the collection of The University Museum, University of Pennsylvania, Philadelphia, until 1974, when it was transferred to the Philadelphia Museum of Art. It is sometimes still mistakenly said to belong to The University Museum. It is published in Griffing, *The Art of the Korean Potter*, pp.121, 179, no.38.

8. The Song dynasty witnessed the revival of numerous forms from the Great Bronze Age, particularly those of the bronze ritual vessels that had been used in ceremonies honouring the spirits of deceased ancestors. See Robert D. Mowry, *China's Renaissance in Bronze: The Robert H. Clague Collection of Later Chinese Bronzes, 1100-1900*, exhibition catalogue, Phoenix Art Museum, Phoenix, Arizona, 1993, pp.9-12, 23-27, no.2, pp.31-35, nos.4-5.

9. This Ru ware bowl must have been part of a large set, perhaps including foliate dishes, made expressly for the Northern Song imperial palace in Kaifeng, Henan province. It is very possible that the Chinese ambassador who travelled to Korea late in 1121 carried several pieces from this set to present as gifts to the Korean king. For an illustration of the National Palace Museum bowl, see Wen Fong and James C.Y. Watt, *Possessing the Past: Treasures from the National Palace Museum, Taipei*, exhibition catalogue, The Metropolitan Museum of Art, New York, 1996, p.231, pl.104. For an in-depth study of Ru ware, see Wang Qing-zheng, Fan Dong-qing, and Zhou Li-li, *The Discovery of Ru Kiln: A Famous Song-Ware Kiln of China*, Hong Kong, 1991.

10. For an in-depth study of these bowls and saucers, see Robert D. Mowry, 'Koryo Celadons', *Orientations*, May 1986, pp.24-39.

SELECT BIBLIOGRAPHY

Choi, Sunu (ed), *National Museum of Korea, Seoul*, vol.2 in *Oriental Ceramics: The World's Great Collections*, Tokyo, New York, and San Francisco, 1982.

d'Argencé, René Yvon Lefebvre (ed), *5000 Years of Korean Art*, (exhibition catalogue), Asian Art Museum of San Francisco, San Francisco, 1979.

Gompertz, G. St. G.M., *Chinese Celadon Wares*, 2nd edn., London and Boston, 1980.

Gompertz, G. St. G.M., *Korean Celadon and Other Wares of the Koryo Period*, London, 1963.

Gray, Basil, *Sung Porcelain and Stoneware*, London and Boston, 1984.

Griffing, Robert P., *The Art of the Korean Potter: Silla, Koryo, Yi*, exhibition catalogue, The Asia Society, New York, 1968.

Kim, Chewon and Lena Kim Lee, *Arts of Korea*, Tokyo, New York, and San Francisco, 1974.

Kim, Chewon and Won-Yong Kim, *Treasures of Korean Art, 2000 Years of Ceramics, Sculpture and Jeweled

Arts, New York, 1966.

Medley, Margaret, *Korean and Chinese Ceramics from the 10th to the 14th Century*, exhibition catalogue, Fitzwilliam Museum, Oxford University, and Percival David Foundation, 1975.

Mino, Yutaka, *The Radiance of Jade and the Clarity of Water: Korean Ceramics from the Ataka Collection*, exhibition catalogue, The Art Institute of Chicago, Chicago, 1991.

Mowry, Robert D., 'Korean Technical Sophistication Mirrored in the Korean Ceramic Heritage', *Korea Magazine*, March 1993, pp.26-27.

Mowry, Robert D., 'Koryo Celadons', *Orientations*, May 1986, pp.24-39.

Nelson, Sarah Milledge, *The Archaeology of Korea*, *Cambridge World Archaeology* series, Cambridge, New York and Victoria, 1993.

Sekai Toji Zenshu (Ceramic Art of the World), vol.18, *Korai (Koryo)*, Tokyo, 1978.

Tregear, Mary, *Song Ceramics*, New York, 1982.

Whitfield, Roderick (ed.), *Treasures from Korea: Art Through 5000 Years*, exhibition catalogue, London, 1984.

10 COURT LADIES, MONKS AND MONSTERS

Pages 150-167

NOTES

1. This expression is borrowed from Ivan Moris, *The World of the Shining Prince. Court Life in Ancient Japan*, Oxford, 1964.
2. Cf. Penelope E. Mason, 'Yamato-e, in *Kodansha Encyclopedia of Japan*, vol.8, p.309; for a detailed discussion of the subject see Ienaga Saburo, *Painting in the Yamato Style*, New York and Tokyo, 1973.
3. See Max Loehr, 'Das Museum für Asiatische Kunst in Bamberg', in *Ostasiatische Zeitschrift*, N.F. 13, 1937, pp.77-81.
4. Cf. 'Bedeutende Ostasien-Sammlung angeboten', in *Frankfurter Allgemeine Zeitung*, 2 June 1959.
5. On 4 June 1992, Sotheby's New York sold a single illustrated book (in two volumes) for US$16,000 (Sale 6327, lot 235). Nowadays, even this sum looks modest.
6. Cf. James Araki, 'Otogi-zoshi and Nara ehon. A Field Study in Flux', in *Monumenta Nipponica*, vol.36, no.1, Spring 1981, p.13.
7. For the varying terminology among scholars in this field see Araki, op. cit. note 5, pp.16ff.
8. See Yoshiko Ushioda, *Tales of Japan, Three Centuries of Japanese Painting from the Chester Beatty Library*, Dublin, 1992, p.65.
9. In this dating I agree with Prof. Midori Sano, an expert on *yamato-e* from Seijo University, Tokyo, who examined the collection of the Museum für Kunsthandwerk in the summer of 1996.
10. 29 March 1996, Sale 6822, lot 6.
11. For an English translation see James T. Araki, 'Bunsho Soshi. The Tale of Bunsho, the Saltmaker', in *Monumenta Nipponica*, vol. 38, no.3, Autumn 1983, pp.223-249.
12. I would like to thank Prof. Sano who discovered this fact during our joint examination of the books.
13. This dating is again in accordance with Prof. Sano.
14. The other is also a two volume edition of the *Bunsho soshi* at 33 x 24.7 cm (1'1" x 9 ⁴/₅"), MKH 12790.
15. For a German translation and thorough analysis of this edition see Bernd Jesse, *Die Vorgeschichte der Götter von Kumano. Das Nara-ehon 'Kumano no honji' aus der Sammlung Voretzsch im Besitz des Museums für Kunsthandwerk, Frankfurt am Main*, Wiesbaden, 1996.

16. Cf. Kogoro Yoshida, *Tanrokubon. Rare Books of Seventeenth-Century Japan*, Tokyo, New York and San Francisco, 1984, pp.134-140; this beautiful publication includes colour reproductions of all illustrations of the Kumano *tanrokubon* and a summary of the legend in English. One of the very rare originals left of the Kumano *tanrokubon* can be studied in the New York Public Library, Spencer Collection, MS 286.

17. Matsumoto Ryushin mentions a work dated in its colophon to 1595 as one of the oldest *Nara ehon* in book form – see Matsumoto Ryushi, 'Nara ehon to otogi-zoshi', in *Nihon Bungaku XXVI*, 2, February 1977, also mentioned in Araki, op. cit. note 5, p.14.
18. Cf. a pair of six-fold *Nanban* screens reproduced in Okada Jo, *Genre Screens from the Suntory Museum of Art*, New York, 1978, cat. no.17.
19. Cf. Melanie Trede, '"Die große Gewebekrone" – Taishokkan', in *Quellen ed, Das Wasser in der Kunst Ostasiens*, Hamburg: Museum für Kunst und Gewerbe, and Köln: Museum für Ostasiatische Kunst, 1992, p.71; for a detailed analysis of the *Taishokan* in Japanese litera ture and art see also Melanie Trede, *Der Kampf um das Juwel. Die Taishokan-Legende in Literatur und Kunst am Beispiel des Bilderzyklus im Museum für Ostasiatische Kunst in Köln* (unpublished M.A. thesis at Heidelberg University, Institut für Kunstgeschichte Ostasiens, 1994).
20. Kamatari was an ancestor of the Fujiwara clan that politically dominated most of the Heian period (794-1185), the period between 898 and 1185, which has also been known as the Fujiwara period.
21. Cf. W.M. Hawley, *Mon. The Japanese Family Crest*, Hollywood, 1976, p.57; the same type of cover is used in another *Nara ehon* in the Frankfurt collection, the *Hozo biku*, inv.no. 12800, that probably formed part of the same wedding dowry with the *Taishokan*.
22. The series was bought in 1994 from Rolf Ernst, a former dealer in Hofheim near Frankfurt. My explanations concerning this work are largely based on the translations of the texts in relation to the illustrations in Bernd Jesse's 'Beschreibung eines Japanischen Stellschirms mit Gedichten aus den heian-zeitlichen Romanen Genji monogatari und Sagoromo mono-gatari' in *Referate des Achten Deutschsprachigen Japanologentages, Wien*, Vienna 1991.

PHOTOGRAPHIC CREDITS

1. *The World is a Garden*
 Los Angeles County Museum of Art, 6, 8, 12, 31; Walter B. Denny, 7; Ernst J. Grube 16, 20, 23, 24, 25, 29; Daniel McGrath, 26.
2. *Hybrid Temples in Karnataka*
 Gerard Foeckema, 2, 3, 5, 6, 9, 10, 11, 12, 13, 15, 16, 17, 18, 19, 20, 21, 22, 23, 24, 25; Adam Hardy, 1, 4, 7, 8, 14 and all drawings.
4. *Public Showcase, Private Residence*
 Roger Asselberghs, Brussels, 1, 2, 8, 12, 13, 16, 18; C. Tiberghien, 4, 11.

6. *Fengruan Rutan*
 Longevity, London, 2, 3, 4, 5, 6, 7, 8, 9, 10, 12, 13, 14, 15, 16, 18, 19, 20, 21, 22, 26, 27, 29: Gary McKinnis, 24.
7. *By the Pen*
 Sheila Blair & Jonathan Bloom 3, 4, 5, 6, 20, 21, 22; Bernard O'Kane 1, 12; RMN 13, 17.
10. *Court Ladies, Monks and Monsters*
 Ursula Seitz-Gray, all except 3, 4, 6, 7, 10, 21.
11. *Glamour and Restraint*
 Alexandria Press, London, 1, 6, 12, 13.

See also individual captions.

AUTHORS

SHEILA BLAIR AND JONATHAN BLOOM
Sheila Blair and Jonathan Bloom are a husband-and-wife team of independent scholars of Islamic art and architecture. They both received their PhDs from Harvard in 1980 and have taught at several universities in the United States and Europe. From 1987-1996 they were editors in charge of Islamic and Central Asian art for *The Dictionary of Art* (London, 1996). They have published many articles and books together, including the acclaimed *Art and Architecture of Islam: 1250-1800* (New Haven/London, 1994), *Islamic Arts* (London, 1997) and *Images of Paradise in Islamic Art* (Hanover NH, 1991). They live with their two children, two cats and one dog in rural New Hampshire.

GRACE WU BRUCE
Grace Wu Bruce is a leading international dealer in classical Chinese furniture based in Hong Kong. She was a collector of Ming furniture for ten years before opening her gallery in 1987. She has exhibited at major international fairs and has written numerous articles on the subject. Her book *Classical Chinese Furniture* was published by Oxford University Press in 1996. Many of the most important collections of the last decade have been formed with her assistance including that of the Museum of Classical Chinese Furniture, whose collection was sold by Christie's, New York in September 1996.

MICHAEL FRANSES
Michael Franses is one of the world's foremost dealers in carpet and textile art and an acknowledged authority on the subject. After an 'apprenticeship' in the family business during the 1960s, in 1972 he founded The Textile Gallery in London, initially in association with the Far Eastern art dealers Hugh Moss Limited, and began to arrange specialist exhibitions. In 1975, together with Robert Pinner, he co-founded the International Conference on Oriental Carpets (ICOC), jointly organising the first conference in London in 1976. At the same time he established Oguz Press, a publishing house specialising in books on oriental carpets and the textile arts. In 1978 he co-founded *Hali, The International Journal of Oriental Carpets and Textiles*. As co-editor and publisher for its first eight years he wrote and co-authored many articles – including an in-depth survey of much of the carpet collection in the Victoria and Albert Museum. A frequent lecturer, exhibition organiser and regular participant in international art fairs, in 1993 he returned to publishing, forming Textile & Art Publications Limited.

ERNST J. GRUBE
Professor Ernst J. Grube was educated in Berlin and started his career as an assistant to Ernst Kühnel at the Department of Islamic Art in the Berlin Museum. In 1959 he joined the Metropolitan Museum of Art, New York, becoming Curator of the newly created Department of Islamic Art in 1962, a post he held until 1969. He has taught Islamic art at Columbia University and Hunter College, and in Italy at the Universities of Padua, Naples and Venice. He has written widely about all aspects of Islamic art. His publications include *Islamic Pottery in the Keir Collection*, London, 1976 and *The Nasser D. Khalili Collection of Islamic Pottery, I*, London, 1996. *Studies in Islamic Painting*, a reprint of 16 articles written between 1959 and 1985, was published in 1995 by The Pindar Press.

ADAM HARDY
Dr Adam Hardy is Director of PRASADA (Practice, Research and Advancement in South Asian Design and Architecture) at De Montfort University, Leicester. He is an architect and his work, under the auspices of PRASADA, includes consultancy to a number of new Hindu temple projects in Britain. His publications on Indian architecture include *Indian Temple Architecture, Form and Transformation* (New Delhi, 1996).

HEIDE LEIGH-THEISEN
Heide Leigh-Theisen is Curator of the Department of Insular Southeast Asia at the Museum für Völkerkunde in Vienna. Her fields of research include the material culture of Indonesia and the Philippines, especially textiles.

REINHOLD MITTERSAKSCHMÖLLER
Reinhold Mittersakschmöller is an ethnologist and photographer engaged in independent research into the anthropology of art and Indonesian cultures, especially Nias Island.

ROBERT D. MOWRY
Robert D. Mowry is Curator of Chinese Art and Head of the Department of Asian Art at the Harvard University Art Museums; he is also Senior Lecturer on Chinese and Korean Art in Harvard's Department of Fine Arts. He was the founding Curator of the Mr and Mrs John D. Rockefeller 3rd Collection at The Asia Society, New York (1980-1986) and Assistant Curator of Oriental Art at the Fogg Art Museum (1977-1980). Service as a US Peace Corps Volunteer in the Republic of Korea (1967-1969) sparked his interest in Asian art.

NING QIANG
Ning Qiang spent eight years as part of a research team studying Chinese Buddhist art in the Dunhuang Caves. He received his PhD from Harvard and is now teaching art history at San Diego State University. His research interests include both religious and secular art, particularly that of medieval China from the third to the tenth centuries. His publications include two award-winning books on the Dunhuang Caves and more than thirty articles.

STEPHAN VON DER SCHULENBURG
Stephan von der Schulenburg studied art history, philosophy and German literature in Munich and Berlin. From 1982-5 he was a research student in Tokyo and Kyoto, followed by an MA at Heidelberg University on Aodo Denzen (1748-1822) and early Western influences in Edo period painting and prints. This was followed by a PhD on the concept of realism in the paintings of Kishida Ryusei (1891-1929). He joined the Lindenmuseum Stuttgart in 1987 as Assistant Curator in the East Asia Department. Since 1990 he has been Curator for East Asian Art at the Museum für Kunsthandwerk in Frankfurt.

JANE CASEY SINGER
Jane Casey Singer is an art historian specialising in Tibetan art. She received her undergraduate and graduate degrees at Harvard University and was awarded a Fulbright fellowship for research on early Tibetan painting. She was Chairman of the 1994 international conference 'Towards a Definition of Style: The Arts of Tibet', held at the Victoria and Albert Museum in London, and has co-edited a volume based on the proceedings. She lectures and writes on many aspects of Himalayan art and is currently co-curator of an exhibition of early Tibetan painting organised by the Metropolitan Museum of Art, to open in New York in autumn 1998.

MARK ZEBROWSKI
Mark Zebrowski, an expert in the field of Islamic and Indian art, trained at the Musée Guimet, Paris, and at Harvard University where he received his doctorate. He is the author of *Deccani Painting* (1983), the first book to explore the artistic patronage of Sultans of the Deccan, responsible for some of the greatest masterpieces of Indian painting and architecture. He has written numerous articles on Mughal decorative arts and has just completed two books *Silver, Gold and Bronze from Mughal India* for Alexandria Press and *The Architecture and Art of the Deccani Sultanates* (with George Michell) for Cambridge University Press.

ADVERTISEMENTS

HDH
Davide Halevim

I TAPPETI, GLI ARAZZI.

www.halevim.com

Milano 5, via Borgospesso - tel. 02/76002292 - 76003367 - fax 02/784328
orario continuato dalle 12.00 alle 19.30 - si riceve su appuntamento - lunedì chiuso

Cortina d'Ampezzo 147, corso Italia - tel. 0436/868314 - fax 0436/868316

Head of Bacchus

Gandhara, Eastern Afghanistan

4th/5th century

Terracotta with traces of pigmentation

Height: 24 cm

John Eskenazi

Antique rugs and textiles

Oriental art

John Eskenazi Ltd
15 Old Bond Street
London W1X 4JL
Telephone 0171-409 3001
Fax 0171-629 2146

Eskenazi & C.
Via Borgonuovo 5
20121 Milano
Telephone 02-86464883
Fax 02-86465018

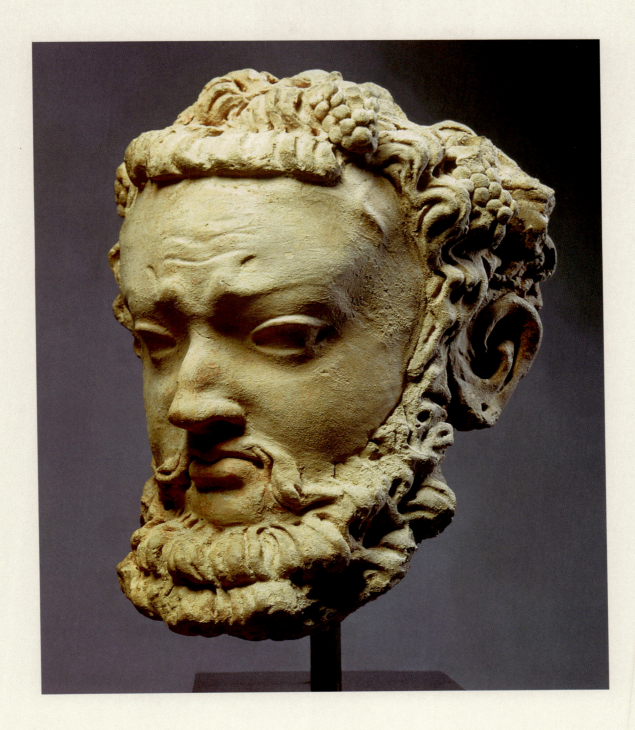

UMBERTO SORGATO

Valuable antique collections

Linen Tapestry
Egypt, Early 12th century c. A.D.
31.4 x 34.5 cm
Hight of letters 2 cm

Inscription: Three lines of text in very deformed,
nearly unreadable late kufi, originally with the same text,
"nasr min Allâh": *helped by God*

Umberto Sorgato - Via Cerva, 18 - 20122 Milano - Tel. 02/784323 - Fax 02/76014004

Saf fragment, early 18th century, 2.40 x 2.70 m (7'10" x 8'10")

This is a rare and beautiful fragment.
Safs are assumed to be family prayer carpets,
and this piece was woven in India in the 17th/18th century
after the style of contemporary Esfahan carpets of Central Persia.
This rug once formed part of the famous Gueron Collection.

Literature:
F. Lewis, Oriental Rugs and Textiles,
"The Perez Collection", 1953, pl. 22

Charles Grant Ellis, Oriental Carpets
in the Philadelphia Museum of Art, 1988, p. 238, fig. 66a.

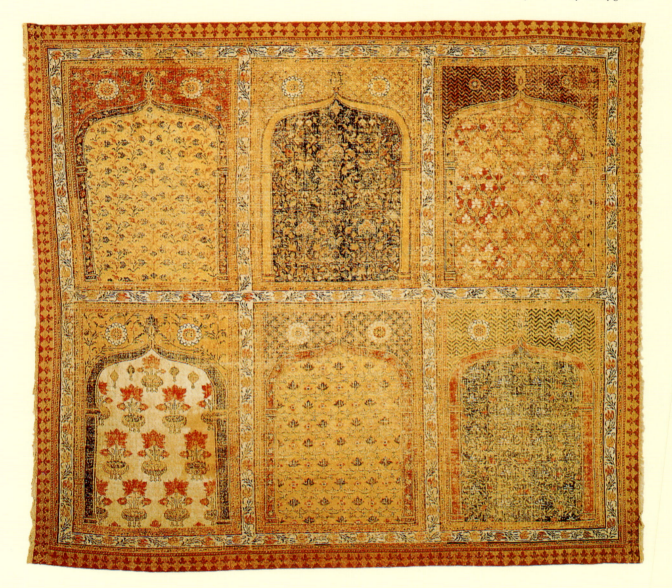

A tower shaped pottery container
preserving Buddhist holy relics
AD439-577
Height : 56cm Width:53cm

Lin Huai Lo Collection

Add:1~4F,No.190,Lane75,Sec.3,Kang Ning Rd ;Taipei Taiwan. Tel:886-2-6327733 Fax:886-2-6339021

Opening Hours : Tu ~Sun. Am:10:00 to Pm:6:00

For appointments, please contact Ms. Glenda Hsu

Gisèle Croës

ARTS D'EXTRÊME-ORIENT
54 BOULEVARD DE WATERLOO
1000 BRUSSELS - BELGIUM
TELEPHONE 322/511.82.16
TELEFAX 322/514.04.19

PAIR OF BRONZE ORNAMENTAL PLAQUES
WESTERN ZHOU PERIOD (1027-771 BC)
HEIGHT 24.2 cm - 22.7 cm
TRACES OF SILK

Carpets at Sotheby's

Specialised sales of Oriental & European carpets are held in London and New York approximately 10 times a year.

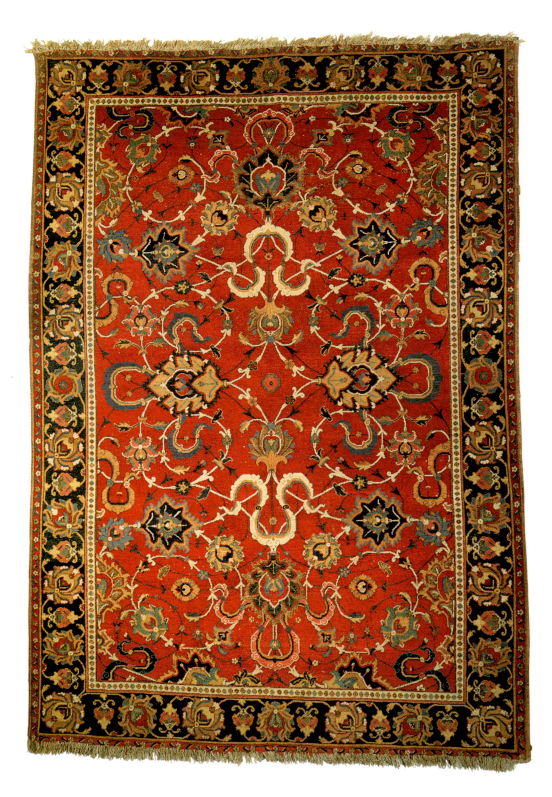

SOTHEBY'S

Islamic Art at Sotheby's

Our specialised sales include manuscripts, miniatures, paintings, works of art, calligraphy, jewellery and lacquer.

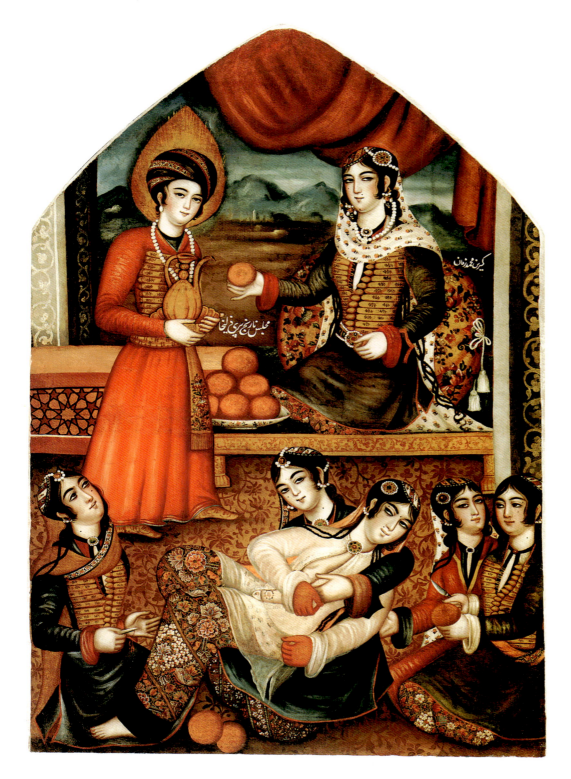

SOTHEBY'S

Head Office

37 Vakil Mosque Ave. Shiraz Iran

Telephone (+98) 71- 2 95 60

Facsimile (+98) 71- 2 72 51

The Specialist for Tribal Rugs

and Kilims of Southern Persia

Unusual Kilim

Dated 1374 AH, 1904 AD

Zollanvari AG

8043 Zurich, Switzerland

Freilagerstrasse 47

Block 4, 5th Floor

Postbox 156

Tel. 01-493 28 29

Fax 01-493 07 73

Zollanvari GmbH

Kehrwieder 4

20457 Hamburg Germany

Telephone (+49) 40- 37 50 05 70

Facsimile (+49) 40- 37 50 05 71

ZOLLANVARI

MOROCCAN IMAGINATIONS

CREATED IN TYPICAL MOROCCAN STYLE

HANDKNOTTED CARPETS AND HANDWOVEN KILIMS IN ANY DESIGN. FOR MORE INFORMATION PLEASE CONTACT:

THE MOROCCAN MINISTRY OF TRADE, INDUSTRY & HANDICRAFT

MAISON DE L'ARTISAN,

QUARTIER ADMINISTRATIF, HAUT AGDAL, RABAT, MOROCCO. TEL. (2127) 777 161, FAX (2127) 777 170

Porisitutu (funerary cloth), Rongkong Valley, Sulawesi, Indonesia, circa 1915 or earlier, cotton ikat 2.66 x 1.54m (8'9" x 5'1")

For a comparable example in the Australian National Gallery, Canberra, see Robyn Maxwell, *Textiles of Southeast Asia,* 1990, plate 188

THOMAS MURRAY

ASIATICA - ETHNOGRAPHICA

P.O. BOX 1177 . MILL VALLEY, CA 94942 . USA . TEL 415.679.4940 . FAX 415.453.8451

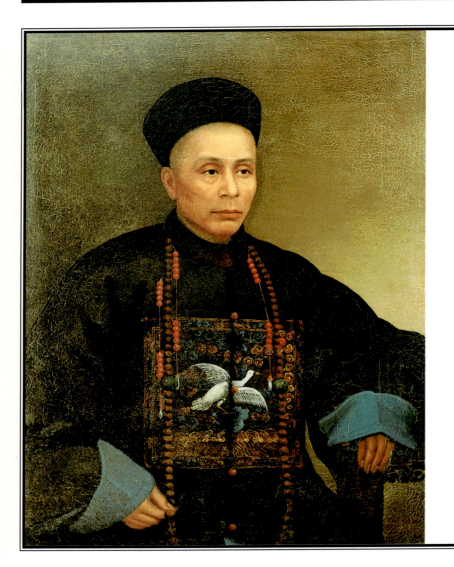

BRANDT ORIENTAL ART

Robert Brandt
First Floor, 29 New Bond Street
London W1Y 9HD
Tel./Fax: (44 171) 499 8835

AN OIL PORTRAIT OF A
CHINESE HONG MERCHANT, CIRCA 1860

Ottoman Art

di Ziya Bozoğlu
ANTIQUE CARPETS AND TEXTILES

KAITAG DAGHESTAN

DHULCHUR UZBEKISTAN

NINGXIA CINA

KONIA FRAGMENT

USHAK SELENDI FRAGMENT

KAITAG DAGHESTAN

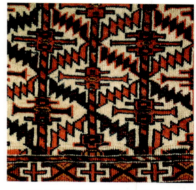

YOMUT TORBA TURKMENISTAN

IKAT VELVET UZBEKISTAN

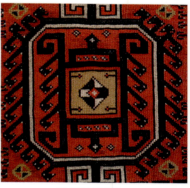

YASTIK KONIA

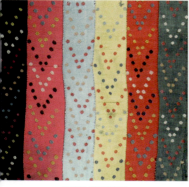

YAZD TEXTILE

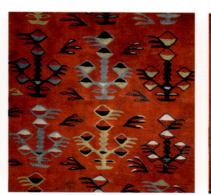

SARKOY KILIM

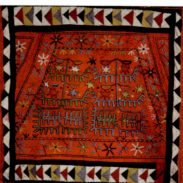

LAKAI UZBEKISTAN

SILK IKAT UZBEKISTAN

SHOWROOM: VIA SAN FRANCESCO 9/11 06123 PERUGIA, ITALY
GALLERIES: VIA DELLA SPOSA 10 & 15, 06123 PERUGIA, ITALY TEL/FAX: (39 75) 573 6842
RESTORATION WORKSHOP: VIA DELLA SPOSA 16, 06123 PERUGIA, ITALY

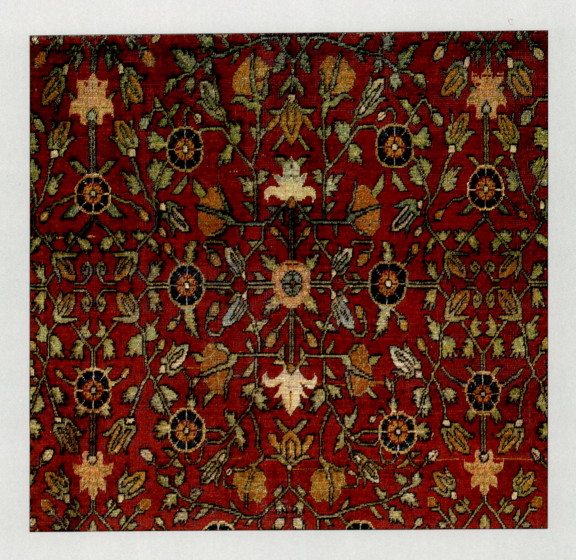

Textile Art from the Silk Road
Silk embroideries, brocades, tapestries, velvets and carpets, 900 -1800

An exhibition of works for sale to be held at
MD Flacks Ltd., 6th Floor, 38 East 57th Street, New York
Tuesday 3rd March to Thursday 2nd April 1998, weekdays 12.00 hrs – 18.00 hrs

Visit our website: www.textile-art.com

THE TEXTILE GALLERY
TWELVE QUEEN STREET MAYFAIR
LONDON W1X 7PL ENGLAND

Weekdays by appointment only

TELEPHONE: (44.171) 499 7979 FACSIMILE: (44.171) 409 2596
E-MAIL: post@textile-art.com

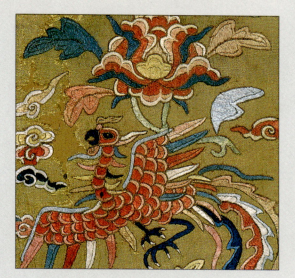

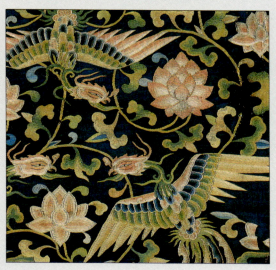

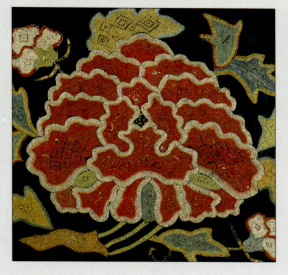

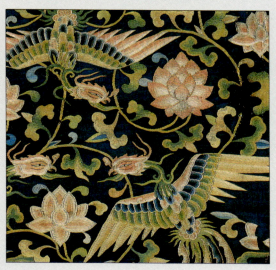

Lotuses and Five Phoenixes
Yuan dynasty, 14th century
20 x 128 cm (8" x 50¹/₂"), detail
silk embroidery on silk cloth

Ascending Flowers and Leaves
Song or Yuan dynasty, 12th to 14th century
59 x 68 cm (23¹/₄" x 26³/₄"), detail
silk brocade

Boys in Pomegranates
Liao dynasty, 10th-12th century
the largest of four sections 13.5 x 46 cm (5¹/₄" x 18"), detail
painted with ink and brush on woven silk cloth

Goat Riders
Ming dynasty, 16th century
68 x 87 cm (26³/₄" x 34¹/₄"), detail
silk brocade with gold leaf on paper

Lotus
Yuan dynasty, 13th to 14th century
24 x 22cm (9¹/₂" x 8¹/₂"), detail
needleloop with gold leaf on paper

Peonies and Phoenixes
Yuan dynasty, 13th to 14th century
35 x 58 cm (14" x 23"), detail
kesi, tapestry-woven in silk

Millefleurs, Kashgar, Xinjiang, north-west China, end of the 17th century
117 x 198 cm (46" x 78"), detail shown opposite, incomplete, silk pile on a silk foundation. Formerly in the Baltimore Museum of Art

Silks for the Sultans

OTTOMAN
IMPERIAL
GARMENTS
FROM TOPKAPI
PALACE

A BOOK BY ERTUĞ & KOCABIYIK

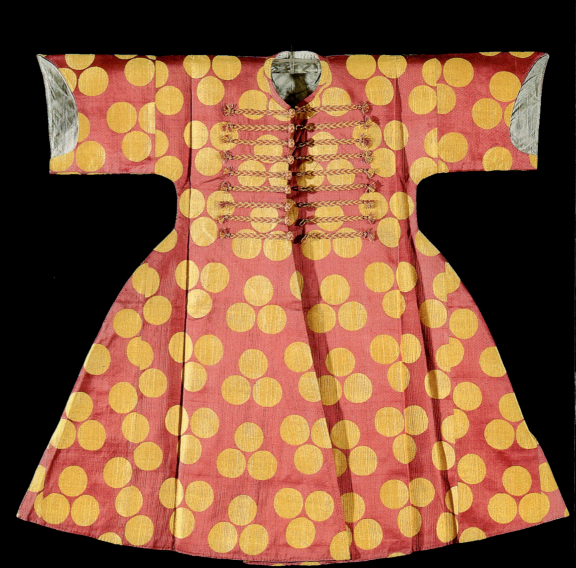

"The opulent kaftans photo-graphed and examined in this publication are breathtaking to behold. Floating on a black ground, the image, whether it be a detailed close-up or the entire piece, beautifully exhibits the intricate, luxurious threads and the imperial, patterned silks of these Topkapı treasures."

THE TEXTILE MUSEUM, WASHINGTON

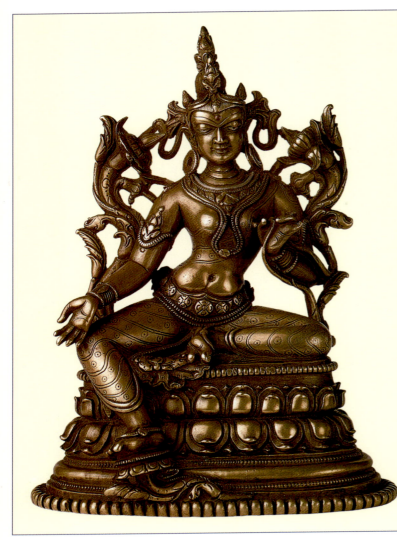

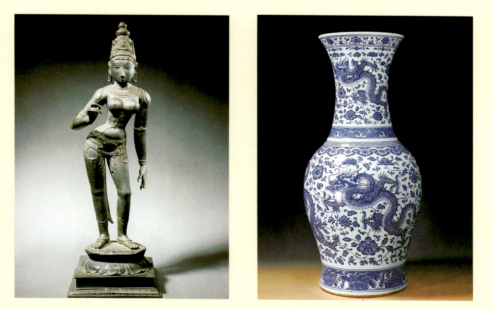

ASIAN ART DIRECTORY

A directory of some leading international galleries and dealers in all areas of Asian Art and related fields, classified alphabetically by country. Each individual advertisement provides full contact details, lists specialities, and indicates the gallery or dealer's anticipated schedule of exhibitions and participation at art and antiques fairs worldwide.

BELGIUM

GISÈLE CROËS SA
54 Boulevard de Waterloo
1000 Brussels
Tel (32 2) 511 82 16
Fax (32 2) 514 04 19

Far Eastern Works of Art

Early Chinese art

See Advertisement

Founded 1976
Director **Gisèle Croës**

Forthcoming Exhibitions
TEFAF Maastricht; International Asian Art Fair, New York; Paris Biennale

TERESA COLEMAN FINE ARTS
Ground Floor, 79 Wyndham Street
Central, Hong Kong
Tel (85 2) 2526 2450
Fax (85 2) 2525 7159
E-mail tcl@iohk.com
Other branches
The Tibetan Gallery, G/F
55 Wyndham Street

Oriental Antiques

Fine antique oriental textiles, rugs, fans and paintings. The Tibetan Gallery: fine antique thankas, bronzes, rugs and furniture

Founded 1982
Director **Teresa Coleman**

PLUM BLOSSOMS GALLERY
17/F Coda Plaza, 51 Garden Road
Central, Hong Kong
Tel (852) 2521 2189
Fax (852) 2868 4398
Other branches
02-37 Raffles Hotel Arcade, 328 North
Bridge Road, Singapore 188719

Contemporary Art and Antique Textiles

Chinese and Tibetan textiles and carpets. Chinese and Vietnamese contemporary art

Please visit our internet site:
www.plumblossoms. com

Founded 1987
Directors **Priscilla Liang Norton** and
Stephen McGuinness

Forthcoming Exhibitions
International Asian Art Fair, New York, Stand G2

CHINA

CHINE GALLERY
G/F 42A Hollywood Road
Central, Hong Kong
Tel (85 2) 2543 0023
Fax (85 2) 2850 4740

Chinese Antique Furniture and Rugs

Wholesale and retail of Chinese antique furniture, Chinese antique rugs, Japanese antique furniture

Founded 1989
Directors **Anwer Islam** and
Zafar Islam

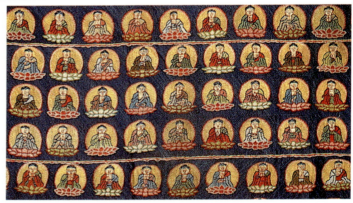

Panel from a One Thousand Buddha cape (detail), embroidered on silk gauze silk and metal wrapped thread. China, early Ming dynasty. 0.69 x 0.74m (2'3" x 2'5")

FRANCE

GALERIE BENLI
17 Rue Saint Roch
75001 Paris
Tel/Fax (33 1) 4260 4976

Islamic Works of Art

Textiles, miniatures, ceramics, metalwork and wood of the Islamic world including North Africa, Persia, Turkey, Middle East and Indian art

See Advertisement

Founded 1979
Director **Ahmet Benli**

ITALY

ALBERTO LEVI GALLERY
Via San Maurilio 24
Milan 20123
Tel (39 2) 8901 1553
Fax (39 2) 7201 5118

Antique Textile Art

Founded 1997
Director **Alberto Levi**

Antique oriental and European carpets and textiles

DAVIDE HALEVIM
5 Via Borgospesso
Milan
Tel (39 2) 7600 2292 / 7600 3367
Fax (39 2) 784 328
Other branches
**La Passeggiata, Porto Cervo,
Costa Smeralda
147 Corso Italia, Cortina d'Amprezzo**

Antique Carpets and Tapestries

Founded 1977
Director **Davide Levi**

Antique carpets from the 16th to the 19th century. Tapestries of the 16th century

See Advertisement

MICHAIL SNC.
Via Caminadella 18
Milan 20123
Tel/Fax (39 2) 8645 3592
Other branches
Via Santo Spirito 19, 20121 Milan

Carpets, Tapestries, Islamic Ceramics and Chinese Art

Founded 1981, 1991
Director **David Sorgato**

Carpets, textiles and tapestries from all corners of the world

OTTOMAN ART
Via della Sposa 10/15
Perugia 06123
Tel/Fax (39 75) 573 6842
Other branches
**Restoration workshop, Via della Sposa 16, Perugia 06123
Showroom, Via San Francesco 9/11
Perugia 06123**

Rare Antique Carpets and Textiles

Founded 1991
Director **Ziya Bozoğlu**

Ottoman embroidery, early carpets and textile fragments from Anatolia, the Caucasus and Central Asia. Restoration and cleaning workshop

See Advertisement

Special Exhibitions

Two gallery exhibitions each year

CARLO CRISTI
Via Moscati 6
20154 Milan
Tel (39 2) 349 1528
Fax (39 2) 345 0656

Oriental Art and Textiles

Founded 1984
Director **Carlo Cristi**

Himalayan bronzes, wood and paintings. Asian textiles. Southeast Asian art

See Advertisement

Forthcoming Exhibitions

Padova Antiquaria; Antiquaria Milano

GIACOMO MANOUKIAN NOSEDA
Piazza San Simpliciano 2
Ang. Corso Garibaldi, 20121 Milan
Tel/Fax (39 2) 805 1637

Oriental Art and Textiles

Founded 1982
Director **Giacomo Manoukian Noseda**

Carpet and textile art; tapestries. Oriental antiquities

See Advertisement

Forthcoming Exhibitions

Internazionale dell'Antiquariato di Milano; Antiquaria Milano

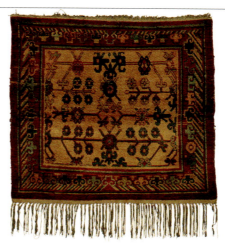

Kashgar throne cover, East Turkestan, late 18th century, silk pile. 84 x 91cm (2'9" x 3'0")

UMBERTO SORGATO
Via Cerva 18
Milan
Tel (39 2) 784 323
Fax (39 2) 760 140 04

Occidental and Islamic textile art

Founded 1975
Director **Umberto Sorgato**

Antique rugs and European tapestries

See Advertisement

Forthcoming Exhibitions

Internazionale dell'Antiquariato di Milano; Padova Antiquaria

LIN HUAI LO COLLECTION

1-4F, No. 190, Lane 75
Sec. 3, Kang Ning Road
Taipei
Tel (886 2) 632 7733
Fax (886 2) 633 9021

Chinese Works of Art

Founded 1992
Director Lin Huai Lo

Ancient Chinese Buddhist
sculpture

See Advertisement

Special Exhibition
November 1997, "Annual
Exhibition - Statue Making
of the Highest Grade"

*Sandstone Boddhisatva for
offerings, 618-907 AD.
Height 76cm (2'6").
Excavated in Ho Nan Province,
China*

CHRISTIAN BOEHM ORIENTAL ART

Marlowe Court, 2 Petyward
London SW3 3PD
Tel/Fax (44 171) 584 1265
By appointment

Early Chinese and Japanese Art

Founded 1993
Director Christian Boehm

Specialising in early Chinese
ceramics from the Neolithic
period to the Song dynasty
as well as Chinese and
Japanese buddhist sculpture

Forthcoming Exhibition
TEFAF Basel

BRANDT ORIENTAL ART

First Floor, 29 New Bond Street
London W1Y 9HD
Tel/Fax (44 171) 499 8835
By appointment

Asian Works of Art

Founded 1980
Director Robert Brandt

Chinese and Japanese works
of art

See Advertisement

MAHARUKH DESAI

91C Jermyn Street
London SW1Y 6JB
Tel (44 171) 839 4341
Fax (44 171) 321 0546

Indian Art and Jewellery

Founded 1967
Director Maharukh Desai

Indian art of the early 17th
century to the late 19th cen-
tury including architectural
elements, jewellery, textiles,
costume and photography

Forthcoming Exhibitions
International Asian Art Fair,
New York; TEFAF Basel.
Two private exhibitions at
the gallery each year

ESKENAZI LTD.

10 Clifford Street
London W1X 1RB
Tel: (44 171) 493 5464
Fax: (44 171) 499 3136

Oriental Works of Art

Founded 1960
Directors J.E. Eskenazi,
P.S. Constantinidi, L. Eskenazi,
I. Casson and D.M. Eskenazi

Specialists in Chinese and
Japanese art

Special Exhibitions
The gallery holds two to three
special exhibitions annually

JOHN ESKENAZI LTD.

15 Old Bond Street
London W1X 4JL, UK
Tel (44 171) 409 3001
Fax (44 171) 629 2146
Other branches
Eskenazi & Co. Srl
Via Borgonuovo 5, Milan 20121, Italy

Oriental Works of Art

Founded London 1994; Milan 1923
Director John Eskenazi

Antique rugs and textiles.
Indian, Himalayan and
Southeast Asian art

See Advertisement

Forthcoming Exhibitions
International Asian Art Fair,
New York; TEFAF Basel

ESTHER FITZGERALD RARE TEXTILES

28 Church Row
London NW3 6YP
Tel (44 171) 431 3076
Fax (44 171) 431 0646
By appointment

*4th - 20th Century Textiles of
Exceptional Merit*

Founded 1980
Directors Esther Fitzgerald and
Alexander Fitzgerald

Rare textiles of all types and
cultures

Forthcoming Exhibitions
Olympia, London, February
and June 1998

UNITED KINGDOM

FRANCESCA GALLOWAY

21 Cornwall Gardens
London SW7 4AW
Tel (44 171) 937 3192
Fax (44 171) 937 4958

Textiles and Indian Miniatures

Founded 1992
Director **Francesca Galloway**

Indian miniatures, European and Asian textiles, Indian trade cloths and British Post War textile design

Special Exhibitions
Oct 20 - Nov 14 1997, "Austerity to Affluence – British Art & Design 1945-1962", Fine Art Society (haute couture contributor).
Autumn 1998, "Arts & Crafts Textiles" with the Fine Art Society

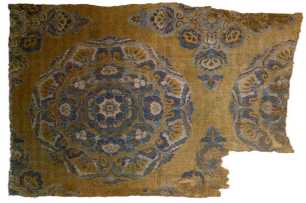

Chinese silk samite (weft-faced compound twill), Tang period, 8th century. 2'0" x 2'10¼" (0.60 x 0.87m). Similar designs depicted on Dunhuang wall paintings

OLIVER HOARE LTD.

Flat 3 7 Onslow Gardens
London SW7 3LY
Tel (44 171) 835 1600
Fax (44 171) 373 5187

Islamic and Ancient Asian Art

Founded 1975
Director **Oliver Hoare**

Metalwork, pottery, glassware, ceramics, caligraphy, architectural elements, arms and armour, paintings and jewellery

Forthcoming Exhibitions
International Asian Art Fair, New York; TEFAF Basel

ROBERT KLEINER & CO. LTD.

30 Old Bond Street
London W1X 4HN
Tel (44 171) 629 1814
Fax (44 171) 629 1239

Chinese Works of Art and Snuff Bottles

Founded 1989
Director **Robert Kleiner**

Chinese snuff bottles, ceramics, jades and works of art. Member of BADA and CINOA

Forthcoming Exhibition
Olympia, London, June 1998

MOMTAZ ISLAMIC ART

79A Albany Street, Regent's Park
London NW1 4BT
Tel (44 171) 486 5411
Fax (44 171) 487 5250
By appointment

Islamic Works of Art

Founded 1922
Director **Irène Momtaz**

Metalwork, ceramics, glassware, calligraphy, textiles, arms and armour, wood and jewellery from the Umayyad, Seljuk, Timurid, Mamluk, Safavid, Ottoman and Qajar periods. Curator and consultant for private and corporate collections

Forthcoming Exhibitions
TEFAF Basel.
Occasional thematic gallery exhibitions

PRIESTLEY & FERRARO

17 King Street, St. James's
London SW1Y 6QU
Tel (44 171) 930 6228
Fax (44 171) 930 6226

Early Chinese Art

Founded 1994
Directors **David Priestley** and **Benedicta Ferraro**

Early ceramics, bronzes, sculpture and works of art

Forthcoming Exhibitions
International Asian Art Fair, New York; International Ceramics Fair, London; TEFAF Basel

ROSSI AND ROSSI

91C Jermyn Street
London SW1Y 6JB
Tel (44 171) 321 0208
Fax (44 171) 321 0546

Oriental Works of Art

Founded **Italy 1970; London 1985**
Directors **Anna Maria Rossi** and **Fabio Rossi**

Early Indian, Gandharan and Himalayan art. Early Chinese textiles

Special Exhibition
May – June 1998, "Tibet". Previous catalogues available

THE TEXTILE GALLERY

12 Queen Street, Mayfair
London W1X 7PL
Tel (44 171) 499 7979
Fax (44 171) 409 2596

Classical Carpets and Textile Art

Founded 1972
Directors **Michael** and **Jacqueline Franses**

Carpets and textiles from a wide variety of cultures. Specialising in the Near East, Central Asia and the Far East including carpets from the 17th century and earlier

See Advertisement

Please visit our internet site:
www.textile-art.com

UNITED KINGDOM

LINDA WRIGGLESWORTH

34 Brook Street
London W1Y 1YA
Tel (44 171) 408 0177
Fax (44 171) 491 9812
E-mail
linda@wrigglesworth.demon.co.uk

*Antique Chinese, Tibetan, Korean
Costume and Textiles*

Founded 1978
Director **Linda Wrigglesworth**

Qing dynasty costume and
textiles; earlier Chinese weav-
ings and embroideries

Forthcoming Exhibitions

TEFAF Maastricht and Basel;
Arts of Pacific Asia, New
York and San Francisco.
Thematic exhibitions also
held at the gallery (e.g. rank
badges, bound-feet shoes and
Tibetan geometric textiles).
1998: inaugural exhibition of
Korean textiles

*A simple but elegant
informal winter
robe of the Empress
Dowager Cixi,
China,
19th century*

UNITED STATES East Coast

ELEANOR ABRAHAM
ASIAN ART

345 East Fifty-Second Street
New York, NY 10022
Tel/Fax (1 212) 688 1667
By appointment

Sculpture, Textiles, Jewellery

Founded 1990
Director **Eleanor Abraham**

4th to 18th century sculpture
of stone and bronze from
India, Tibet and Pakistan.
Colourful hand-embroidered
textiles from Central and
South Asia. Unique tribal
jewellery

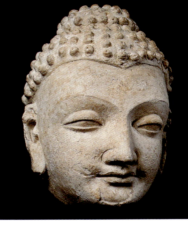

*Gandharan head of Buddha,
stucco, pronounced aquiline
nose, Pakistan, 4th century.
Height 37cm (14 1/2")*

BODHICITTA

19 East 69th Street, 4th Floor
New York, NY 10021
Tel (1 212) 639 9574
Fax (1 212) 639 9684

*Himalayan, Indian and South Asian
Antiques*

Founded 1974
Directors **Mrs Palmo Tsering,
Mr Namkha Dorjee** and
Mr Pemba Tsering

Indian, Tibetan, Nepalese
and South Asian sculpture
and paintings

Forthcoming Exhibitions

International Asian Art Fair,
New York; TEFAF Basel

*Buddha Sakyamuni, Yuan dynasty,
China, 1279 - 1368, silk brocade.
71 x 51 cm (2'4" x 1'8")*

THE CHINESE PORCELAIN
COMPANY

475 Park Avenue
New York, NY 10022
Tel (1 212) 838 7744
Fax (1 212) 838 4922

Asian Ceramics

Founded 1984
Directors **Khalil Rizk, Conor
Mahony, Margaret Kaelin** and
Cynthia Volk

Asian ceramics, works of art
and sculpture; European
furniture and decorations

Forthcoming Exhibitions

International Asian Art Fair,
New York. Bi-annual exhi-
bitions with fully illustrated
and researched catalogues.
Past themes include: Ancient
Khmer Sculpture; Famille
Verte Porcelain; Chinese
Export Porcelain; Chinese
Glass Paintings

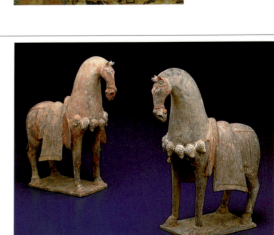

*A pair of grey
earthenware
figures of
caparisoned
horses, China,
Northern Wei
Period, 386-535.
Height 32.7cm
(12 7/8")*

UNITED STATES — East Coast

M.D. FLACKS LTD.
38 East 57th Street, 6th Floor
New York, NY 10022, USA
Tel (1 212) 838 4575
Fax (1 212) 838 2976

Chinese Furniture

Founded 1995
Director **Marcus Flacks**

Chinese furniture, sculpture, scholars' objects, textiles and rugs

Forthcoming Exhibitions
International Asian Art Fair, New York; International Fine Art and Antique Dealers Show, New York.
Regular gallery exhibitions with catalogue (available at $30+postage)

A collection of classical Chinese furniture. 17th century

E & J FRANKEL LTD.
1040 Madison Avenue at 79th Street
New York, NY 10021
Tel (1 212) 879 5733
Fax (1 212) 879 1998

East Asian Art and Antiques

Founded 1967
Directors **Edith** and **Joel Frankel**

Chinese and Japanese paintings, sculpture and ceramics; Chinese writing implements; jade; Chinese antiquities; textiles

Forthcoming Exhibitions
International Asian Art Fair, NY; Philadelphia Antiques Show; International Ceramics Fair, London; International Fine Art & Antique Dealers Show, NY. Also special annual exhibitions in January, March and September at the gallery

KAIKODO
164 East 64th Street
New York, NY 10021
Tel (212) 223 0121
Fax (212) 223 0124
Other branches
690 Yamanouchi, Kamakura, Japan

Chinese Works of Art and Paintings and Japanese Paintings

Founded 1983
Directors **Howard** and **Mary Ann Rogers**

Chinese ceramics and bronzes. Traditional Chinese and Japanese paintings. Contemporary Chinese paintings

J. J. LALLY & CO. ORIENTAL ART
41 East 57 Street
New York, NY 10022
Tel (1 212) 371 3380
Fax (1 212) 593 4699

Oriental Works of Art

Founded 1986
Director **James Lally**

Chinese ceramics, bronzes, jades, sculpture and works of art; Korean works of art; Asian Buddhist sculpture

Special Exhibition
September 19 – October 18, 1997: "Brush and Clay", Paintings by Robert Ferris and Chinese ceramics of the Song dynasty from the artist's collection.
Catalogue available

Finely engraved and parcel gilt bronze phoenix-form finial. Warring States Period, circa 4th century BC. Length 13.7cm (5 3/8")

DORIS WIENER INC.
1001 Fifth Avenue
Suite 3B
New York, NY 10028
Tel (1 212) 772 8631
Fax (1 212) 439 6626
By appointment

Ancient Asian Art

Founded 1966
Director **Doris Wiener**

Ancient art of India, Southeast Asia and the Himalayas; Indian miniature paintings

UNITED STATES — West Coast

THOMAS MURRAY
ASIATICA – ETHNOGRAPHICA
Box 1177
Mill Valley, California 94942
Tel (1 415) 679 4940
Fax (1 415) 453 8451

Textiles and Sculptures of Indonesia and the Andes. Himalayan Masks

Founded 1978
Director **Thomas Murray**

Lecturer, appraiser and museum consultant. Member of the Antique Tribal Art Dealers' Association and the National Association of Dealers in Ancient, Oriental and Primitive Art

Forthcoming Exhibitions
San Francisco Tribal and Asian Art Fair; Santa Fe Ethnographic Arts Show; Tribal Arts Fair, NY; San Rafael American Indian Fair

ADVERTISERS' INDEX

Whilst every care is taken by the publishers, the descriptions and attributions of pieces advertised are the sole responsibility of individual advertisers

The NutcrackeR

ADAPTED BY DANIEL WALDEN · FROM THE STORY BY E. T. A. HOFFMAN

ILLUSTRATED BY DON DAILY

Courage
BOOKS

AN IMPRINT OF RUNNING PRESS
PHILADELPHIA · LONDON

I WOULD LIKE TO THANK:

My daughter, Susie, for her lively portrayal of Maria, and her princely brother, Joe; my wife, Renee, who made the

costumes used in this story, and whose insight and encouragement made these pictures possible; my friends and models—

Donna, Mark, Jim, Randee, and Matthew; and finally, Paul Kepple, for his thoughtful design of this book.

— DON DAILY

© 1996 by Running Press
Illustrations © 1996 by Don Daily

9 8 7 6 5
Digit on the right indicates the number of this printing.

ISBN 1-56138-764-9
Library of Congress Cataloging-in-Publication Number 96-67159

Cover and interior illustrations by Don Daily
Cover and interior design by Paul Kepple

Published by Courage Books, an imprint of
Running Press Book Publishers
125 South Twenty-second Street
Philadelphia, Pennsylvania 19103-4399

INTRODUCTION

HAVE YOU EVER LOVED A TOY SO MUCH YOU WISHED IT CAME TO LIFE? DID YOU DREAM OF THE EXCITING ADVENTURES YOU WOULD HAVE WITH YOUR SPECIAL FRIEND? IF SO, YOU ARE NOT THE ONLY ONE. NEARLY TWO hundred years ago, in 1815, the German writer E. T. A. Hoffman wrote a story called *The Nutcracker and the Mouse King*, telling how a little girl's love brought to life her cherished Nutcracker, an enchanted Christmas gift from her mysterious godfather.

The tale charmed readers of all ages, including the French writer Alexandre Dumas, who published a retelling of the story in 1847. From that adaptation, the Russian composer Peter Ilich Tchaikovsky and the choreographer Lev Ivanov created their ballet, *The Nutcracker*. First performed in St. Petersburg in 1892, it is now a classic performed throughout the world every holiday season.

Why has *The Nutcracker* remained so popular? As the story itself explains, "If you love something very much, it is always alive." Pure love of this extraordinary story has kept the words alive for nearly two hundred years, so they can dance for you across these colorful pages.

CHAPTER ONE

⁓

IT HAD BEEN SNOWING ALL DAY, AND THE GRAY CITY OF FRANKFURT WAS TRANSFORMED. FROM HER BEDROOM WINDOW MARIA STAHLBAUM WATCHED THE WHITE FLAKES FALLING ACROSS THE CHIMNEYS AND TILED ROOFS, WHIRLING AGAINST

dark windows, and laying a thick carpet down every street and alley. The wind was rising, frequently blowing the snow in layers so dense as to hide the houses opposite. Then the layers would open and you could see every lintel and cornice growing bigger with the snow.

Presently lamps were lighted in the windows next door, and in the bright beams the driven snowflakes surged up like a crowd of elfin dancers in ballet dress. Waltzing and following fast behind each other, they moved on in a mighty leap straight across

the space toward Maria's window. She heard the tinkle of tiny diamonds upon the panes. She saw the fairylike figures, just for a moment, before a great blast of wind shook the old house and threw a blanket of snow against the glass.

Luckily, Maria thought, the fir tree had been brought to the door that morning—for it was Christmas eve—the party gifts had all been wrapped and the good things to eat prepared or delivered. But how would the guests ever get here through such a storm? There was to be a dance in the big room

at the back of the house, and Maria could not bear to miss any of the ladies in their evening dresses.

And what of old Papa Drosselmeyer? He was godfather to both Maria and her brother Fritz. Christmas would not be Christmas without Godfather Drosselmeyer! Such a strange old man, so wise and so clever. So severe at times, in his black formal clothes, his old-fashioned manners, and grave voice. For years he had worn a dark patch over one eye—but the other eye was as staring and sharp as an owl's. And yet Maria and Fritz loved him completely. No one else could tell such exciting stories, or bring such a feeling of wonder to every part of the festivities. And his presents were fantastic beyond belief—and each one made by himself. It was almost as if he were a magician!

Last year he had brought them a toy castle on a hill above a moat, and when you turned a crank a troop of knights rode up to the gate. Then the drawbridge was lowered, the great door opened, and out came a princess to receive her guests. Before that, one year, there had been a magic theater with two scenes from Sleeping Beauty acted out by tiny figures. And other inventions so precious that Father had a special cupboard built to keep them safe behind glass doors. That cupboard, too, stood in the big room downstairs where the Christmas party always took place.

Maria unlatched the window and pushed it open against the snow piled on the sill. The icy, white powder rushed up into her face, but as she leaned out a little she could see people with lanterns coming down the street. There were four grown-ups and several children. All of them were bundled tight in heavy coats. They looked funny because their feet were almost buried in the soft snow. Beyond them was another group of people. Surely that was her Aunt Lisa in the scarlet greatcoat! All of them were coming toward Maria's house. Soon she and Fritz would be summoned to the big room, and the wonderful Christmas party would begin.

Suddenly Maria felt herself lifted from behind by two strong arms. She struggled and kicked backward, and came down in the room with a thud. She had scooped up a fistful of snow and now she held it menacingly toward her brother Fritz. He was always playing tricks like that. But he let her go, to dodge the snowball, which broke on the carpet behind him.

"Ria," he said, "Mr. and Mrs. Kretchmas have come, and Mr. and Mrs. Krone, with all their children, and the whole Zimmerman family. Come down the back stairs! You can see the grown-ups trimming the tree through the keyhole of the side door. The tree is the best we've ever had . . . and I think I have a real cannon . . . and you have a doll with a big moustache!"

"You're making it up! No doll has a moustache."

"This one does, and a blue hat with a plume. It's a man doll, I guess, and I think he has a long sword . . . he must be a general."

"You're crazy! Who ever heard of a general doll?"

"I saw it," Fritz said. "And at any rate there is a table loaded with food—chocolate cake, ginger cookies, and heaps of peppermint stripes and all-colored bonbons. Come on!"

"Has Godfather come?"

"Godfather never comes at the beginning. Don't you remember?"

"But will he come through this storm? He's so old and wrinkled . . . and then he has only one good eye."

"He'll come all right . . . with some mad present that has to be kept locked up. The snow won't keep him away. You know, I think he can fly like an owl and see in the dark. How he scares me sometimes! I'll bet he could fly right through that window. . . . Look out, here he comes!"

"Whoo—whoo," the blizzard shrieked against the windowpane. A chunk of solid snow dropped unexpectedly from the roof like a white owl upon the ledge outside. Fritz ran and locked the window tight,

then grabbed his sister's hand, and the children rushed laughing out of the room.

A mouse scurried out of sight as Maria and Fritz hurried down the hall. Dr. Stahlbaum's house was old and huge and there were a number of mice in the walls, but he was too kind-hearted to trap them. Fritz did not mind them at all. But ever since Maria had seen one running off with a little rug from her doll house she did not like them. They were big, blackish mice, too, and having such kind-hearted people to live with had made them very bold. Sometimes at night, most often when the moon was shining, Maria would be wakened by the faint but persistent *cranch, cranch* of a mouse gnawing a hole in the wall behind her bureau.

There was a broad, steep stairway going down to the family rooms on the floors below. On the ground floor, running out like a wing into the garden, was the largest room in the house. It was a kind of drawing-room and play-room combined. You could reach it

through the main hall and you could also reach it by way of the back stairs, which was the way Fritz and Maria now took.

When this house was built, long ago, doors often had keyholes as big as your middle finger, and since this door was a double one, the keyhole was extra large. At first, as Maria looked, everything was blurred by people moving back and forth as busy as squirrels, each one adding some bit to the preparations. The carpet had been rolled back for dancing. Along the right side was a long table spread with platters and raised dishes of all kinds of food.

Behind and above the people, in front of one window and nearly as tall, rose the Christmas tree. Its dark and beautiful branches curved out into the room, layer above layer, adorned with marvelous little toys, with fairy-tale angels and birds, with flowers of spun glass, and with amusing cotton kittens and gnomes and animals of all kinds—so many that you could not possibly count them. And, in much the way that snow

might lie on a fir tree in the forest, a frosting of silver tinsel dripped from bough to bough in even curves, growing smaller as the tree narrowed upward. Near the top was a figure of Father Christmas, and at the very top a star.

"Isn't the tree wonderful!" Maria exclaimed.

Clara and Karl were only two of several cousins who had come to the Christmas Eve party here. But they also knew about the side door to the great room and now came running in upon Fritz and Maria.

"Merry Christmas!" they called. "Oh, you're peeking! Let me look. Let me look."

And, pushing and shoving, as overhasty people do, they all tried to look through the keyhole, no one having time enough to catch more than a blurred image before another child was close upon him trying to see,

and finally all of them falling on top of one another in a mad scramble of giggles and acrobatics. They would have rolled in a heap, right into the room, had the door been suddenly opened.

Just then the clock struck seven and the children heard Mrs. Stahlbaum calling: "Children, Father Christmas has come!"

They had just managed to disentangle themselves, to stand up and smooth out their party clothes when the doors were thrown open wide. Maria's mother stood inside with her arms extended.

"Merry Christmas, my darlings," she said.

The tree had been lighted. Its glow and its fragrance filled the room. At the top of the tree the star shone; every ornament twinkled.

"Merry Christmas," the children said softly.

CHAPTER TWO

IT WAS THE CUSTOM FOR THE CHILDREN TO HAVE A LITTLE DANCE FIRST, AND THEN FOR THE GROWN-UPS TO HAVE A WALTZ, AND THEN FOR YOUNG AND OLD TO DANCE TOGETHER. BETWEEN DANCES THEY HAD GLASSES OF PUNCH, AND Maria helped her mother pass the little cups around.

She did not see Godfather Drosselmeyer. She kept looking, too, for the strange man doll that Fritz had described—but there was nothing like that among her many presents. And now she was far too busy passing the cold meat and sandwiches and little cakes to think about her gift. But quite suddenly, as she offered a slice of cake to old Mrs. Gumpel, who was sitting close to the tree, Maria saw the most remarkable thing.

Fritz had been telling the truth. Standing stiffly on a little table, as if at attention, was a little soldier. He wore highly polished boots, red trousers with a blue stripe, a white vest crossed by two bands of crimson, a deep blue general's coat, and an impressive hat with a plume. He must be made out of some kind of metal, Maria thought, for he looked so sturdy and strong. He had a high-arched nose, a jutting chin, and round and brave-looking eyes. A rather extra-large moustache grew from his upper lip.

He held a long sword at his left side, and his eyes had such a trusting and noble expression—brave and gentle at the same time—that Maria lost her heart to him at once.

Why, he is like a little prince! she thought. The soldier looked up at her steadily. His painted eyelashes gave him a very alert and appealing expression, like a big dog begging for a piece of your cake. How could anyone resist him? He made you feel protective and brave yourself.

". . . Thank you, child," she heard Mrs. Gumpel saying. "The almond torte is delicious. . . ."

The clock struck again, and as it did so the door to the big hall opened slowly, and there stood Godfather Drosselmeyer. He was dressed all in black, with a gold chain around his neck. His white cravat and his hair like spun silver made the black suit look very somber. He always wore a black patch over his left eye, but his other eye was so bright and piercing that it well served

him for two. His usually white face was flushed with a rosy glow from the snowy night. When he came forward, he was followed by two tiny, little menservants, each carrying a Christmas package nearly as big as a big boy. No one had seen such large packages before. When the greetings were over, the two servants untied and opened the packages. Out of one box they took a huge cabbage; out of the other a very pink cake. Everyone crowded around in astonishment and curiosity.

The servants then lifted the cabbage and the cake, and underneath each was a doll nearly three feet tall, and almost real-looking. They were dressed as a shepherd and shepherdess. Then they seemed to come alive! The dolls rose and bowed to the audience and then to each other, and executed a most graceful and charming dance. They ended by bowing low and sitting again in position ready for the green cabbage and pink cake to cover them. Everyone was delighted and charmed by the performance.

When they had vanished under their covers, God-father Drosselmeyer came over to Maria and Fritz. He kissed each of them and said:

"My dear godchildren, these creations were made for you. They come to wish you a Happy Christmas, to give you old Drosselmeyer's love."

"Thank you, Godfather," they said together, "and Merry Christmas to you."

Drosselmeyer took Maria's hand affectionately. "I sent you and Fritz another little gift," he said. "Have you seen it? No? Well, look here!"

He went across toward the tree, past old Mrs. Gumpel, who was still munching sweet cakes, and picked up the brave, iron soldier.

"Oh, I love him, Godfather!" Maria cried.

"He is a nutcracker," said Papa Drosselmeyer. "Look! His jaws are so strong that he can crack the hardest nut without hurting his teeth at all."

Papa Drosselmeyer held the soldier with one hand and with his other raised the soldier's long sword back-ward. As he did so the mouth opened wide, revealing two rows of very white teeth. Then Drosselmeyer placed a walnut in the nutcracker's mouth, pressed down the sword, and the jaw closed, cracking the shell into four even pieces. He handed the cracked nut to Maria. Then he tried a hazelnut, an almond, and a Brazil nut, each time giving the opened nut to one little girl or another. The boys, too, had crowded around to see this curious fellow. But Fritz was not much impressed.

"Didn't I tell you, Maria?" he said.

"Now you have a doll with a big, black moustache!"

"He's not a doll. He's a magic nutcracker."

"What's so magic about him?" Fritz asked. He had never seen a nutcracker shaped like a soldier, but he had seen silver ones and wooden ones with springs.

"Let me have him," he demanded. "I'll bet he can't crack every nut."

"No, you'll hurt him. Godfather, please don't give Nutcracker to Fritz."

"But I brought him for both of you my dear. There Fritz . . . and be careful. He'll crack your nuts for years, but you must not abuse him."

Thereupon Godfather Drosselmeyer turned away to speak with some older friends. Fritz held the little soldier high in the air and started putting nuts in his mouth and crushing them, one right after another. *Crack, crack, crack, crack* went the little jaws, and nut after nut fell out perfectly bitten into four pieces. Then Fritz became annoyed and took an exceptionally large and heavy hickory nut, the toughest he could find, and pushed it far back into the soldier's mouth. *Crack, crack, crack,* . . . Fritz banged the sword up and down. The nut fell out, its shell broken in four even pieces, but there was a loose, clanking sound. The little mouth fell open again, though no one had lifted the sword. Nutcracker was badly hurt.

"Fritz, you did it on purpose! You hurt him on purpose! How unhappy he looks now!"

Maria was dreadfully upset. Fritz laughed, to cover his shame, and turned away. But Maria took Nutcracker up in her arms and tried again and again to get his lower jaw into position. For Nutcracker seemed more real to her than did any of her dolls, and she felt certain he was in pain. What would she do now?

Papa Drosselmeyer had been watching her from across the room. He came over and shook his head. Gently he took up Nutcracker and tried to set the broken jaw, but it was no use.

He is badly hurt, Maria," he said. "But perhaps we can heal the wound in time. Let us bandage it well and give him some rest."

Taking a large linen handkerchief from his coat pocket, Drosselmeyer bound it firmly around the jaw, holding it in position as he did so.

"With love and good care he should recover. Now put him down and enjoy the rest of the party."

Maria went to the toy cupboard, where one of her doll's beds stood on the lowest shelf. It was just the

right size for Nutcracker. Gently, she made him comfortable in the bed, and she was not at all surprised when his eyes closed as she laid him down. He had no fever, she could tell. He could sleep now. In the morning she would come to look after him and bring him some nourishment.

Meanwhile the party had become very merry. People were laughing and talking gaily. Coming back from the cupboard, Maria saw that the presents had just been given. For each girl a handsomely dressed doll, with a doll's blanket and pillow. For each boy a little rifle, and either a drum or a fife. Soon the girls were rocking their new babies in their arms, and the boys, led by Fritz, formed into a platoon of well-drilled troops and went parading back and forth across the room. Shrill fifes pierced the air and drum rolls thundered out over all conversation. On they came, in full battle array, and suddenly making a left-march, they plunged head-on into the group of girls with their

dolls. Maria started scolding Fritz, and in two minutes there was more noise in the room than in the wild storm outside.

At length Fritz's father could tolerate it no longer. "Stop it, stop it!" he cried. "This is a party for everyone, not just for boys and girls. Come all of you and take partners. We need another dance."

Aunt Lisa sat at the square piano, and soon they were all off in a lively polka. It was great fun, and had to be followed by an easier waltz. Then the ices and rich mocha cake were served, with hot chocolate for the children. Some of the grown people had wine, and they offered toasts to each other and to Christmas itself. They stood in front of the tree and sang the carol of Christmas Night.

And then it was time to be going. Old Mrs. Gumpel was already nodding, and several boys were struggling to keep from yawning. The warm room, the rich food, and the dancing had made everyone tired. So into their winter wraps and out into the snowy night they

went, with such fond farewells that you would have thought there is no time so wonderful as Christmas time—and you would have been right.

The last to come was the last to leave. Long after the children were in their beds, Mother and Father stood in the front hall saying good-night to the lingering guests. It was getting chilly from the constant opening of the outer door. Only when everyone else had gone did Godfather Drosselmeyer appear—at the far end of the hall, not from the cloak room, although he was covered from shoulders to shoes in an immense gray fur coat. There was a crafty glint in his eye and a smile on his face.

"Well, you have made an old man feel young again," Papa Drosselmeyer said to his hosts. "What a splendid and joyous party! I have not spent a more enjoyable

evening in many a year. Truly, a spell was put upon this house tonight."

He shook hands with Dr. Stahlbaum, put on his tall fur hat, and stood on the top step. The snowstorm swirled down around him and he seemed to vanish in it like a wizard.

Days later a maid, who had come back into the empty party room that night to tidy up a bit after all the guests had gone, said she had been badly frightened by finding an old man there in the corner, bending over a doll's bed. He had a slender shining object in one hand, like a medicine dropper or a small screwdriver. When she called out to him he just raised one finger to his lips and made the sign of silence. In the dim room the maid was too startled to know if it was one of the guests—she thought it could not possibly be.

CHAPTER THREE

RANCH, CRANCH . . . CRANCH . . . THERE WAS THAT SOUND IN THE WALLS AGAIN. MARIA SAT UP IN BED, HOLDING THE QUILT AROUND HER. HOW COLD IT WAS. SHE LEANED FROM HER BED TO LOOK AT THE SKY. THE SNOW HAD STOPPED

falling and the moon had come out. She could see it glinting on the tiny, tinsel wrapper of a candy on her bed table. She had brought it up for a goodnight snack and had been too sleepy to eat it. She felt wide awake now, though she could not have slept very long, for it was deep night.

Cranch, cranch—they were louder than ever. Were they bigger mice? Or were there more of them?

She thought of the Christmas tree and of Nutcracker lying in his little bed with its thin cover. She

wished she had brought him up here. Surely she should have given him more covers, for the party room would be bitterly cold by now.

Maria slid out of bed, and into her slippers and wrapper. When she lighted her bedside candle-lamp, the sound in the walls stopped abruptly. She opened the door quietly and went down the long, dark hall towards the stairs. Maria's velvet slippers muffled her steps. The stairs were carpeted and firm and she went down them in complete silence.

Even going into the big room made no sound, for the door was ajar and she could pass through. Most of the room lay in shadow; her candle beam lighted only a narrow strip of the floor. As she came in it followed across the wall, up the tall owl-clock. It picked out the dial and then both golden hands pointing together to the owl's head on top.

The owl stirred and opened its eyes, and at that very instant, the clock spoke—a loud, deep, and hollow O-o-o-o that echoed from wall to wall. The owl raised itself up and began beating its wings. The clock struck again, and again, as Maria went on to the toy cupboard. In front of it was the doll's bed. And there was Nutcracker sound asleep. To her great joy, his mouth was peacefully closed and the bandage had slipped off. He would get well!

She started to take him up in her arms . . . and there came that sound, faintly, *cranch, cranch, cranchety-cranch.*

The sound came again, closer and louder: *cranch, cranch!* It was followed by the rattle of tiny running feet.

A mouse's face appeared under the Christmas tree, and vanished. Then another one, much nearer. Oh what a big and ugly mouse! He seemed to be getting larger and coming straight for Maria.

At this moment her candle went out. A score of wicked little mouse eyes danced around the room. Terrified, Maria threw herself on the sofa and buried her face in the pillows.

When she looked out again there was a strange dim light all over the room. She could not tell where it came from. Mice—large, fat, and nearly black mice, with long and stringy tails—were moving back and forth in a kind of planned activity, as if following orders. They had sharp, little knives like swords, and they were assembling on the side of the room opposite the toy cupboard.

Then Maria noticed the strangest thing. The mice and the sofa and the table and chairs were getting larger and larger. The Christmas tree boughs reached out into the room, the needles growing much longer, and

all the ornaments blowing out like balloons but keeping their various forms. The tinsel garlands were thick ropes of silver and gold. The doll's bed—and Nutcracker in it—were becoming nearly life-size. The room itself was expanding.

Or was Maria growing smaller and smaller? She felt the sofa rising beneath her. The seat was already about six feet from the floor. She had better get off right away. She slid down the curving leg, and touched the floor just a few feet from her doll's bed, which was now roomy enough for Maria herself. Nutcracker was gone!

The room was in a great commotion. The mice, as large as big dogs, were crowding together across the room, lining up in regular rows. One of them gave a high shriek, flourished his knife, and the whole band came charging toward the cupboard. Their wiry black feet made that scratchy sound Maria knew so well.

In another second the mice would have been upon her. But a bugle sounded, the cupboard door opened, and a troop of wooden soldiers as large as the mice rushed out to engage them. Cannons were wheeled into position, and ball after ball—red, pink, white, and blue—was sent in showers against the mice. But how strangely soft they were, more like big gumdrops. They seemed only to bounce off the fat mice's fur.

The bugle sounded again. A noble figure suddenly appeared at the head of the troops, in red trousers, blue coat, and plumed head dress. It was Nutcracker.

He had drawn his sword. He turned halfway round to the first line of troops, gave a command, and led them straight into the front ranks of the mouse army. What fierce hand-to-hand combat followed! The soldiers stood there bravely, but their tin swords were no match for the knives and sharp teeth of the mice.

Cranch, cranch, sounded the mouse battle-cry.

Nutcracker signaled again, and the second line of soldiers ran into the fight. Pausing a few feet from their huddled foes, they fell to their knees and took aim with their rifles. The savage mouse horde came

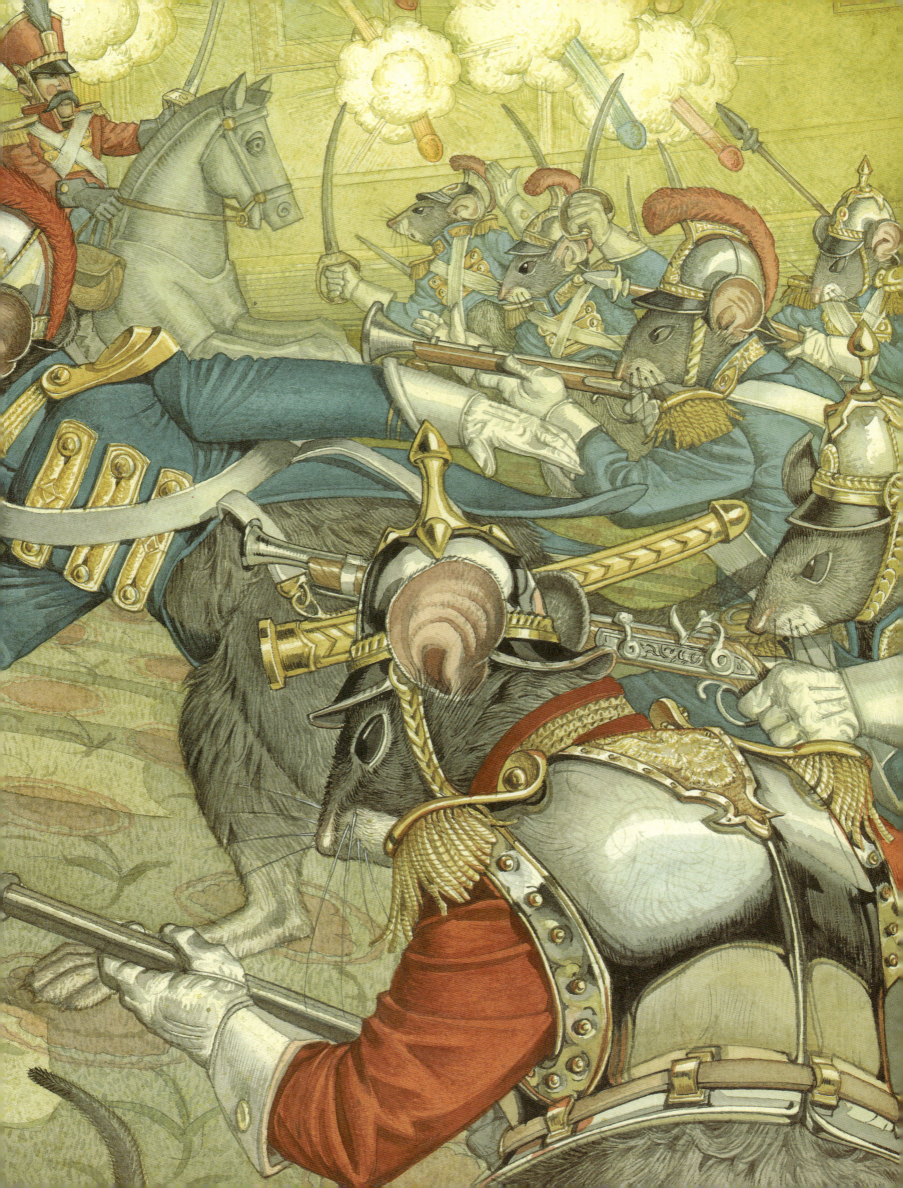

on then, eyes and teeth flashing. The riflemen fired. Their courage was not matched by arms of sufficient power, and the shots only tickled the tough skins of the mice. One or two squealed in pain. The rest were only made more angry.

Nutcracker now summoned his last defenses. The third rank came on at a run, guns lowered and sharp steel bayonets thrust forward. The mouse villains did not move and were about to be pierced through and through when they dropped on all fours. They scampered cunningly between the soldiers' legs, unbalancing many of them, which they then carried off as prisoners.

It seemed certain now that the toy cupboard, with all its treasures, would fall victim to the mouse army. At this moment a horrible creature appeared, largest of all the mice, his terrible eyes flashing from left to right, his whiskers vibrating with rage. He wore a headdress of seven crowns. He was the Mouse King. He put himself at the front of his cutthroat band, puffed himself up with pride and prepared to lead them to the cupboard.

Nutcracker, rather badly beaten, was directly in the Mouse King's path. He stood as usual, feet planted together, holding his long, strong sword.

The Mouse King had a club—black and dreadful to look at. And he had his very large, very sharp teeth.

There has never been such a strange and furious encounter. The Mouse King feigned a terrific blow with his club and then darted under his raised weapon to give his foe a savage bite. But Nutcracker was made of iron, and the Mouse King hurt his teeth so severely that he became enraged. Taking his black club in both hands, he began beating Nutcracker mercilessly. But the brave soldier warded off the club with his sword. Quickly, Nutcracker followed that with a sharp thrust at his enemy's fat belly.

But for all his fatness, the Mouse King was the quickest of the mice, and so expert at twisting and dodging and leaping and ducking this way and that,

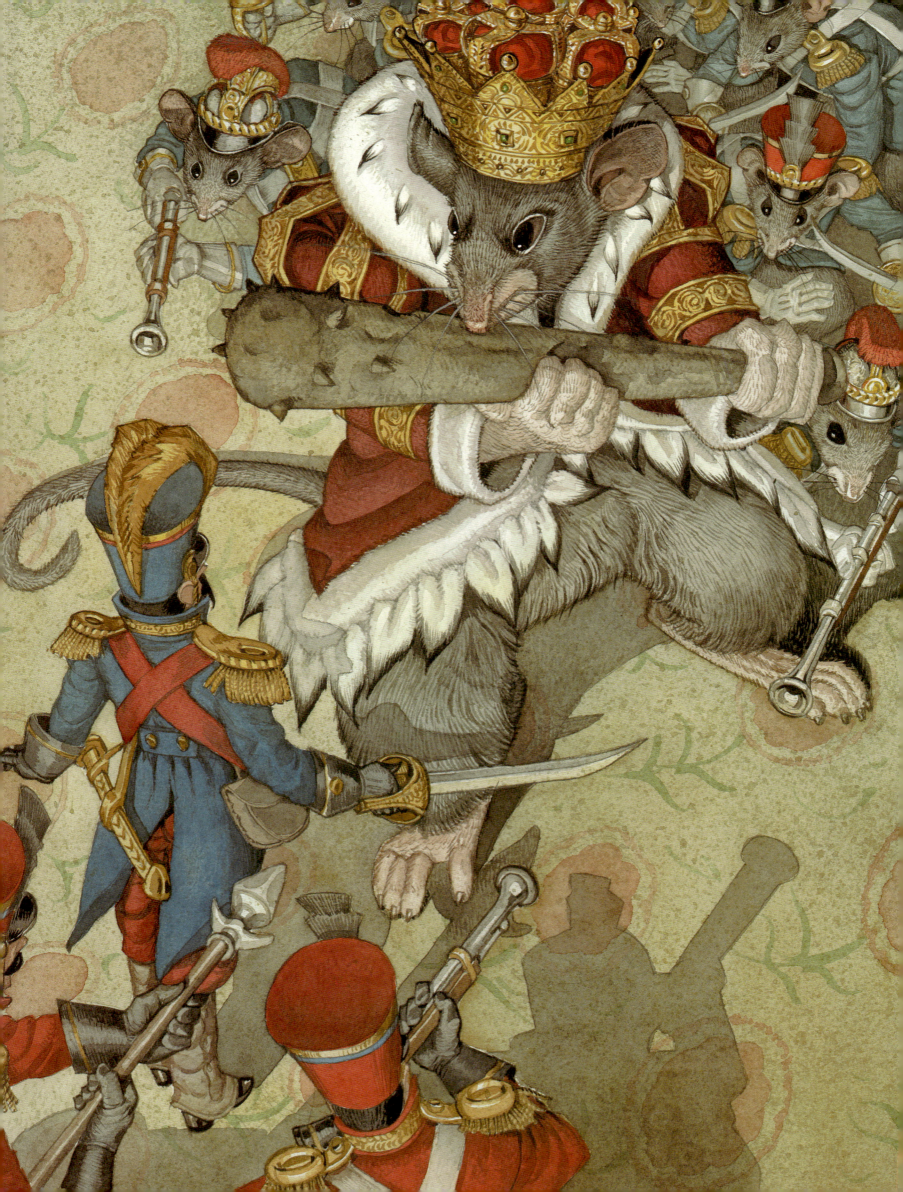

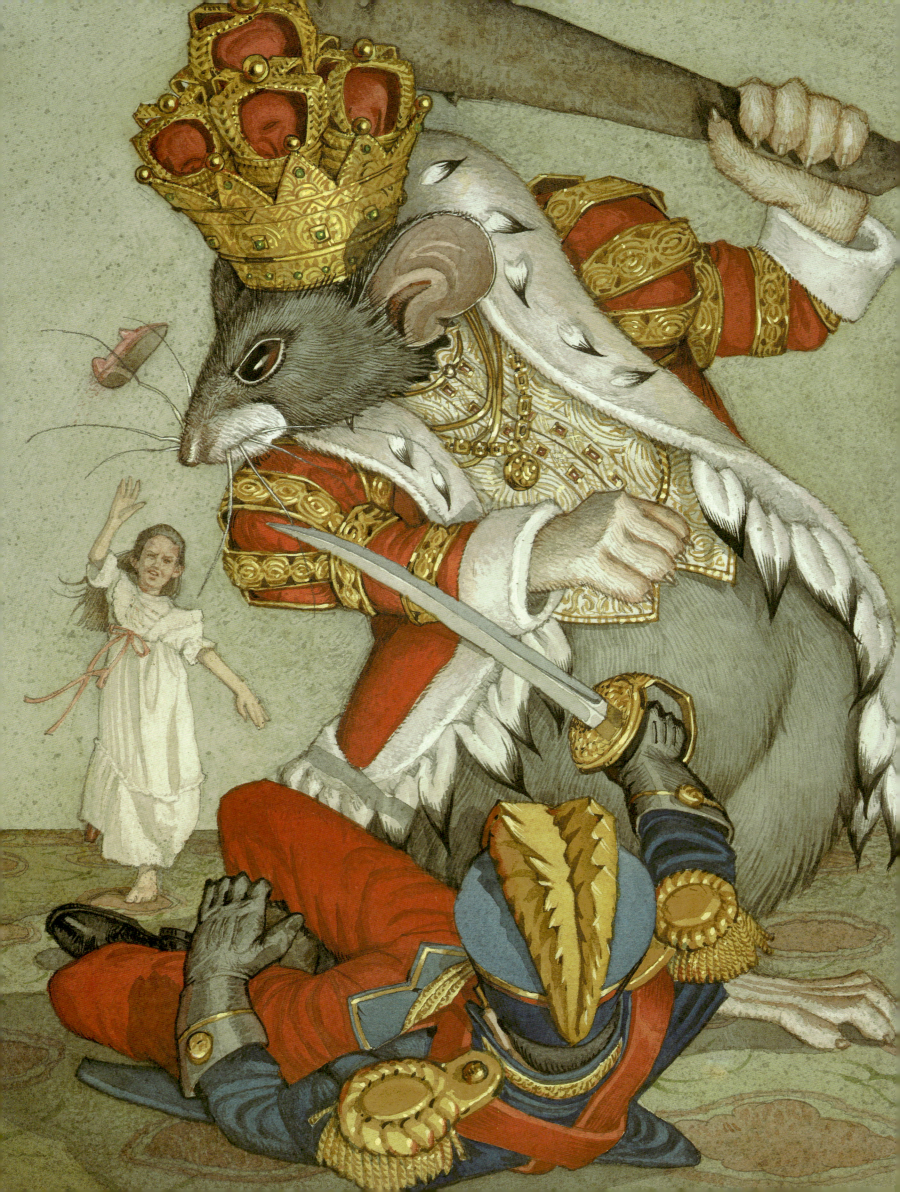

that Nutcracker could barely touch him lightly here and there. All the time he had to fend off the blows of that terrible club. Down, down, the blows kept falling on Nutcracker's head and shoulders.

Maria had been watching the combat from her place at the sofa. She saw that Nutcracker could not last much longer. But she had no gun and no sword. What could she do? Her fear for Nutcracker made her both cunning and bold. She took off one velvet slipper. No longer afraid, she ran up to the Mouse King, and as he lifted his club high over his head, she threw the slipper right in his face.

Astonished and enraged, the Mouse King deserted his opponent and raced after Maria. And that was just what she wanted. Immediately, Nutcracker came up behind the Mouse King and struck down the monster

with his sword. Maria bounced into her doll's bed. She was not hurt at all.

Nutcracker stood perfectly still for a moment. He was overcome with weariness and relief. His deep-drawn breathing was the only sound in the entire room—or was it the thudding of his heart? He put away his sword. Suddenly he toppled over, without bending, like a toy.

The horde of mice, who had thought their monarch invincible, fell down in grief and terror at his death. In another moment they gathered up his swollen body in their arms, and fled. You could hear the scampering of their wiry feet, even after the last one had disappeared. Where they went, or how they went, is a mystery. All we know is that their wicked little eyes were never seen in that house again.

CHAPTER FOUR

✦

UTCRACKER STIRRED AND OPENED HIS EYES. HE RAISED HIMSELF ON ONE ARM. THEN HE STOOD UP, RESTORED. RESTORED NOT ONLY TO HIS FULL STRENGTH BUT TO HIS TRUE SELF. HE WAS NO LONGER DRESSED LIKE A SOLDIER; HE WAS

no longer made of iron; he no longer had a moustache and a high-arched nose. He was a handsome youth dressed in long, blue hose, a jacket and slippers of silver, and a little cloak lined with crimson. His hair was cut close, of a ruddy blond color almost matching his belt and scabbard of gold. Only his gentle eyes had not changed. They were as deep and round and confident as before.

Nutcracker crossed to the far corner of the room and found the velvet slipper that had saved his life,

and then to the opposite side, where Maria's wrapper hung over the foot of the bed. He put the wrapper around her and the slipper on her foot.

"Is it you, Nutcracker?" Maria said, so astonished she could only stand and stare. "What does it all mean?"

He smiled at her very tenderly.

"It means," he said, "that the spell has been broken. I was a young boy who did not appreciate his good fortune. I had health and friends and work to do—but I was so foolish as to be discontented and to complain

of this and that all the time. An enchanter deprived me of speech and turned me into a nutcracker so that my mouth would no longer whine, but would serve some kind of purpose until I should learn to be glad of living and being of use. The spell would only be broken when someone realized how much I had changed and believed that I had a new heart under my funny costume of painted iron. It was you, Maria, who broke the enchantment—or rather, completed it. For you see, it was a lucky enchantment, since now I do know that it is good and wonderful to be alive."

The room became illuminated as the moon began to shine on the snow outside the window. It shone on Maria's slipper and on the golden sword at Nutcracker's side. It shone on all the twinkling ornaments on the Christmas tree.

"What is your real name?" Maria asked.

"My name is Prince Nikita, but now I like Nutcracker better."

"And what are you going to do now?"

"I think I shall go on being a nutcracker," he said. "That is as good a job as any, at least for a while."

"But if you are a prince you must live far away, Nutcracker. Will you go there?"

"No, I want to stay here with you, Maria. Where I live is quite far away, if you think it is far away. But it is only a few steps really. Come, I will show you."

One of the tall French windows blew open. Nutcracker lifted his beautiful sword and walked out into the night. Maria was spellbound for a moment. And then as she was about to rise and follow him, her little bed began to move like a sleigh toward the window. She tucked the wrapper and coverlet close around her. She was quite warm. Without a sound her bed glided on, under the yellow curtains, through the window, and out of doors.

Have you ever been in a forest in deep winter? With the snow frozen so hard that you can walk on it's glassy surface, and green fir and pine trees wearing edgings

of snow like white fur? With little tracks of rabbits and birds criss-crossing on the white floor, and tiny crystals of ice blinking on and off like winter fireflies? When it is so still that you can hear the least movement of twig or shifting snow?

Through such a forest Maria found herself moving in her sleighbed. Nutcracker strode on ahead, his red cloak like a beckoning torch. It was no longer night, and it was snowing again—large flakes that circled

around the bed and came rushing toward it in a great throng at every new turn in the path. Then Maria saw what she had only glimpsed from the window hours ago—the Snow Fairies soaring through the air and dancing down the aisles of the forest. They were extraordinarily lovely with their costumes of silver hoarfrost and diadems of snowflakes more brilliant than diamonds. They surrounded the sleigh-bed, whirling and leaping so close together that it was quite

dizzying. Then at the height of their wild dance, the forest and all its spirits seemed to melt into air.

The snow was gone. The path had become a little canal of water bordered with green plants and colorful flowers. The bed was a boat upon it. Far down the canal, Maria could see a flight of stairs at one side, with Nutcracker waiting on the lowest step. As the little boat-bed drew up, he stepped aboard beside Maria, and they sailed on.

In the distance, a castle seemed to rise out of the water. It gleamed like a giant party cake. Its walls were made of icing; over the windows were candy flowers; and peppermint stripes spiraled up the tall towers. At intervals stood statues carved out of marzipan.

An archway of golden taffy spanned the canal, and under it the boat glided into the castle. It stopped at a flight of broad steps, in a great hall made entirely of rock candy in soft pinks and yellows. A stately lady

dressed in gleaming white satin stood at the top of the stairs to receive them, and beyond were many men and women dressed as if for a ball.

Nutcracker said the lady was the Sugar Plum Fairy and that this was the Fortress of Sweets. He introduced Maria, and then he told everyone how Maria had saved his life and broken the magic spell. Everyone said she had been very brave.

The Sugar Plum Fairy escorted the two children to a table overlooking the rock-candy hall. People brought in many delicious and unusual foods. For, after their battle with the mice and their trip through the forest, Nutcracker and Maria were very hungry. Each kind of refreshment was so prettily decorated that you could not tell just what it was. But it was better than ice cream, or cherry pie, or any birthday cake.

While they were eating this delectable feast, the court entertained them with music and a series of dances, each representing something good to eat or drink. Two women in ruffled skirts and two men in

flaring trousers did the dance of Chocolate, which was really a Spanish dance because so much chocolate comes, or used to come, from Spain.

A stern Arab did a slow and rather sleepy dance on a rug. The music and his languid movements made you see the hot and lonely desert at night. Servants gave him tiny cups of coffee now and then, for the Arabians are great coffee drinkers.

Two Chinese girls brought in a big box of bamboo, like a tea chest. Out of it vaulted two Asian acrobats. Around and around the candy hall they turned cartwheels and flip-flops. One of them vaulted right over the table where Nutcracker and Maria were sitting. This dance was called the Dance of Tea, because the Chinese love that drink especially.

Next came a number of muscular young men dressed in red and white stripes, and carrying hoops. This was a dance of great agility and speed. The men seemed to fly through the air as they dove through their whirling hoops. It was the most brilliant dance of all.

The music changed to an airy and soaring waltz. A troop of dancers looking like flowers floated softly down from balconies and windows between the clear-sugar columns. They danced as if borne up by a breeze, and made you think of a mountain meadow. Finally, like dandelion seeds, they were wafted up, one after the other, and out between the columns.

But now came the most amusing one. How Fritz would have like it! A very tall woman came jerkily in, wearing the most tremendous skirt, like a huge round candy box. Suddenly she lifted one part of her skirt, and out came the tiniest children, who tumbled and tripped about, just like dainty bonbons. They were dressed in pink and lavender, pale green and yellow, and there were so many of them! But somehow they all managed to crowd back under the big skirts again, and the candy-box lady sidled off.

Now the Sugar Plum Fairy came forward with a handsome man to show what they could do.

And this was best of all, dancing so wonderful that Nutcracker and Maria forgot their caramel sherbet and sat enraptured.

Only a dancer could describe the grandeur and charm of those figures, responding to the music in perfect unison, creating a pattern of motion that seemed to fill the vast room with advances and retreats, vigor and grace, till you were hypnotized by its splendor. At the climax the Sugar Plum Fairy spun like a top at a furious speed all the length of the room and was caught and lifted up triumphantly by her partner.

When the applause had subsided the dancers smiled and beckoned for Nutcracker and Maria to come down. All of the court gathered around, and the children thanked them, bowing low.

CHAPTER FIVE

As Maria raised her head she knew that the court was not there. The light was different and the ballroom floor was the quilt of her bed at home. She opened her eyes wide. The clear light of the morning was streaming into her room. An icicle glittered outside the window pane, and beyond, the sky was intensely blue. There was a faint smell of toast and coffee from downstairs.

Then she saw, near the fireplace, her doll's bed. And Nutcracker lying in it, in his General's uniform. He seemed to have just awakened, too, and he was looking right at her. She thought that he smiled.

The door to the hall opened, and Maria's mother came in with a tray of food.

"How late you have slept! And on Christmas morning! The storm is over, and the whole world is washed clean. You never saw such a beautiful Christmas Day."

She came over and kissed Maria.

"I've brought you breakfast in bed, for we are all through downstairs. . . . Are you feeling well?"

"Yes, Mother, I am, and thank you for breakfast. What a party it was! . . . I was so excited I don't remember bringing Nutcracker upstairs."

"No, darling, I brought him up early this morning. And one of your slippers. The big room was in such a state . . . there were gumdrops all over the floor!"

"Mother, is Godfather Drosselmeyer a magician?"

"Of course not. He is just a clever and ingenious man who is very fond of you."

"But how did he bring Nutcracker alive?"

"If Nutcracker came alive, it was because you like him so well. If you love something very much it is always alive. . . . What a funny child you are today! Now get washed and dressed and have your breakfast. I'll light the fire."

The End